A Year in Art

A PAINTING A DAY

In cooperation with

ARTOTHEK

Prestel

Munich · Berlin · London · New York

© Prestel Verlag,
Munich · Berlin · London · New York 2006, second edition 2007

© of works illustrated by the artists, their heirs or assigns with the exception of:
Max Beckmann, Marc Chagall, Giorgio de Chirico, Wassily Kandinsky,
René Magritte and Jasper Johns by VG Bild-Kunst, Bonn 2007;
Frida Kahlo by Banco de México Diego Rivera & Frida Kahlo Museums Trust. Av. Cinco de
Mayo No. 2, Col. Centro, Del. Cuauhtémoc 06059, México, D.F.;
Ernst Ludwig Kirchner by Ingeborg and Wolfgang Henze-Ketterer Wichtrach/Bern;
Joan Miró by Successió Miró / VG Bild-Kunst, Bonn 2007;
Pablo Picasso by Succession Picasso / VG Bild-Kunst, Bonn 2007
Photo credits: see last page

Prestel Verlag
Königinstrasse 9, 80539 Munich
Tel. +49 (89) 38 17 09-0
Fax +49 (89) 38 17 09-35

Prestel Publishing Ltd.
4, Bloomsbury Place, London WC1A 2QA
Tel. +44 (20) 7323-5004
Fax +44 (20) 7636-8004

Prestel Publishing
900 Broadway, Suite 603
New York, N.Y. 10003
Tel. +1 (212) 995-2720
Fax +1 (212) 995-2733
www.prestel.com

Library of Congress Control Number: 2006904282

British Library Cataloguing-in-Publication Data
A catalogue record for this book is available from the British Library.

The Deutsche Bibliothek holds a record of this publication in the
Deutsche Nationalbibliografie; detailed bibliographical data can be found under:
http://dnb.ddb.de

Prestel books are available worldwide. Please contact your nearest bookseller or
one of the above addresses for information concerning your local distributor.

Editorial direction by Claudia Stäuble
Copyedited by Reegan Finger & Curt Holtz
Cover and layout concept by LIQUID, Augsburg
Production by René Güttler & Maja Kluy
Typesetting by Vornehm, Munich
Origination by Repro Ludwig, Zell am See
Printing and binding by Print Consult, Munich

Printed on acid-free paper

ISBN: 978-3-7913-3624-4

Painting is just another way of keeping a diary.

PABLO PICASSO

With an apple
I will astonish Paris.

Paul Cézanne

Still Life with Drapery, 1894–95
Paul Cézanne
The State Hermitage Museum, St. Petersburg

1 2 3 4 5 6 7 8 9 10 11 12 13 14 15 16 17 18 19 20 21 22 23 24 25 26 27 28 29 30 31

JANUARY

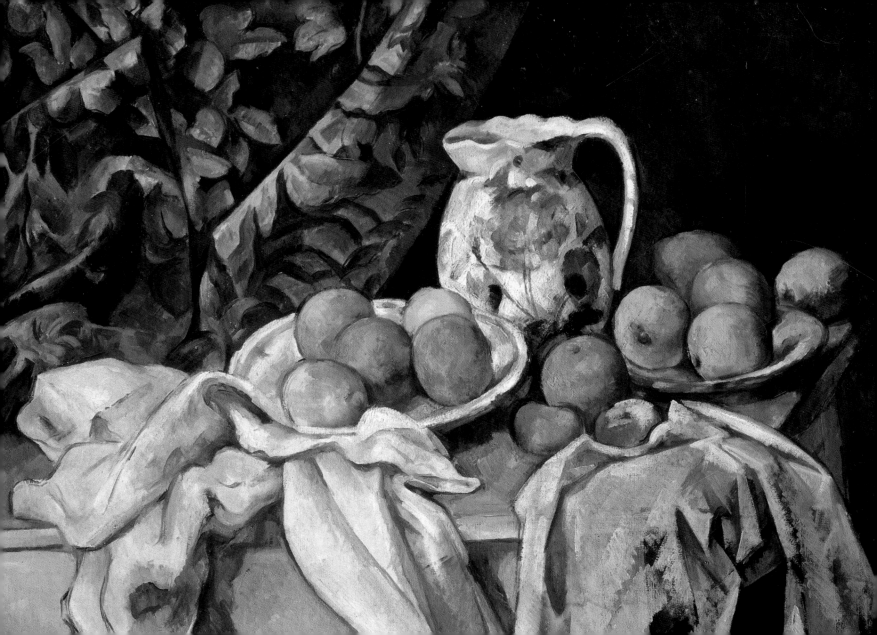

*Anyone of sound reason
considers Titian peerless
in the portrayal of the
female body.*

CARLO RIDOLFI

Venus of Urbino, 1538
Titian
Uffizi Gallery, Florence

1 2 3 4 5 6 7 8 9 10 11 12 13 14 15 16 17 18 19 20 21 22 23 24 25 26 27 28 29 30 31

JANUARY

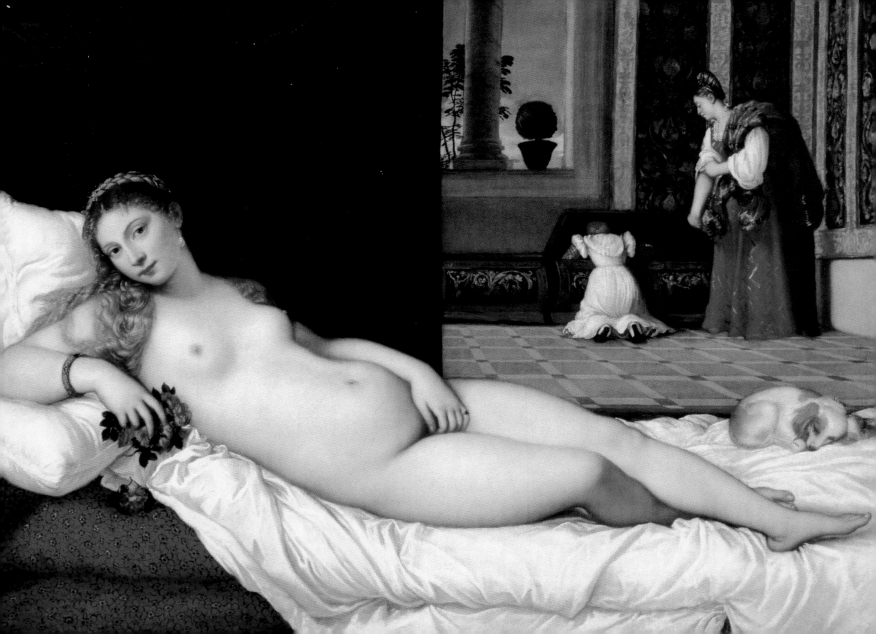

What land is this? You pretty town
of Delft, with all its wares displayed:
The pride, the market-place, the crown
And centre of the potter's trade.

Henry Wadsworth Longfellow

View of Delft, *c.* 1660
Johannes Vermeer
Mauritshuis, The Hague

1 2 **3** 4 5 6 7 8 9 10 11 12 13 14 15 16 17 18 19 20 21 22 23 24 25 26 27 28 29 30 31

JANUARY

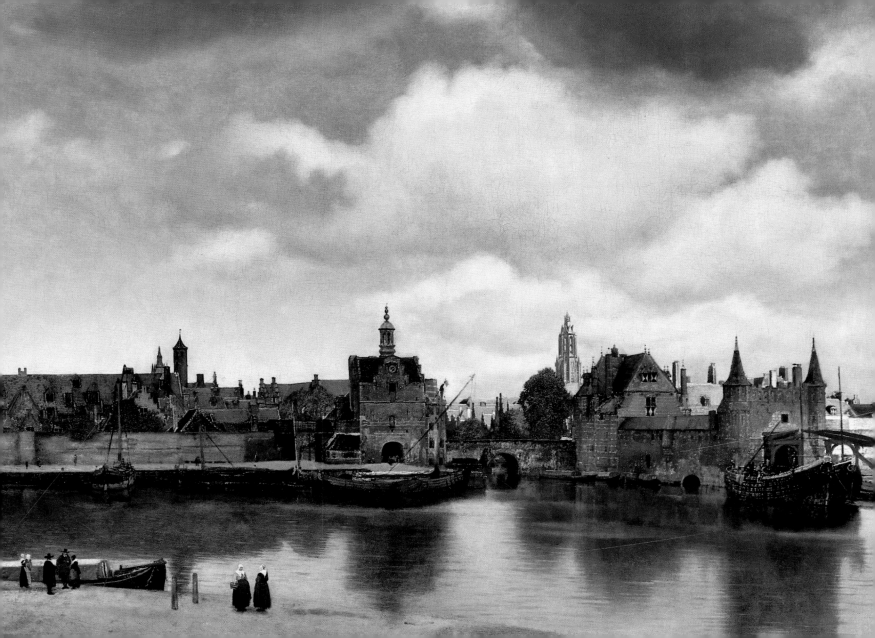

You can't be at the pole and the equator at the same time. You must choose your own line, as I hope to do, and it will probably be color.

Vincent van Gogh

L'Arlésienne:
Madame Joseph-Michel Ginoux with Books, 1888–89
Vincent van Gogh
The Metropolitan Museum of Art, New York

1 2 3 **4** 5 6 7 8 9 10 11 12 13 14 15 16 17 18 19 20 21 22 23 24 25 26 27 28 29 30 31

JANUARY

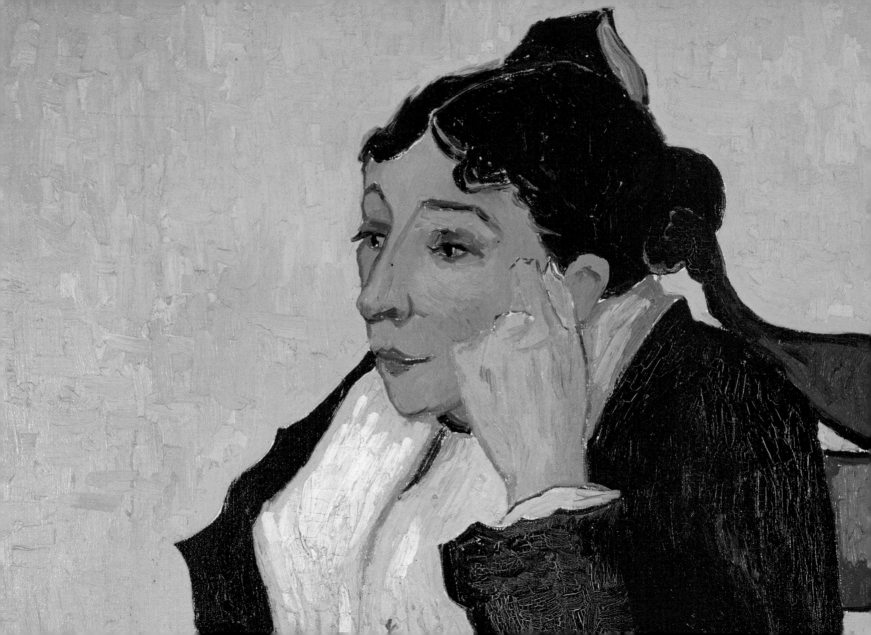

When they saw the star, they rejoiced with exceeding great joy. And when they came into the house, they saw the young child with Mary his mother, and fell down, and worshipped him: and when they had opened their treasures, they presented unto him gifts; gold, and frankincense and myrrh.

THE GOSPEL OF ST. MATTHEW, 2:10-11

The Adoration of the Magi in the Snow, 1567
Pieter Brueghel the Elder
Oskar Reinhart Collection, Winterthur

1 2 3 4 **5** 6 7 8 9 10 11 12 13 14 15 16 17 18 19 20 21 22 23 24 25 26 27 28 29 30 31

JANUARY

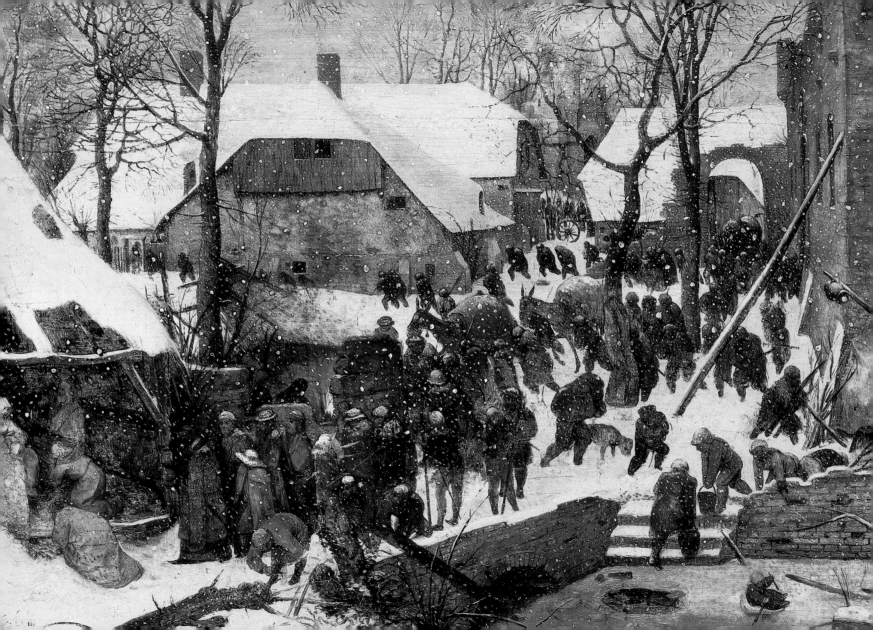

Ring out, ye crystal spheres,
Once bless our human ears,
And let your silver chime
Move in melodious time;
And let the base of heaven's deep organ blow,
And with your ninefold harmony
Make up full consort to the angelic symphony.

JOHN MILTON

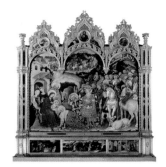

Adoration of the Magi, 1423
Gentile da Fabriano
Uffizi Gallery, Florence

1 2 3 4 5 **6** 7 8 9 10 11 12 13 14 15 16 17 18 19 20 21 22 23 24 25 26 27 28 29 30 31

JANUARY

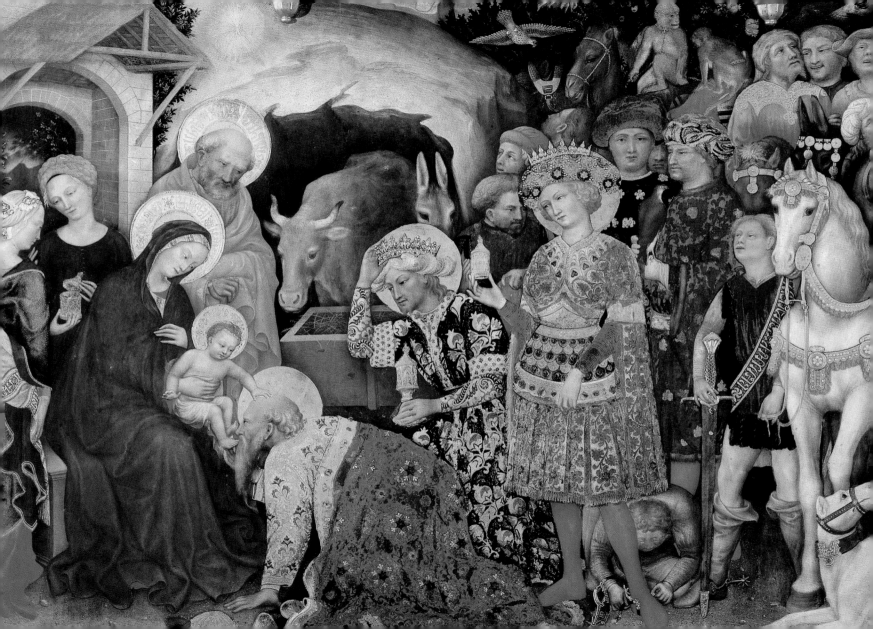

In the bleak midwinter,
Frosty wind made moan,
Earth stood hard as iron,
Water like a stone;
Snow had fallen, snow on snow,
Snow on snow,
In the bleak midwinter,
Long ago.

Christina G. Rossetti

The Road to Louveciennes, 1872
Camille Pissarro
Musée d'Orsay, Paris

1 2 3 4 5 6 **7** 8 9 10 11 12 13 14 15 16 17 18 19 20 21 22 23 24 25 26 27 28 29 30 31

JANUARY

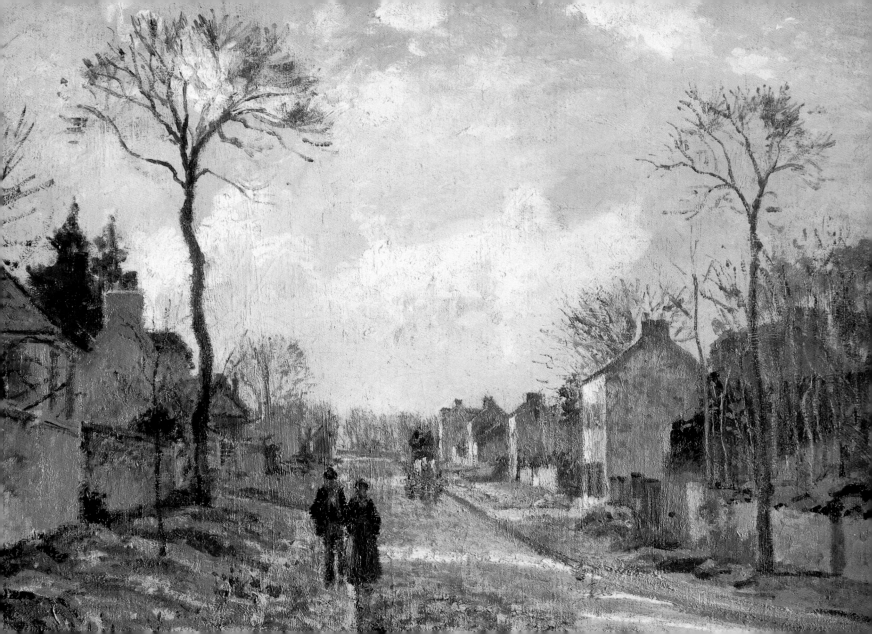

O Winter! Ruler of the inverted year …
I crown thee king of intimate delights,
Fireside enjoyments, home-born happiness,
And all the comforts that the lowly roof
of undisturb'd retirement, and the hours
of long uninterrupted evening, know.

WILLIAM COWPER

Breakfast, 1646
Pieter Claesz
The State Hermitage Museum, St. Petersburg

1 2 3 4 5 6 7 **8** 9 10 11 12 13 14 15 16 17 18 19 20 21 22 23 24 25 26 27 28 29 30 31

JANUARY

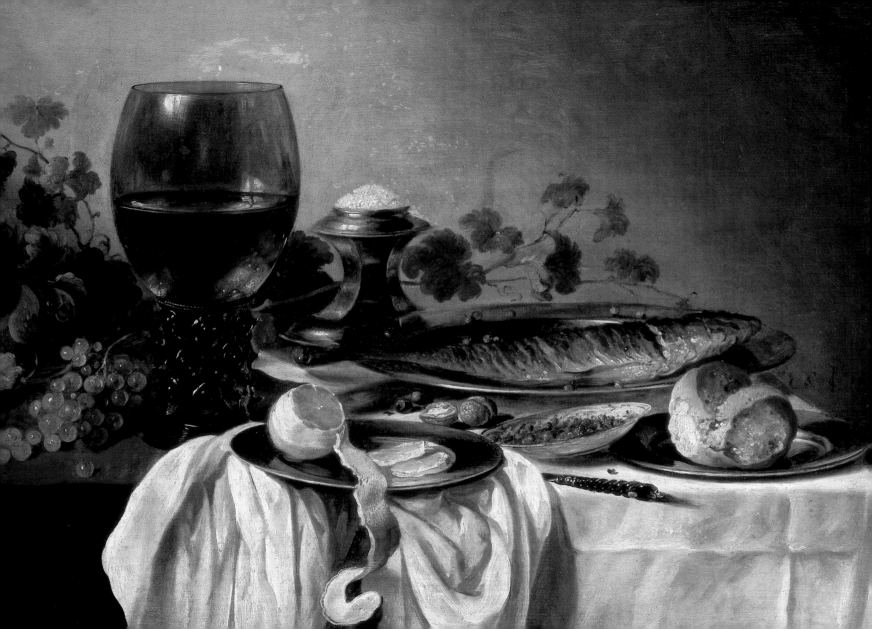

*An artist is not paid
for his labor
but for his vision.*

JAMES MCNEILL WHISTLER

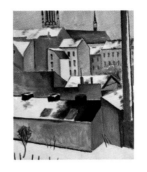

The Church of Our Lady in the Snow, 1911
August Macke
Kunsthalle, Hamburg

1 2 3 4 5 6 7 8 **9** 10 11 12 13 14 15 16 17 18 19 20 21 22 23 24 25 26 27 28 29 30 31

JANUARY

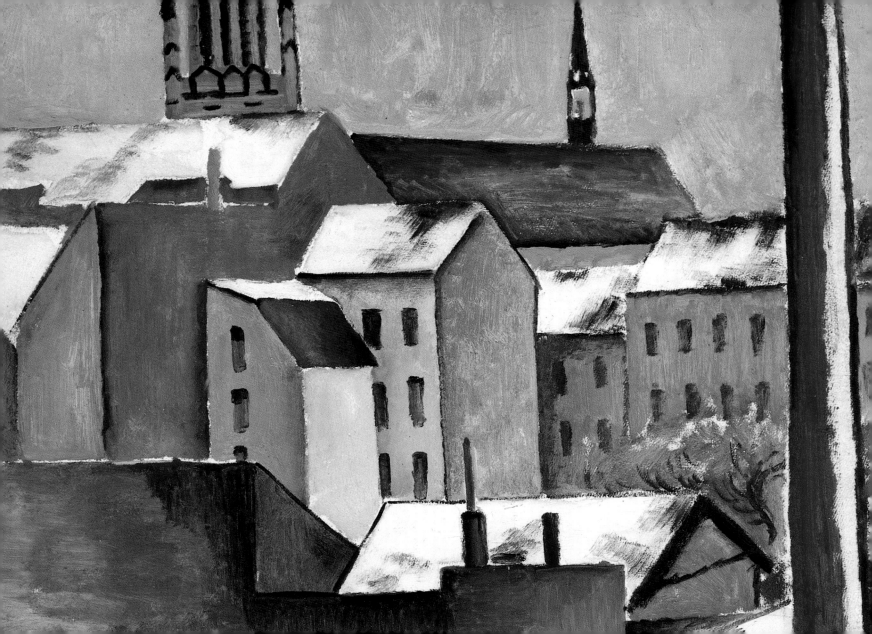

*Children and mothers
never truly part—
Bound in the beating
of each other's heart.*

CHARLOTTE GRAY

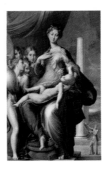

Madonna with the Long Neck, 1534–40
Parmigianino
Uffizi Gallery, Florence

1 2 3 4 5 6 7 8 9 **10** 11 12 13 14 15 16 17 18 19 20 21 22 23 24 25 26 27 28 29 30 31

JANUARY

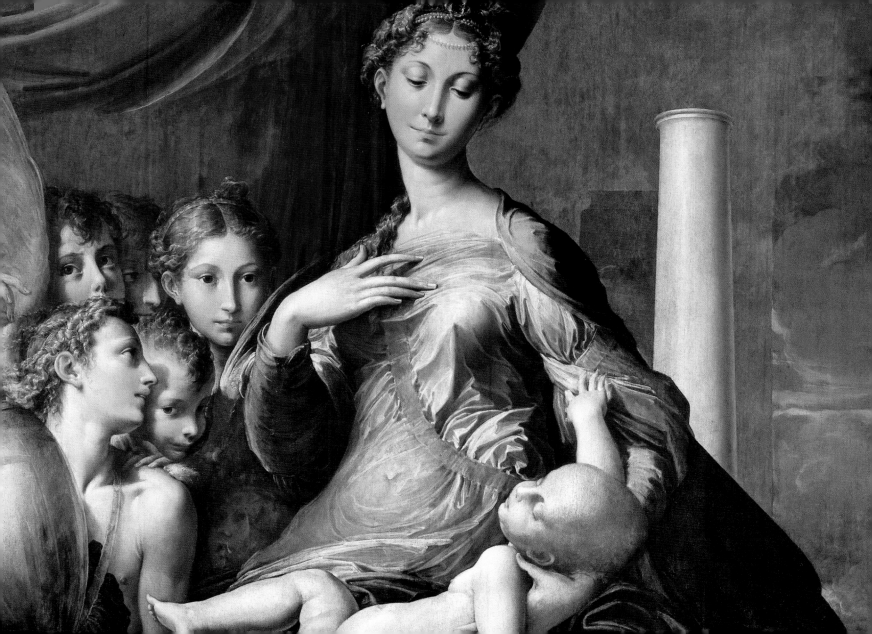

Life is short, art eternal.

Hippocrates

**The Middle-Class Patrician
Sons in Nuremberg,** 1561
Jost Amann
Bayerisches Nationalmuseum, Munich

1 2 3 4 5 6 7 8 9 10 **11** 12 13 14 15 16 17 18 19 20 21 22 23 24 25 26 27 28 29 30 31

January

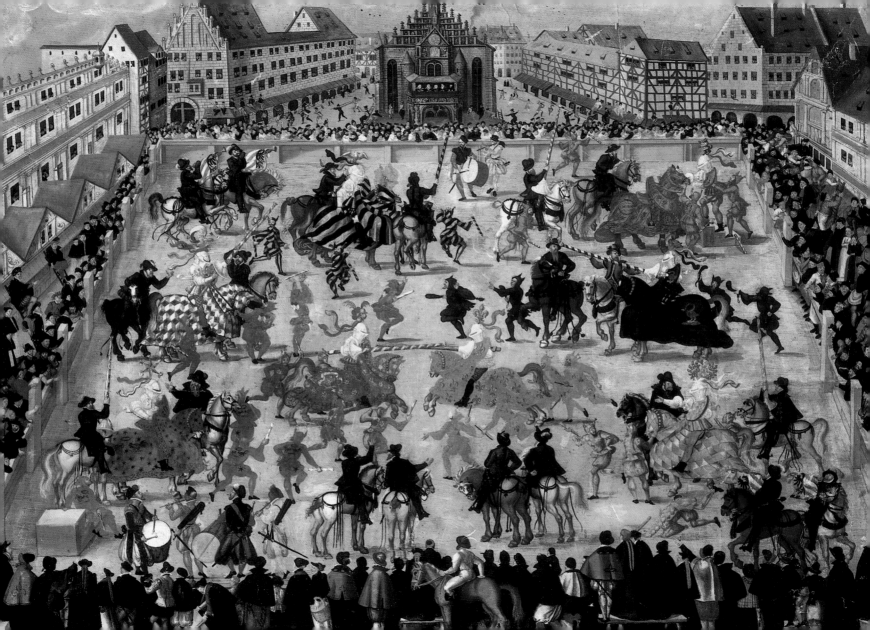

*He who teaches children
learns more than they do.*

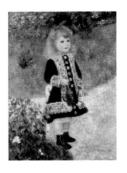

A Girl with a Watering Can, 1876
Pierre-Auguste Renoir
National Gallery of Art, Washington D.C.

1 2 3 4 5 6 7 8 9 10 11 **12** 13 14 15 16 17 18 19 20 21 22 23 24 25 26 27 **28 29** 30 31

JANUARY

For it is in giving that we receive.

ST. FRANCIS OF ASSISI

The Queen of Sheba before Solomon, c. 1435–37
Konrad Witz
Gemäldegalerie, Berlin

1 2 3 4 5 6 7 8 9 10 11 12 **13** 14 15 16 17 18 19 20 21 22 23 24 25 26 27 28 29 30 31

JANUARY

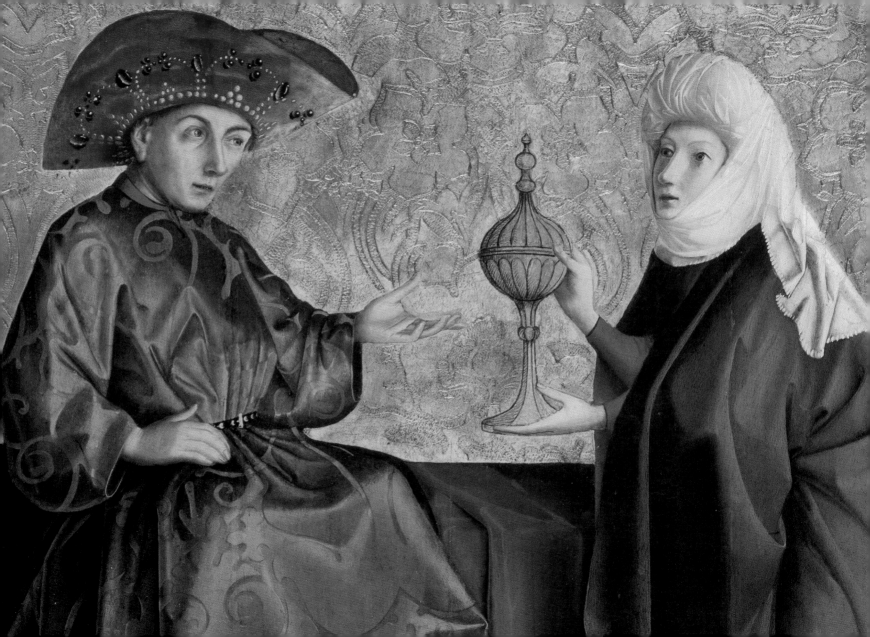

Independence is happiness.

Salome, 1906
Franz von Stuck
Lenbachhaus, Munich

1 2 3 4 5 6 7 8 9 10 11 12 13 **14** 15 16 17 18 19 20 21 22 23 24 25 26 27 28 29 30 31

JANUARY

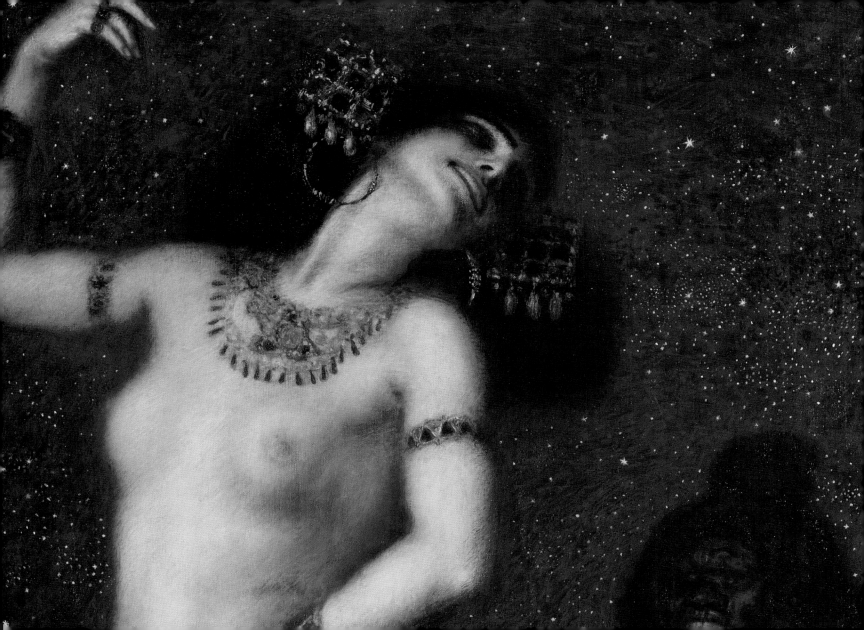

The ornament of a house
is the friends who frequent it.

<small>RALPH WALDO EMERSON</small>

Monkeys in a Kitchen, 1640
David Teniers
The State Hermitage Museum, St. Petersburg

1 2 3 4 5 6 7 8 9 10 11 12 13 14 **15** 16 17 18 19 20 21 22 23 24 25 26 27 28 29 30 31

JANUARY

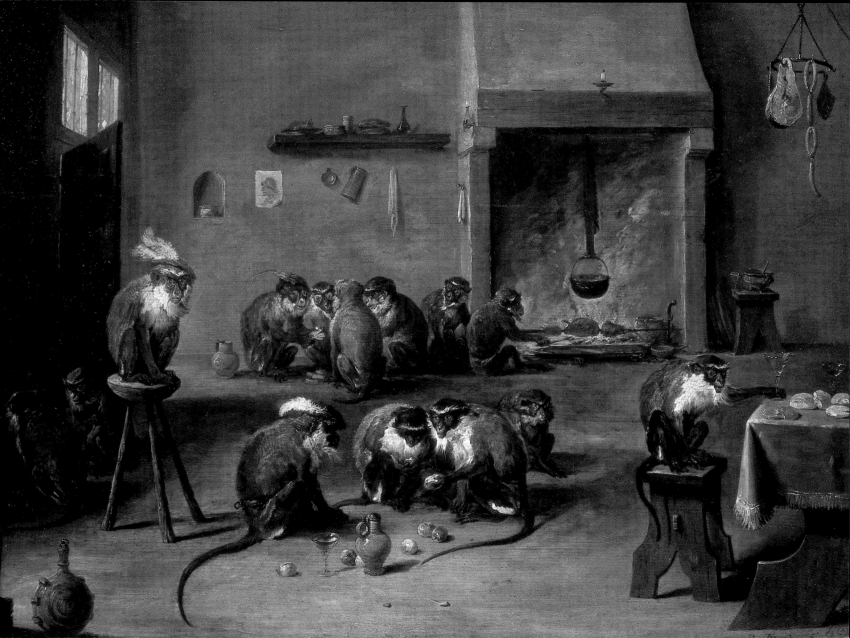

Knowing others is intelligence;
knowing yourself is true wisdom.
Mastering others is strength;
mastering yourself is true power.

LAO TZU

Okazaki, Plate 39 from the Series
"Fifty-three Stations of the Tokaido," *c.* 1833–34
Utagawa Hiroshige
Private Collection

1 2 3 4 5 6 7 8 9 10 11 12 13 14 15 **16** 17 18 19 20 21 22 23 24 25 26 27 28 29 30 31

JANUARY

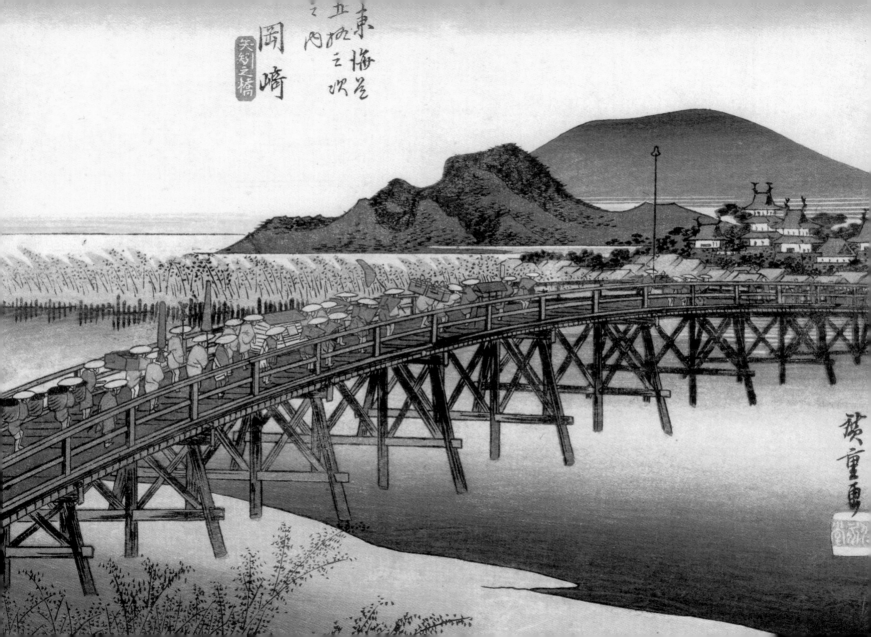

Objects speak: they possess will and form,
why should we interrupt them! We have nothing
sensible to say to them. Haven't we learned in the
last thousand years that the more we confront
objects with the reflection of their appearance,
the more silent they become?

FRANZ MARC

Haystacks in the Snow, 1911
Franz Marc
Franz Marc Museum, Kochel am See

1 2 3 4 5 6 7 8 9 10 11 12 13 14 15 16 **17** 18 19 20 21 22 23 24 25 26 27 28 29 30 31

JANUARY

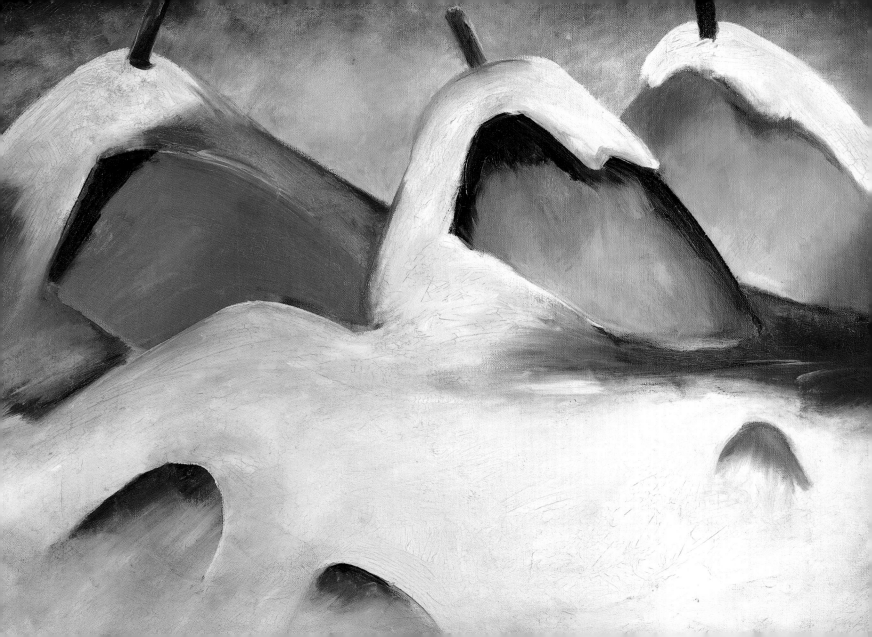

Make no mistake, my friend,
it takes more than money
to make men rich.

A. P. GOUTHEY

The Money Changer and his Wife, 1514
Quentin Massys
Musée du Louvre, Paris

1 2 3 4 5 6 7 8 9 10 11 12 13 14 15 16 17 **18** 19 20 21 22 23 24 25 26 27 28 29 30 31

JANUARY

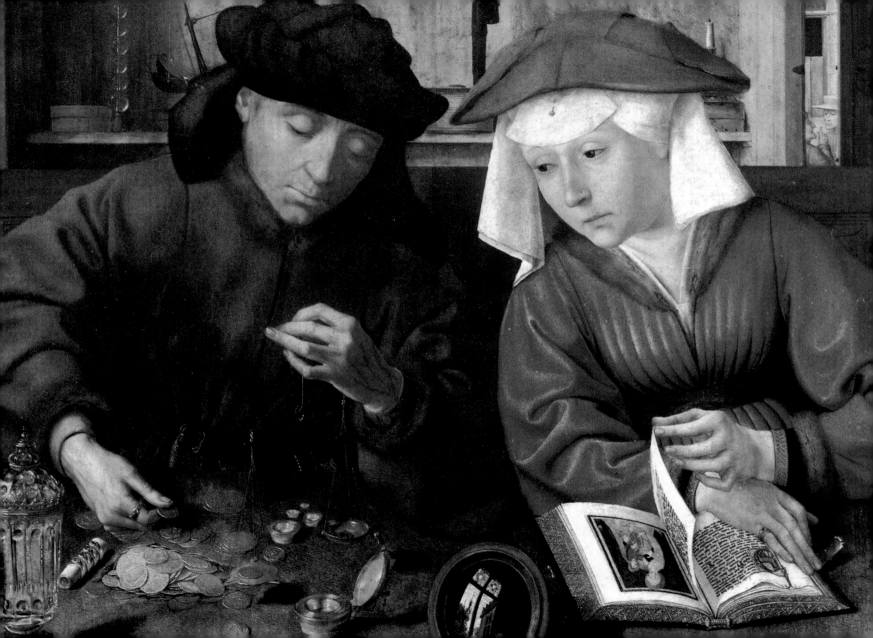

*A work of art must not be something
that leaves the viewer unmoved …
something passed by with a casual glance.
It has to be moving, make the viewer react,
feel strongly, start creating too … if only
in the imagination.*

GUSTAV KLIMT

The Virgin, 1913
Gustav Klimt
National Gallery, Prague

1 2 3 4 5 6 7 8 9 10 11 12 13 14 15 16 17 18 **19** 20 21 22 23 24 25 26 27 28 29 30 31

JANUARY

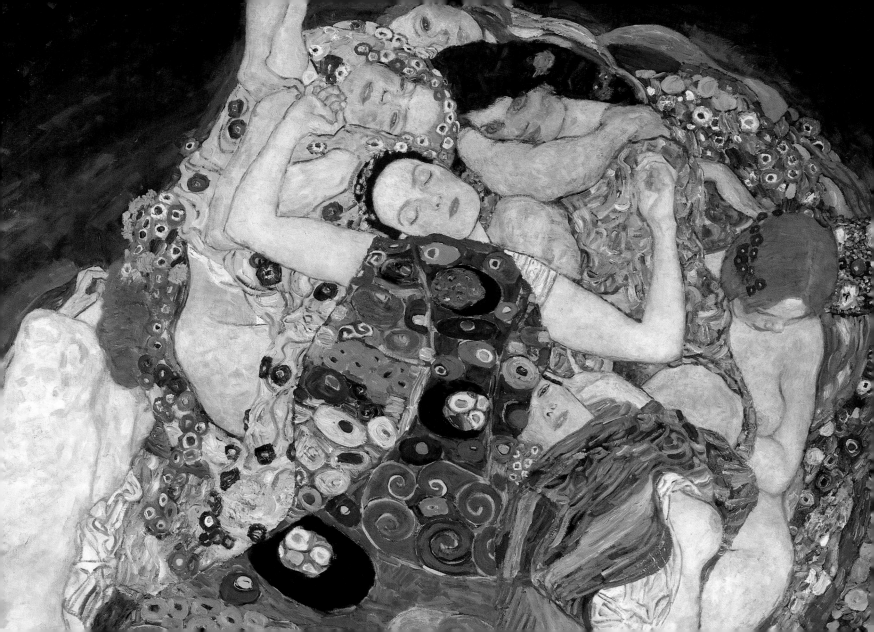

The ice was here, the ice was there,
The ice was all around;
It cracked and growled, and roared and howled,
Like noises in a swound!

Polar Ice, 1904
Alexander Borisov
Art Museum, Nizhny Novgorod

1 2 3 4 5 6 7 8 9 10 11 12 13 14 15 16 17 18 19 **20** 21 22 23 24 25 26 27 28 29 30 31

JANUARY

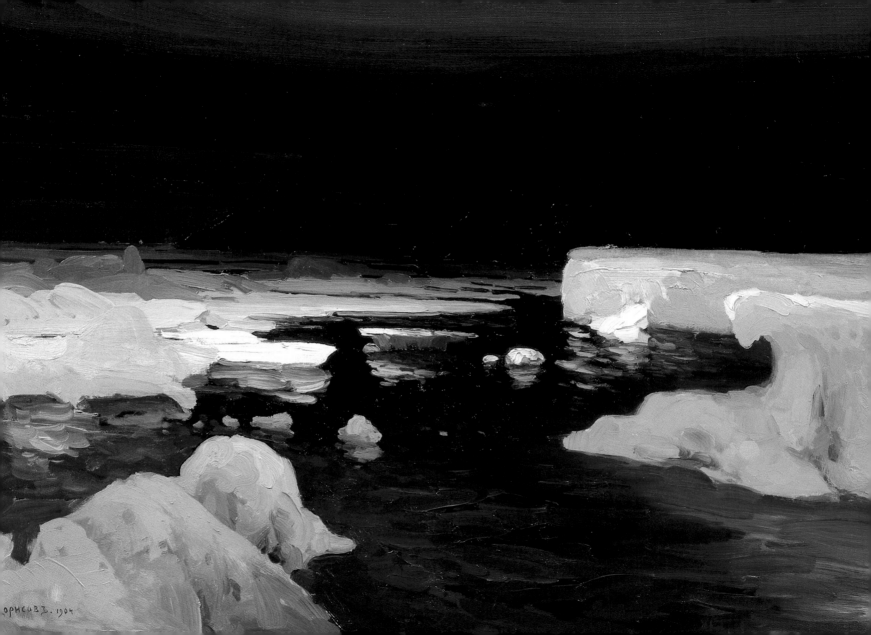

I believe that the reason
why I love painting so much
is that it forces one to be objective.
There is nothing I hate more
than sentimentality.

MAX BECKMANN

Actors, 1942
Max Beckmann
Fogg Art Museum, Cambridge

1 2 3 4 5 6 7 8 9 10 11 12 13 14 15 16 17 18 19 20 **21** 22 23 24 25 26 27 28 29 30 31

JANUARY

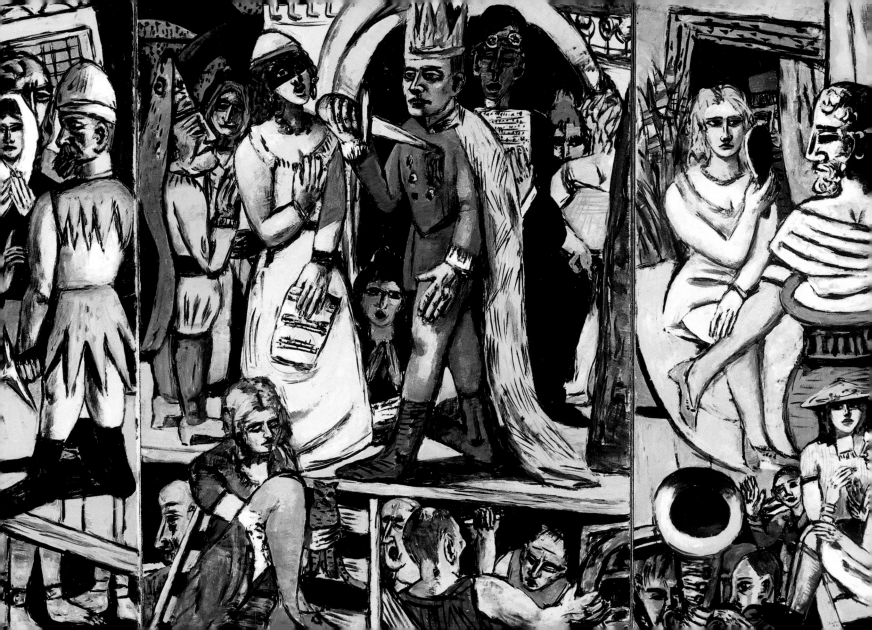

Mirror, mirror on the wall,
who's the fairest one of all?

THE GRIMM BROTHERS

Young Woman at her Toilet, 1515
Giovanni Bellini
Kunsthistorisches Museum, Vienna

1 2 3 4 5 6 7 8 9 10 11 12 13 14 15 16 17 18 19 20 21 **22** 23 24 25 26 27 28 29 30 31

JANUARY

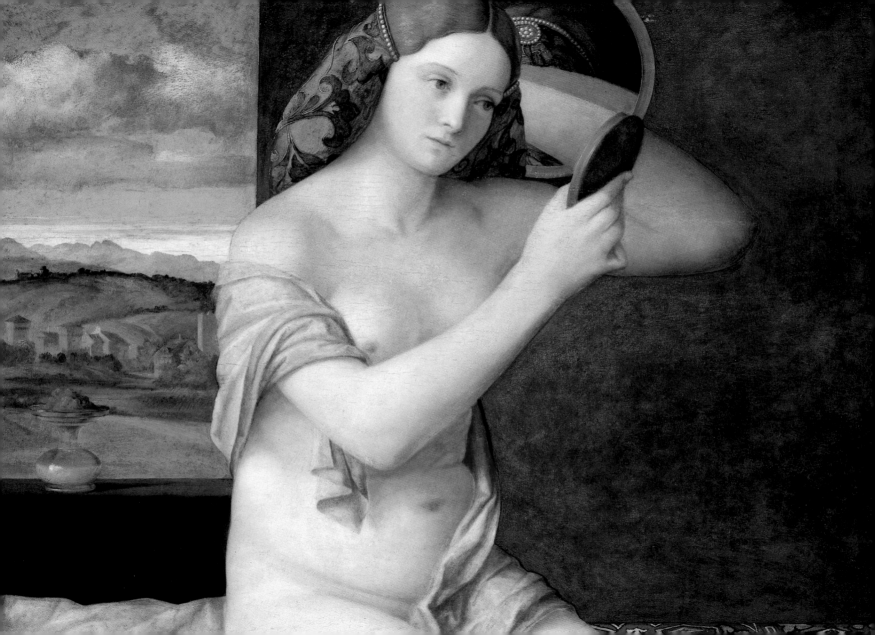

If there were dreams to sell,
what would you buy?

THOMAS LOVELL BEDDOES

The Archduke Leopold Wilhelm
in his Picture Gallery in Brussels, 1650–51
David Teniers
Museo Nacional del Prado, Madrid

1 2 3 4 5 6 7 8 9 10 11 12 13 14 15 16 17 18 19 20 21 22 **23** 24 25 26 27 28 29 30 31

JANUARY

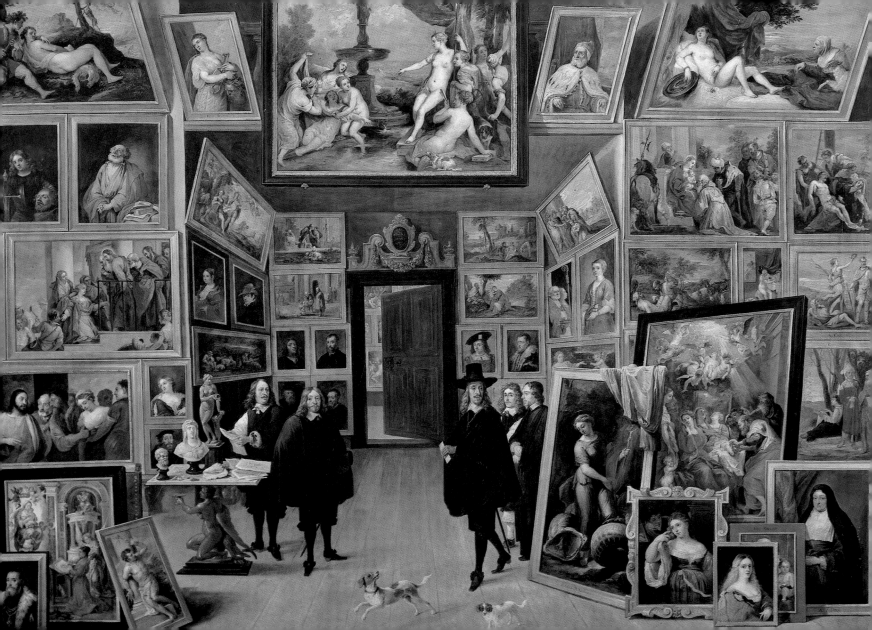

A work of art which did not begin in emotion is not art.

Paul Cézanne

The Bend in the Road, 1900–06
Paul Cézanne
Collection of W. Bareiss, Los Angeles

1 2 3 4 5 6 7 8 9 10 11 12 13 14 15 16 17 18 19 20 21 22 23 **24** 25 26 27 28 29 30 31

JANUARY

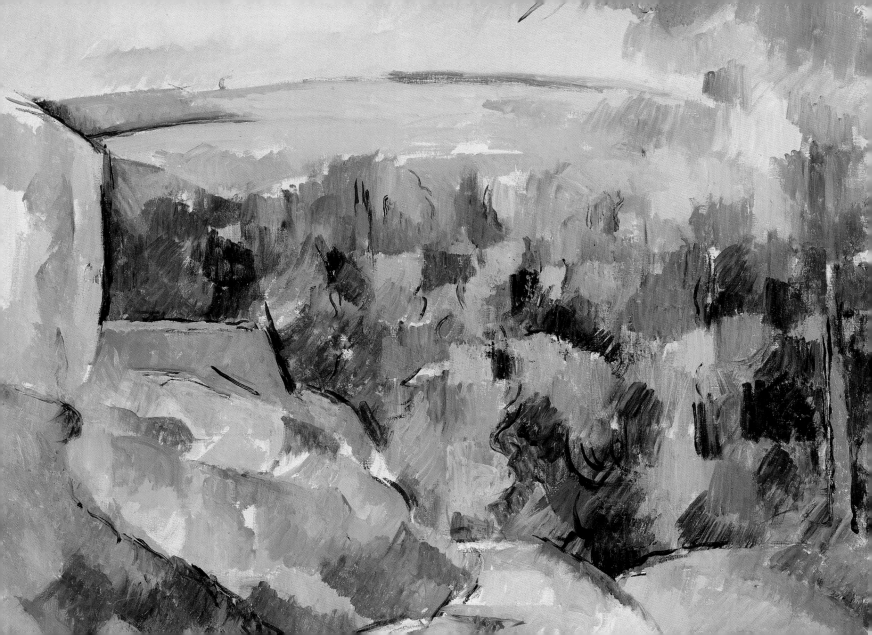

Love conquers all things:
let us give in to Love.

Cupid Carving a Bow, c. 1533–34
Parmigianino
Kunsthistorisches Museum, Vienna

1 2 3 4 5 6 7 8 9 10 11 12 13 14 15 16 17 18 19 20 21 22 23 24 **25** 26 27 28 29 30 31

JANUARY

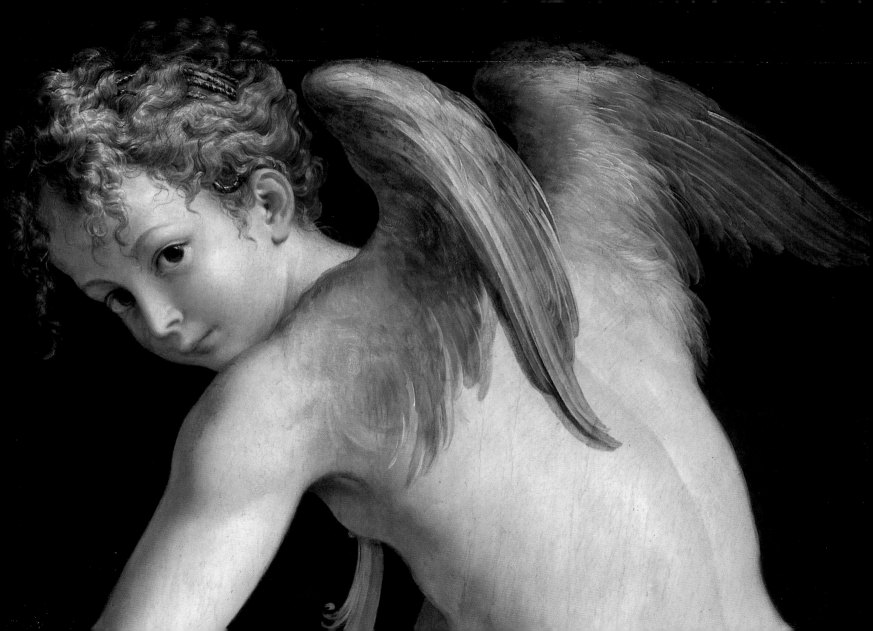

If all the year were playing holidays,
To sport would be as tedious as to work.

WILLIAM SHAKESPEARE

Winter Scene with Figures on Ice, 1600–05
Pieter Brueghel the Younger
The Pushkin Museum of Fine Arts, Moscow

1 2 3 4 5 6 7 8 9 10 11 12 13 14 15 16 17 18 19 20 21 22 23 24 25 **26** 27 28 29 30 31

JANUARY

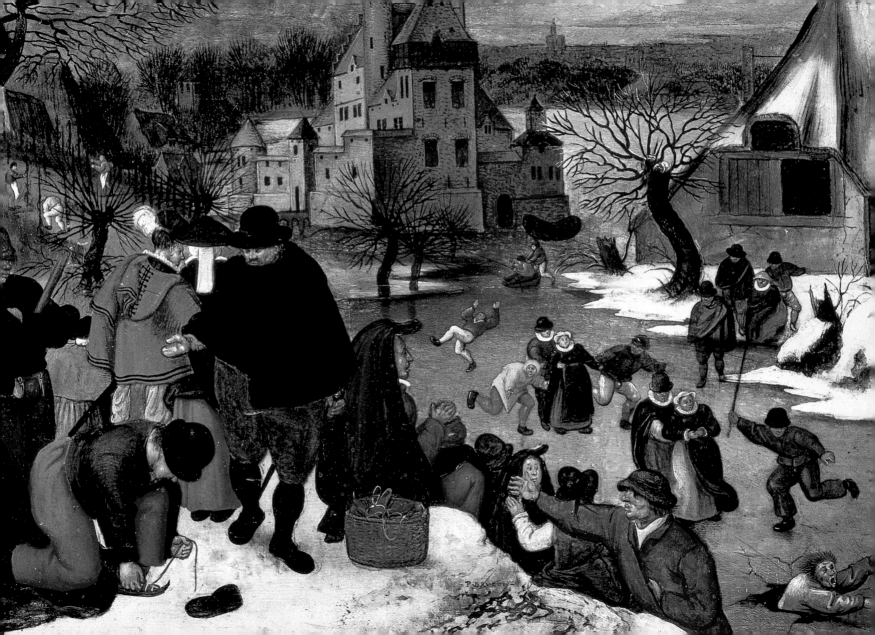

*Most people are about
as happy as they make
up their minds to be.*

Abraham Lincoln

At the Café, 1878
Edouard Manet
Oskar Reinhart Collection, Winterthur

1 2 3 4 5 6 7 8 9 10 11 12 13 14 15 16 17 18 19 20 21 22 23 24 25 26 **27** 28 29 30 31

JANUARY

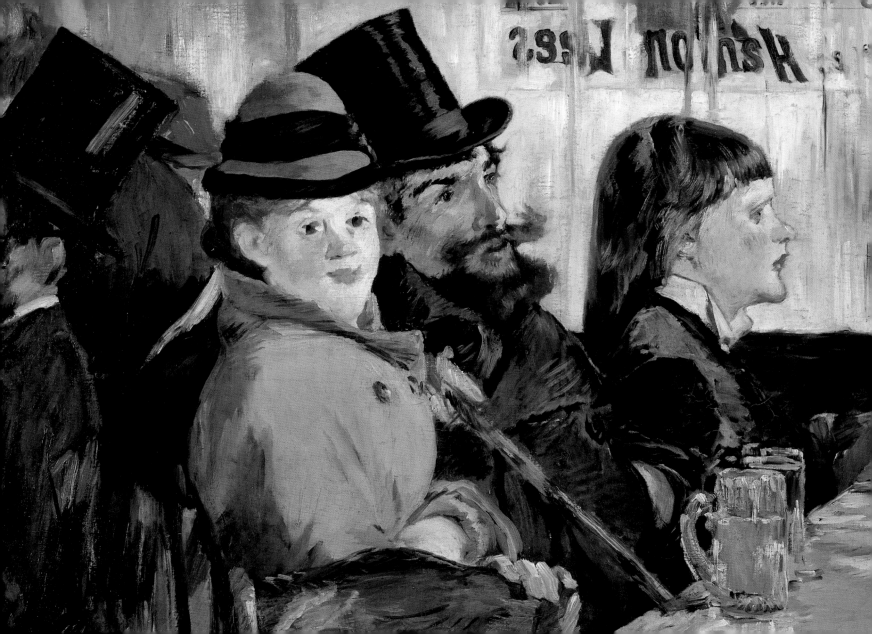

*Faith is a knowledge within the heart,
beyond the reach of proof.*

Kahlil Gibran

Moses Produces Water from a Cliff, 1633–35
Nicolas Poussin
National Gallery of Scotland, Edinburgh

1 2 3 4 5 6 7 8 9 10 11 12 13 14 15 16 17 18 19 20 21 22 23 24 25 26 27 **28** 29 30 31

JANUARY

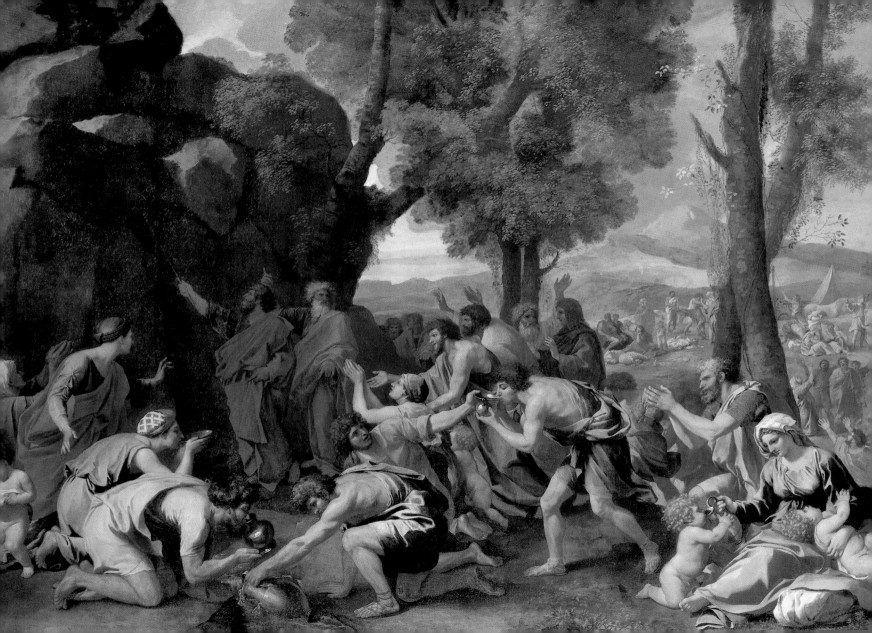

*Let us be grateful to people
who make us happy;
they are the charming gardeners
who make our souls blossom.*

MARCEL PROUST

Flora with a Cornucopia, 1 AD
Fresco, Pompeii
Museo di Capo di Monte, Naples

1 2 3 4 5 6 7 8 9 10 11 12 13 14 15 16 17 18 19 20 21 22 23 24 25 26 27 28 **29** 30 31

JANUARY

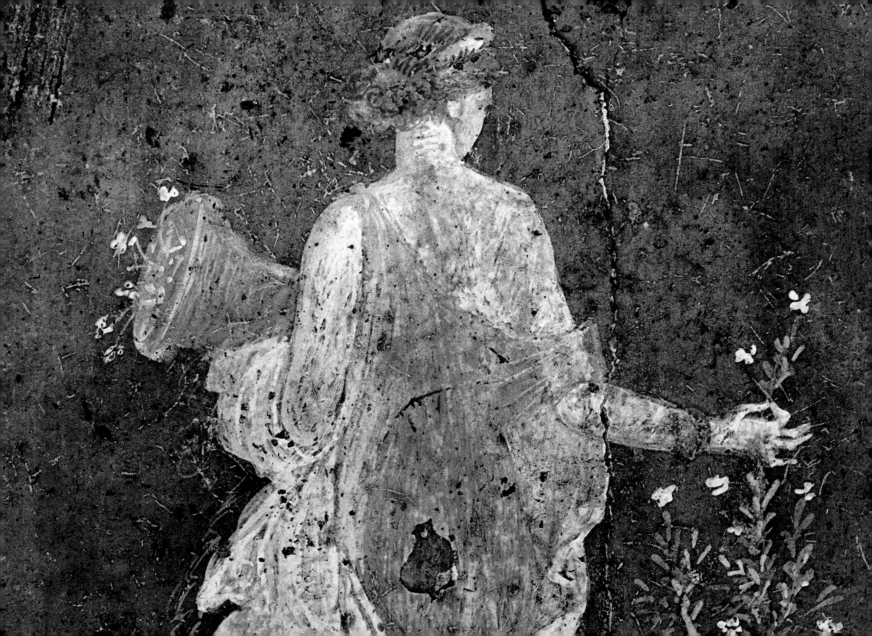

The root of all superstition is that men observe when a thing hits, but not when it misses.

Francis Bacon

Witchcraft or An Allegory on the Choice of Hercules, *c.* 1535
Dosso Dossi
Uffizi Gallery, Florence

1 2 3 4 5 6 7 8 9 10 11 12 13 14 15 16 17 18 19 20 21 22 23 24 25 26 27 28 29 **30** 31

JANUARY

*My hands were too soft. I had to find
some special occupation, some kind of work
that would not force me to turn away from
the sky and the stars, that would allow me
to discover the meaning of life.*

Marc Chagall

The Bride and Groom with the Eiffel Tower, 1938–39
Marc Chagall
Private Collection

1 2 3 4 5 6 7 8 9 10 11 12 13 14 15 16 17 18 19 20 21 22 23 24 25 26 27 28 29 30 **31**

JANUARY

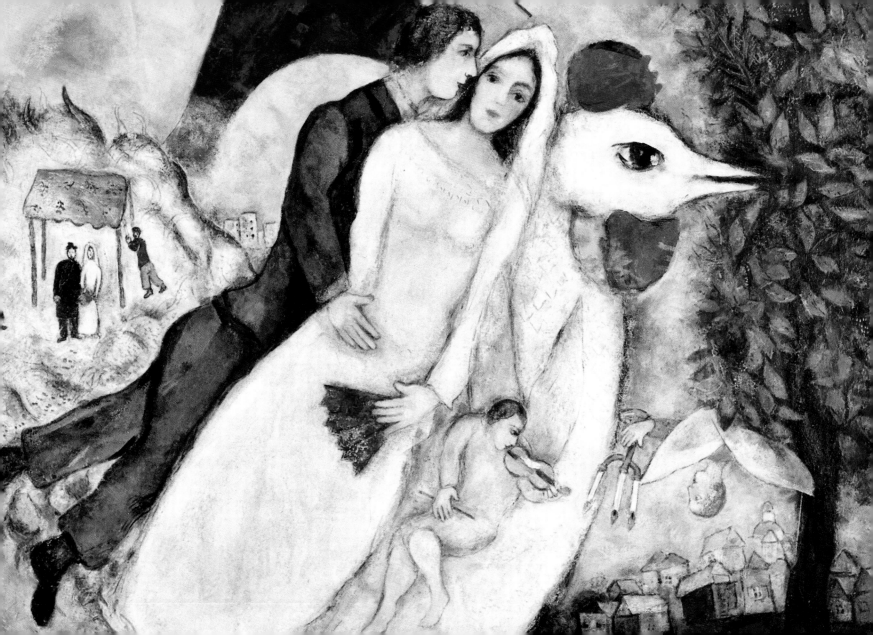

We should count time in heart-throbs.

Philip James Bailey

Les Plaisirs du Bal, 1715–16
Jean-Antoine Watteau
Dulwich College Gallery, London

1 2 3 4 5 6 7 8 9 10 11 12 13 14 15 16 17 18 19 20 21 22 23 24 25 26 27 28 29

FEBRUARY

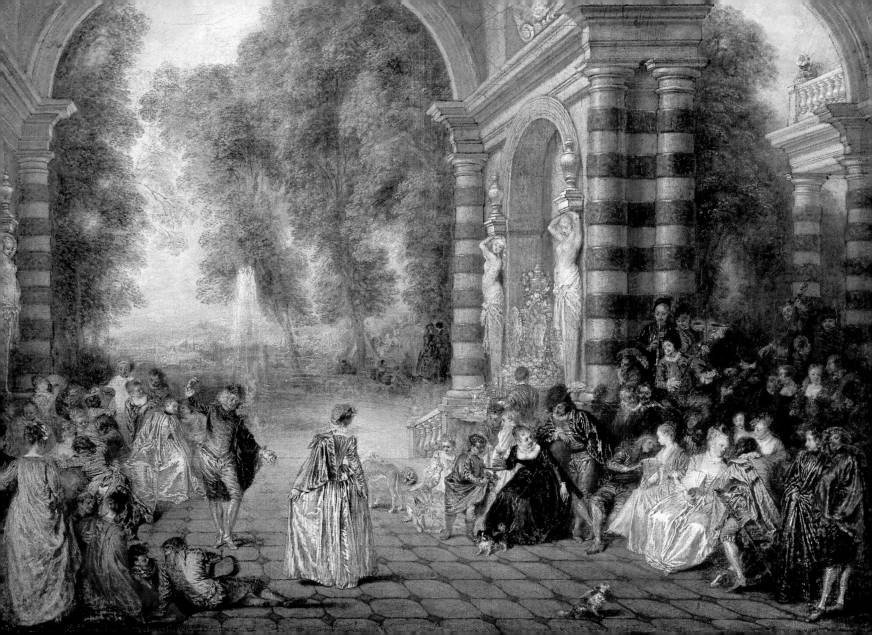

*Let parents bequeath
to their children not riches,
but the spirit of reverence.*

PLATO

Presentation of Christ at the Temple, *c. 1465–66*
Andrea Mantegna
Gemäldegalerie, Berlin

1 **2** 3 4 5 6 7 8 9 10 11 12 13 14 15 16 17 18 19 20 21 22 23 24 25 26 27 28 29

FEBRUARY

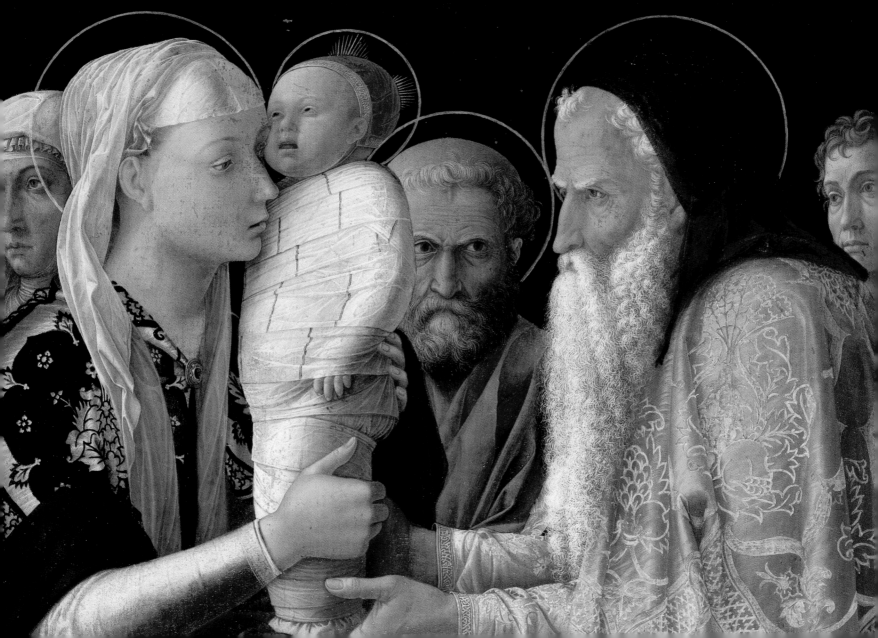

To become truly immortal, a work of art must escape all human limits: logic and common sense will only interfere. But once these barriers are broken, it will enter the realms of childhood visions and dreams.

<small>GIORGIO DE CHIRICO</small>

Melancholy: The Street, *c.* 1924–25
Giorgio de Chirico
Kunsthalle, Hamburg

1 2 **3** 4 5 6 7 8 9 10 11 12 13 14 15 16 17 18 19 20 21 22 23 24 25 26 27 28 29

FEBRUARY

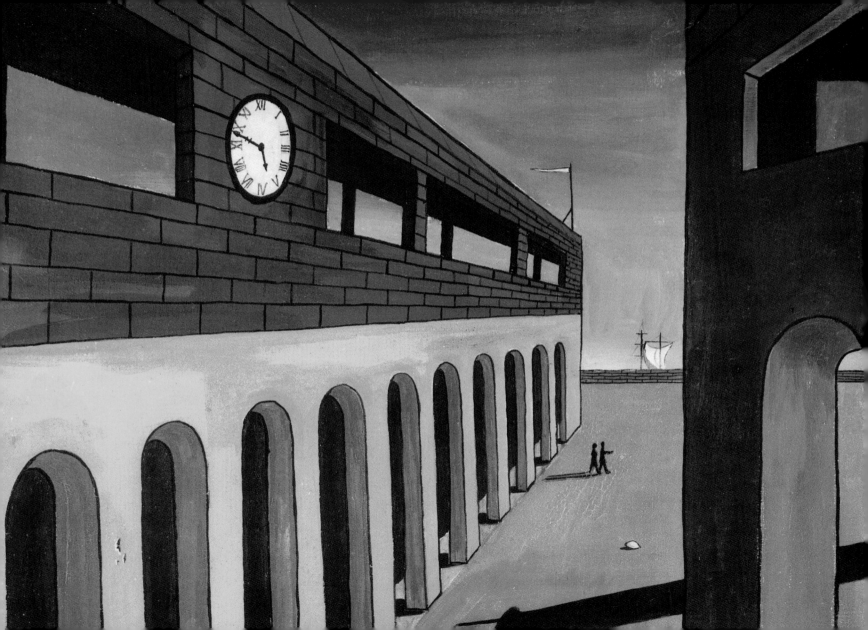

The work of art must seize upon you, wrap you up in itself and carry you away. It is the means by which the artist conveys his passion. It is the current which he puts forth, which sweeps you along in his passion.

PIERRE-AUGUSTE RENOIR

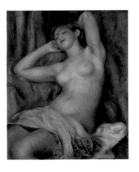

Sleeping Woman, 1897
Pierre-Auguste Renoir
Oskar Reinhart Collection, Winterthur

1 2 3 **4** 5 6 7 8 9 10 11 12 13 14 15 16 17 18 19 20 21 22 23 24 25 26 27 28 29

FEBRUARY

Permanence, perseverance, and persistence
in spite of all obstacles, discouragements,
and impossibilities: It is this that in all things
distinguishes the strong soul from the weak.

SIR FRANCIS DRAKE

Hercules between Vice and Virtue,
early 17th century
Jan van den Hoecke
Uffizi Gallery, Florence

1 2 3 4 **5** 6 7 8 9 10 11 12 13 14 15 16 17 18 19 20 21 22 23 24 25 26 27 28 29

FEBRUARY

*Work is the grand cure
of all the maladies and miseries
that ever beset mankind.*

<small>Thomas Carlyle</small>

The Last Stitches (The Sewer), 1879
Albert von Keller
Lenbachhaus, Munich

1 2 3 4 5 **6** 7 8 9 10 11 12 13 14 15 16 17 18 19 20 21 22 23 24 25 26 27 28 29

February

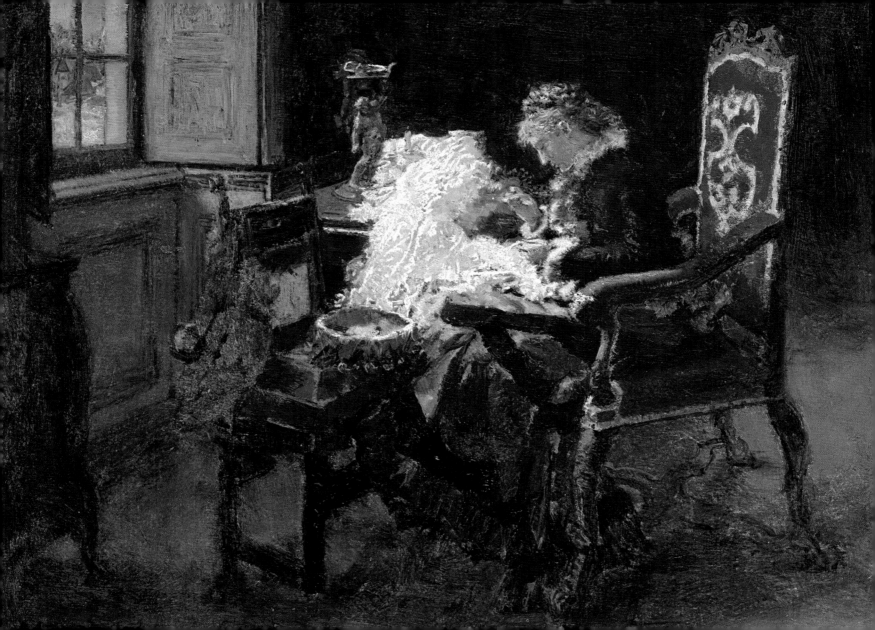

Life begets life.
Energy becomes energy.
It is by spending oneself
that one becomes rich.

Interior of a Farmhouse, *c.* 1597
Jan Brueghel the Elder
Kunsthistorisches Museum, Vienna

1 2 3 4 5 6 **7** 8 9 10 11 12 13 14 15 16 17 18 19 20 21 22 23 24 25 26 27 28 29

FEBRUARY

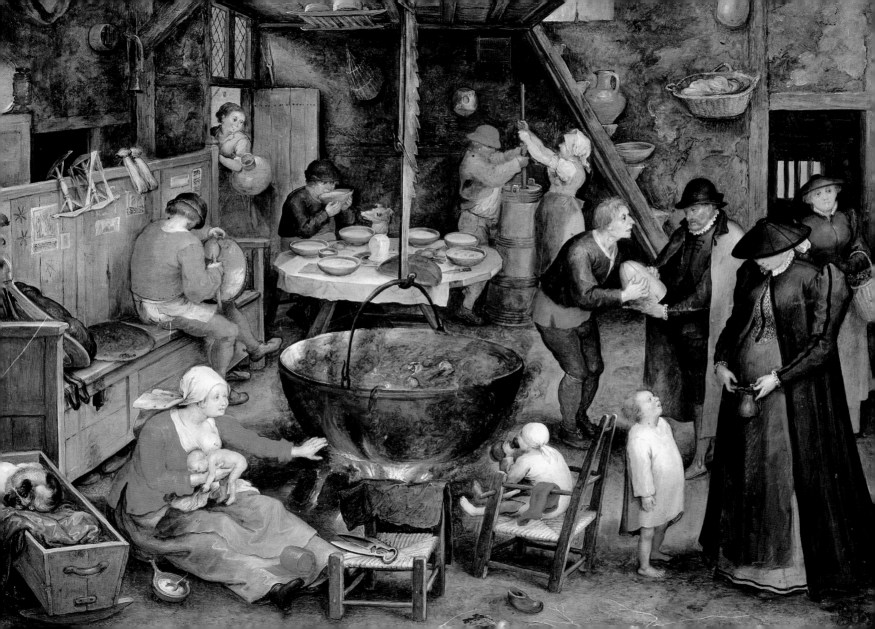

Should we all confess our sins to one another we would all laugh at one another for our lack of originality.

KAHLIL GIBRAN

The Sin, 1893
Franz von Stuck
Stuck-Verein, Munich

1 2 3 4 5 6 7 **8** 9 10 11 12 13 14 15 16 17 18 19 20 21 22 23 24 25 26 27 28 29

FEBRUARY

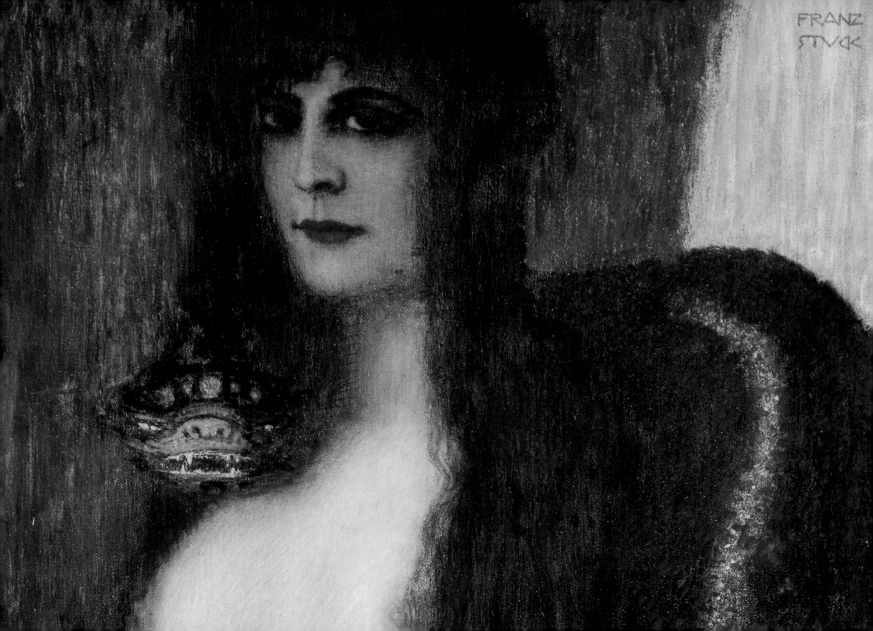

Painting is the aesthetic side of the object but it has never been original, has never been its own goal.

<small>KAZIMIR MALEVICH</small>

Winter Landscape, *c.* 1930
Kazimir Malevich
Museum Ludwig, Cologne

1 2 3 4 5 6 7 8 **9** 10 11 12 13 14 15 16 17 18 19 20 21 22 23 24 25 26 27 28 29

FEBRUARY

The true impressionism is realism.
So many people do not observe.
They take the ready-made axioms
laid down by others, and walk blindly
without trying to see for themselves.

CHILDE HASSAM

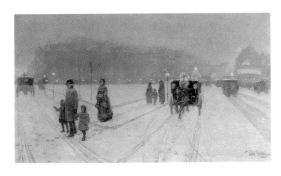

A City Fairyland, 1886
Childe Hassam
Mr. and Mrs. Samuel Peabody

1 2 3 4 5 6 7 8 9 **10** 11 12 13 14 15 16 17 18 19 20 21 22 23 24 25 26 27 28 29

FEBRUARY

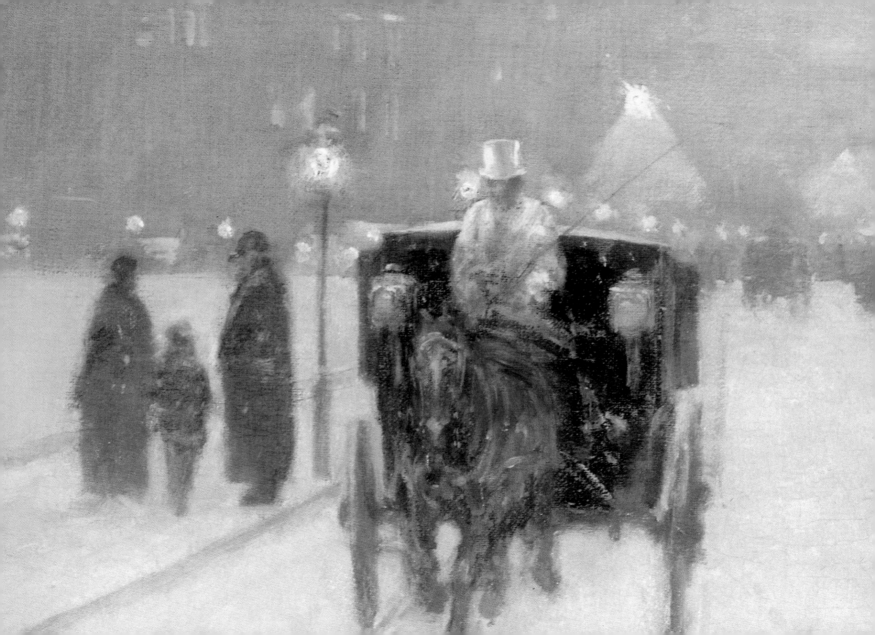

Marriage is the triumph of hope over experience.

The Marriage Feast at Cana, c. 1570
Paolo Veronese
Musée du Louvre, Paris

1 2 3 4 5 6 7 8 9 10 **11** 12 13 14 15 16 17 18 19 20 21 22 23 24 25 26 27 28 29

FEBRUARY

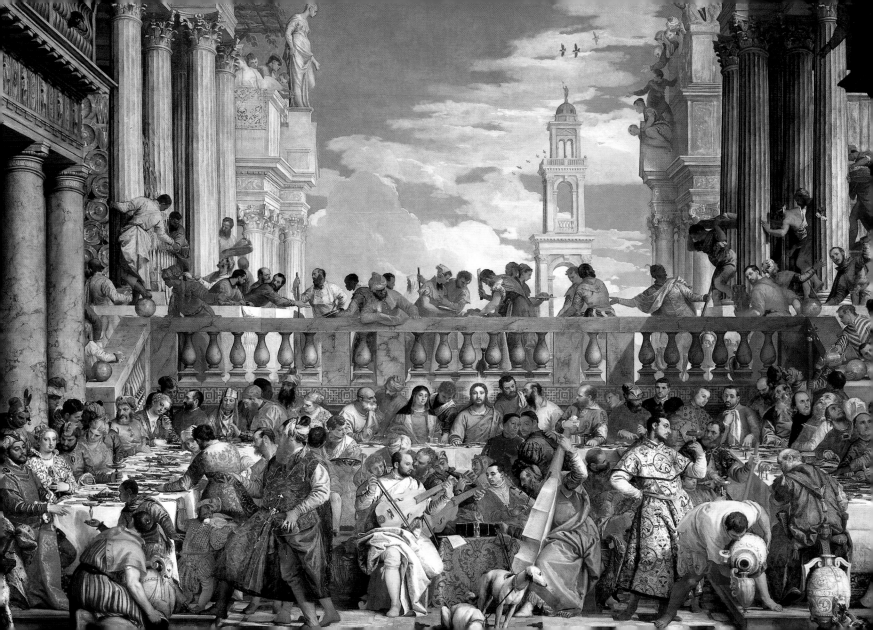

*Painting is easy when you don't know
how, but very difficult when you do.*

Edgar Degas

Dancers at Rehearsal, 1885–90
Edgar Degas
The Pushkin Museum of Fine Arts, Moscow

1 2 3 4 5 6 7 8 9 10 11 **12** 13 14 15 16 17 18 19 20 21 22 23 24 25 26 27 28 29

FEBRUARY

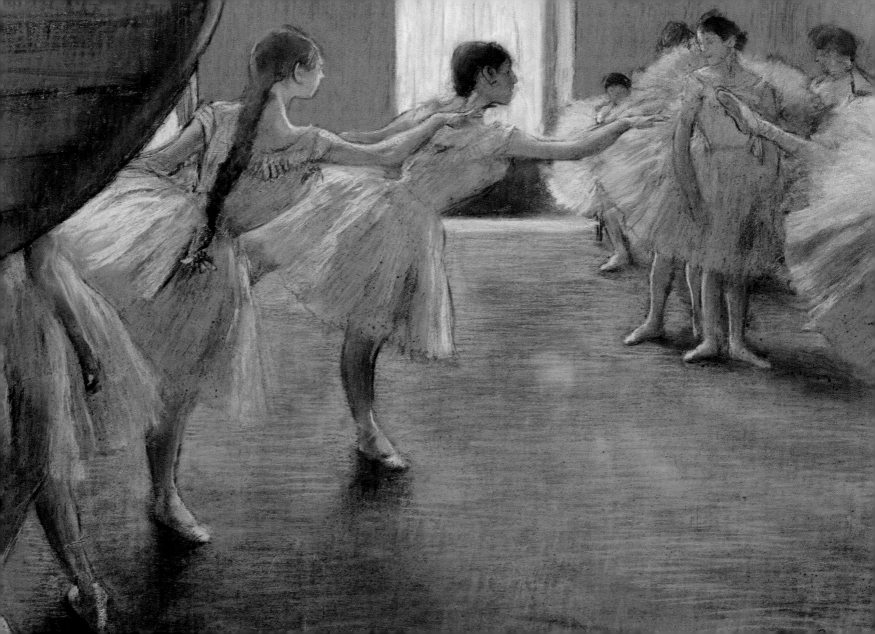

If we had no winter, the spring would not be so pleasant: if we did not sometimes taste adversity, prosperity would not be so welcome.

ANNE BRADSTREET

Winter Landscape, 1586
Lucas I van Valckenborch
Kunsthistorisches Museum, Vienna

1 2 3 4 5 6 7 8 9 10 11 12 **13** 14 15 16 17 18 19 20 21 22 23 24 25 26 27 28 29

FEBRUARY

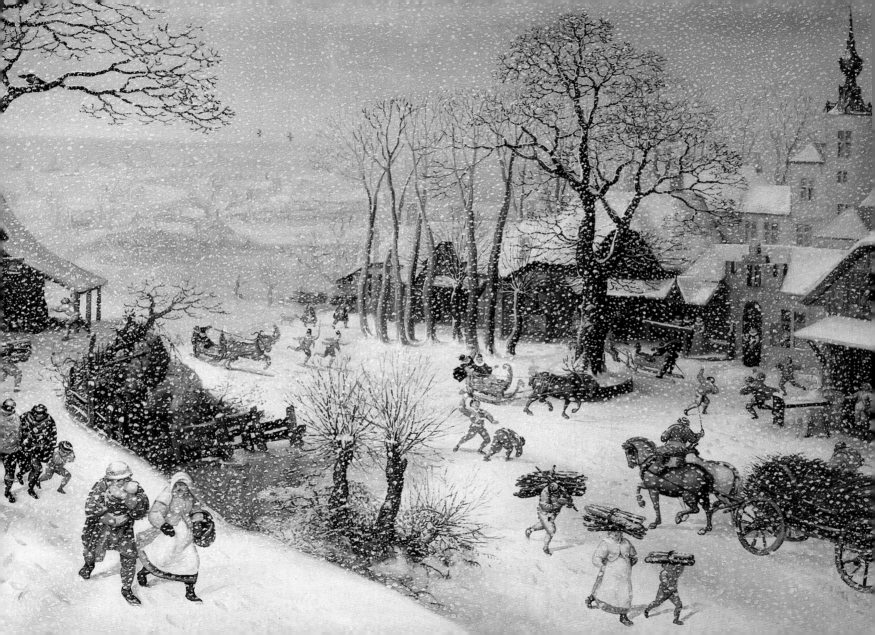

All that I am, or hope to be,
I owe to my angel mother.

ABRAHAM LINCOLN

The Young Mother, 1658
Gerrit Dou
Mauritshuis, The Hague

1 2 3 4 5 6 7 8 9 10 11 12 13 **14** 15 16 17 18 19 20 21 22 23 24 25 26 27 28 29

FEBRUARY

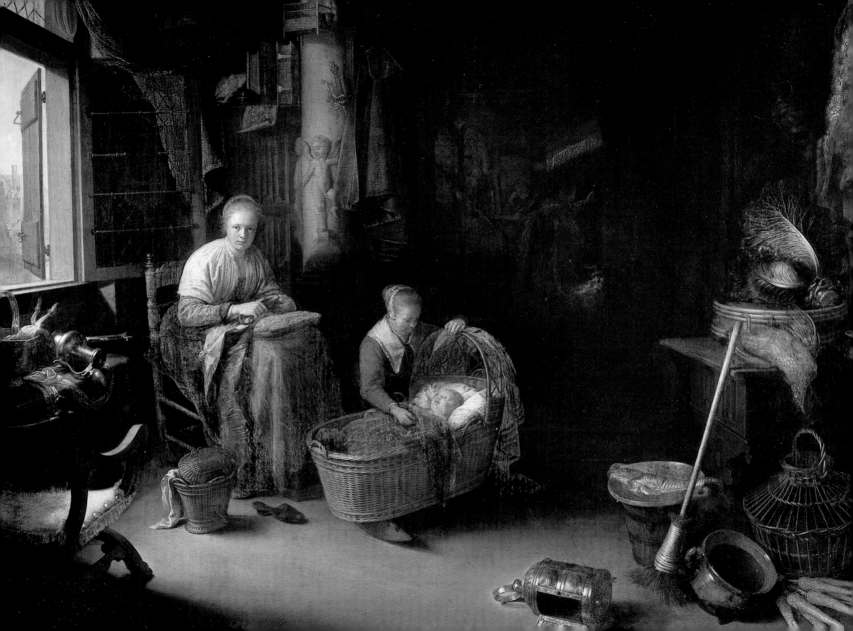

I have neither good sight
nor a steady hand and neither
pen nor inkwell, everything
fails me except my will …

Francisco José de Goya

The Burial of the Sardine, *c.* 1812–19
Francisco José de Goya
Academia di S. Fernando, Madrid

1 2 3 4 5 6 7 8 9 10 11 12 13 14 **15** 16 17 18 19 20 21 22 23 24 25 26 27 28 29

FEBRUARY

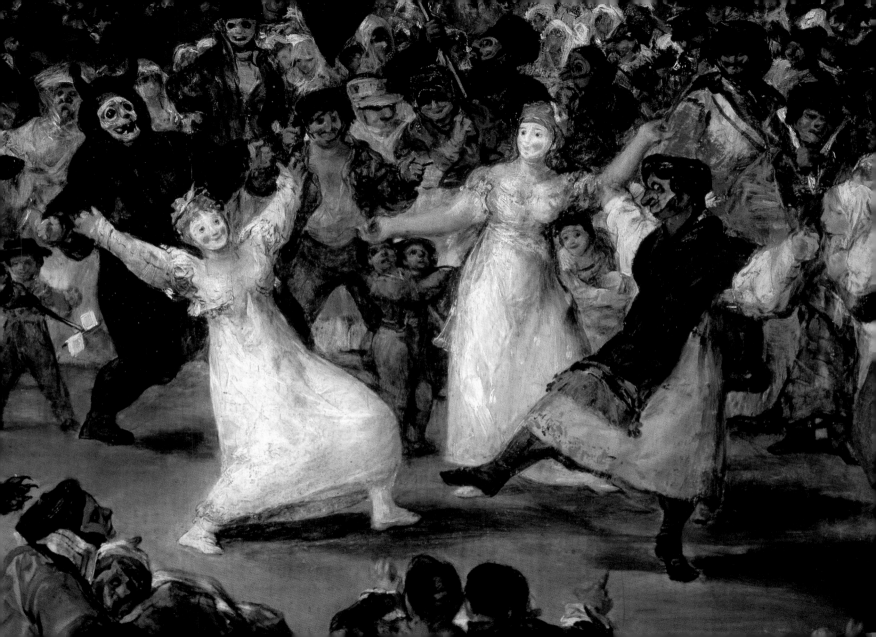

I am an artist …
I am here to live out loud.

Émile Zola

Three Girls in a Small Sailing Boat, 1911
August Macke
Lenbachhaus, Munich

1 2 3 4 5 6 7 8 9 10 11 12 13 14 15 **16** 17 18 19 20 21 22 23 24 25 26 27 28 29

FEBRUARY

The true work of art
is but a shadow of divine perfection.

The Creation of Adam
(Detail of the ceiling, Sistine Chapel, The Vatican), 1511
Michelangelo
Vatican Museum, Vatican City

1 2 3 4 5 6 7 8 9 10 11 12 13 14 15 16 **17** 18 19 20 21 22 23 24 25 26 27 28 29

FEBRUARY

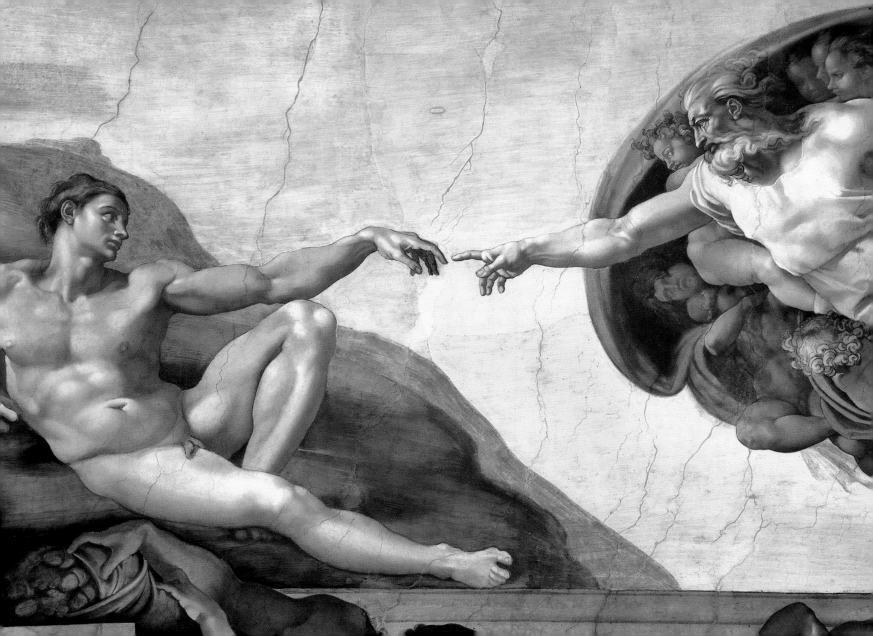

*One kind word can warm
three winter months.*

Monthly Image: February, 1412–16
The Limburg Brothers
Musée Condé, Chantilly

1 2 3 4 5 6 7 8 9 10 11 12 13 14 15 16 17 **18** 19 20 21 22 23 24 25 26 27 28 29

FEBRUARY

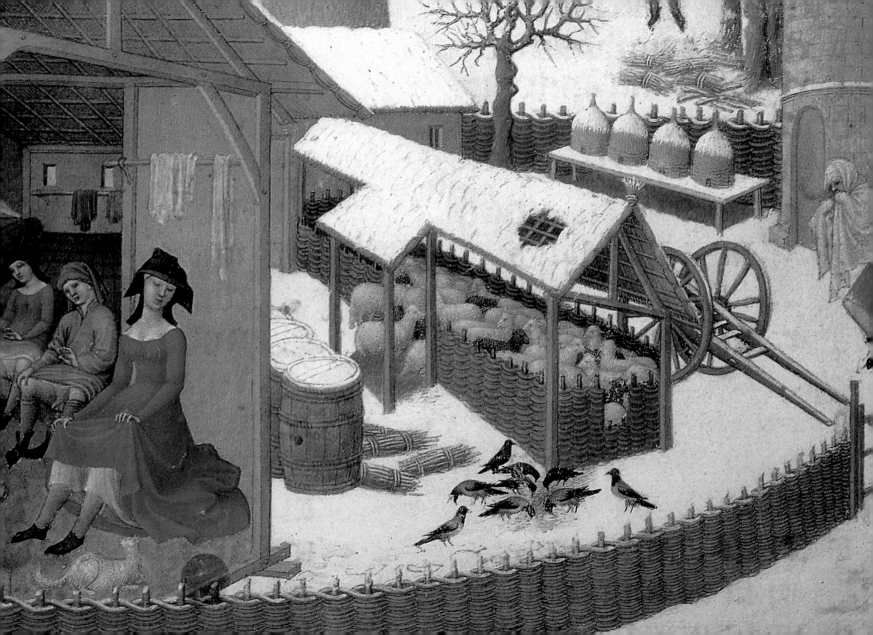

Everyone discusses my art and pretends to understand, as if it were necessary to understand, when it is simply necessary to love.

CLAUDE MONET

Palazzo da Mula, Venice, 1908
Claude Monet
National Gallery of Art, Washington D.C.

1 2 3 4 5 6 7 8 9 10 11 12 13 14 15 16 17 18 **19** 20 21 22 23 24 25 26 27 28 29

FEBRUARY

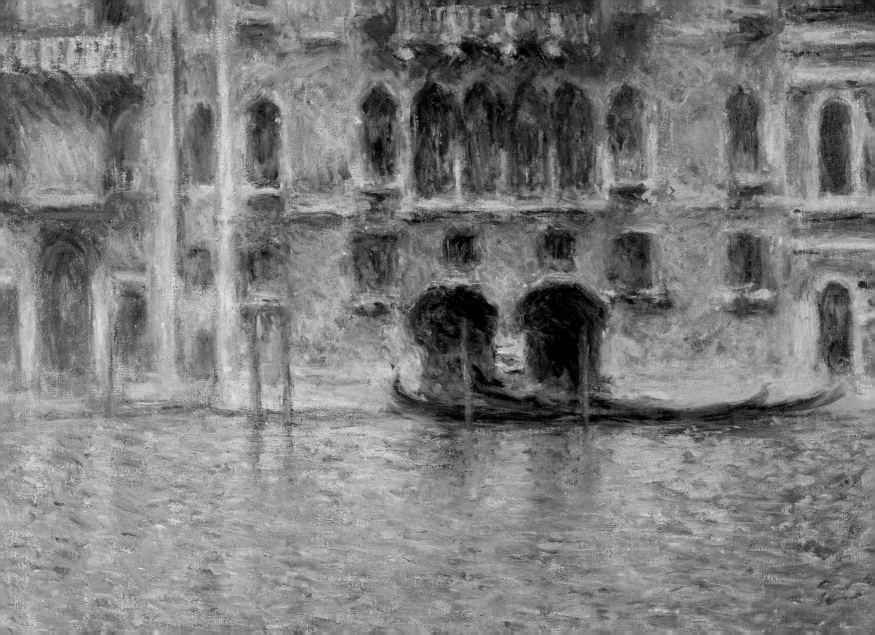

Whether the nymph shall break
Diana's law, or some frail china
jar receive a flaw, or stain her honor,
or her new brocade, forget her pray'rs,
or miss a masquerade.

ALEXANDER POPE

Woman with Mask, early 20th century
Lovis Corinth
MK Ciurlionis National Museum of Art, Kaunas

1 2 3 4 5 6 7 8 9 10 11 12 13 14 15 16 17 18 19 **20** 21 22 23 24 25 26 27 28 29

FEBRUARY

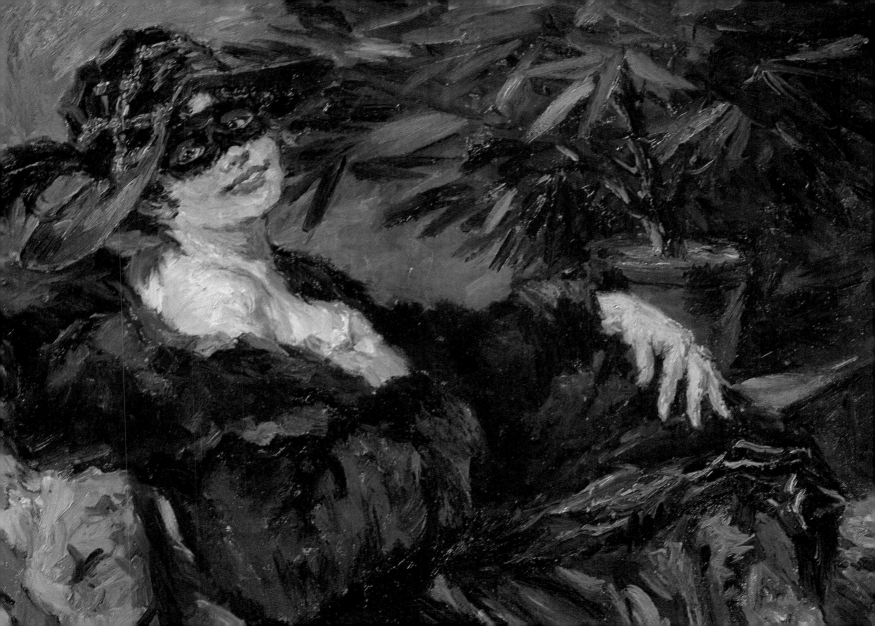

Diligence is the mother of good fortune,
and idleness, its opposite, never led
to good intention's goal.

<small>Miguel de Cervantes</small>

The Battle of Carnival and Lent, 1559
Pieter Brueghel the Elder
Kunsthistorisches Museum, Vienna

1 2 3 4 5 6 7 8 9 10 11 12 13 14 15 16 17 18 19 20 **21** 22 23 24 25 26 27 28 29

FEBRUARY

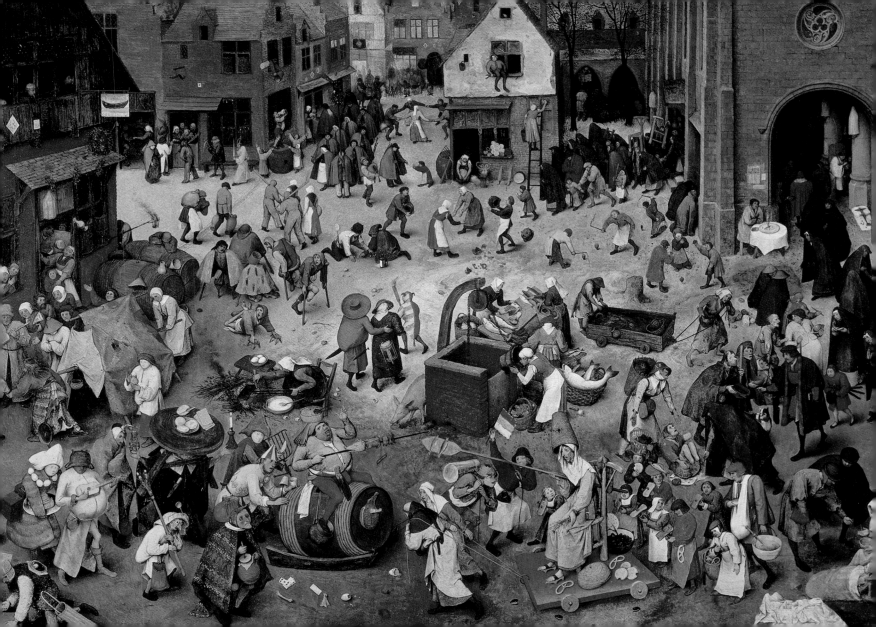

There are only two styles of portrait painting; the serious and the smirk.

Charles Dickens

The Portrait Painter, *c.* 1858
Carl Spitzweg
Private Collection

1 2 3 4 5 6 7 8 9 10 11 12 13 14 15 16 17 18 19 20 21 **22** 23 24 25 26 27 28 29

FEBRUARY

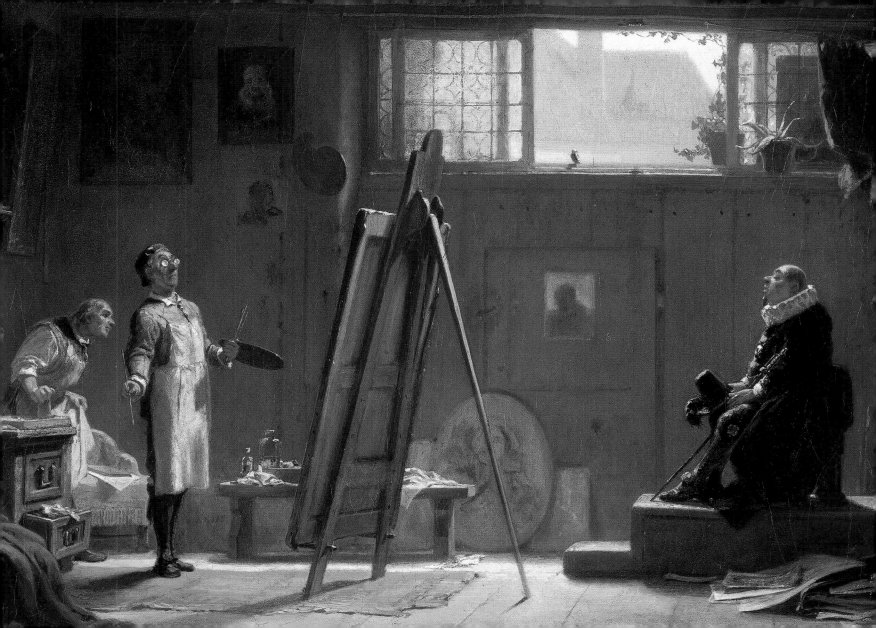

I paint my own reality.
The only thing I know is
that I paint because I need to,
and I paint whatever passes
through my head without any
other consideration.

FRIDA KAHLO

Me and My Parrots, 1941
Frida Kahlo
Private Collection

1 2 3 4 5 6 7 8 9 10 11 12 13 14 15 16 17 18 19 20 21 22 **23** 24 25 26 27 28 29

FEBRUARY

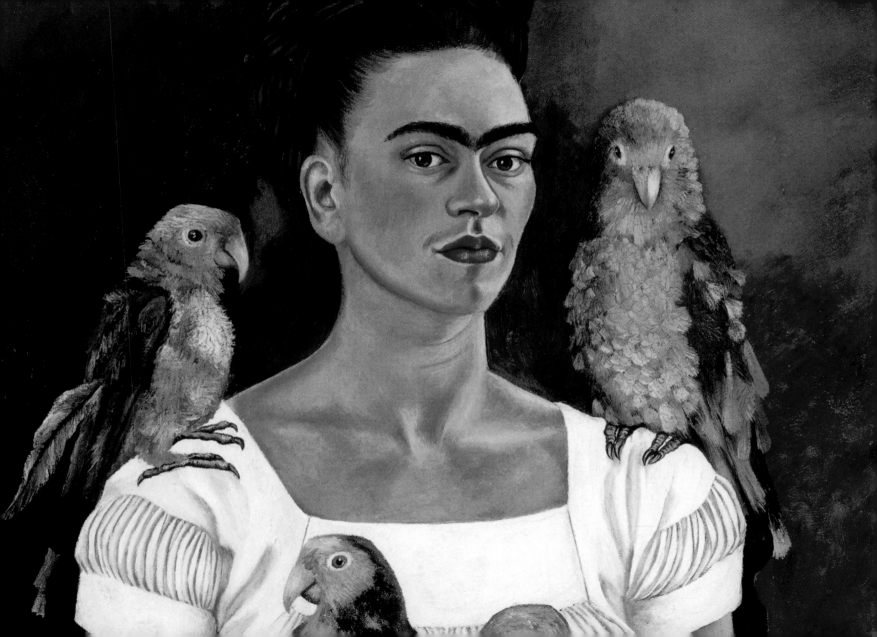

Speed on the ship!—But let her bear
No merchandise of sin,
No groaning cargo of despair
Her roomy hold within;
No Lethean drug for Eastern lands,
Nor poison-draught for ours;
But honest fruits of toiling hands
And Nature's sun and showers.

JOHN GREENLEAF WHITTIER

The Maria at Honfleur, 1886
Georges Seurat
National Gallery, Prague

1 2 3 4 5 6 7 8 9 10 11 12 13 14 15 16 17 18 19 20 21 22 23 **24** 25 26 27 28 29

FEBRUARY

*This is my beloved
and this is my friend.*

SONG OF SOLOMON

Fulfillment (Stoclet Frieze), *c.* 1909
Gustav Klimt
Musée des Beaux-Arts, Strasbourg

1 2 3 4 5 6 7 8 9 10 11 12 13 14 15 16 17 18 19 20 21 22 23 24 **25** 26 27 28 29

FEBRUARY

Oh! The snow, the beautiful snow,
Filling the sky and earth below,
Over the housetops, over the street,
Over the heads of the people you meet.
Dancing, flirting, skimming along.

Skaters, 1620s
Hendrick Avercamp
The Pushkin Museum of Fine Arts, Moscow

1 2 3 4 5 6 7 8 9 10 11 12 13 14 15 16 17 18 19 20 21 22 23 24 25 **26** 27 28 29

FEBRUARY

No man is an island, entire of it self;
every man is a piece of the continent.

<small>JOHN DONNE</small>

The Freemasons, 1898
Lovis Corinth
Lenbachhaus, Munich

1 2 3 4 5 6 7 8 9 10 11 12 13 14 15 16 17 18 19 20 21 22 23 24 25 26 **27** 28 29

FEBRUARY

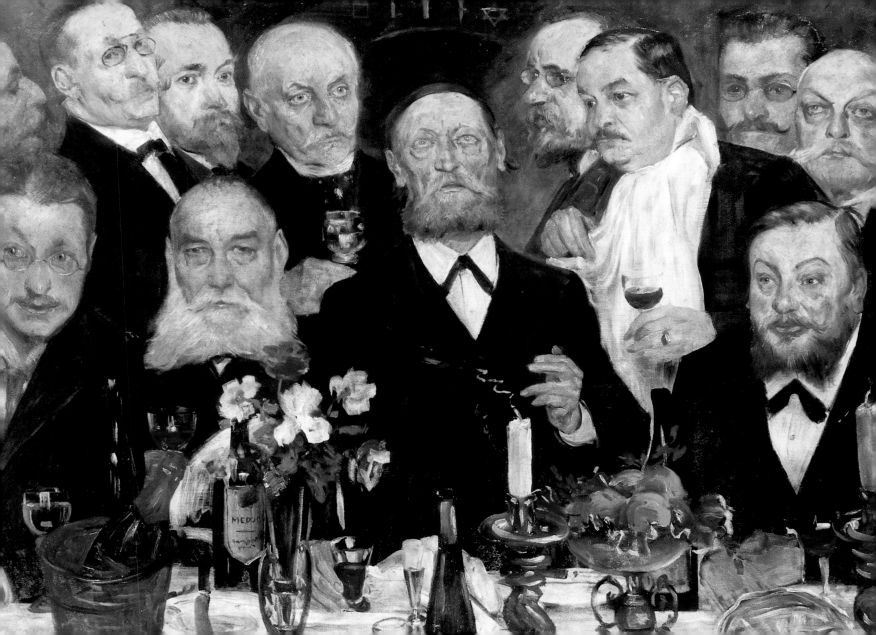

Like everything genuine, its inner life guarantees its truth. All works of art created by truthful minds without regard for the work's conventional exterior remain genuine for all times.

<small>Franz Marc</small>

Small Yellow Horses, 1912
Franz Marc
Staatsgalerie, Stuttgart

1 2 3 4 5 6 7 8 9 10 11 12 13 14 15 16 17 18 19 20 21 22 23 24 25 26 27 **28/29**

FEBRUARY

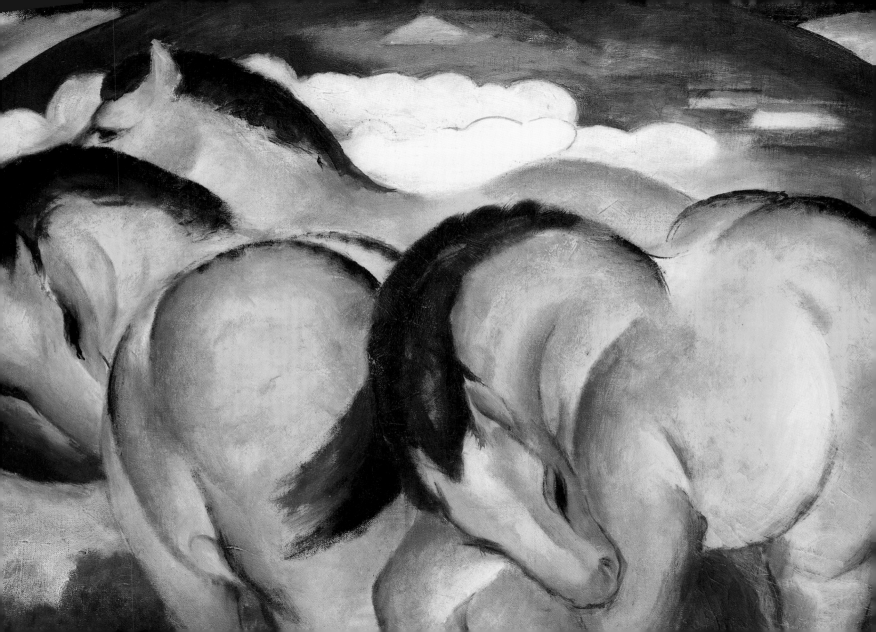

*We look forward to the time when
the Power of Love will replace
the Love of Power. Then will our world
know the blessings of peace.*

<small>William Ewart Gladstone</small>

**Mars Disarmed by Venus
and the Graces,** 1822–24

Jacques-Louis David
Musée des Beaux-Arts, Brussels

1 2 3 4 5 6 7 8 9 10 11 12 13 14 15 16 17 18 19 20 21 22 23 24 25 26 27 28 29 30 31

MARCH

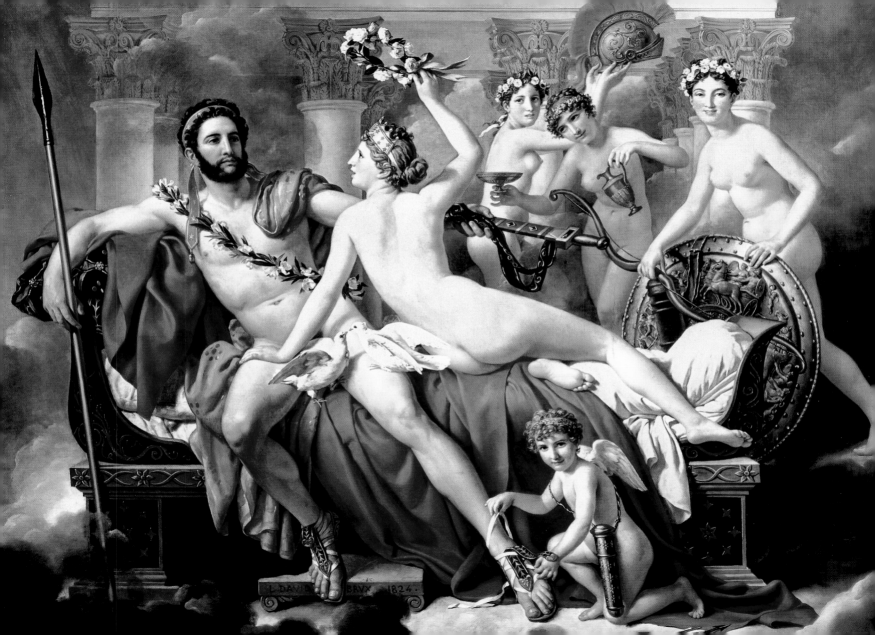

They say, and I am very willing to believe it, that it is difficult to know yourself, but it isn't easy to paint yourself either.

Vincent van Gogh

Self-Portrait in a Gray Felt Hat, 1887
Vincent van Gogh
Stedelijk Museum, Amsterdam

1 **2** 3 4 5 6 7 8 9 10 11 12 13 14 15 16 17 18 19 20 21 22 23 24 25 26 27 28 29 30 31

MARCH

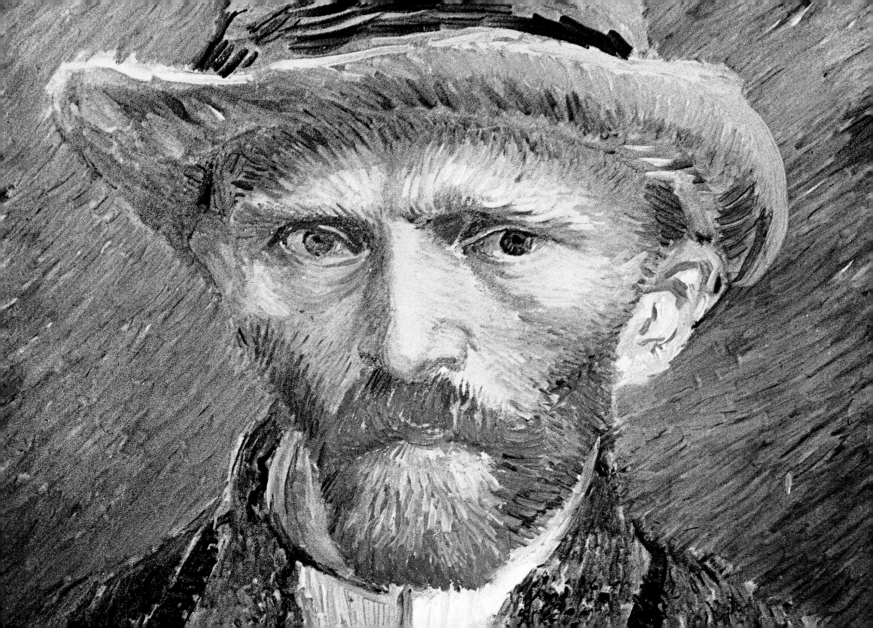

Venus favors the bold.

The Birth of Venus, c. 1490
Sandro Botticelli
Uffizi Gallery, Florence

1 2 **3** 4 5 6 7 8 9 10 11 12 13 14 15 16 17 18 19 20 21 22 23 24 25 26 27 28 29 30 31

MARCH

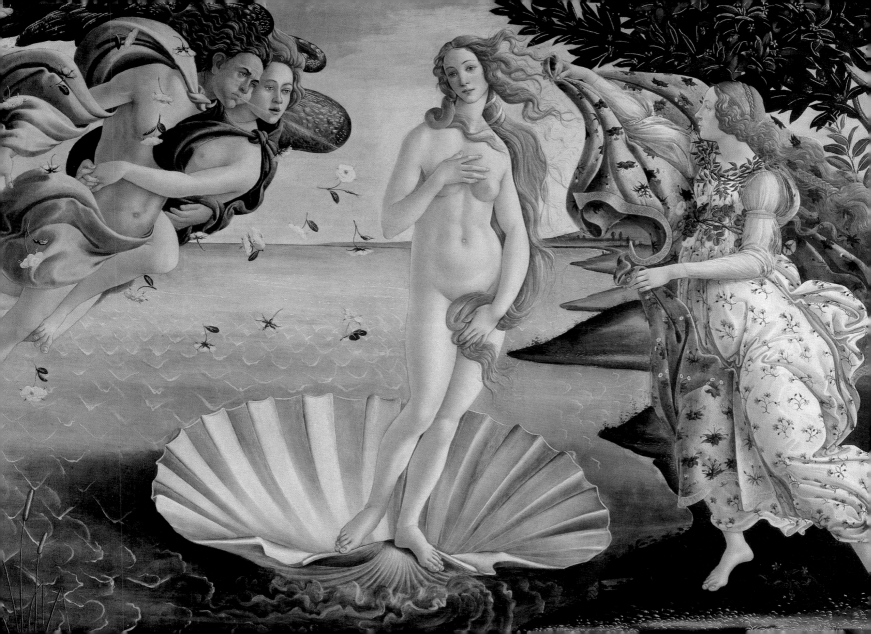

*Without craftsmanship,
inspiration is a mere reed
shaken in the wind.*

JOHANNES BRAHMS

**Departure of the Apostles,
with View of Bamberg from the East,** 15th century
Master of Bamberg
Bayerisches Nationalmuseum, Munich

1 2 3 **4** 5 6 7 8 9 10 11 12 13 14 15 16 17 18 19 20 21 22 23 24 25 26 27 28 29 30 31

MARCH

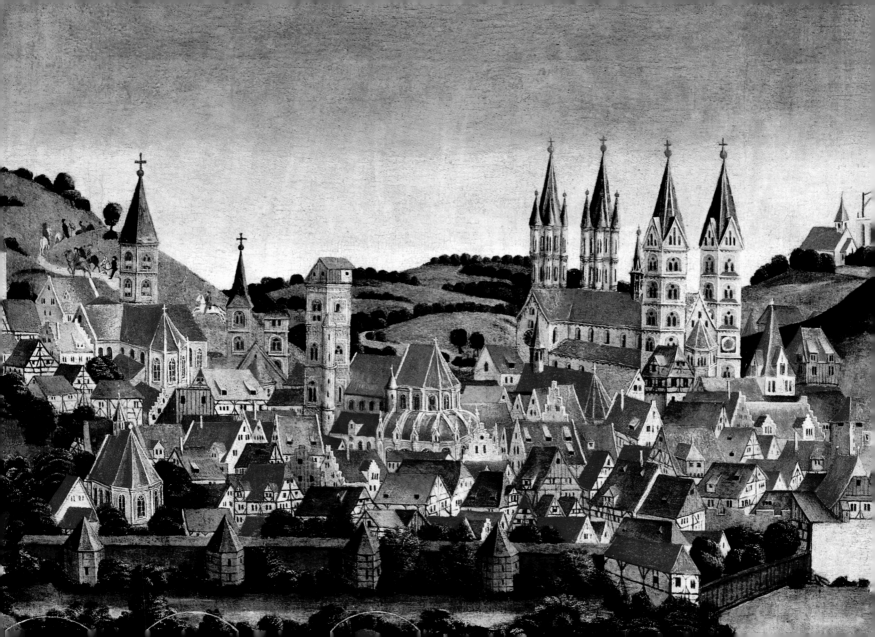

Recreation's purpose is not to kill time,
but to make life, not to keep a person occupied,
but to keep them refreshed; not to offer an escape
from life, but to provide a discovery of life.

Anon.

The Fountain of Youth, 1546
Lucas Cranach the Elder
Gemäldegalerie, Berlin

1 2 3 4 **5** 6 7 8 9 10 11 12 13 14 15 16 17 18 19 20 21 22 23 24 25 26 27 28 29 30 31

MARCH

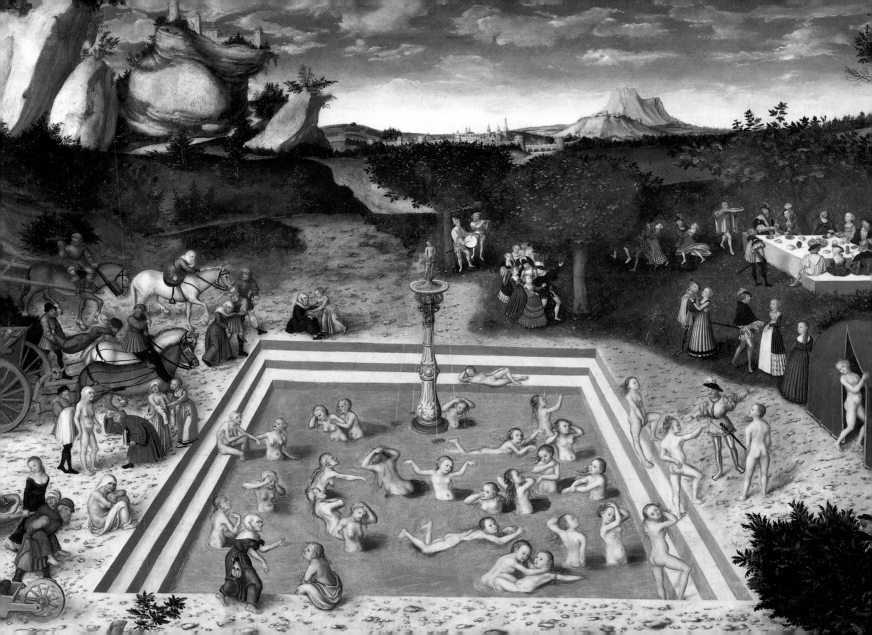

*People want to find a "meaning"
in everything and everyone.
That's the disease of our age,
an age that is anything but
practical but believes itself to be
more practical than any other age.*

PABLO PICASSO

The Guitar, 1913
Pablo Picasso
K20/K21, Düsseldorf

1 2 3 4 5 **6** 7 8 9 10 11 12 13 14 15 16 17 18 19 20 21 22 23 24 25 26 27 28 29 30 31

MARCH

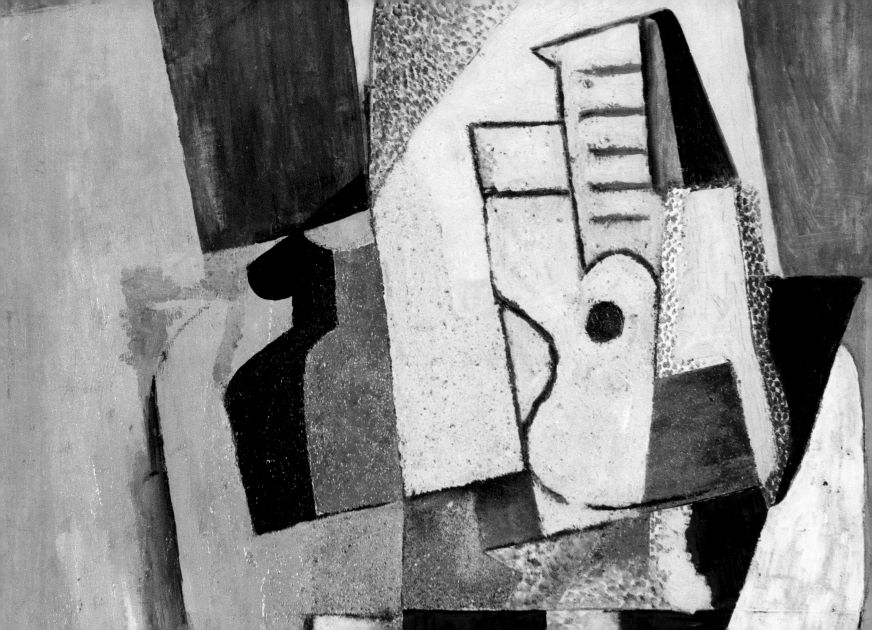

Celestial Cupid, her famed son, advanced,
Holds his dear Psyche sweet entranced,
After her wandering labors long,
Till free consent the gods among
Make her his eternal bride;
And from her fair unspotted side
Two blissful twins are to be born,
Youth and Joy; so Jove hath sworn.

JOHN MILTON

Psyche Discovers Cupid, 1707–09
Giuseppe Crespi
Uffizi Gallery, Florence

1 2 3 4 5 6 **7** 8 9 10 11 12 13 14 15 16 17 18 19 20 21 22 23 24 25 26 27 28 29 30 31

MARCH

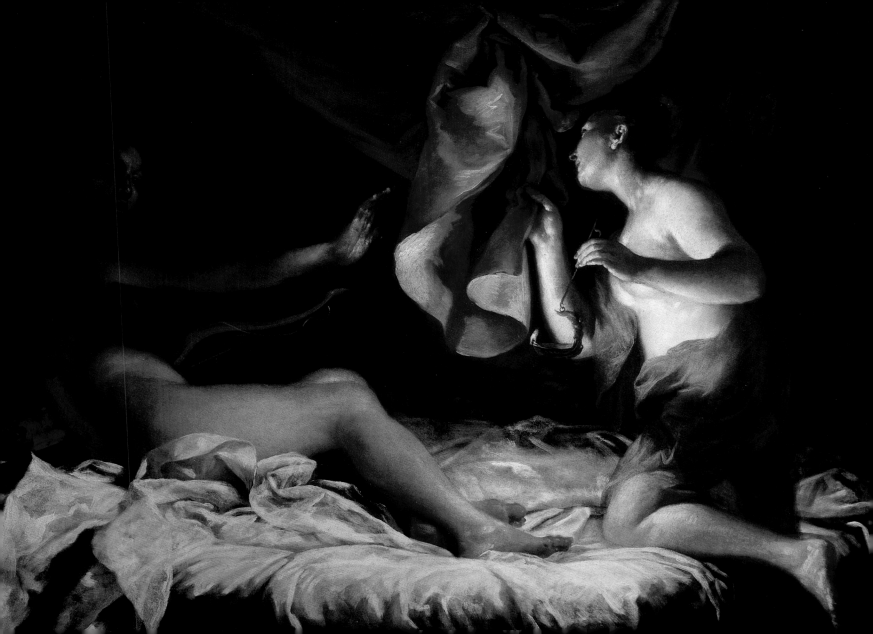

Judas, betrayest thou
the Son of man with a kiss?

THE GOSPEL OF ST. LUKE, 22:48

Gray Passion:
Apprehension of Christ, *c.* 1495
Hans Holbein the Elder
Fürstenberg Collection, Donaueschingen

1 2 3 4 5 6 7 **8** 9 10 11 12 13 14 15 16 17 18 19 20 21 22 23 24 25 26 27 28 29 30 31

MARCH

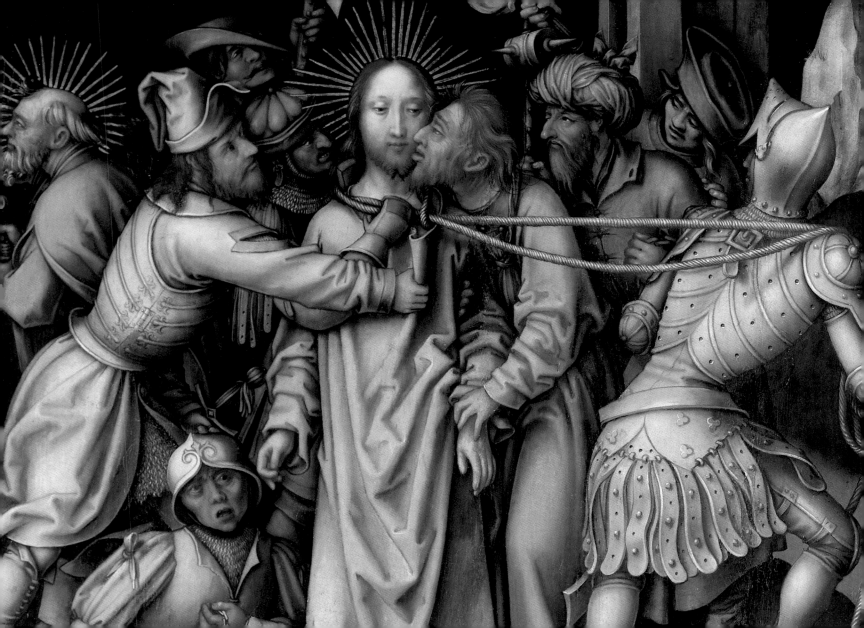

*To be simple is not always
as easy as it seems.*

**Le Grand Muveran
(Bernese Alps),** 1912
Ferdinand Hodler
Von der Heydt-Museum, Wuppertal

1 2 3 4 5 6 7 8 **9** 10 11 12 13 14 15 16 17 18 19 20 21 22 23 24 25 26 27 28 29 30 31

MARCH

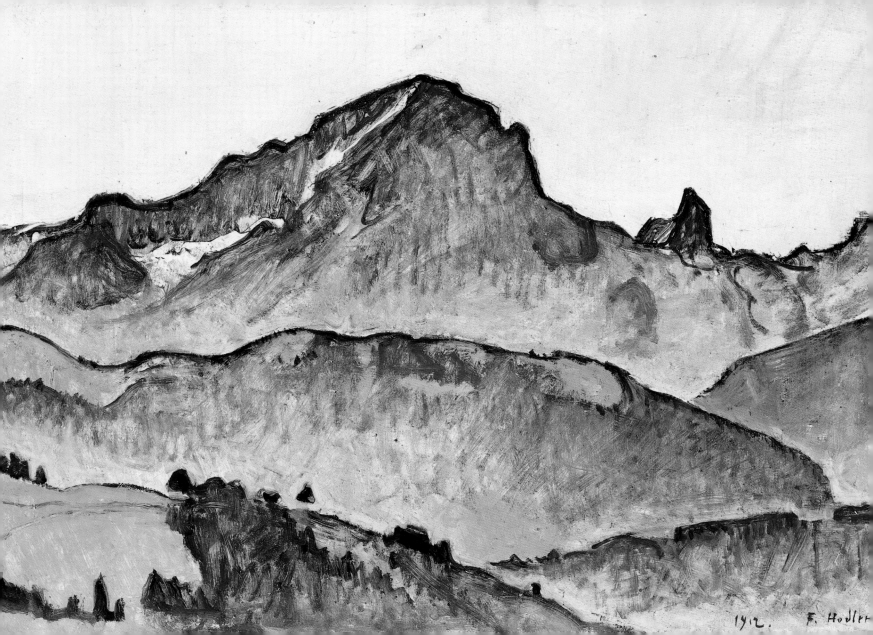

Jupiter, not wanting man's life to be wholly gloomy and grim, has bestowed far more passion than reason.

DESIDERIUS ERASMUS

Jupiter and Io, *c.* 1530
Correggio
Kunsthistorisches Museum, Vienna

1 2 3 4 5 6 7 8 9 **10** 11 12 13 14 15 16 17 18 19 20 21 22 23 24 25 26 27 28 29 30 31

MARCH

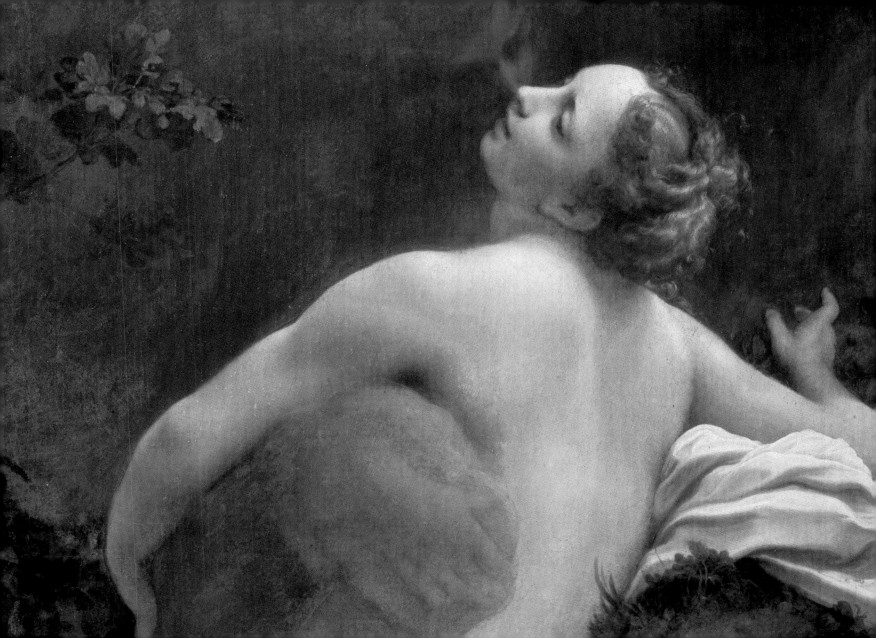

Italia! Oh Italia!
Thou who hast the fatal gift of beauty.

LORD BYRON

The Doge's Palace
and the Piazetta in Venice, c. 1755
Canaletto
Uffizi Gallery, Florence

1 2 3 4 5 6 7 8 9 10 **11** 12 13 14 15 16 17 18 19 20 21 22 23 24 25 26 27 28 29 30 31

MARCH

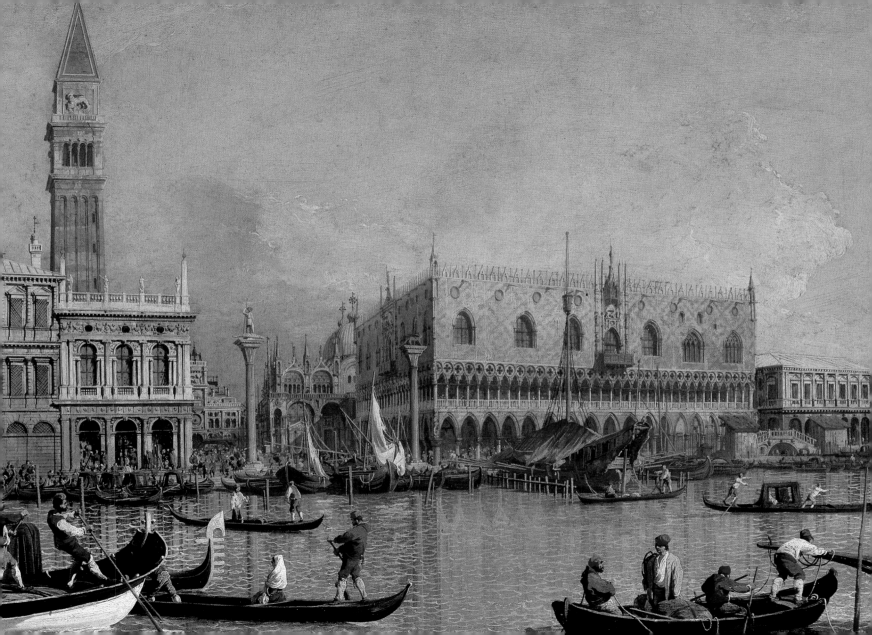

There are no lines in nature,
only areas of color, one against another.

EDOUARD MANET

Luncheon on the Grass, 1863
Edouard Manet
Musée d'Orsay, Paris

1 2 3 4 5 6 7 8 9 10 11 **12** 13 14 15 16 17 18 19 20 21 22 23 24 25 26 27 28 29 30 31

MARCH

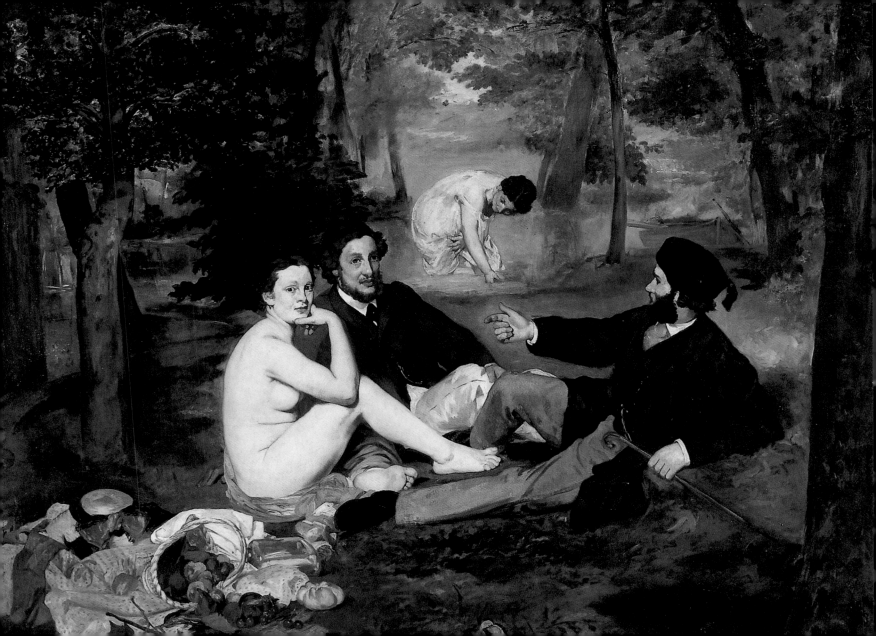

The mountains are fountains of men as well as of rivers, of glaciers, and of fertile soil. The great poets, philosophers, prophets, and able men whose thoughts and deeds have moved the world, have come down from the mountains.

Ｊｏｈｎ Ｍｕｉｒ

Hakone, Plate 11 from the Series "Fifty-three Stations of the Tokaido," *c.* 1830–31
Utagawa Hiroshige
Private Collection

1 2 3 4 5 6 7 8 9 10 11 12 **13** 14 15 16 17 18 19 20 21 22 23 24 25 26 27 28 29 30 31

MARCH

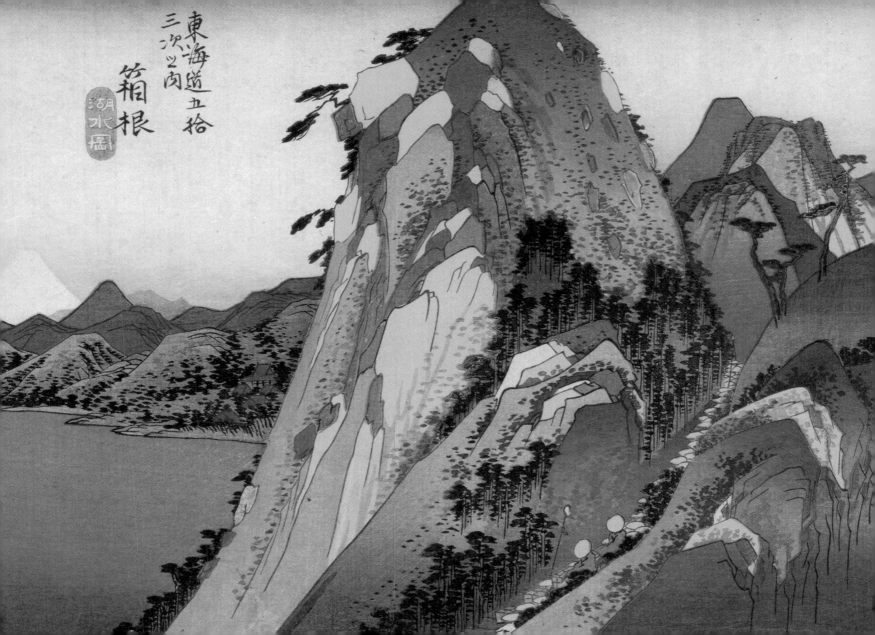

My soul knows that I am part of the human race,
my soul is an organic part of the great human
race, as my spirit is part of my nation.
In my own very self, I am part of my family.

D. H. LAWRENCE

Joyful Company
(The Painter's Family), *c.* 1657
Jan Steen
Mauritshuis, The Hague

1 2 3 4 5 6 7 8 9 10 11 12 13 **14** 15 16 17 18 19 20 21 22 23 24 25 26 27 28 29 30 31

MARCH

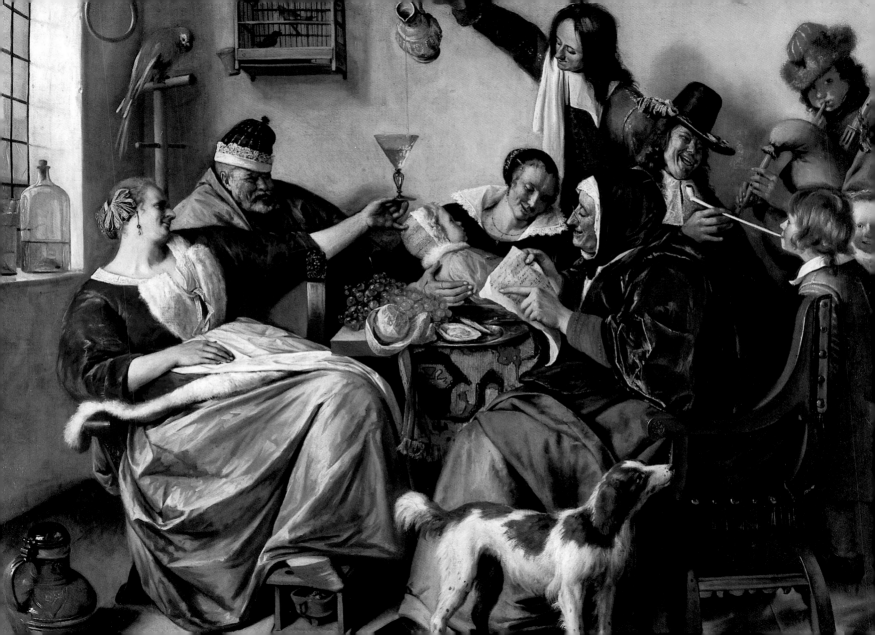

The motif must always be set down in a simple way,
easily grasped and understood by the beholder.
By the elimination of superfluous detail,
the spectator should be led along the road that
the artist indicates to him, and from the first
be made to notice what the artist has felt.

ALFRED SISLEY

Wintry Landscape in Louveciennes, 1873
Alfred Sisley
The Pushkin Museum of Fine Arts, Moscow

1 2 3 4 5 6 7 8 9 10 11 12 13 14 **15** 16 17 18 19 20 21 22 23 24 25 26 27 28 29 30 31

MARCH

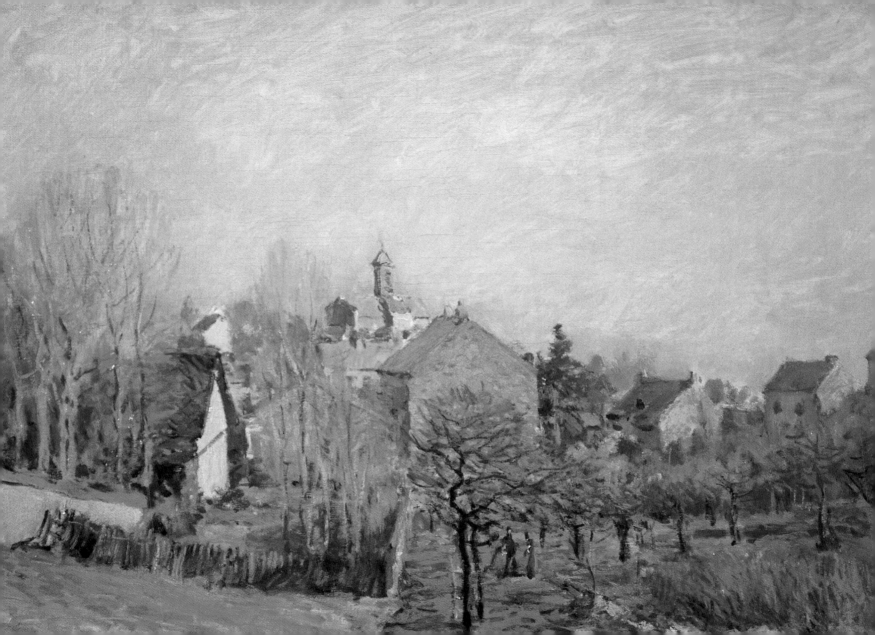

*Grace is given of God, but knowledge
is bought in the market.*

ARTHUR HUGH CLOUGH

Russian Fair, 1906
Boris H. Kustodiev
Tretyakov Gallery, Moscow

1 2 3 4 5 6 7 8 9 10 11 12 13 14 15 **16** 17 18 19 20 21 22 23 24 25 26 27 28 29 30 31

MARCH

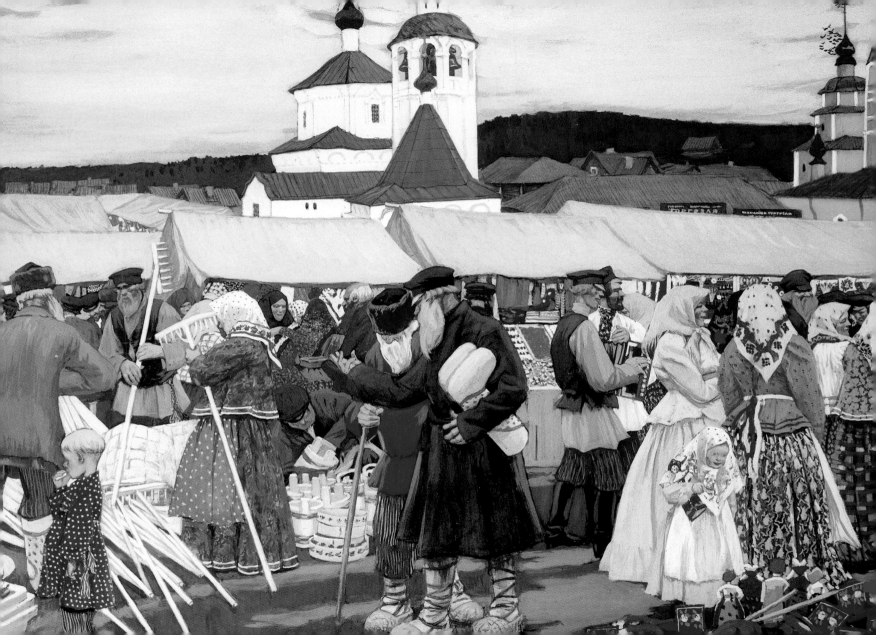

There are no rules in painting.

Francisco José de Goya

The Clothed Maya, 1798–1803
Francisco José de Goya
Museo Nacional del Prado, Madrid

1 2 3 4 5 6 7 8 9 10 11 12 13 14 15 16 **17** 18 19 20 21 22 23 24 25 26 27 28 29 30 31

MARCH

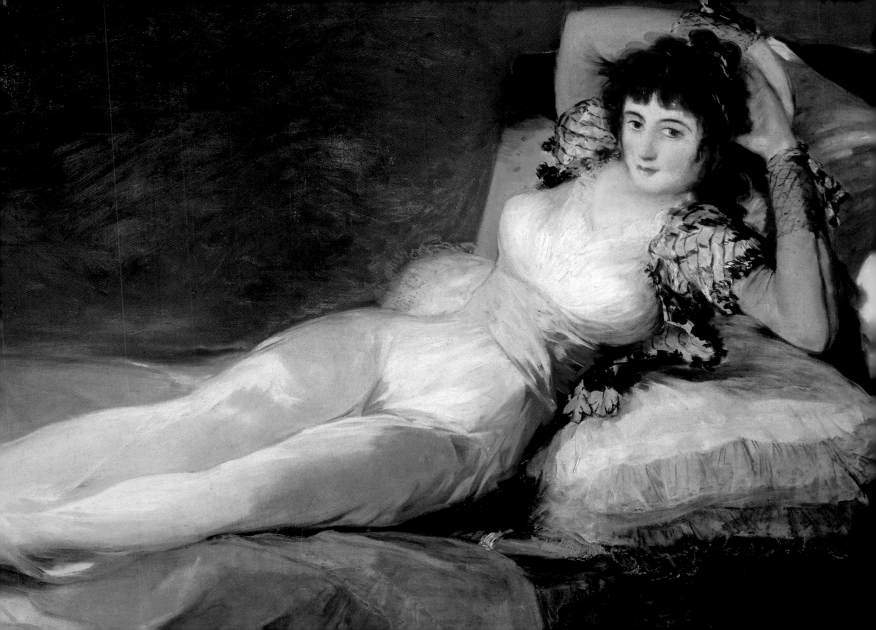

As music is the poetry of sound,
so is painting the poetry of sight.

James McNeill Whistler

Musical Instruments, Sheet Music, and Books,
late 17th century
Bartolomeo Bettera
Silvano Lodi Collection, Campione d.I.

1 2 3 4 5 6 7 8 9 10 11 12 13 14 15 16 17 **18** 19 20 21 22 23 24 25 26 27 28 29 30 31

MARCH

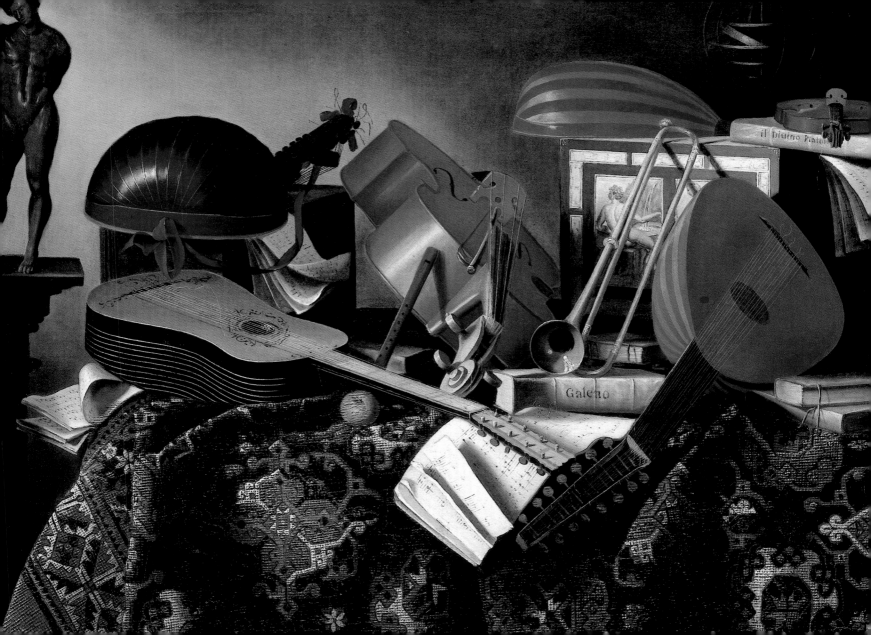

There is nothing to it. You only have to hit the right notes at the right time and the instrument plays itself.

<small>JOHANN SEBASTIAN BACH</small>

**Girl at the Piano
(Overture to Tannhäuser),** 1867–68
Paul Cézanne
The State Hermitage Museum, St. Petersburg

1 2 3 4 5 6 7 8 9 10 11 12 13 14 15 16 17 18 **19** 20 21 22 23 24 25 26 27 28 29 30 31

MARCH

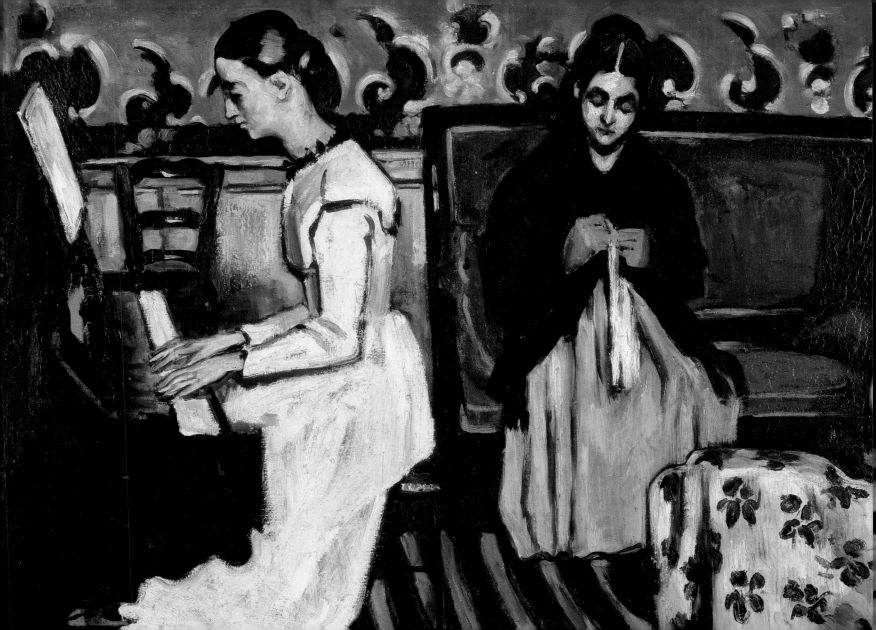

We shall find peace. We shall hear the angels, we shall see the sky sparkling with diamonds.

ANTON PAVLOVICH CHEKHOV

The Annunciation, 1333
Simone Martini
Uffizi Gallery, Florence

1 2 3 4 5 6 7 8 9 10 11 12 13 14 15 16 17 18 19 **20** 21 22 23 24 25 26 27 28 29 30 31

MARCH

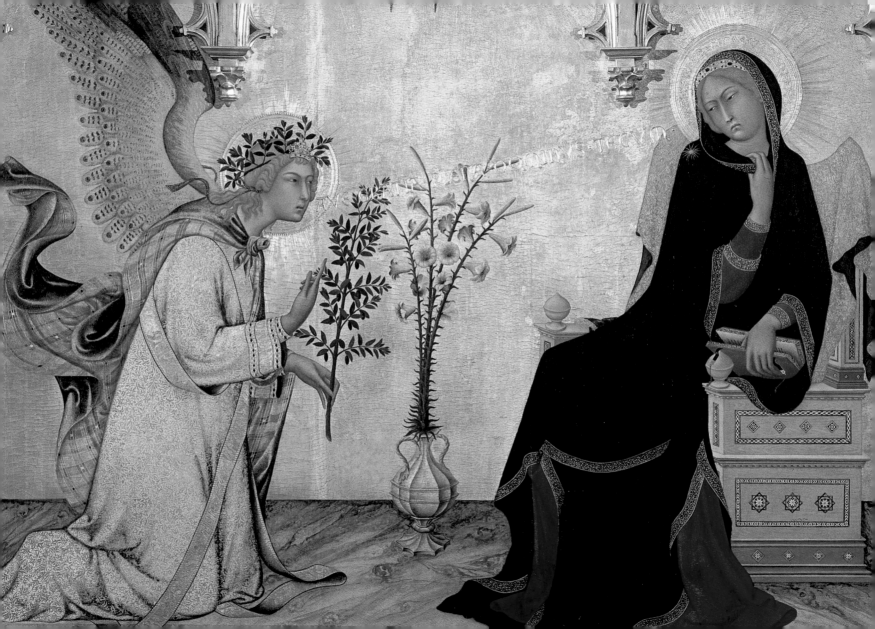

I didn't become an impressionist.
As long as I can remember I always
have been one.

<small>CLAUDE MONET</small>

Gare Saint-Lazare, Paris, 1877
Claude Monet
Musée d'Orsay, Paris

1 2 3 4 5 6 7 8 9 10 11 12 13 14 15 16 17 18 19 20 **21** 22 23 24 25 26 27 28 29 30 31

MARCH

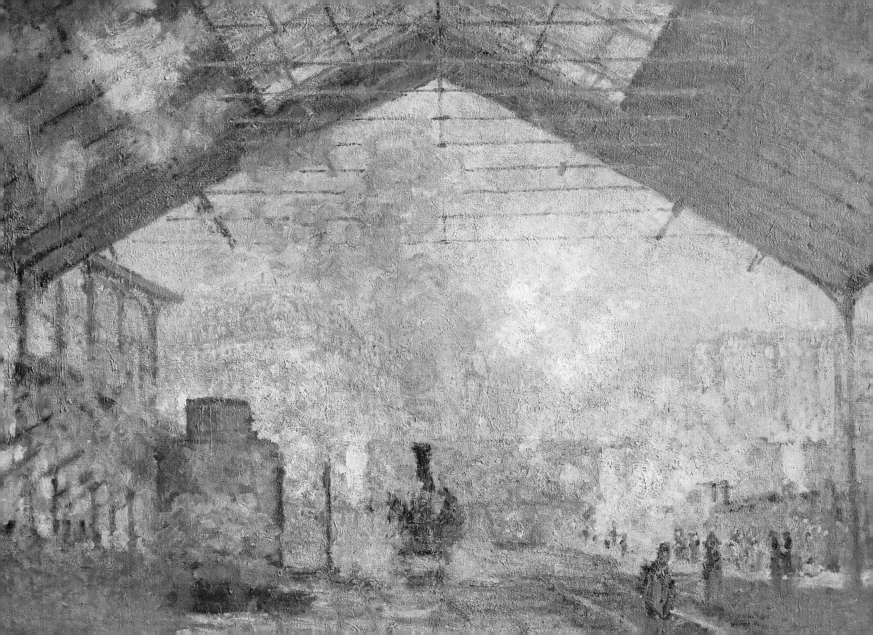

Cruelty and fear shake hands together.

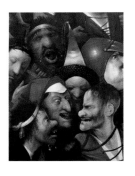

The Carrying of the Cross (detail), *c.* 1500
Hieronymus Bosch
Musée des Beaux-Arts, Ghent

1 2 3 4 5 6 7 8 9 10 11 12 13 14 15 16 17 18 19 20 21 **22** 23 24 25 26 27 28 29 30 31

MARCH

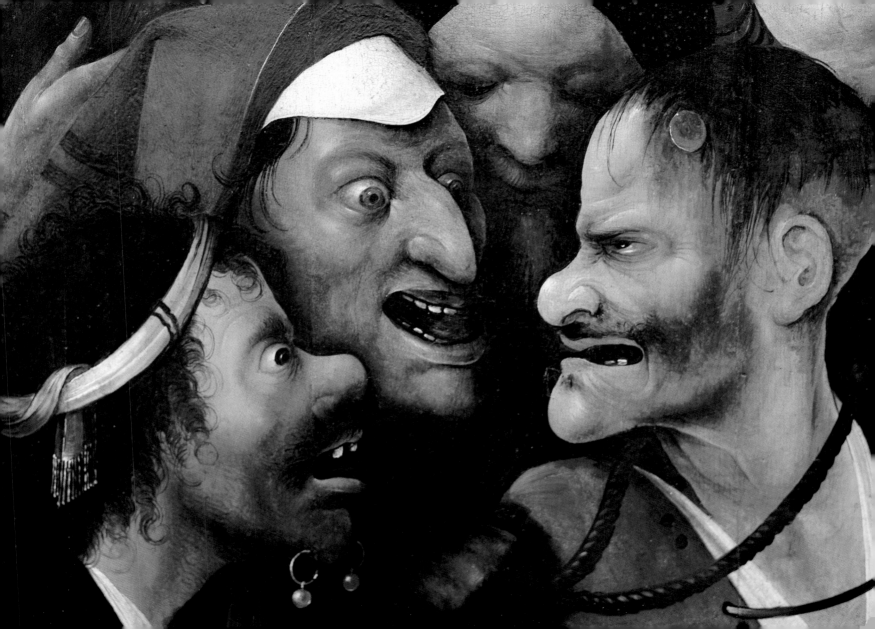

The only decent people
I ever saw at the racecourse
were horses.

JAMES JOYCE

The Races, 1871–72
Edgar Degas
National Gallery of Art, Washington D.C.

1 2 3 4 5 6 7 8 9 10 11 12 13 14 15 16 17 18 19 20 21 22 **23** 24 25 26 27 28 29 30 31

MARCH

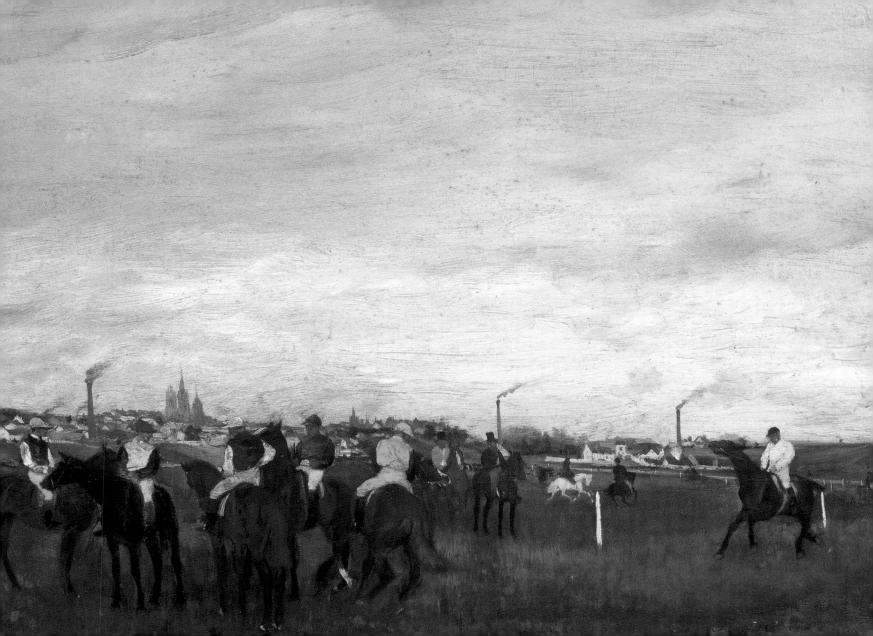

I would rather not see such winds subside, which carry your slow ship away, although they leave me, cast down, on an empty shore, often, with clenched hand, calling you cruel.

PROPERTIUS SEXTUS

Rinaldo abandons Armida, 1750–55
Giovanni Battista Tiepolo
Uffizi Gallery, Florence

1 2 3 4 5 6 7 8 9 10 11 12 13 14 15 16 17 18 19 20 21 22 23 **24** 25 26 27 28 29 30 31

MARCH

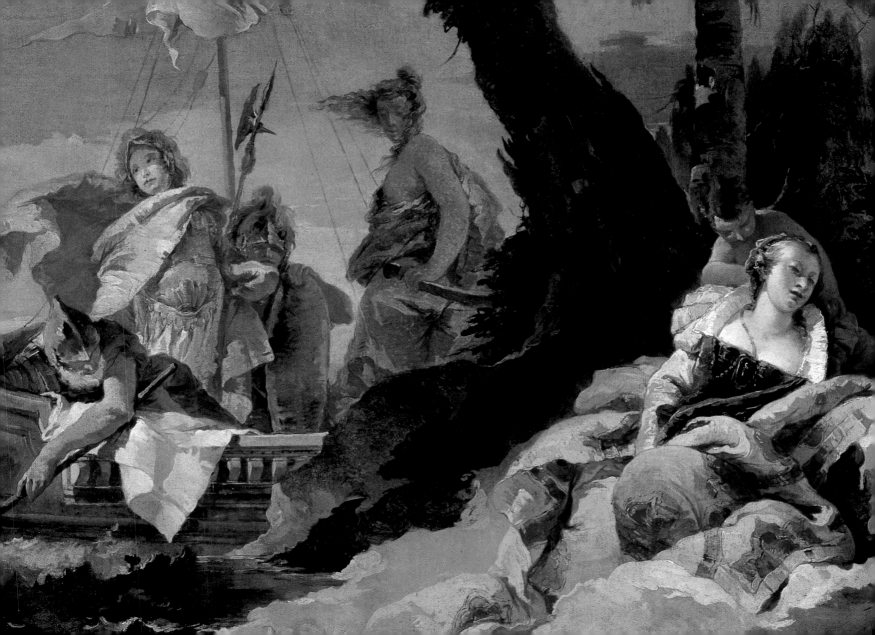

One supreme fact which I have discovered is that it is not willpower, but fantasy-imagination that creates. Imagination is the creative force. Imagination creates reality.

RICHARD WAGNER

Pavane Fantastique, *c.* 1916–17
Alexander Sacharoff
Lenbachhaus, Munich

1 2 3 4 5 6 7 8 9 10 11 12 13 14 15 16 17 18 19 20 21 22 23 24 **25** 26 27 28 29 30 31

MARCH

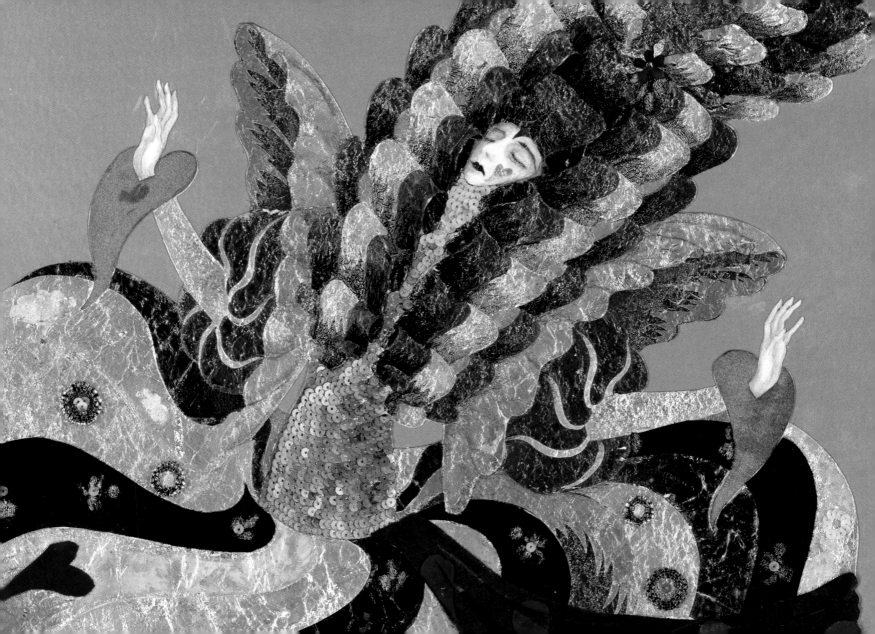

A friend is one to whom one may pour
out all the contents of one's heart,
chaff and grain together, knowing that
the gentlest of hands will take and sift it,
keep what is worth keeping and with
a breath of kindness blow the rest away.

<small>ARABIAN PROVERB</small>

Two Young Women, 19th century
Louis Eugène Bertier
Art Museum, Sevastopol

1 2 3 4 5 6 7 8 9 10 11 12 13 14 15 16 17 18 19 20 21 22 23 24 25 **26** 27 28 29 30 31

MARCH

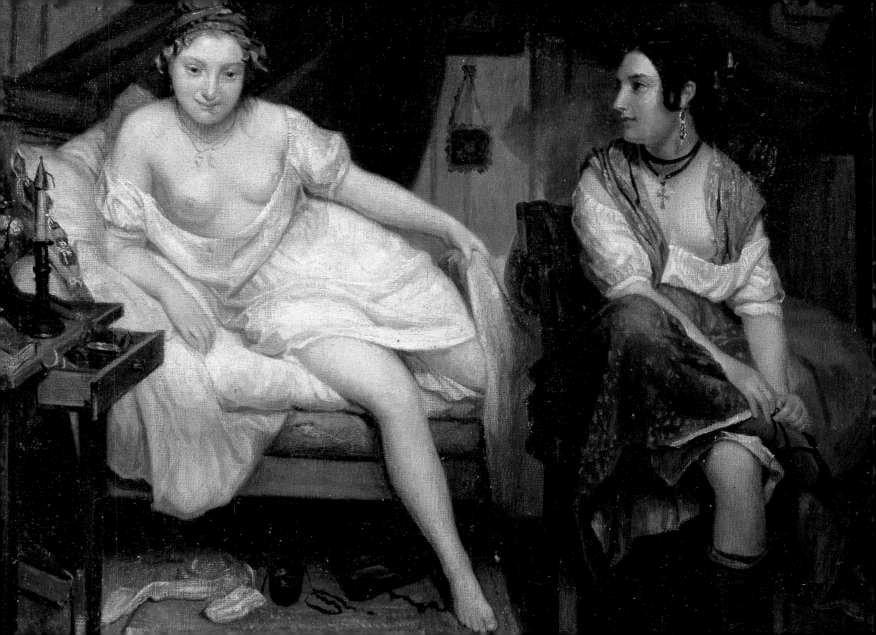

Today we are searching for things in nature that are hidden behind the veil of appearance ... We look for and paint this inner, spiritual side of nature.

Franz Marc

Little Monkey, 1912
Franz Marc
Lenbachhaus, Munich

1 2 3 4 5 6 7 8 9 10 11 12 13 14 15 16 17 18 19 20 21 22 23 24 25 26 **27** 28 29 30 31

MARCH

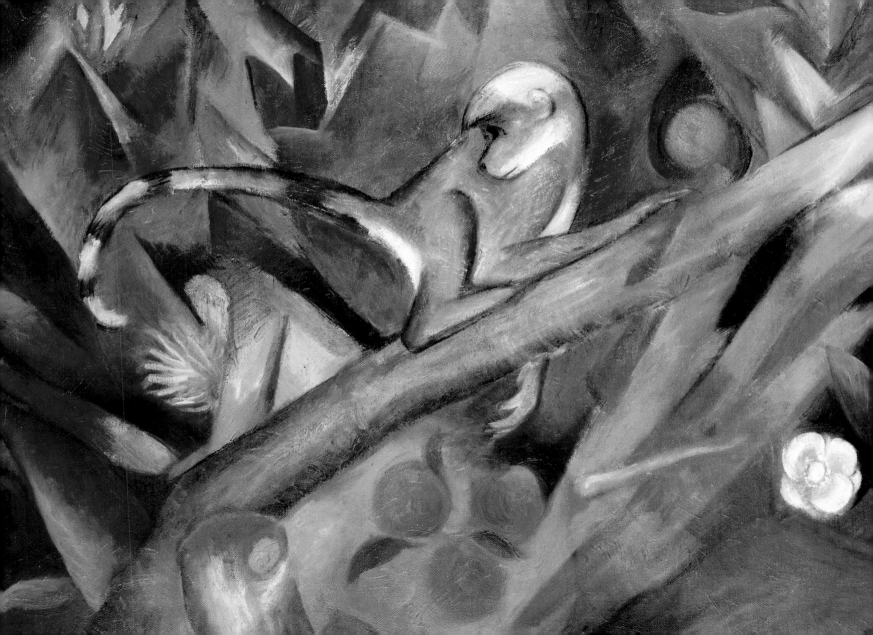

All the world's a stage,
And all the men and women
merely players.

WILLIAM SHAKESPEARE

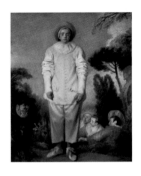

Gilles, 1720
Jean-Antoine Watteau
Musée du Louvre, Paris

1 2 3 4 5 6 7 8 9 10 11 12 13 14 15 16 17 18 19 20 21 22 23 24 25 26 27 **28** 29 30 31

MARCH

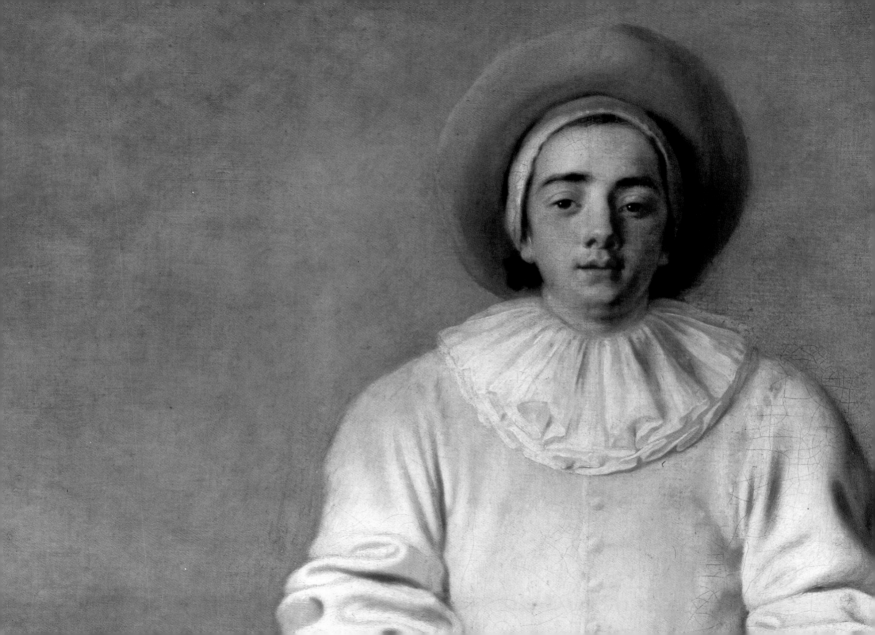

They say the sea is cold, but the sea contains the hottest blood of all, and the wildest, the most urgent.

D. H. LAWRENCE

Neptune and Amphitrite, 1618
Filippo Napoletano
Palazzo Pitti, Florence

1 2 3 4 5 6 7 8 9 10 11 12 13 14 15 16 17 18 19 20 21 22 23 24 25 26 27 28 **29** 30 31

MARCH

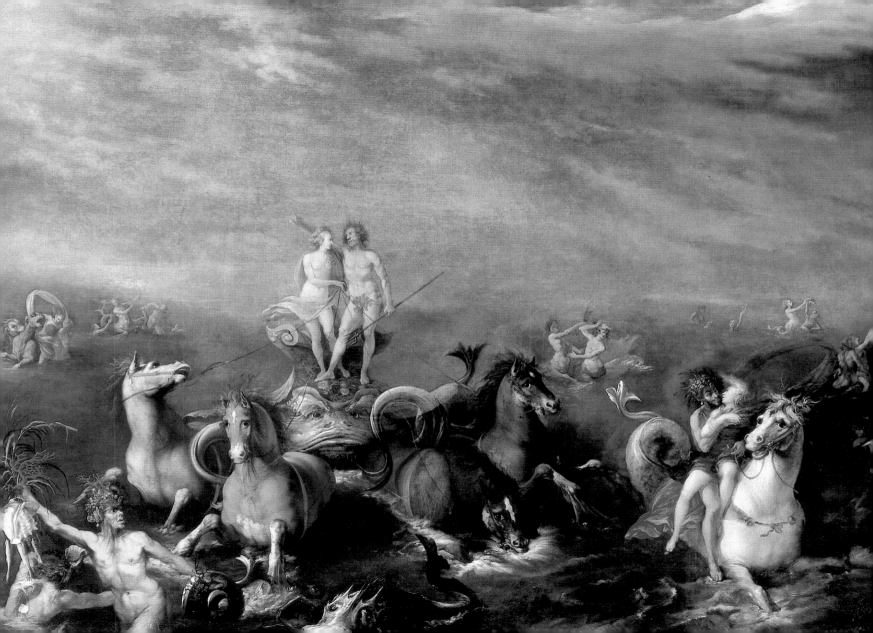

*On matters of style,
swim with the current,
on matters of principle,
stand like a rock.*

THOMAS JEFFERSON

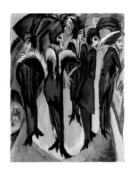

Five Women on the Street, 1913
Ernst Ludwig Kirchner
Museum Ludwig, Cologne

1 2 3 4 5 6 7 8 9 10 11 12 13 14 15 16 17 18 19 20 21 22 23 24 25 26 27 28 29 **30** 31

MARCH

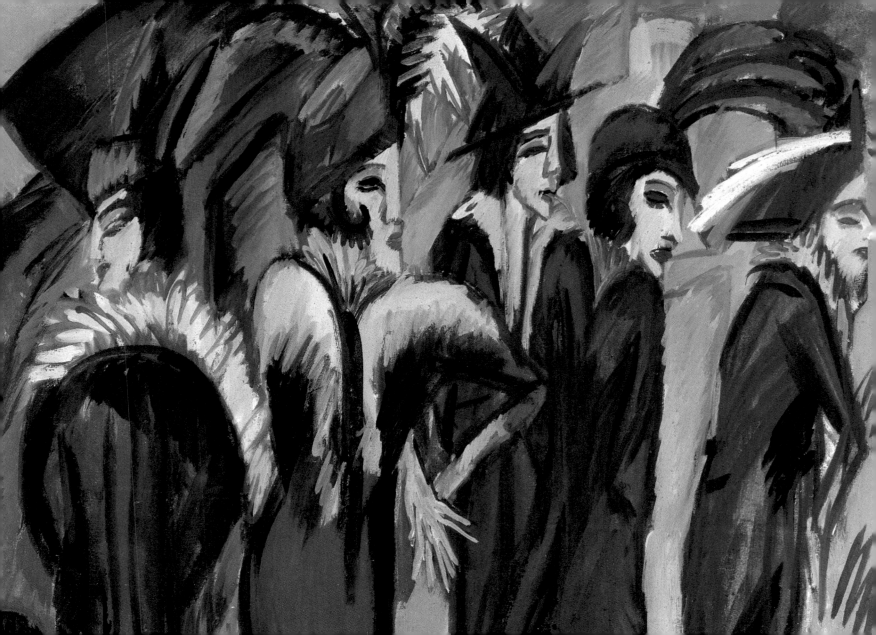

Dance like no one is watching.
Sing like no one is listening.
Love like you've never been hurt
and live like it's heaven on Earth.

<small>MARK TWAIN</small>

Country Meal, after 1566
Maerten van Cleve
Kunsthistorisches Museum, Vienna

1 2 3 4 5 6 7 8 9 10 11 12 13 14 15 16 17 18 19 20 21 22 23 24 25 26 27 28 29 30 **31**

MARCH

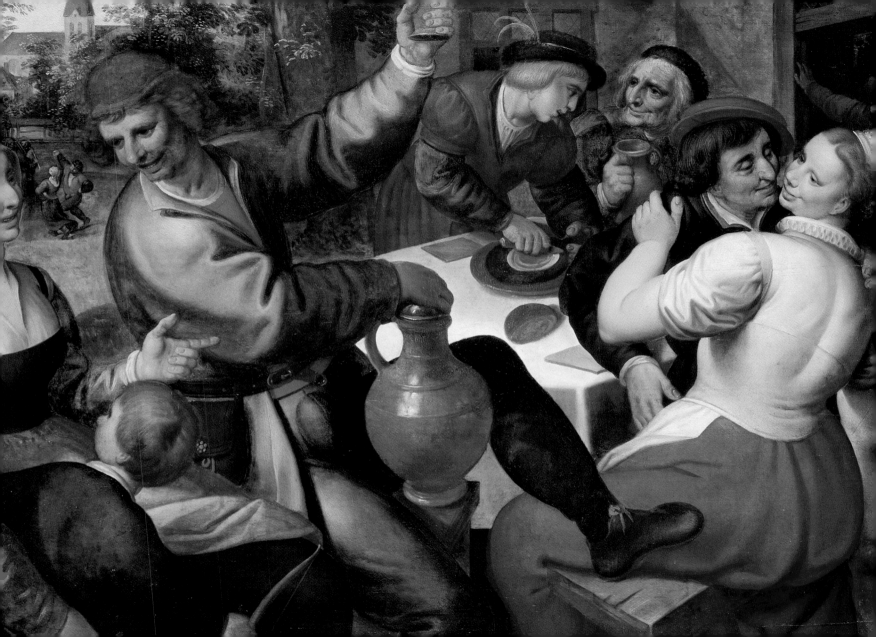

It is respectable to have no illusions—
and safe—and profitable, and dull.

Joseph Conrad

Cabinet of Curiosities, late 17th century
Domenico Remps
Opificio delle Pietre Dure, Florence

1 2 3 4 5 6 7 8 9 10 11 12 13 14 15 16 17 18 19 20 21 22 23 24 25 26 27 28 29 30

APRIL

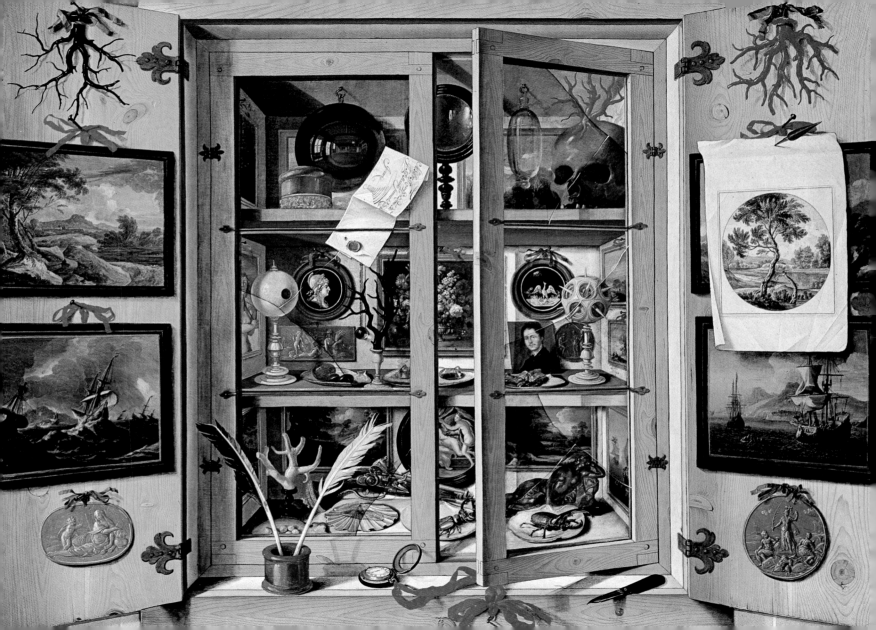

Painting is stronger than me,
it makes me do its bidding.

<small>PABLO PICASSO</small>

Harlequins, 1905
Pablo Picasso
The Pushkin Museum of Fine Arts, Moscow

1 **2** 3 4 5 6 7 8 9 10 11 12 13 14 15 16 17 18 19 20 21 22 23 24 25 26 27 28 29 30

APRIL

I Sing the Body Electric.

Walt Whitman

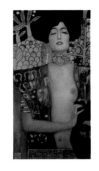

Judith I, 1901
Gustav Klimt
Art Gallery, Ostrava

3

1 2 3 4 5 6 7 8 9 10 11 12 13 14 15 16 17 18 19 20 21 22 23 24 25 26 27 28 29 30

APRIL

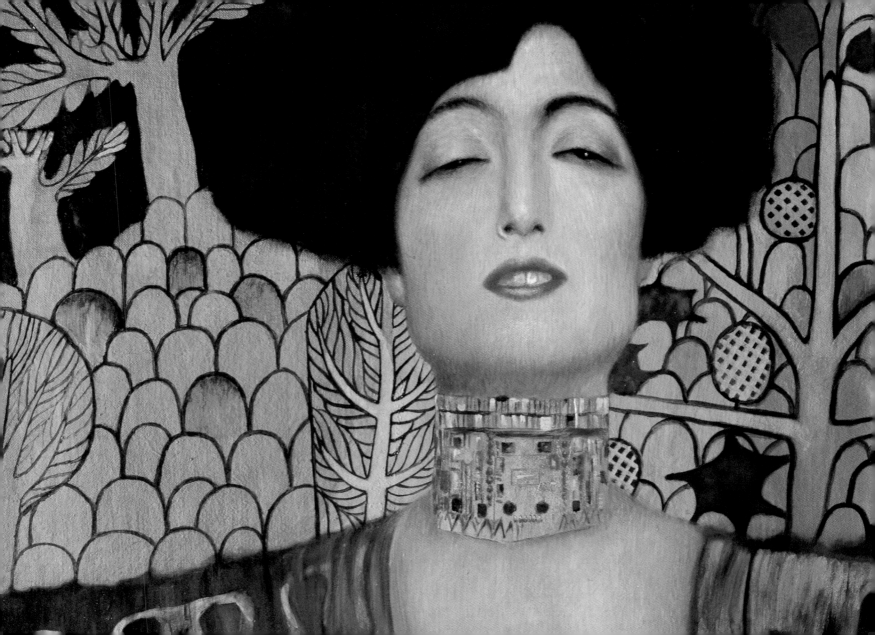

*The sun does not forget a village
just because it is small.*

Village on a River, 16th century
Jan Brueghel the Elder
Kunsthistorisches Museum, Vienna

1 2 3 **4** 5 6 7 8 9 10 11 12 13 14 15 16 17 18 19 20 21 22 23 24 25 26 27 28 29 30

APRIL

There is nothing nobler or more admirable than when two people who see eye to eye keep house as man and wife, confounding their enemies and delighting their friends.

HOMER

Joseph, the Choosen Husband of Mary, 1476
Christoforo de Predis
Biblioteca Reale, Turin

1 2 3 4 **5** 6 7 8 9 10 11 12 13 14 15 16 17 18 19 20 21 22 23 24 25 26 27 28 29 30

APRIL

The aim of art is to represent not the outward appearance of things, but their inward significance.

Aristotle

Still-Life with Attributes of Art,
late 18th century
Jean-Baptiste Siméon Chardin
The Pushkin Museum of Fine Arts, Moscow

1 2 3 4 5 **6** 7 8 9 10 11 12 13 14 15 16 17 18 19 20 21 22 23 24 25 26 27 28 29 30

APRIL

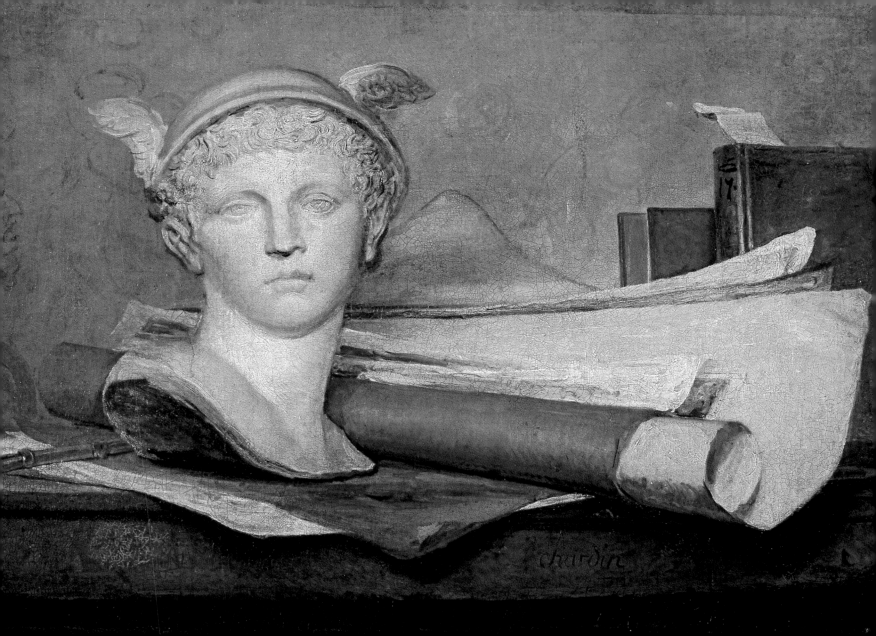

chardin

Use what talents you possess;
the woods would be very silent
if no birds sang there
except those that sang best.

<small>HENRY VAN DYKE</small>

A Visit, c. 1850
Carl Spitzweg
Private Collection

1 2 3 4 5 6 **7** 8 9 10 11 12 13 14 15 16 17 18 19 20 21 22 23 24 25 26 27 28 29 30

APRIL

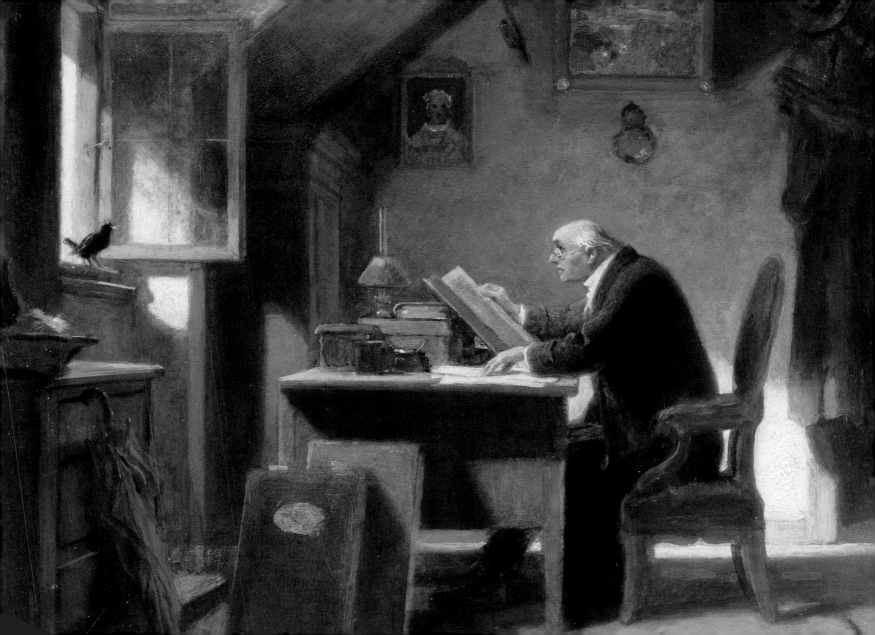

It is not enough to know your craft—you have to have feeling. Science is all very well, but for us imagination is worth far more.

EDOUARD MANET

The Railway, 1873
Edouard Manet
National Gallery of Art, Washington D.C.

8

1 2 3 4 5 6 7 **8** 9 10 11 12 13 14 15 16 17 18 19 20 21 22 23 24 25 26 27 28 29 30

APRIL

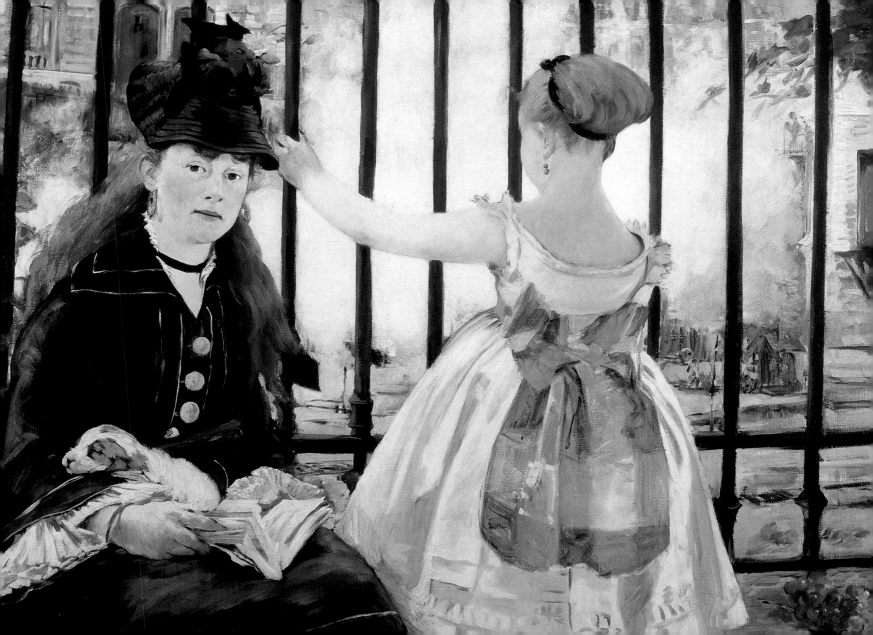

Again the blackbirds sings; the streams,
Wake, laughing, from their winter dreams,
And tremble in the April showers,
The tassels of the maple flowers.

JOHN GREENLEAF WHITTIER

April, late 16th century
Leandro Bassano
The Art Museum, Tula

1 2 3 4 5 6 7 8 **9** 10 11 12 13 14 15 16 17 18 19 20 21 22 23 24 25 26 27 28 29 30

APRIL

Turner has made a picture with real rain,
behind which is real sunshine, and you expect
a rainbow every minute. Meanwhile there comes
a train down upon you, really moving at the rate
of fifty miles an hour ...

WILLIAM MAKEPEACE THACKERAY

Rain, Steam and Speed—
The Great Western Railway, 1844
Joseph Mallord William Turner
National Gallery, London

1 2 3 4 5 6 7 8 9 **10** 11 12 13 14 15 16 17 18 19 20 21 22 23 24 25 26 27 28 29 30

APRIL

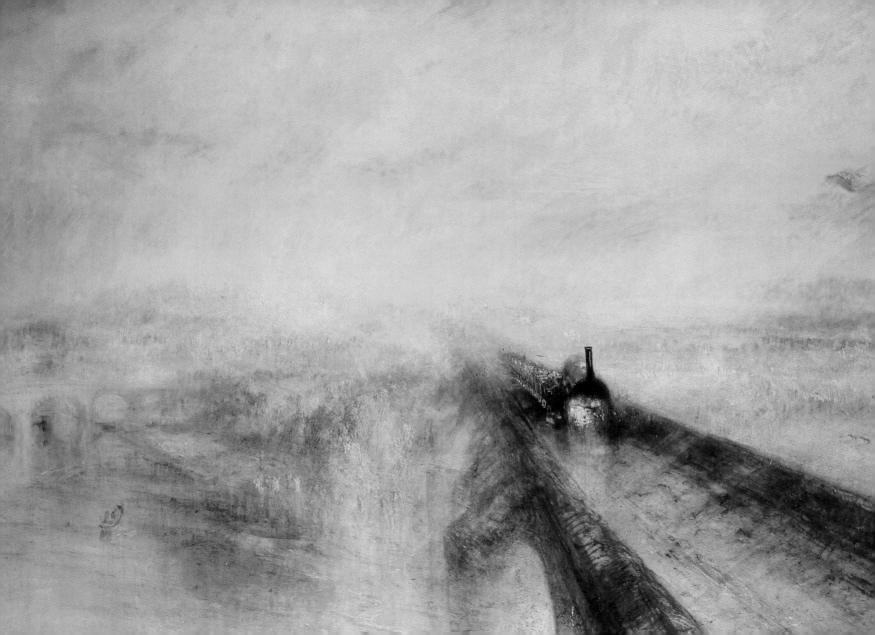

Death and life have their determined appointments; riches and honors depend upon heaven.

CONFUCIUS

Tribute Money, 1425
Masaccio
Santa Maria del Carmine, Florence

1 2 3 4 5 6 7 8 9 10 **11** 12 13 14 15 16 17 18 19 20 21 22 23 24 25 26 27 28 29 30

APRIL

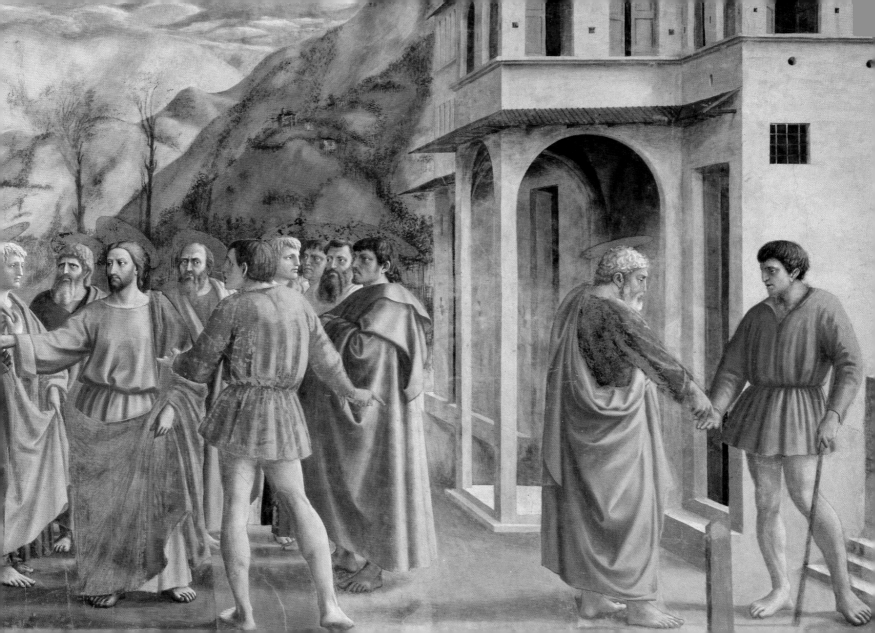

Love of beauty is Taste.
The creation of beauty is Art.

Ralph Waldo Emerson

The Rokeby Venus, 1648–51
Diego Rodriguez de Velázquez
National Gallery, London

1 2 3 4 5 6 7 8 9 10 11 **12** 13 14 15 16 17 18 19 20 21 22 23 24 25 26 27 28 29 30

April

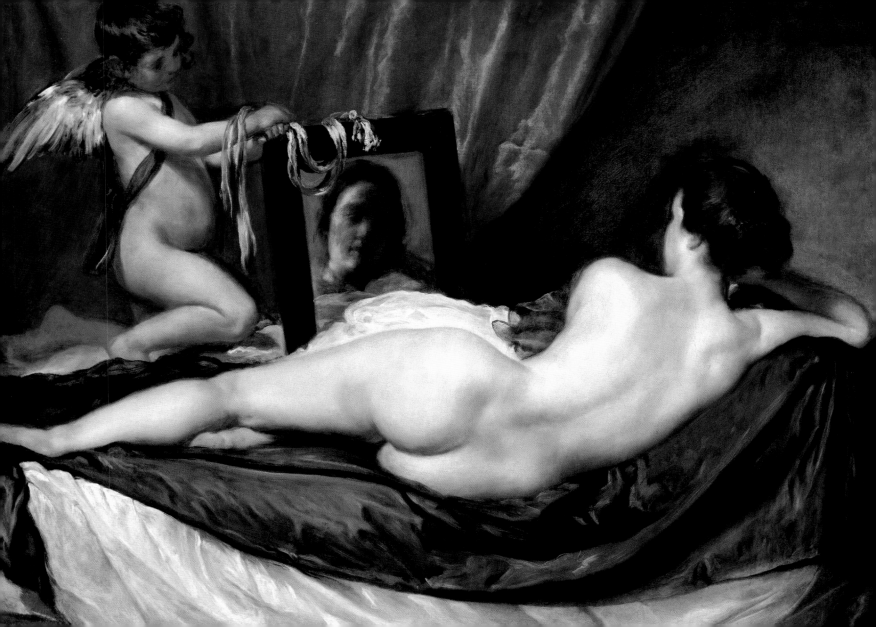

India is the cradle of the human race,
the birthplace of human speech, the mother
of history, the grandmother of legend,
and the great-grandmother of tradition.
Our most valuable and most instructive
materials in the history of man are
treasured up in India only.

MARK TWAIN

The Ape, Maimun, Licks the Bears in the Traps, 1570–71
Illustration of Anvar-I Suhaili for Jalaluddin Muhammad Akbar
School of Oriental and African Studies, University of London

1 2 3 4 5 6 7 8 9 10 11 12 **13** 14 15 16 17 18 19 20 21 22 23 24 25 26 27 28 29 30

APRIL

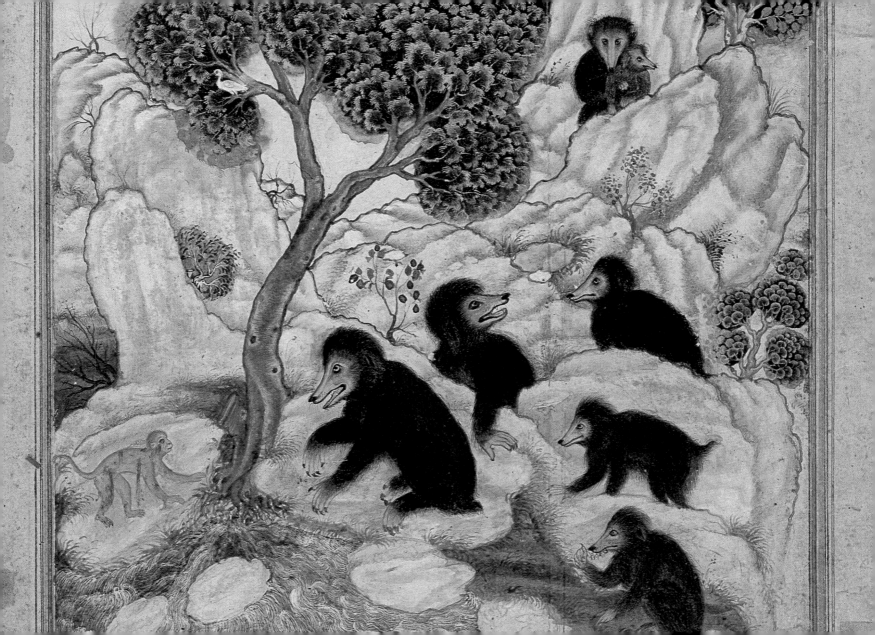

*Besides the noble art of getting things done,
there is a nobler art of leaving things undone …
The wisdom of life consists in the elimination
of nonessentials.*

LIN YUTANG

Four Bathers, 1909
Ernst Ludwig Kirchner
Von der Heydt-Museum, Wuppertal

1 2 3 4 5 6 7 8 9 10 11 12 13 **14** 15 16 17 18 19 20 21 22 23 24 25 26 27 28 29 30

APRIL

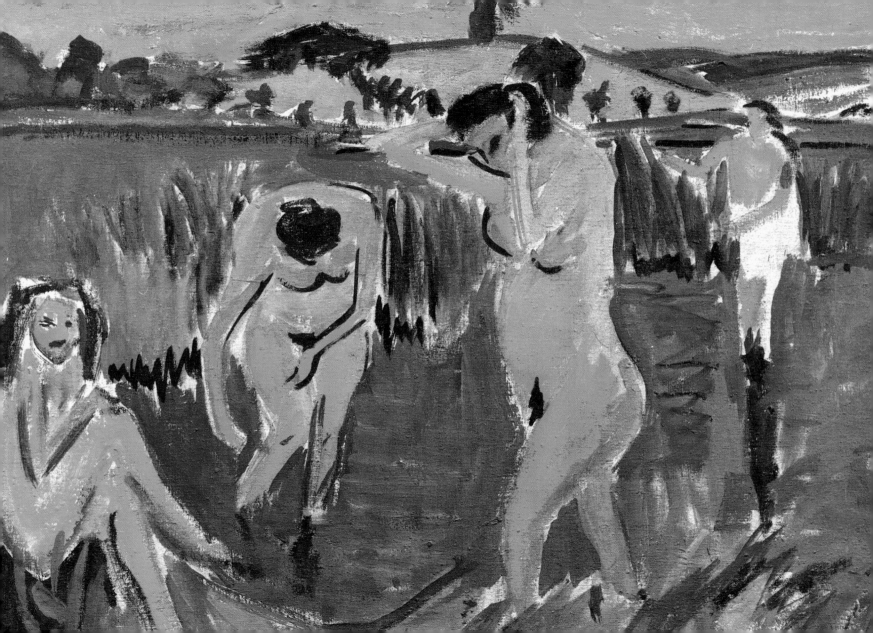

To send light into the darkness of men's hearts—such is the duty of the artist.

ROBERT A. SCHUMANN

The Art of Painting, *c.* 1665–66
Johannes Vermeer
Kunsthistorisches Museum, Vienna

1 2 3 4 5 6 7 8 9 10 11 12 13 14 **15** 16 17 18 19 20 21 22 23 24 25 26 27 28 29 30

APRIL

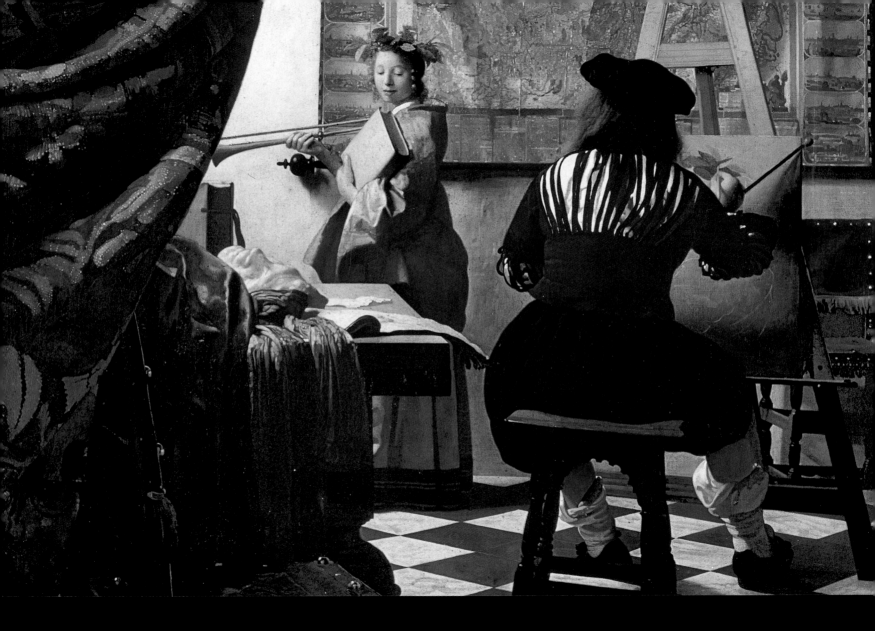

God so loved the world
that he gave his one and only Son,
that whoever believes in him
shall not perish
but have eternal life.

THE GOSPEL OF ST. JOHN, 3:16

Isenheimer Altarpiece, second view of the altar, right panel:
Resurrection of Christ, 1515
Matthias Grünewald
Musée d'Unterlinden, Colmar

1 2 3 4 5 6 7 8 9 10 11 12 13 14 15 **16** 17 18 19 20 21 22 23 24 25 26 27 28 29 30

APRIL

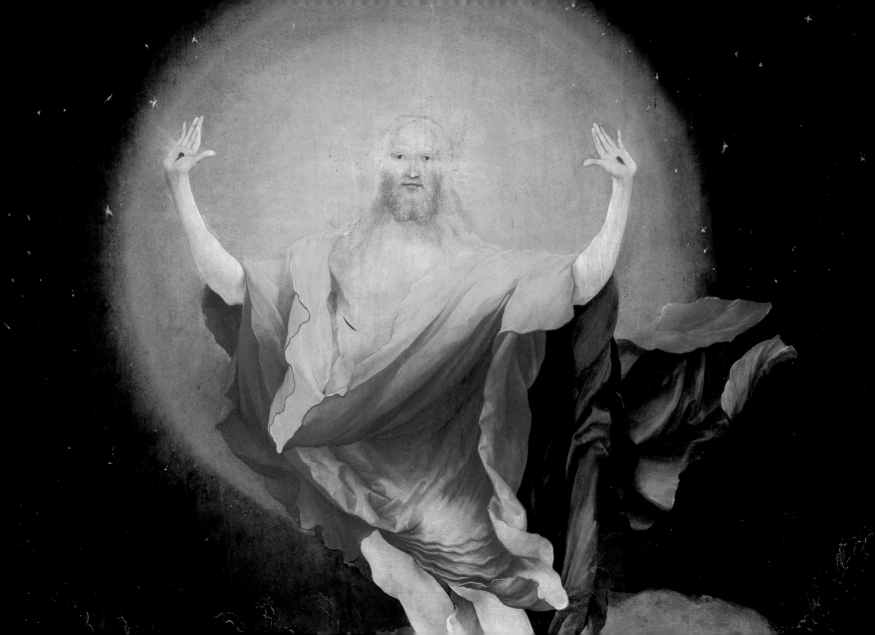

Modesty is the only sure bait
when you are fishing for praise.

Landscape with Fishermen, c. 1911
August Macke
Lenbachhaus, Munich

1 2 3 4 5 6 7 8 9 10 11 12 13 14 15 16 **17** 18 19 20 21 22 23 24 25 26 27 28 29 30

APRIL

Oh Art of Painting, You may well consider Yourself most fortunate in having one of Your artisans elevate You, by his talent and manners, above the heavens!

Giorgio Vasari (on Raphael)

The Holy Family with a Palm Tree, 1506
Raphael
National Gallery of Scotland, Edinburgh

1 2 3 4 5 6 7 8 9 10 11 12 13 14 15 16 17 **18** 19 20 21 22 23 24 25 26 27 28 29 30

APRIL

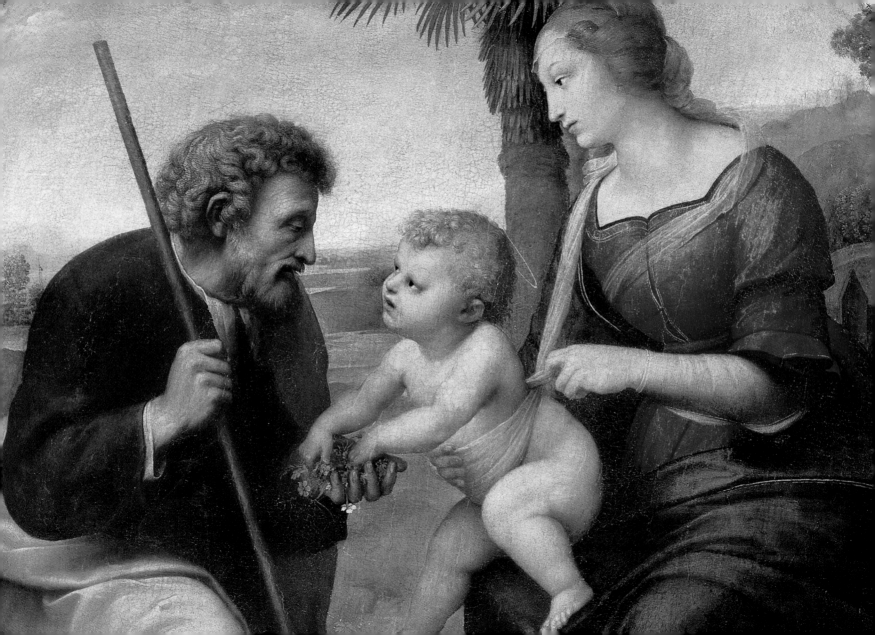

*I must see new things
and investigate them.
I want to taste dark water
and see crackling
trees and wild winds.*

EGON SCHIELE

Houses with Clothes Hanging Out to Dry, 1917
Egon Schiele
Private Collection, Santa Barbara

1 2 3 4 5 6 7 8 9 10 11 12 13 14 15 16 17 18 **19** 20 21 22 23 24 25 26 27 28 29 30

APRIL

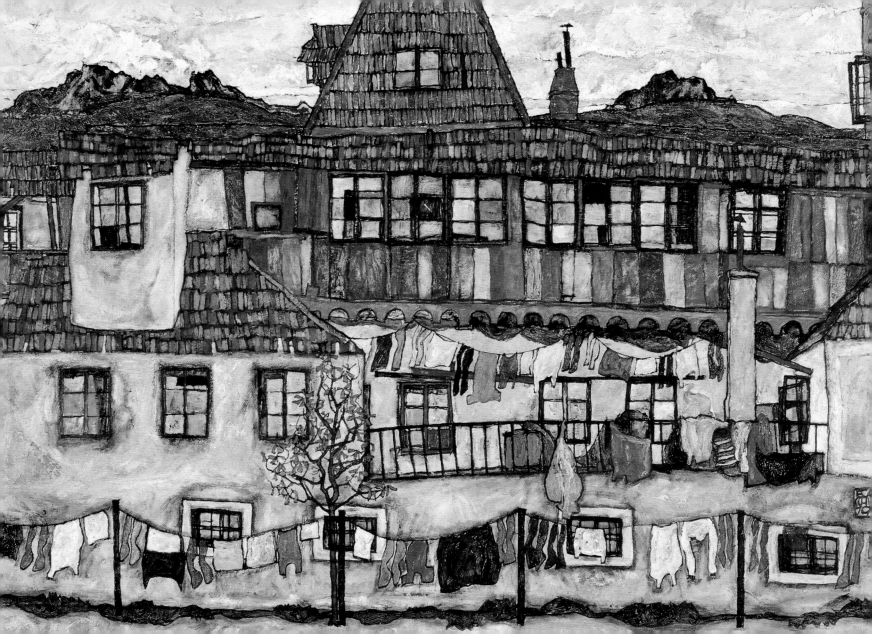

Flowers have an expression of countenance as much as men or animals. Some seem to smile; some have a sad expression; some are pensive and diffident; others again are plain, honest and upright, like the broad-faced sunflower and the hollyhock.

HENRY WARD BEECHER

Spring, 1573
Giuseppe Arcimboldo
Academia di S. Fernando, Madrid

1 2 3 4 5 6 7 8 9 10 11 12 13 14 15 16 17 18 19 **20** 21 22 23 24 25 26 27 28 29 30

APRIL

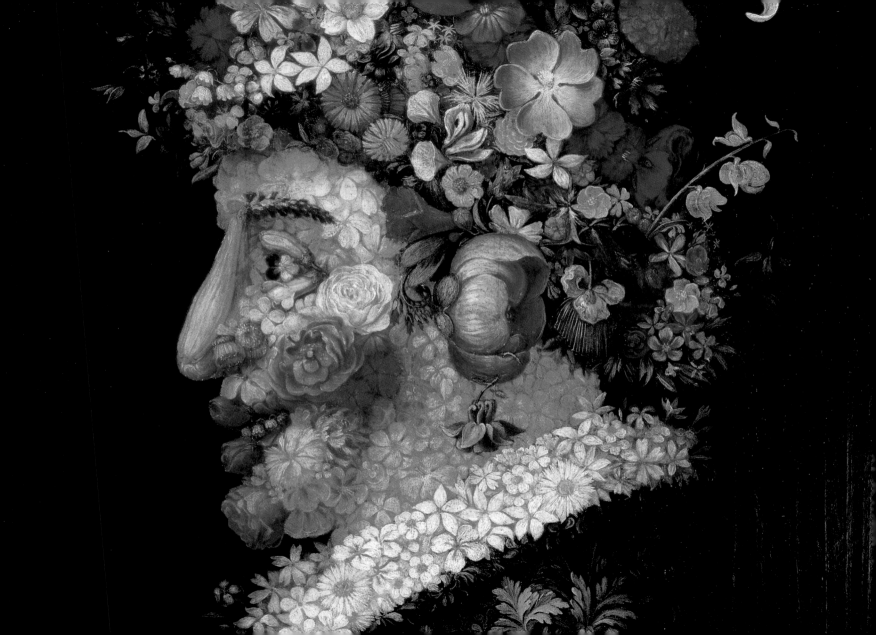

Life grants nothing to us mortals without hard work.

**For Eighty Cents
(Working in the Rice Fields),** 1895
Alessandro Morbelli
Museo Borgogna, Vercelli

1 2 3 4 5 6 7 8 9 10 11 12 13 14 15 16 17 18 19 20 **21** 22 23 24 25 26 27 28 29 30

APRIL

For there is no friend like a sister
In calm or stormy weather;
To cheer one on the tedious way,
To fetch one if one goes astray,
To lift one if one totters down,
To strengthen while one stands.

CHRISTINA G. ROSSETTI

The Waldegrave Sisters, 1780–81
Sir Joshua Reynolds
National Gallery of Scotland, Edinburgh

1 2 3 4 5 6 7 8 9 10 11 12 13 14 15 16 17 18 19 20 21 **22** 23 24 25 26 27 28 29 30

APRIL

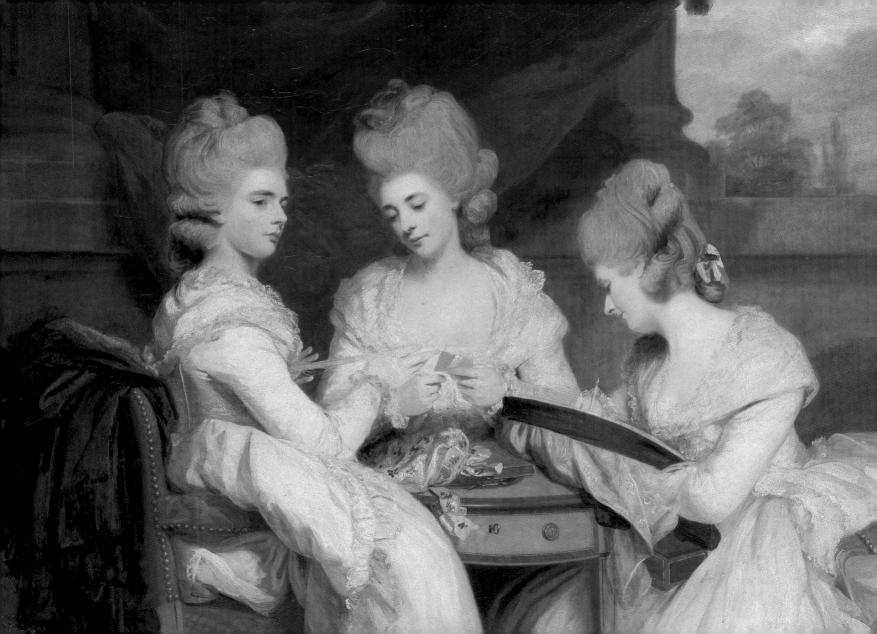

*Far better it is to dare mighty things,
to win glorious triumphs, even though checkered
by failure, than to rank with those poor spirits
who neither enjoy much nor suffer much
because they live in the grey twilight that
knows neither victory or defeat.*

THEODORE ROOSEVELT

Saint George, 18th century
Russian Icon
Winokurow Gallery, Munich

1 2 3 4 5 6 7 8 9 10 11 12 13 14 15 16 17 18 19 20 21 22 **23** 24 25 26 27 28 29 30

APRIL

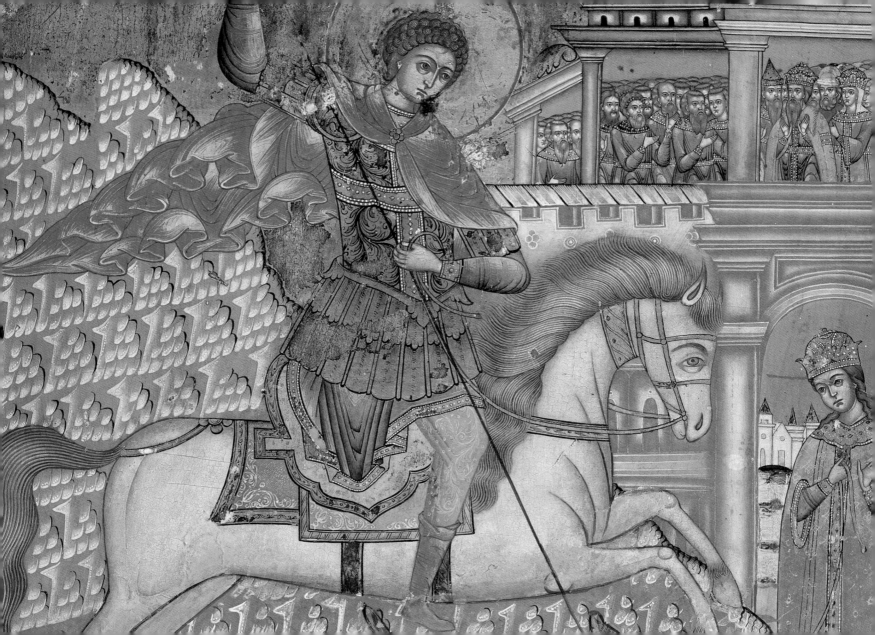

Infancy conforms to nobody:
all conform to it, so that one babe
commonly makes four or five out of the
adults who prattle and play to it.

R<small>ALPH</small> W<small>ALDO</small> E<small>MERSON</small>

The Birth of Mary, *c.* 1750
Corrado Giaquinto
Uffizi Gallery, Florence

1 2 3 4 5 6 7 8 9 10 11 12 13 14 15 16 17 18 19 20 21 22 23 **24** 25 26 27 28 29 30

A<small>PRIL</small>

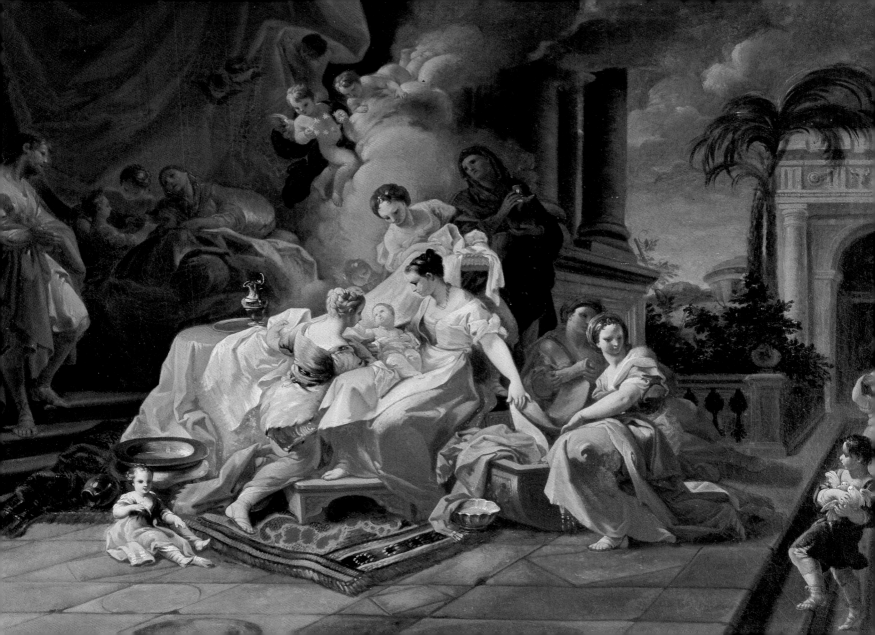

Art is viable when it finds elements
in the surrounding environment.
Our ancestors drew their subject matter
from the religious attitudes which weighed
on their souls. We must now learn to draw
inspiration from the tangible miracles
around us.

UMBERTO BOCCIONI

The City Rises, 1910
Umberto Boccioni
Museum of Modern Art, New York

1 2 3 4 5 6 7 8 9 10 11 12 13 14 15 16 17 18 19 20 21 22 23 24 **25** 26 27 28 29 30

APRIL

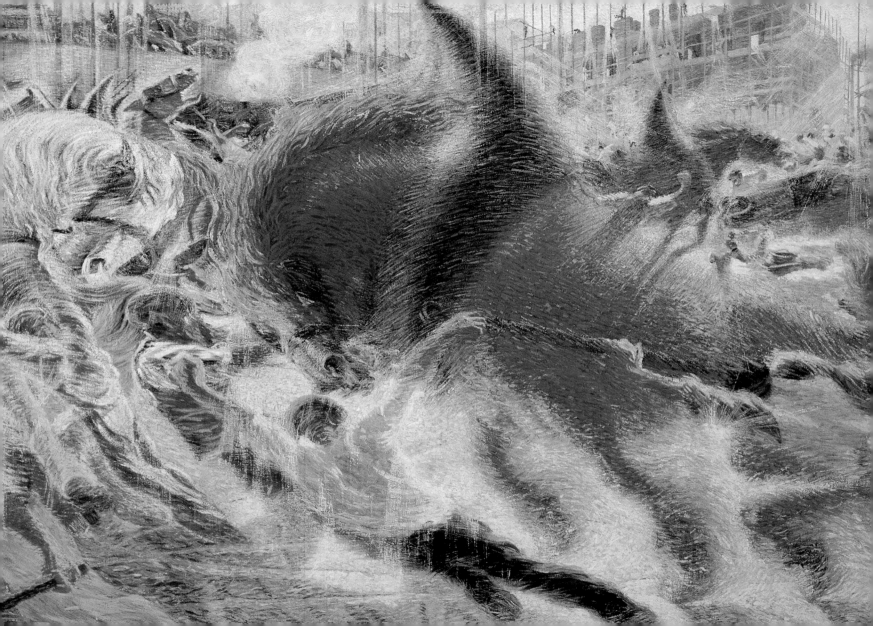

The best doctors in the world
are Doctor Diet, Doctor Quiet,
and Doctor Merryman.

<small>Jonathan Swift</small>

Anatomy Lesson of Dr. Nicolaes Tulp, 1632
Rembrandt van Rijn
Mauritshuis, The Hague

1 2 3 4 5 6 7 8 9 10 11 12 13 14 15 16 17 18 19 20 21 22 23 24 25 **26** 27 28 29 30

APRIL

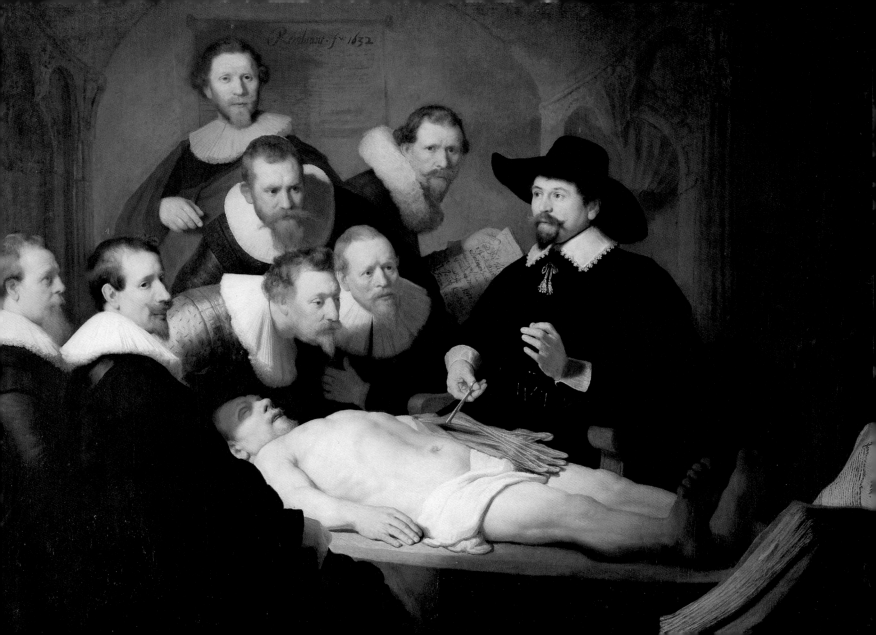

Easy is the way down to the Underworld:
by night and by day dark Hades' door stands open;
but to retrace one's steps and to make a way out
to the upper air, that's the task, that is the labor.

Virgil

**Charon Crossing the Styx,
the River to Hades,** 1512–24
Joachim Patinir
Museo Nacional del Prado, Madrid

1 2 3 4 5 6 7 8 9 10 11 12 13 14 15 16 17 18 19 20 21 22 23 24 25 26 **27** 28 29 30

APRIL

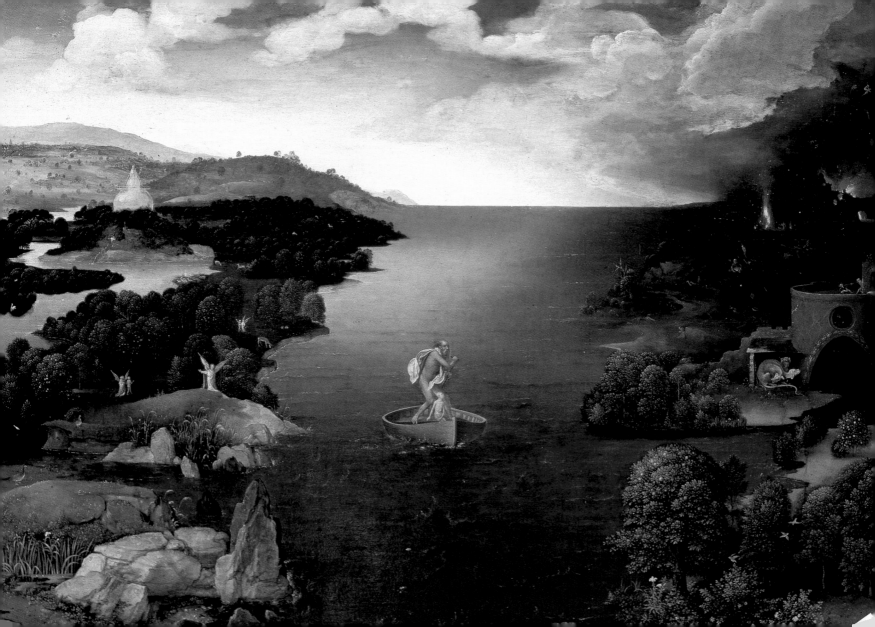

*Shall I tell you what I think are
the two qualities of a work of art?
First, it must be the indescribable,
and second, it must be inimitable.*

Pierre-Auguste Renoir

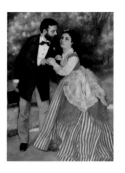

Alfred Sisley and his Wife, 1868
Pierre-Auguste Renoir
Wallraf-Richartz Museum, Cologne

1 2 3 4 5 6 7 8 9 10 11 12 13 14 15 16 17 18 19 20 21 22 23 24 25 26 27 **28** 29 30

APRIL

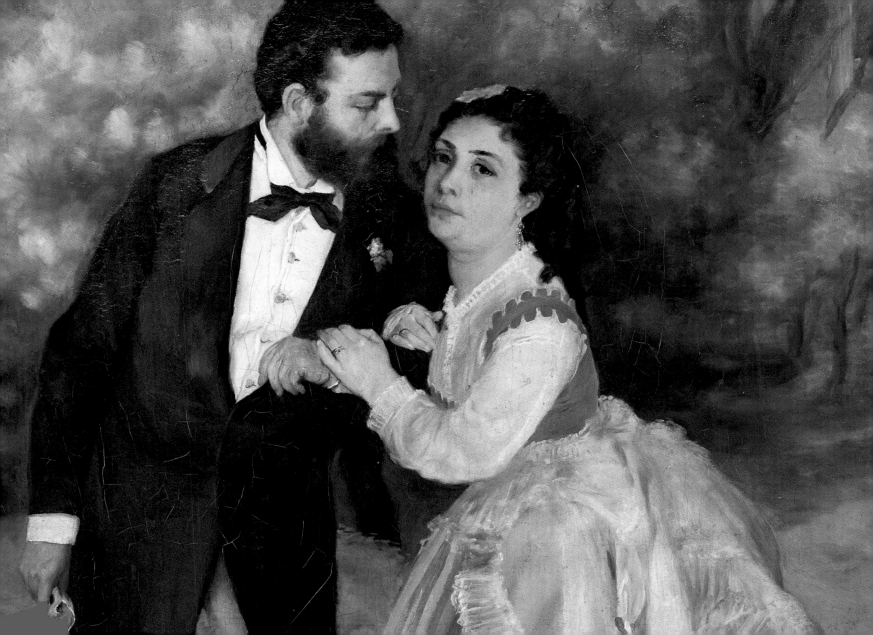

Practice is the best of all instructors.

The Piano Lesson, late 18th century
Jean-Honoré Fragonard
Musée du Louvre, Paris

1 2 3 4 5 6 7 8 9 10 11 12 13 14 15 16 17 18 19 20 21 22 23 24 25 26 27 28 **29** 30

APRIL

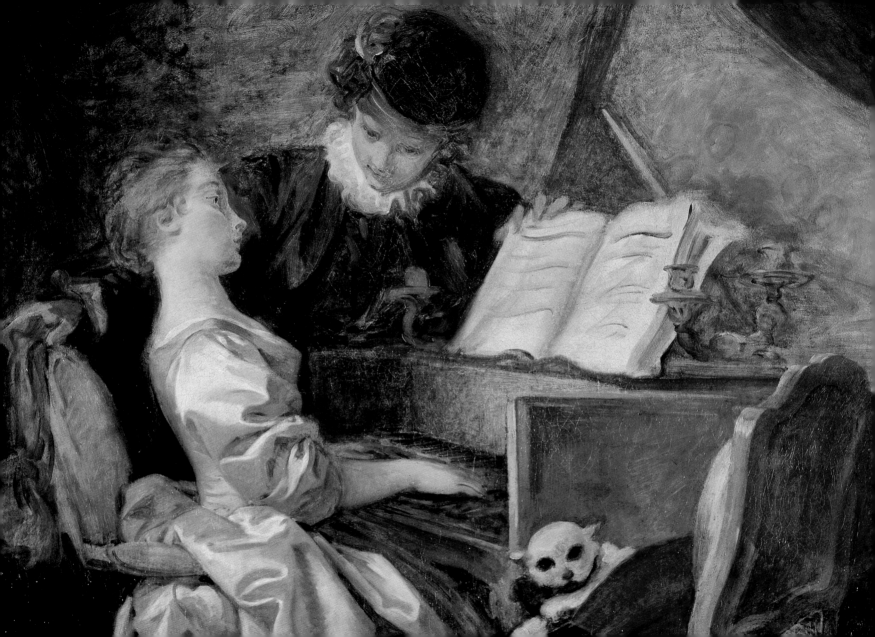

One can have no smaller
or greater mastery
than mastry of oneself.

Leonardo da Vinci

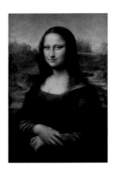

Mona Lisa, *c.* 1503
Leonardo da Vinci
Musée du Louvre, Paris

1 2 3 4 5 6 7 8 9 10 11 12 13 14 15 16 17 18 19 20 21 22 23 24 25 26 27 28 29 **30**

APRIL

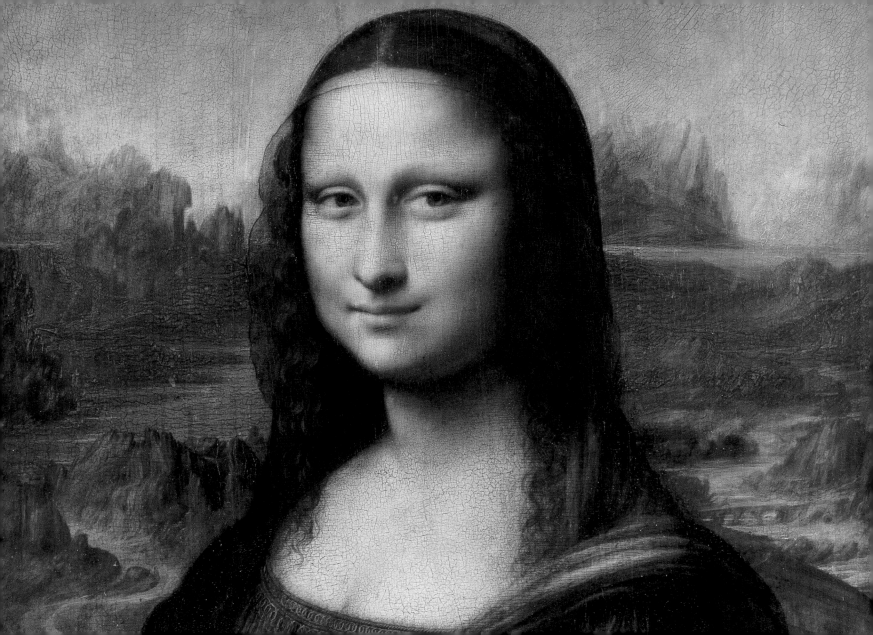

Even in the games of children,
even in the hat of a cocotte,
in our joy at a sunny day,
invisible ideas gently assume
material form.

AUGUST MACKE

Woman in a Green Coat, 1913
August Macke
Museum Ludwig, Cologne

1 2 3 4 5 6 7 8 9 10 11 12 13 14 15 16 17 18 19 20 21 22 23 24 25 26 27 28 29 30 31

MAY

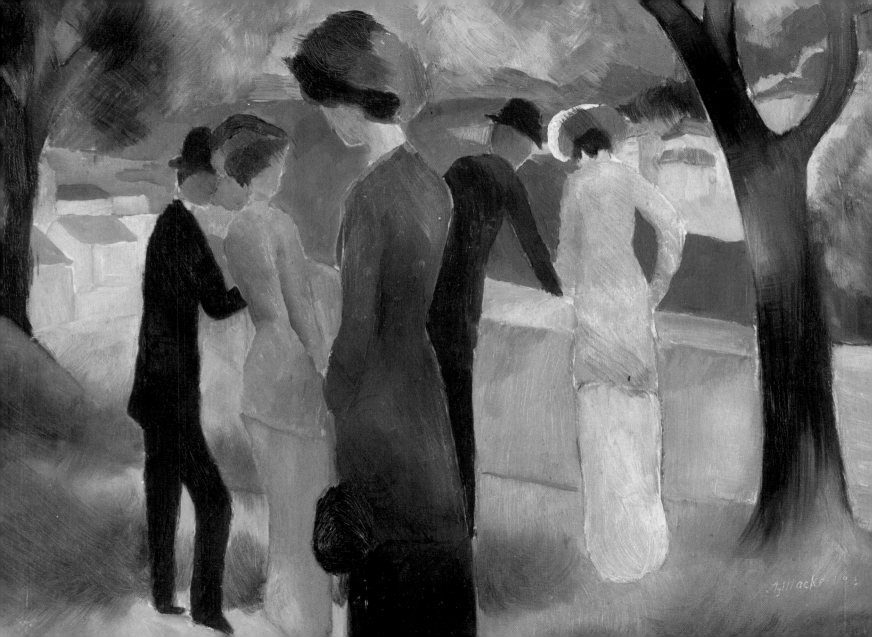

O! She doth teach the torches to burn bright.
It seems she hangs apon the cheek of night
Like a rich jewel in an Ethop's ear;
Beauty too rich for use, for earth too dear.

WILLIAM SHAKESPEARE

Young Woman on a Balcony, 17th century
Gerrit Dou
National Gallery, Prague

1 **2** 3 4 5 6 7 8 9 10 11 12 13 14 15 16 17 18 19 20 21 22 23 24 25 26 27 28 29 30 31

MAY

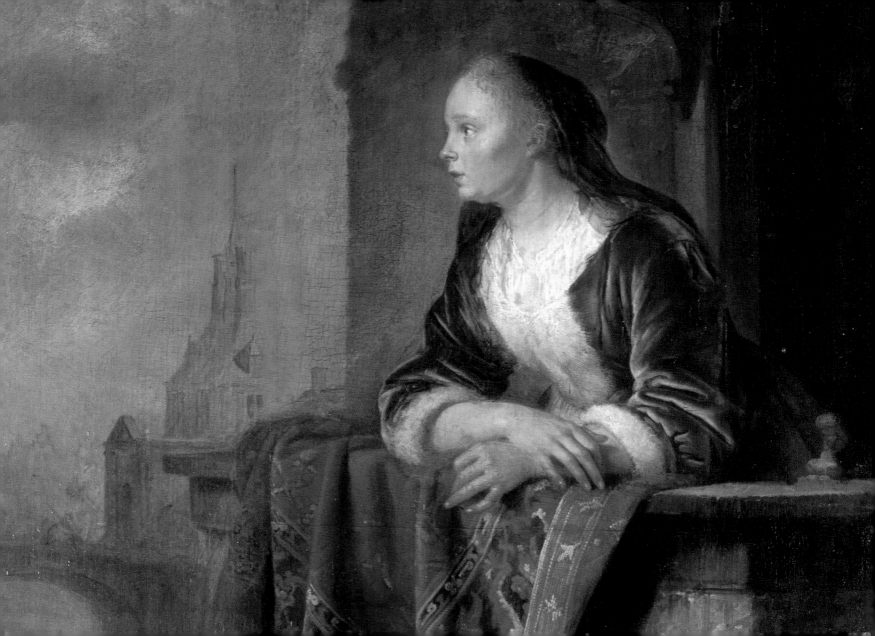

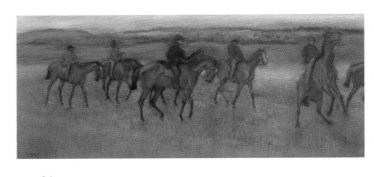

Breaking-In, *c.* 1880
Edgar Degas
The Pushkin Museum of Fine Arts, Moscow

I'm glad I haven't found my style yet.
I'd be bored to death.

3
1 2 **3** 4 5 6 7 8 9 10 11 12 13 14 15 16 17 18 19 20 21 22 23 24 25 26 27 28 29 30 31

MAY

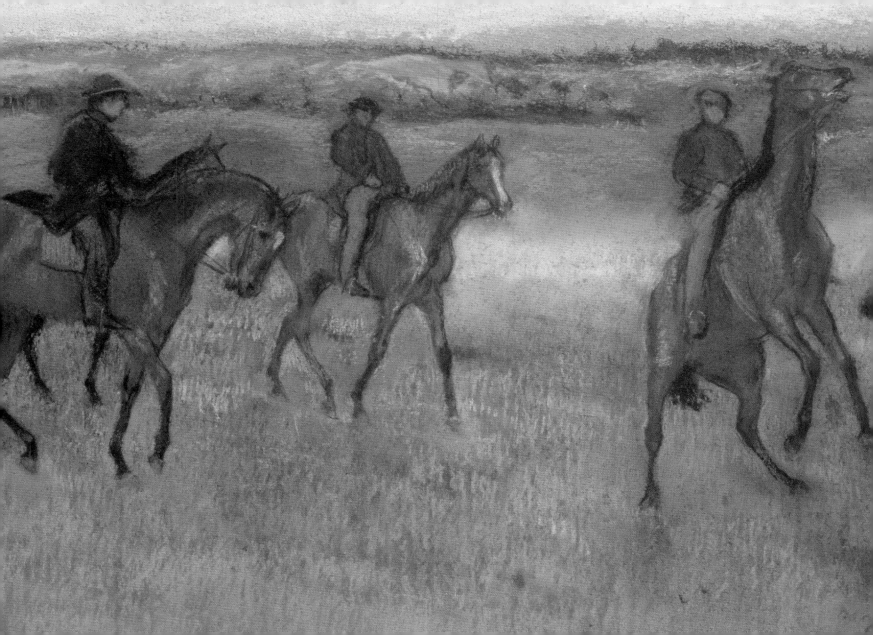

Color is the essence of painting,
which the subject always killed.

KAZIMIR MALEVICH

2-Dimensional Self-Portrait, 1915
Kazimir Malevich
Stedelijk Museum, Amsterdam

1 2 3 **4** 5 6 7 8 9 10 11 12 13 14 15 16 17 18 19 20 21 22 23 24 25 26 27 28 29 30 31

MAY

The phoenix hope, can wing her way through the desert skies, and still defying fortune's spite; revive from ashes and rise.

<small>MIGUEL DE CERVANTES</small>

John the Baptist in the Desert, 1504–05
Hieronymus Bosch
Museo Lazaro Galdiano, Madrid

1 2 3 4 **5** 6 7 8 9 10 11 12 13 14 15 16 17 18 19 20 21 22 23 24 25 26 27 28 29 30 31

MAY

Play has been man's most useful preoccupation.

Frank Caplan

The Seesaw, 1898
Franz von Stuck
Stuck-Verein, Munich

6
1 2 3 4 5 6 7 8 9 10 11 12 13 14 15 16 17 18 19 20 21 22 23 24 25 26 27 28 29 30 31

May

Nothing is more the child of art than a garden.

<small>Sir Walter Scott</small>

In the Garden of Aranjuez, 1908
Santiago Rusiñol y Prats
Museo Nacional del Prado, Madrid

1 2 3 4 5 6 **7** 8 9 10 11 12 13 14 15 16 17 18 19 20 21 22 23 24 25 26 27 28 29 30 31

MAY

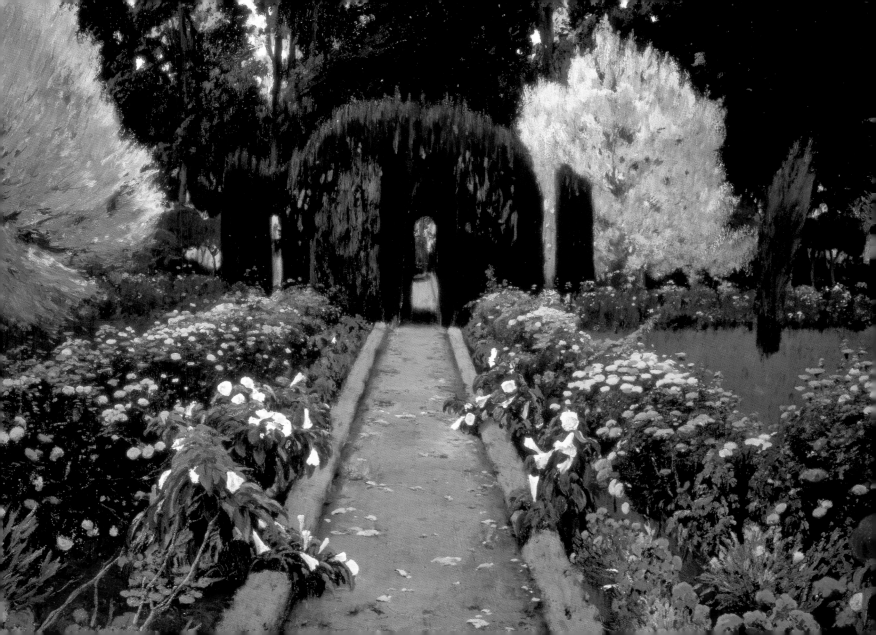

*Muses work all day long
and then at night
get together and dance.*

Edgar Degas

Apollo and the Dancing Muses, early 16th century
Baldassare Peruzzi
Palazzo Pitti, Florence

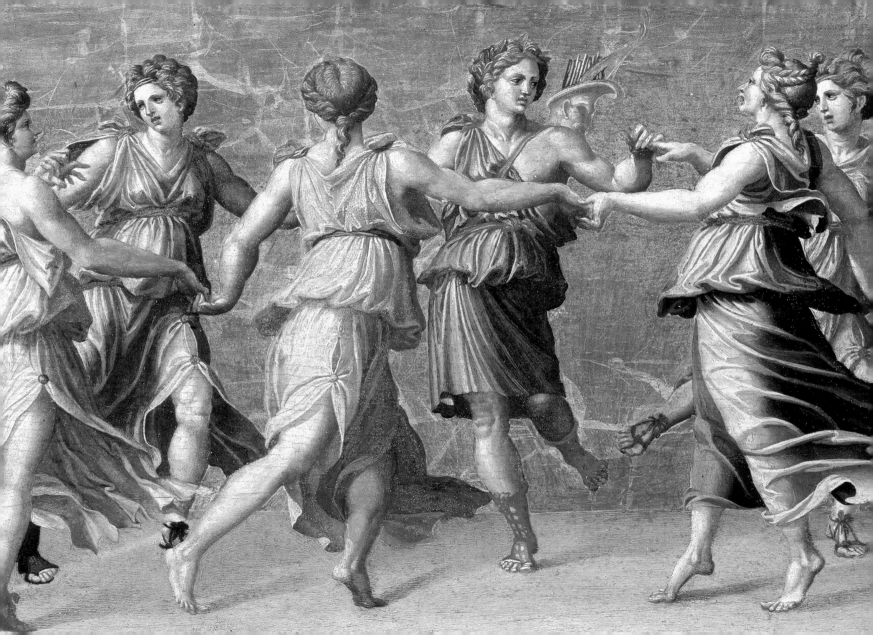

He that would be a painter must have a natural turn thereto. Love and delight therein are better teachers of the Art of Painting than compulsion is.

ALBRECHT DÜRER

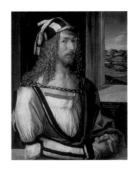

Self-Portrait at 26, 1498
Albrecht Dürer
Museo Nacional del Prado, Madrid

1 2 3 4 5 6 7 8 **9** 10 11 12 13 14 15 16 17 18 19 20 21 22 23 24 25 26 27 28 29 30 31

MAY

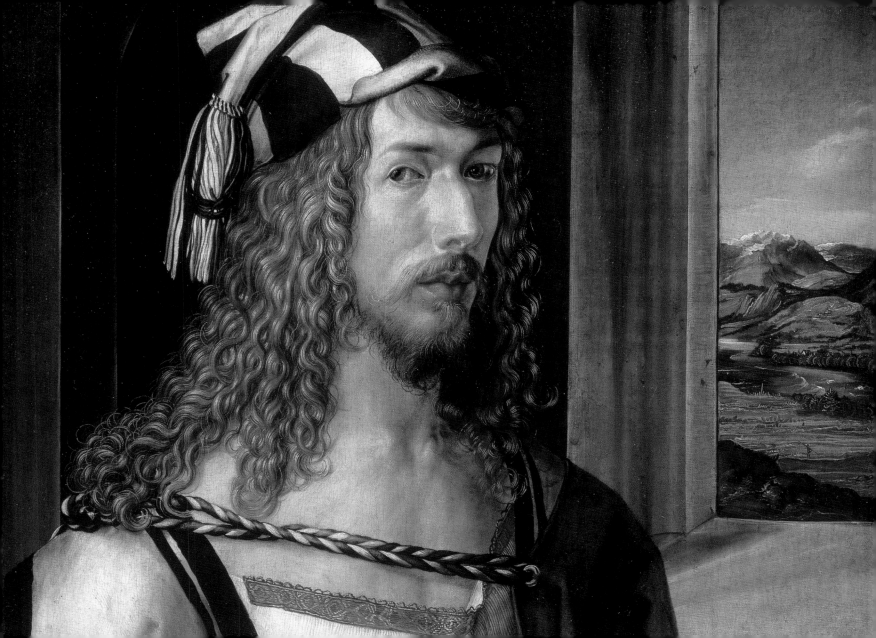

Nature always begins by resisting the artist,
but he who really takes it seriously does not allow
that resistance to put him off his stride;
on the contrary, it is that much more of a stimulus
to fight for victory.

Vincent van Gogh

A Road in Auvers after the Rain, 1890
Vincent van Gogh
The Pushkin Museum of Fine Arts, Moscow

1 2 3 4 5 6 7 8 9 **10** 11 12 13 14 15 16 17 18 19 20 21 22 23 24 25 26 27 28 29 30 31

MAY

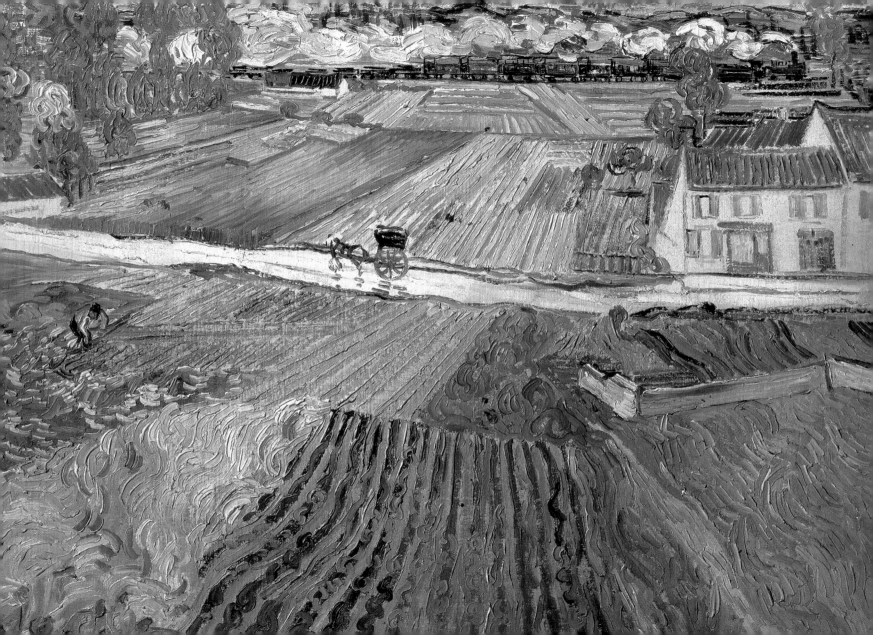

I'm not moaning, nor thinking of moaning,
for I believe that no one is richer than he
who is content with what he has,
and that I am …

FRANCISCO JOSÉ DE GOYA

Blind Man's Bluff, 1788–89
Francisco José de Goya
Museo Nacional del Prado, Madrid

1 2 3 4 5 6 7 8 9 10 **11** 12 13 14 15 16 17 18 19 20 21 22 23 24 25 26 27 28 29 30 31

MAY

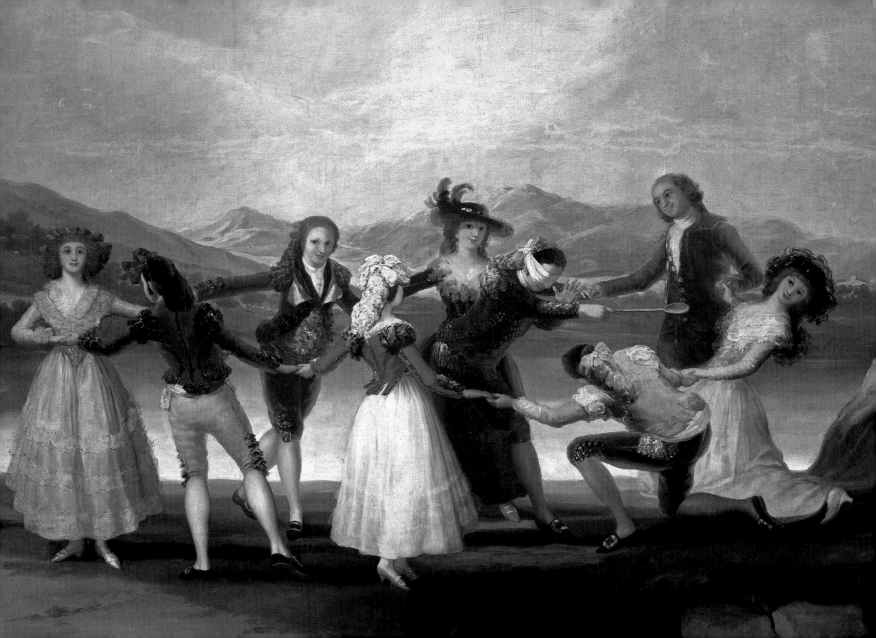

People travel to wonder
at the height of the mountains,
at the huge waves of the seas,
at the long course of the rivers,
at the vast compass of the ocean,
at the circular motion of the stars,
and yet they pass by themselves
without wondering.

SAINT AUGUSTINE

The Great Wave. From the Series
"Thirty-six Views of Mount Fuji," *c. 1830–31*
Katsushika Hokusai
Private Collection

1 2 3 4 5 6 7 8 9 10 11 **12** 13 14 15 16 17 18 19 20 21 22 23 24 25 26 27 28 29 30 31

MAY

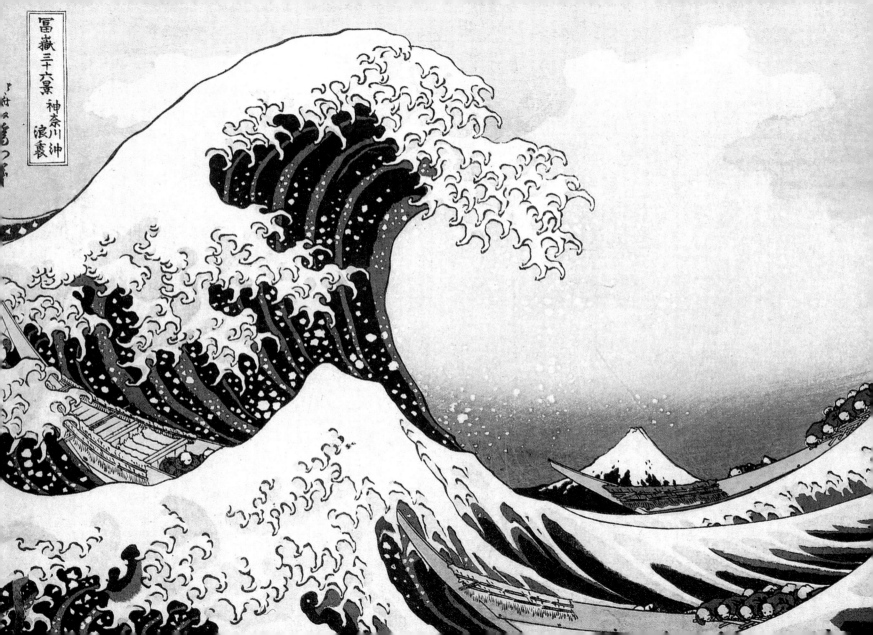

*An ounce of mother
is worth a pound of clergy.*

Spanish Proverb

**The Virgin with Child between
the Saints Rochus and Antonius,** *c.* 1510
Giorgione
Museo Nacional del Prado, Madrid

1 2 3 4 5 6 7 8 9 10 11 12 **13** 14 15 16 17 18 19 20 21 22 23 24 25 26 27 28 29 30 31

May

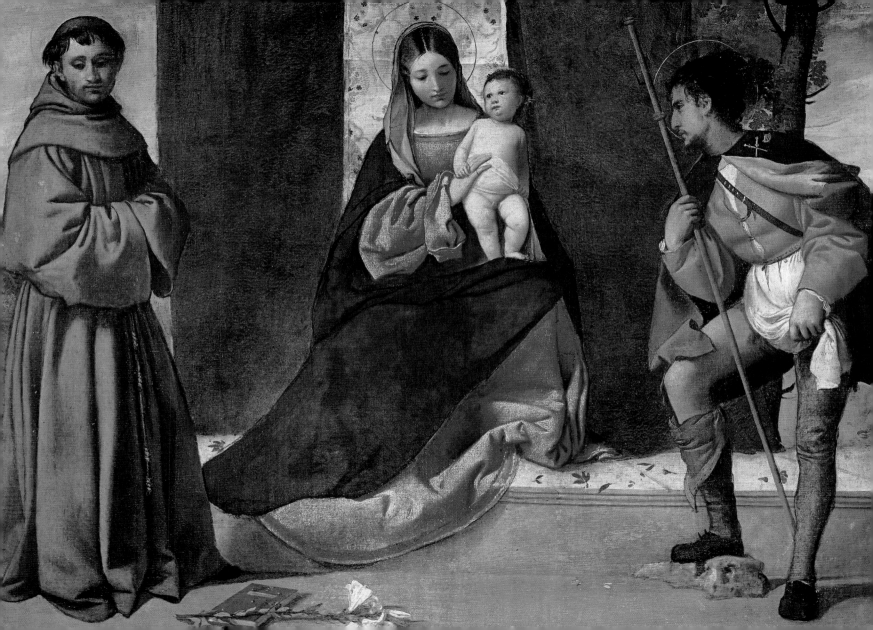

The apple blossoms' shower of pearl,
Though blent with rosier hue,
As beautiful as woman's blush,
As evanescent too.

LETITIA ELIZABETH LANDON

Spring (Apple Blossom), 1859
John Everett Millais
Board of Trustees of the National Museums and Galleries
on Merseyside (Lady Lever Art Gallery, Port Sunlight)

1 2 3 4 5 6 7 8 9 10 11 12 13 **14** 15 16 17 18 19 20 21 22 23 24 25 26 27 28 29 30 31

MAY

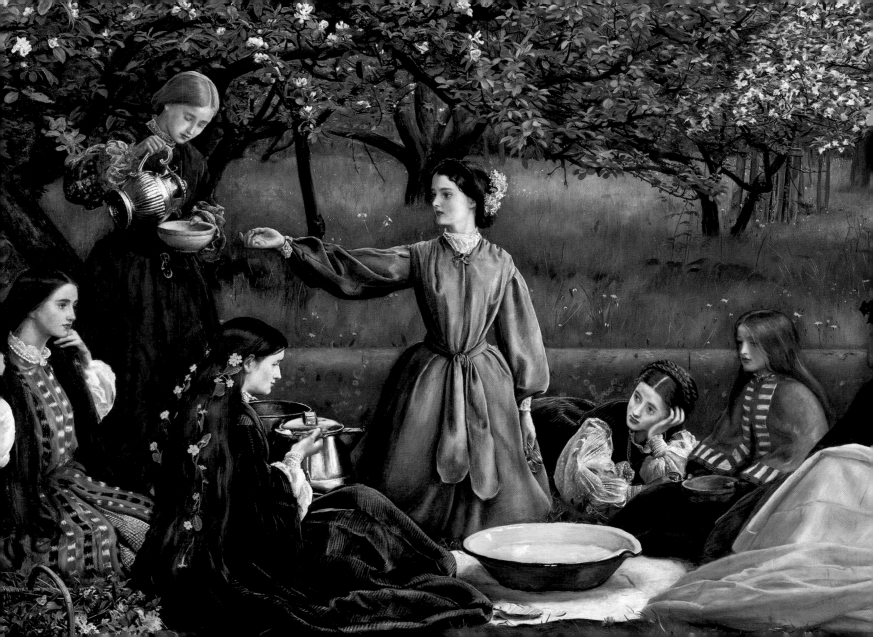

To see a world in a grain of sand
And a heaven in a wild flower,
Hold infinity in the palm of your hand
And eternity in an hour.

WILLIAM BLAKE

Carpet of Flowers, 1913
August Macke
Lenbachhaus, Munich

1 2 3 4 5 6 7 8 9 10 11 12 13 14 **15** 16 17 18 19 20 21 22 23 24 25 26 27 28 29 30 31

MAY

Property is surely a right of mankind as real as liberty.

JOHN ADAMS

Robert Andrews and His Wife Frances, *c.* 1750
Thomas Gainsborough
National Gallery, London

1 2 3 4 5 6 7 8 9 10 11 12 13 14 15 **16** 17 18 19 20 21 22 23 24 25 26 27 28 29 30 31

MAY

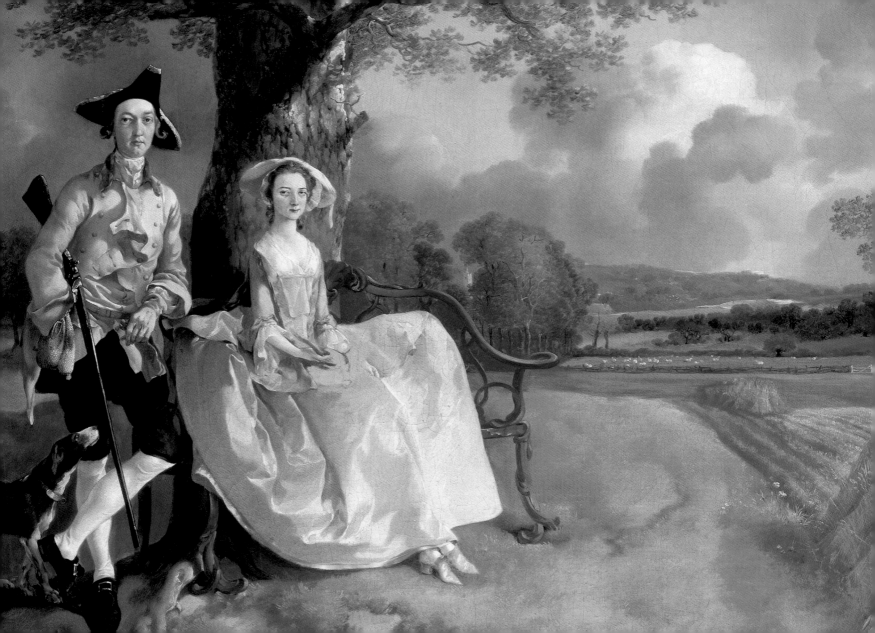

Now Nature hangs her mantle green
On every blooming tree,
And spreads her sheets o' daisies white
Out o'er the grassy lea.

<small>ROBERT BURNS</small>

Spring, 1478
Sandro Botticelli
Uffizi Gallery, Florence

1 2 3 4 5 6 7 8 9 10 11 12 13 14 15 16 **17** 18 19 20 21 22 23 24 25 26 27 28 29 30 31

MAY

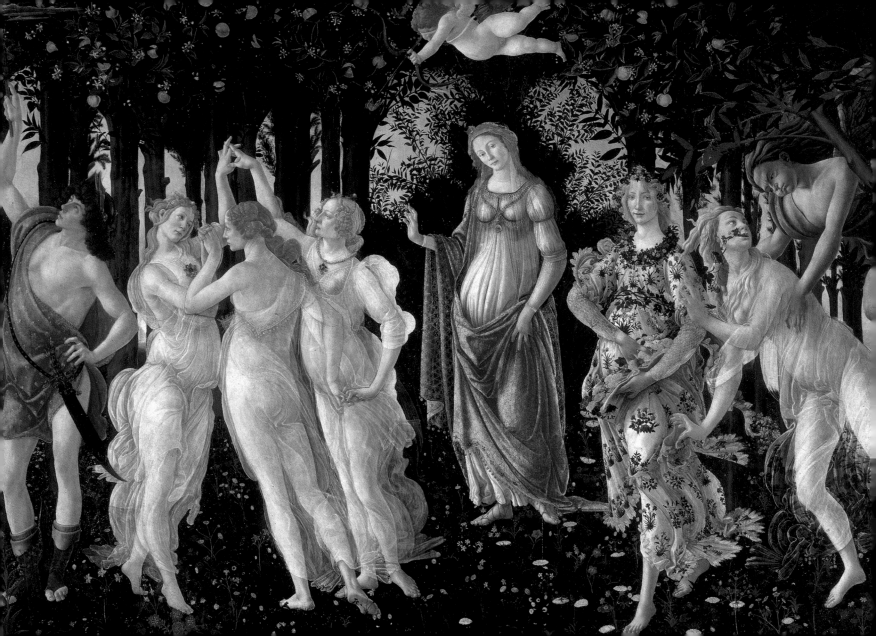

Gustav Klimt showed me how to see real contour.

<small>Frank Bruno</small>

Island in Lake Atter, 1901
Gustav Klimt
Private Collection

1 2 3 4 5 6 7 8 9 10 11 12 13 14 15 16 17 **18** 19 20 21 22 23 24 25 26 27 28 29 30 31

May

In the portrayal of all that can be seen,
your hand rivals only Nature,
so keenly does it imitate the spirit
within each object, so that Nature itself
begins to doubt which of you is greater
and better.

PIETRO ARETINO (ON TITIAN)

The Three Ages of Man, 1512
Titian
On loan from the Duke of Sutherland, National Gallery of Scotland, Edinburgh

1 2 3 4 5 6 7 8 9 10 11 12 13 14 15 16 17 18 **19** 20 21 22 23 24 25 26 27 28 29 30 31

MAY

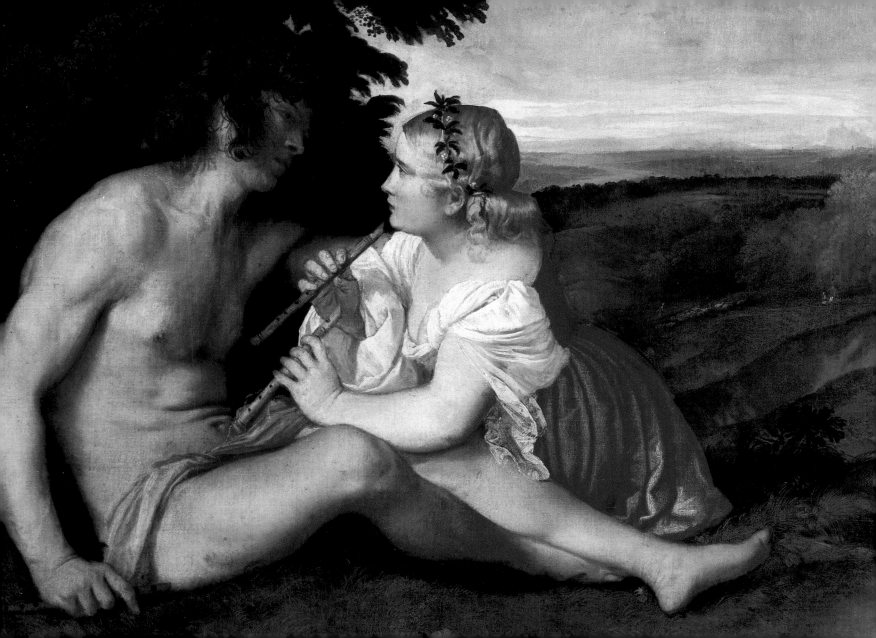

Paradoxically though it may seem, it is none the less true that life imitates art far more than art imitates life.

Oscar Wilde

The Old Man and the Maidservant, 17th century
David Teniers
Museo Nacional del Prado, Madrid

1 2 3 4 5 6 7 8 9 10 11 12 13 14 15 16 17 18 19 **20** 21 22 23 24 25 26 27 28 29 30 31

MAY

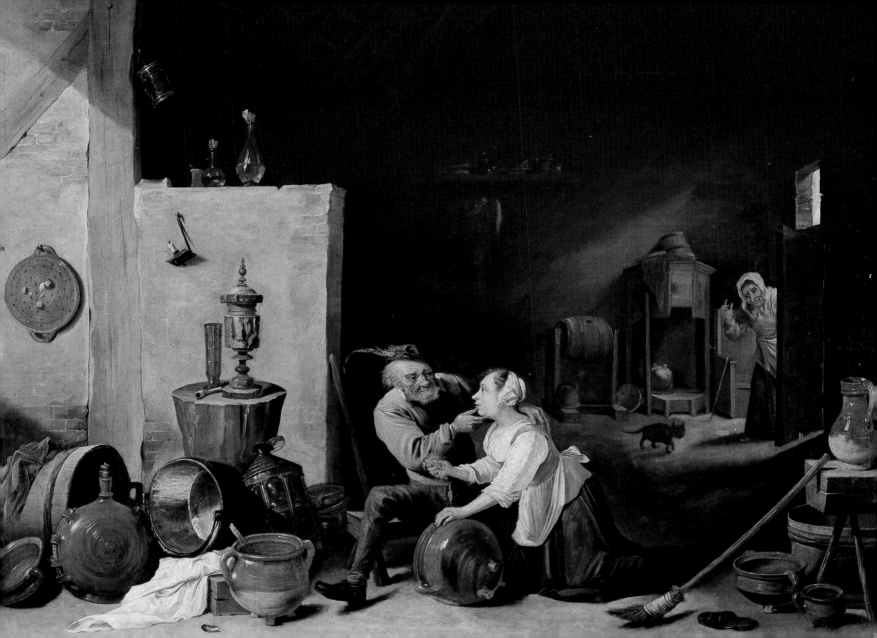

*The richness I achieve
comes from nature,
the source of my inspiration.*

Flora, 1882
Friedrich August von Kaulbach
Board of Trustees of the Bavarian Collection of Art

1 2 3 4 5 6 7 8 9 10 11 12 13 14 15 16 17 18 19 20 **21** 22 23 24 25 26 27 28 29 30 31

MAY

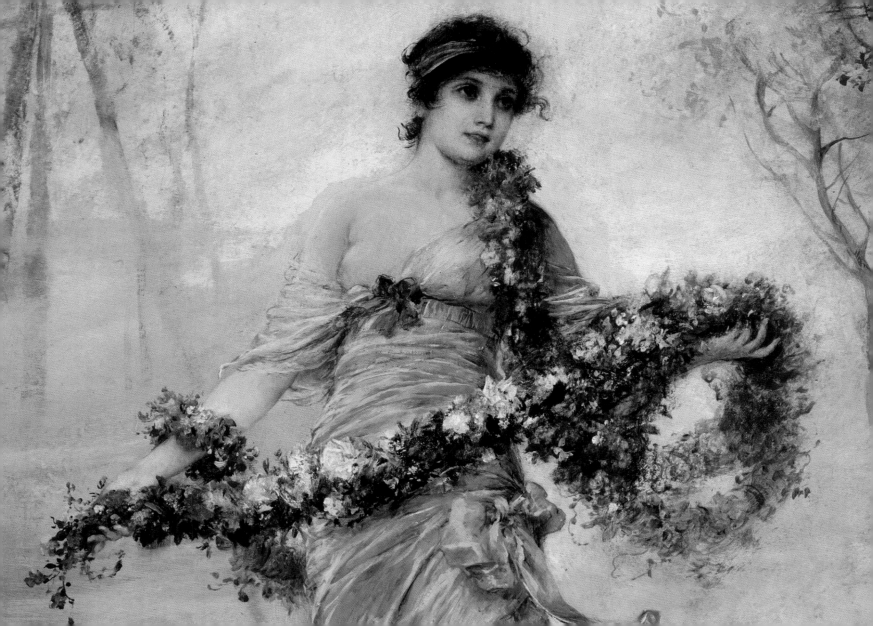

There is no must in art because art is free.

Wassily Kandinsky

Impression III (Concert), 1911
Wassily Kandinsky
Lenbachhaus, Munich

1 2 3 4 5 6 7 8 9 10 11 12 13 14 15 16 17 18 19 20 21 **22** 23 24 25 26 27 28 29 30 31

MAY

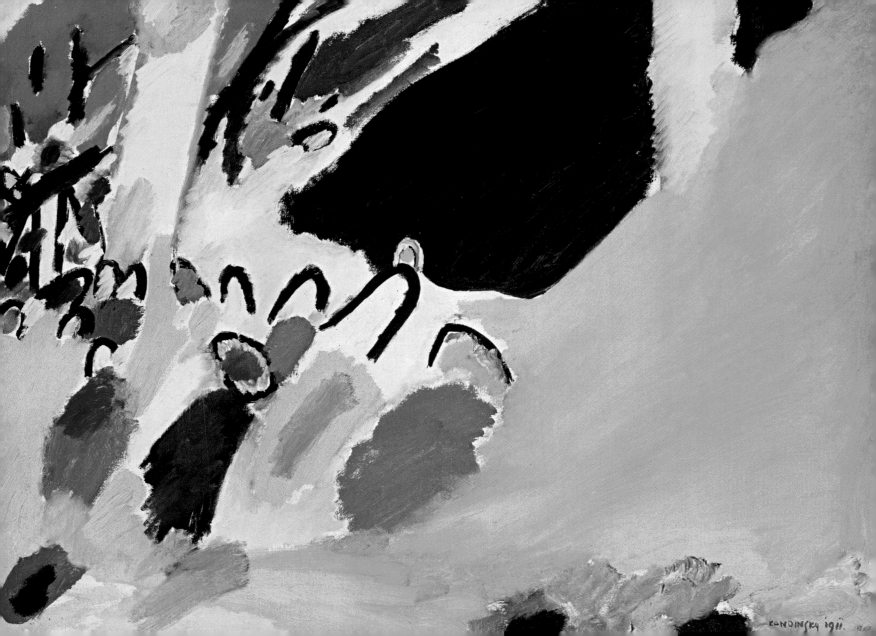

You come to nature
with all your theories,
and she knocks them all flat.

Noirmoutier, *c.* 1897 or later
Pierre-Auguste Renoir
Oskar Reinhart Collection, Winterthur

PIERRE-AUGUSTE RENOIR

1 2 3 4 5 6 7 8 9 10 11 12 13 14 15 16 17 18 19 20 21 22 **23** 24 25 26 27 28 29 30 31

MAY

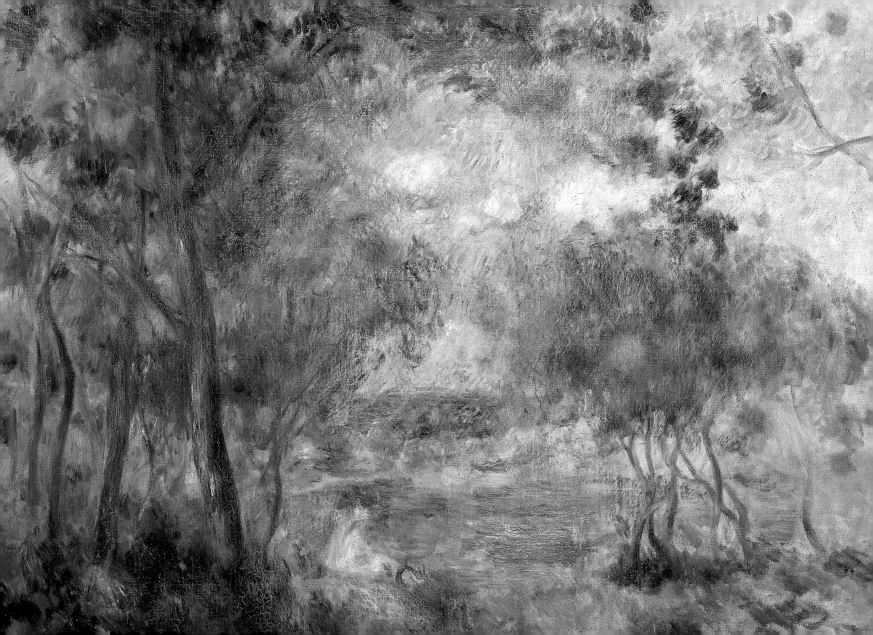

It lies not in our power to love or hate,
For will in us is overrul'd by fate.
Where both deliberate, the love is slight,
Who ever loved, that loved not at first sight?

<small>CHRISTOPHER MARLOWE</small>

Nessus, Deianira, and Hercules, 1612
David Vinckboons
Kunsthistorisches Museum, Vienna

1 2 3 4 5 6 7 8 9 10 11 12 13 14 15 16 17 18 19 20 21 22 23 **24** 25 26 27 28 29 30 31

MAY

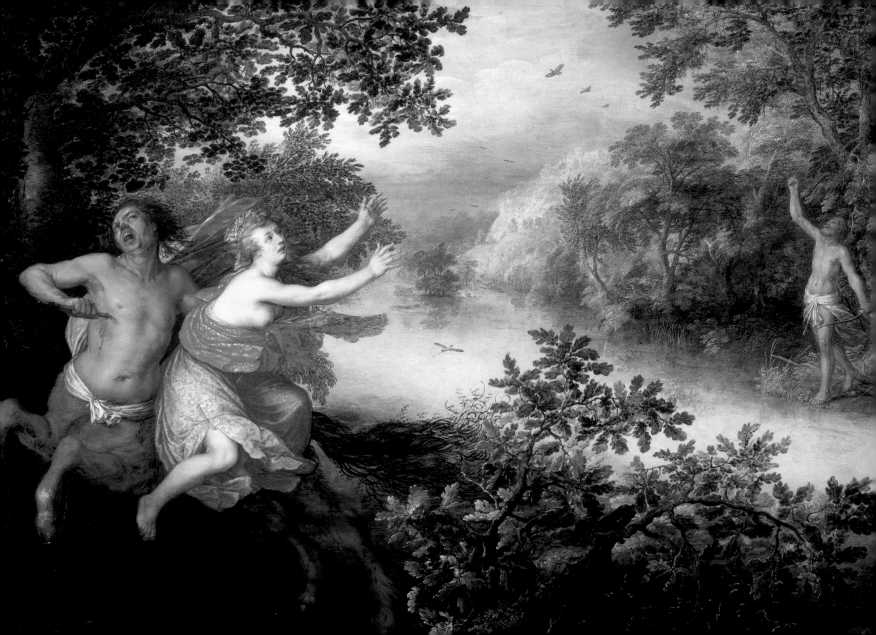

*Life would be tolerable
but for its amusements.*

GEORGE CORNEWALL LEWIS

The Feast of the Bean King, 1640
Jacob Jordaens
Kunsthistorisches Museum, Vienna

1 2 3 4 5 6 7 8 9 10 11 12 13 14 15 16 17 18 19 20 21 22 23 24 **25** 26 27 28 29 30 31

MAY

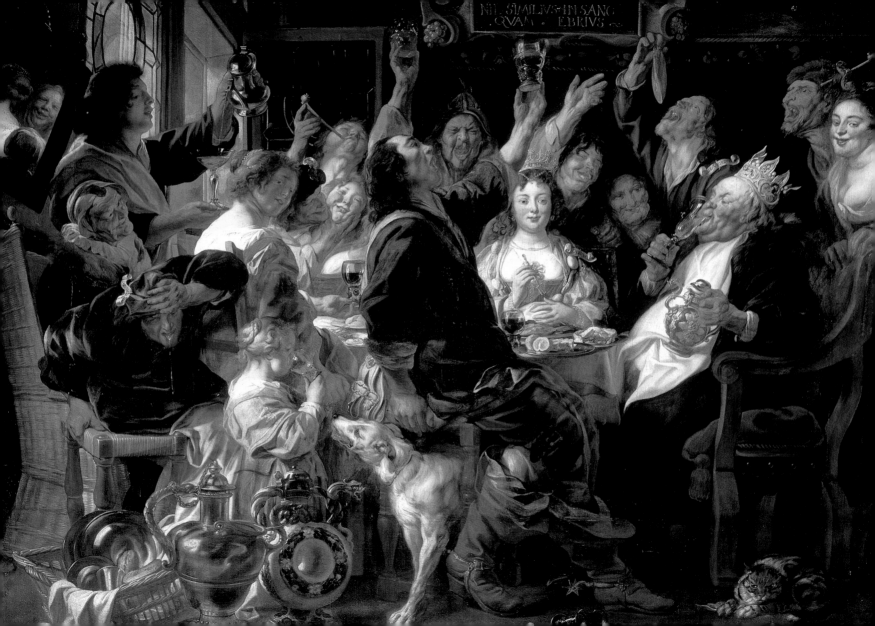

NIL SIMILIVS INSANO
QVAM EBRIVS

I try to apply colors like words
that shape poems,
like notes that shape music.

Joan Miró

Painting, 1933

Joan Miró
Jan Krugier, Ditesheim & Cie. Gallery, Geneva

26

1 2 3 4 5 6 7 8 9 10 11 12 13 14 15 16 17 18 19 20 21 22 23 24 25 **26** 27 28 29 30 31

MAY

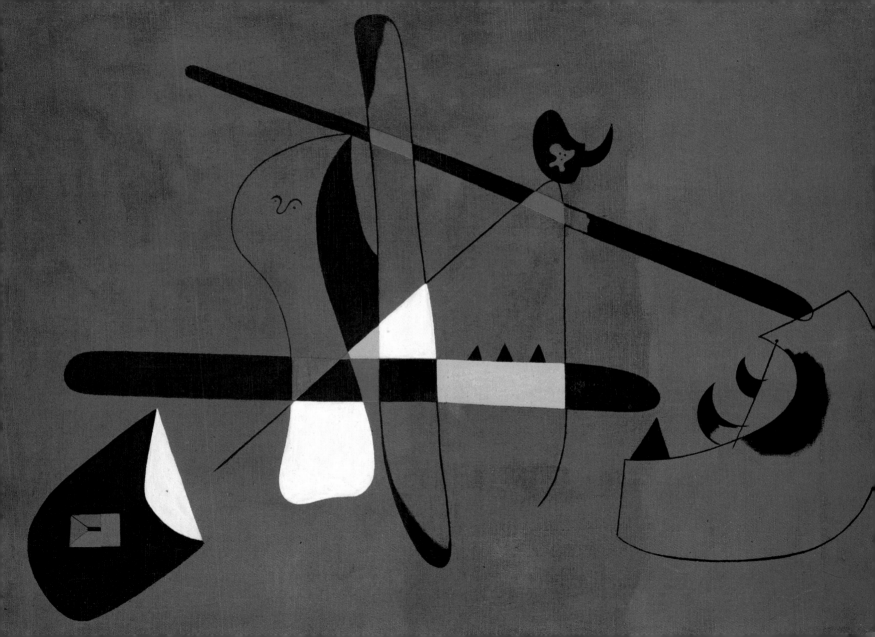

A legal kiss is never as good
as a stolen one.

Guy de Maupassant

The Stolen Kiss, 1786–88
Jean-Honoré Fragonard
The State Hermitage Museum, St. Petersburg

1 2 3 4 5 6 7 8 9 10 11 12 13 14 15 16 17 18 19 20 21 22 23 24 25 26 **27** 28 29 30 31

MAY

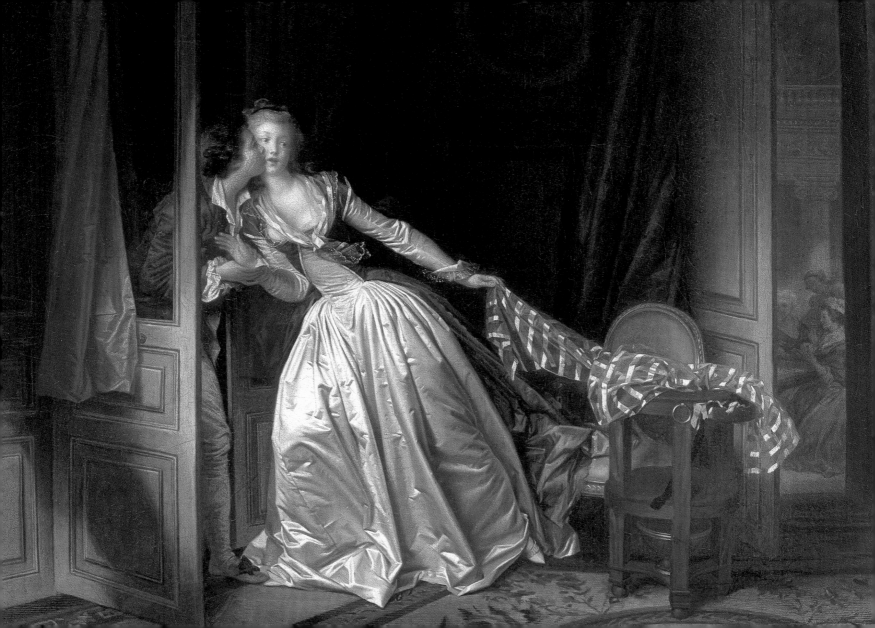

Spring has returned.
The Earth is like a
child that knows poems.

<small>Rainer Maria Rilke</small>

The Morning of Corpus Christi, 1857
Ferdinand Georg Waldmüller
Österreichische Galerie Belvedere, Vienna

1 2 3 4 5 6 7 8 9 10 11 12 13 14 15 16 17 18 19 20 21 22 23 24 25 26 27 **28** 29 30 31

MAY

The heart has its reasons which reason knows not of.

BLAISE PASCAL

Madonna and Child with Saints, c. 1518
Rosso Fiorentino
Uffizi Gallery, Florence

1 2 3 4 5 6 7 8 9 10 11 12 13 14 15 16 17 18 19 20 21 22 23 24 25 26 27 28 **29** 30 31

May

Beautiful colors can be bought in the shops on the Rialto, but a good drawing can only be bought from the casket of the artist's talent with patient study and nights without sleep.

Tintoretto

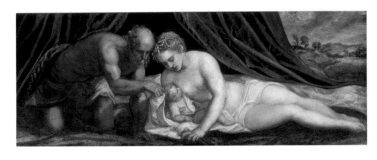

Venus, Vulcan, and Cupid, 16th century
Tintoretto
Palazzo Pitti, Florence

1 2 3 4 5 6 7 8 9 10 11 12 13 14 15 16 17 18 19 20 21 22 23 24 25 26 27 28 29 **30** 31

MAY

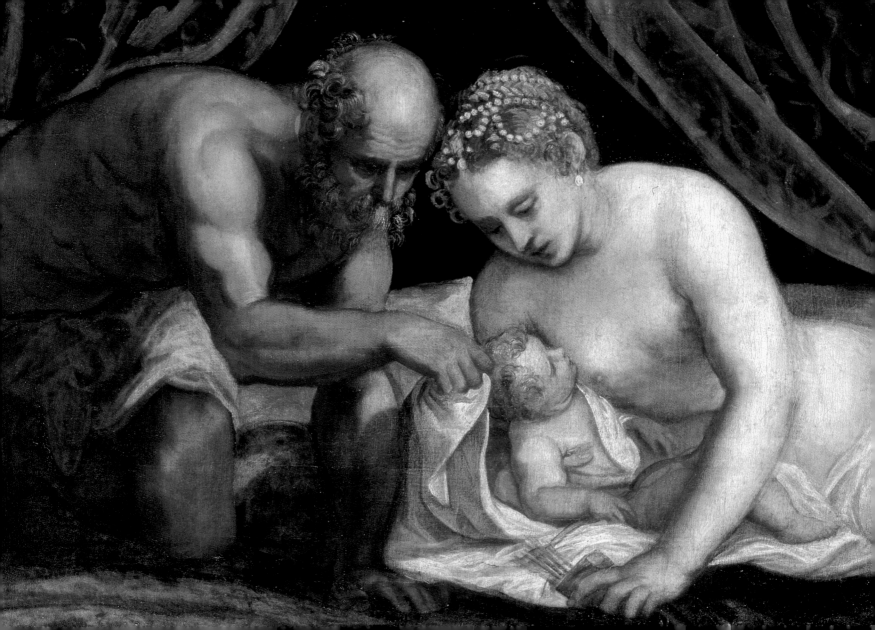

The golden age has not passed;
it lies in the future.

<small>PAUL SIGNAC</small>

Harbour at Marseilles, 1906–07
Paul Signac
The State Hermitage Museum, St. Petersburg

1 2 3 4 5 6 7 8 9 10 11 12 13 14 15 16 17 18 19 20 21 22 23 24 25 26 27 28 29 30 **31**

MAY

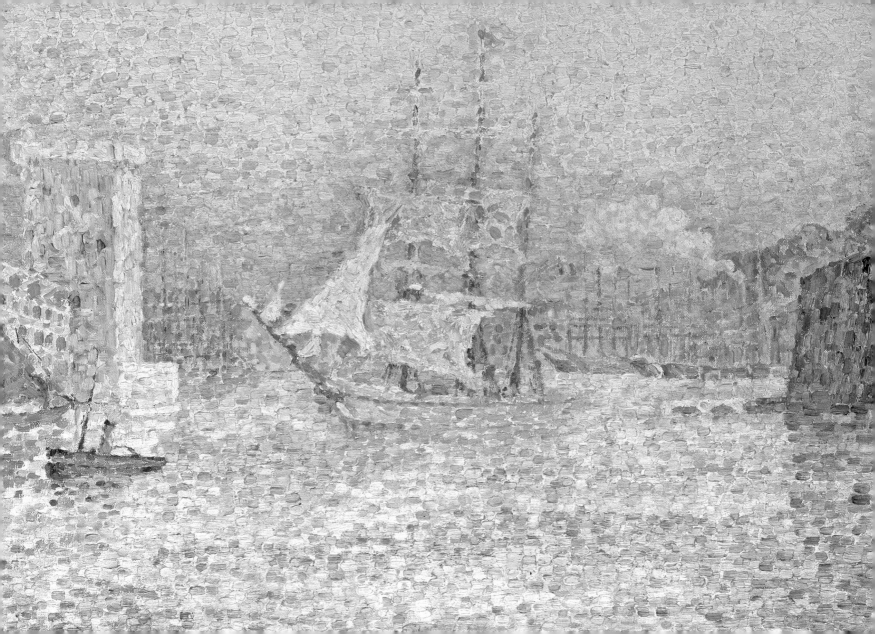

Talent develops in quiet places,
character in the full current
of human life.

JOHANN WOLFGANG VON GOETHE

Love in the French Theater, after 1716
Jean-Antoine Watteau
Gemäldegalerie, Berlin

1 2 3 4 5 6 7 8 9 10 11 12 13 14 15 16 17 18 19 20 21 22 23 24 25 26 27 28 29 30

JUNE

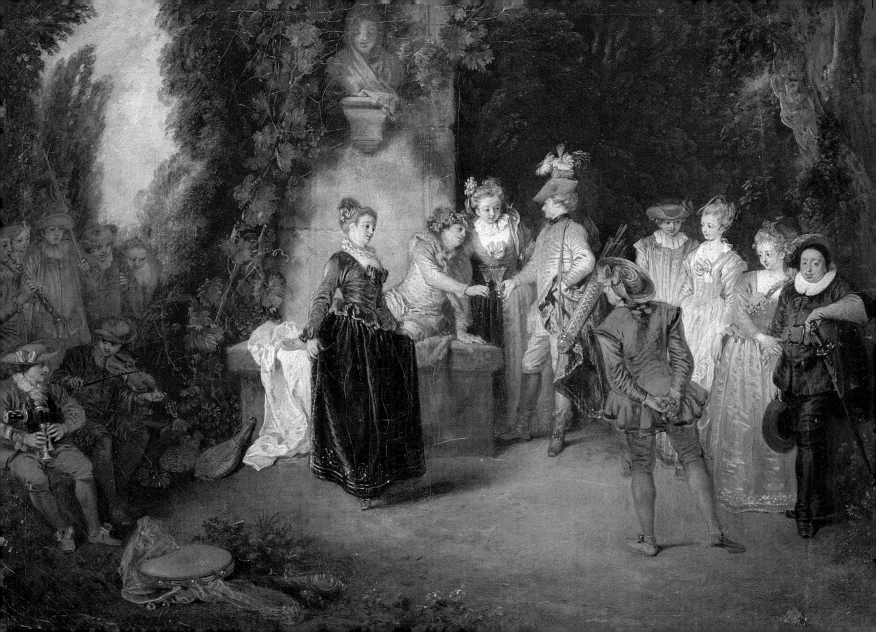

My dearest, of you alone I think day and night.
Your red lips take all that is sad from me.
To you have I given myself. Your own will I be,
with you to live in joy until my ending.

HANS LEO HASSLER

The Arnolfini Wedding, *c.* 1435
Jan van Eyck
National Gallery, London

1 **2** 3 4 5 6 7 8 9 10 11 12 13 14 15 16 17 18 19 20 21 22 23 24 25 26 27 28 29 30

JUNE

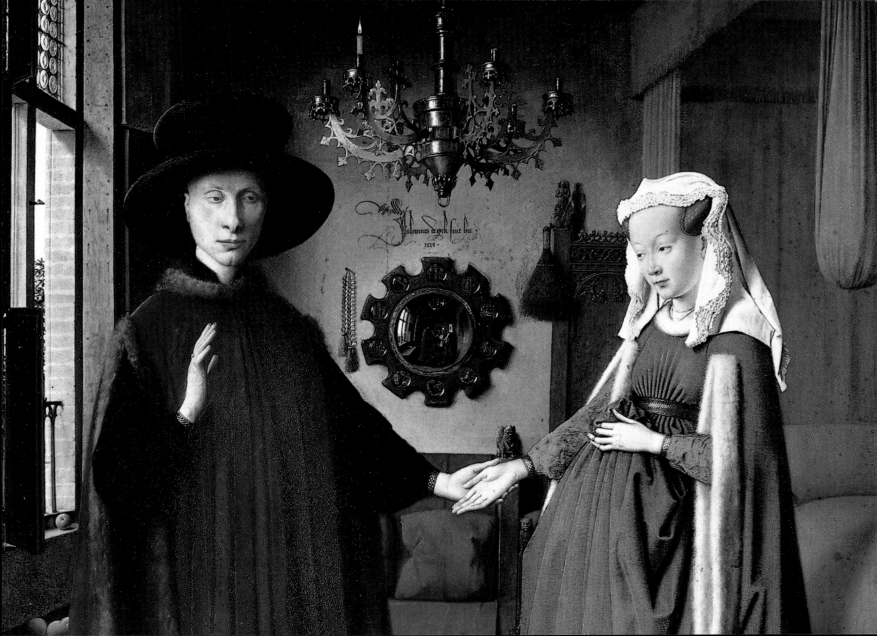

Underneath Day's azure eye
Ocean's nursling, Venice lies,
A peopled labyrinth of walls,
Amphitrite's destined halls.

Percy Bysshe Shelley

Venice, early 18th century
Canaletto
MK Ciurlionis National Museum of Art, Kaunas

1 2 **3** 4 5 6 7 8 9 10 11 12 13 14 15 16 17 18 19 20 21 22 23 24 25 26 27 28 29 30

JUNE

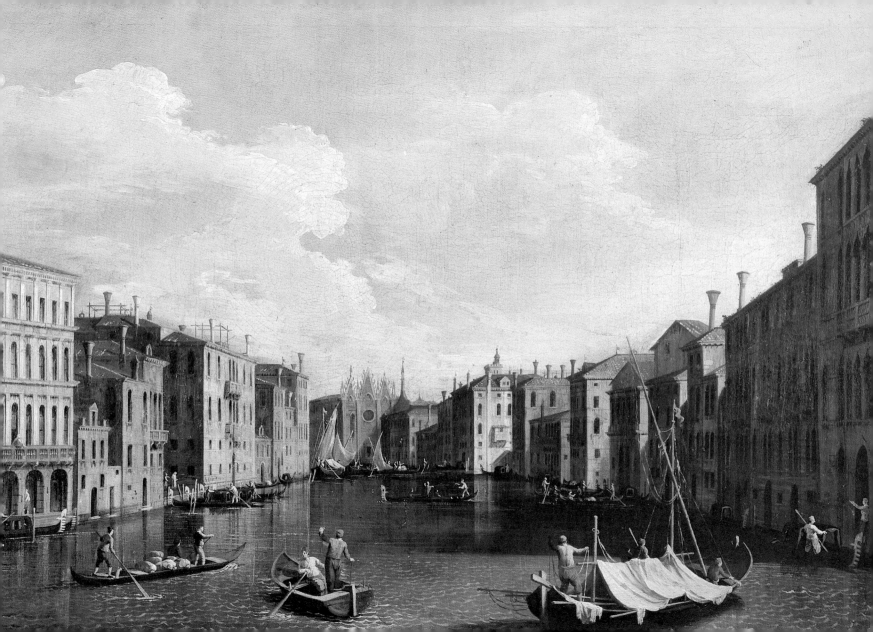

*All colors are the friends
of their neighbors and
the lovers of their opposites.*

Marc Chagall

The Red Sun, 1949
Marc Chagall
Private Collection

1 2 3 **4** 5 6 7 8 9 10 11 12 13 14 15 16 17 18 19 20 21 22 23 24 25 26 27 28 29 30

June

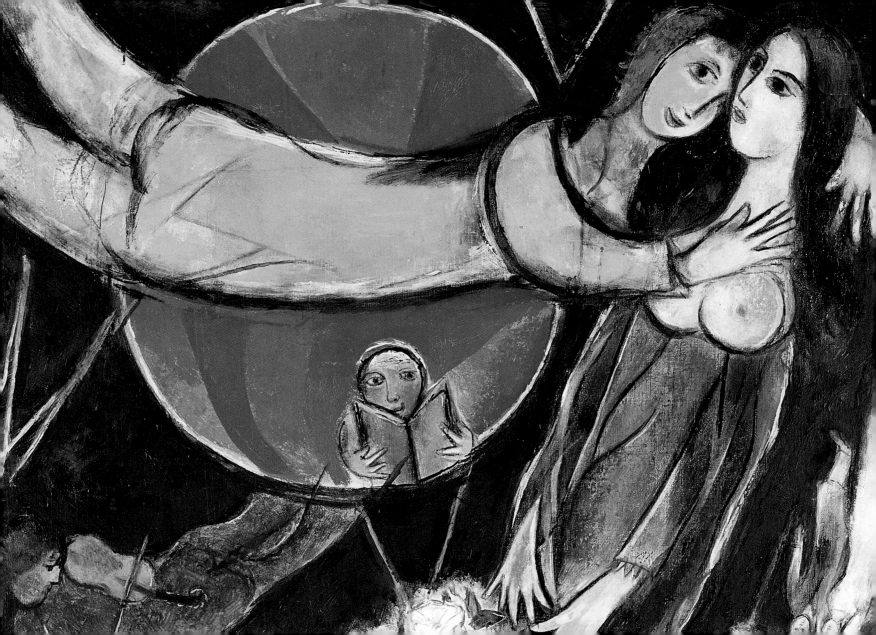

There was never a good war,
or a bad peace.

BENJAMIN FRANKLIN

The Surrender of Breda, 1634–35
Diego Rodriguez de Velázquez
Museo Nacional del Prado, Madrid

1 2 3 4 **5** 6 7 8 9 10 11 12 13 14 15 16 17 18 19 20 21 22 23 24 25 26 27 28 29 30

JUNE

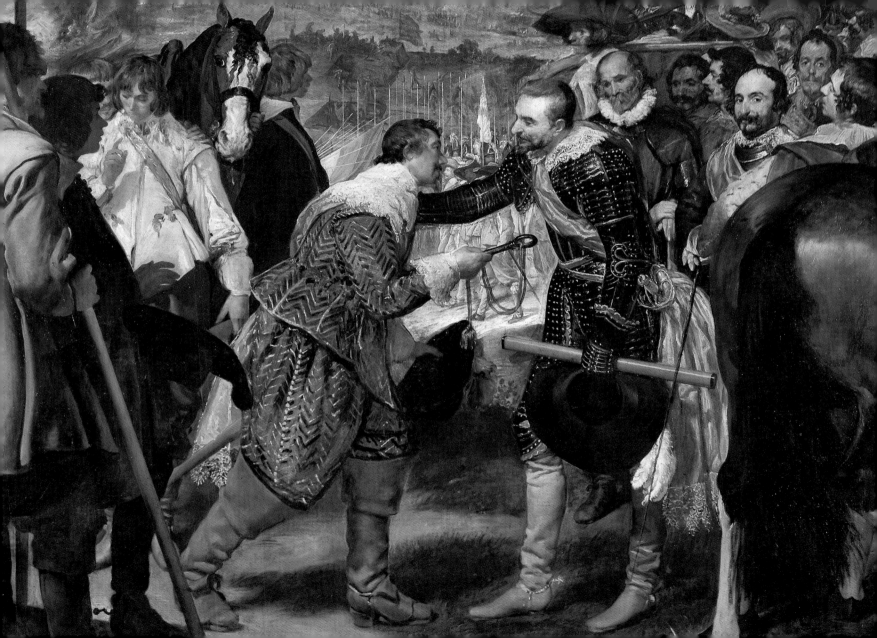

These landscapes of water and reflection have become an obsession.

<small>Claude Monet</small>

Poplars on the Bank of the River Epte, 1891
Claude Monet
National Gallery of Scotland, Edinburgh

1 2 3 4 5 **6** 7 8 9 10 11 12 13 14 15 16 17 18 19 20 21 22 23 24 25 26 27 28 29 30

June

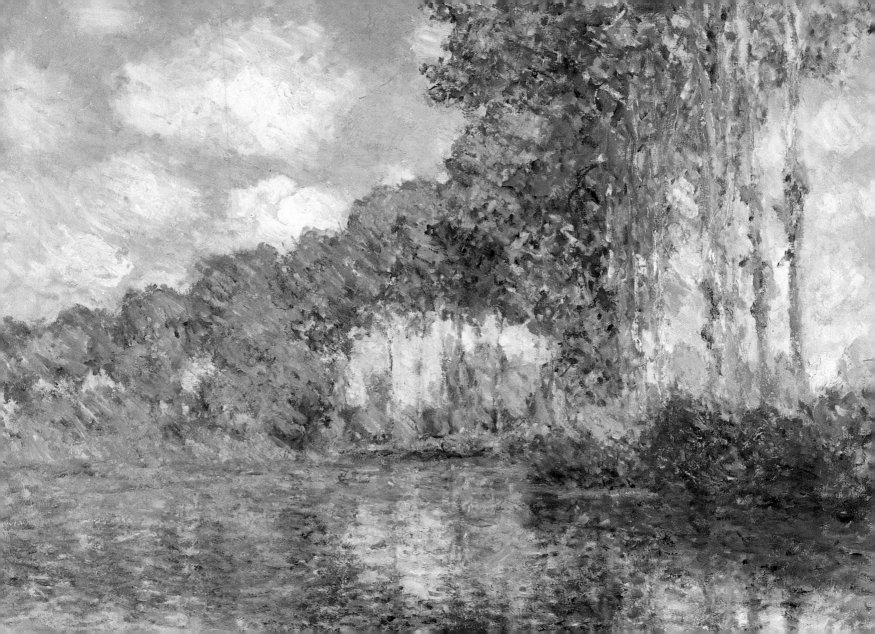

We are the music makers,
We are the dreamers of dreams …
We are the movers and shakers
Of the world for ever, it seems.

ARTHUR O'SHAUGHNESSY

Parnasus, 1630s
Nicolas Poussin
Museo Nacional del Prado, Madrid

1 2 3 4 5 6 **7** 8 9 10 11 12 13 14 15 16 17 18 19 20 21 22 23 24 25 26 27 28 29 30

JUNE

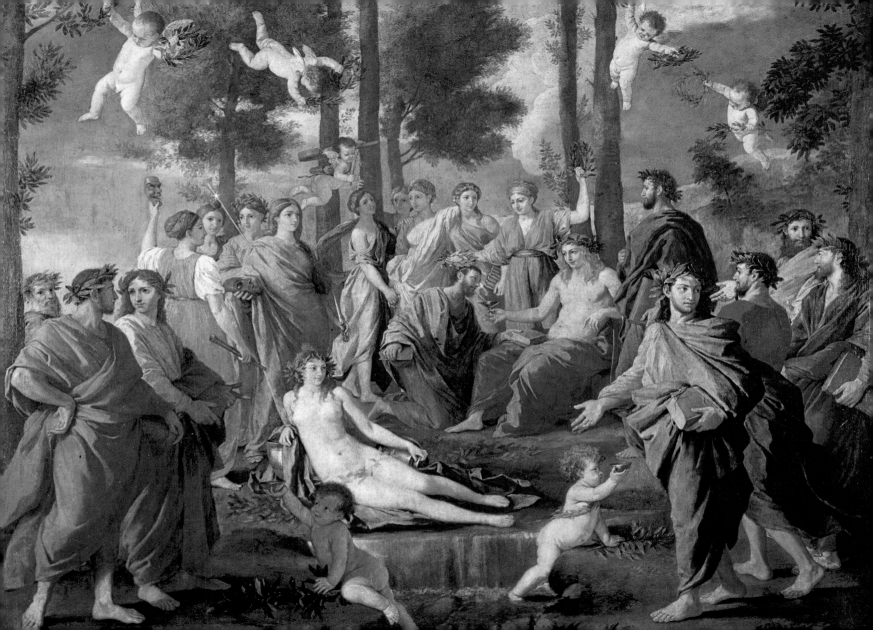

If a man be gracious
and courteous to strangers,
it shows he is a citizen
of the world.

<small>FRANCIS BACON</small>

Allegory, 1531
Albrecht Altdorfer
Gemäldegalerie, Berlin

1 2 3 4 5 6 7 **8** 9 10 11 12 13 14 15 16 17 18 19 20 21 22 23 24 25 26 27 28 29 30

JUNE

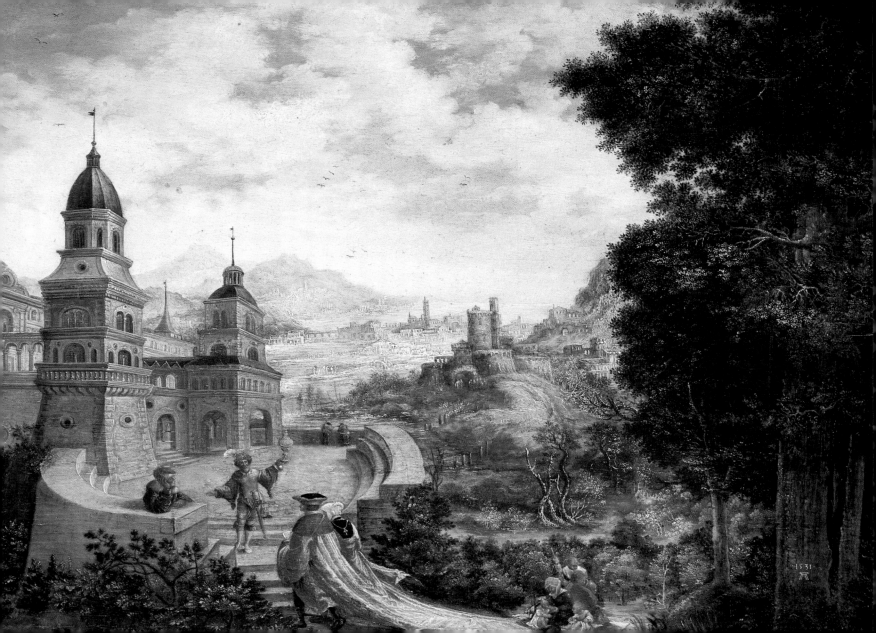

The pain passes,
but the beauty remains.

Pierre-Auguste Renoir

The Red-haired Bather, 1903–06
Pierre-Auguste Renoir
Kunsthistorisches Museum, Vienna

1 2 3 4 5 6 7 8 **9** 10 11 12 13 14 15 16 17 18 19 20 21 22 23 24 25 26 27 28 29 30

JUNE

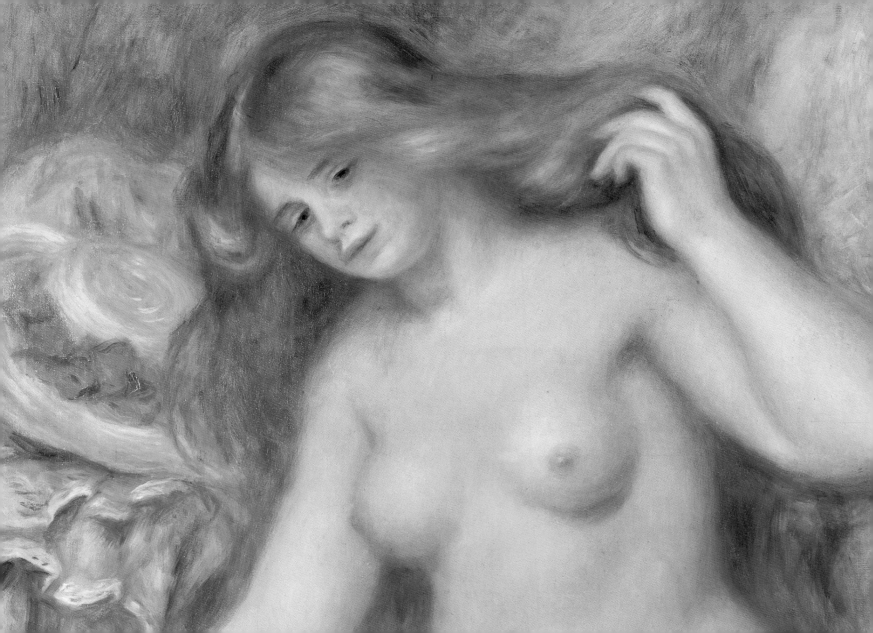

One may know the world
without going out of doors.
One may see the way of heaven
without looking through windows.
The further one goes,
the less one knows.

LAO TZU

Yui, From the Series
"Fifty-three Stations of the Tokaido," *c.* 1835–36
Utagawa Hiroshige
Private Collection

1 2 3 4 5 6 7 8 9 **10** 11 12 13 14 15 16 17 18 19 20 21 22 23 24 25 26 27 28 29 30

JUNE

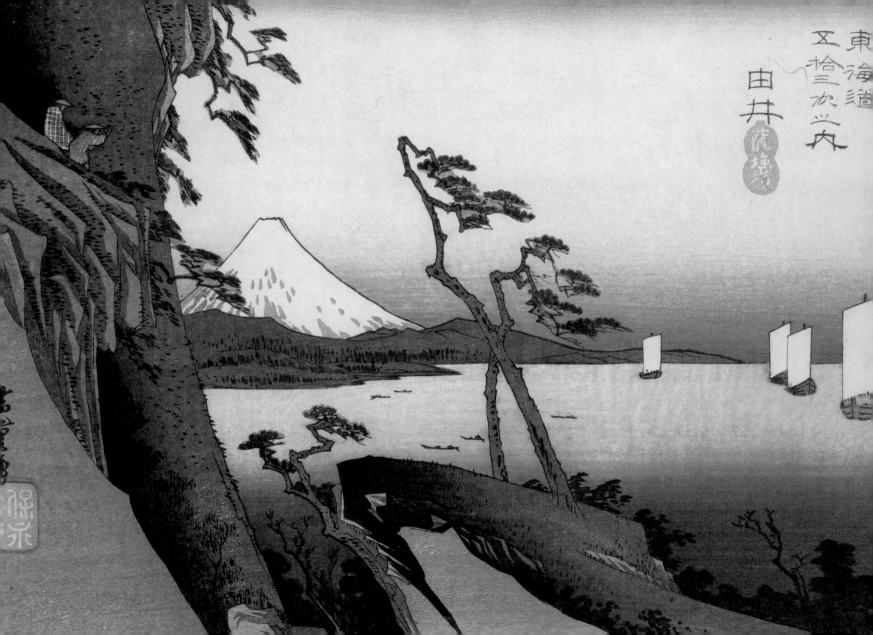

A pipe is to the troubled soul what caresses of a mother are for her suffering child.

Two Turkish Men in a Coffee House, 1860
Carl Spitzweg
Private Collection

1 2 3 4 5 6 7 8 9 10 **11** 12 13 14 15 16 17 18 19 20 21 22 23 24 25 26 27 28 29 30

JUNE

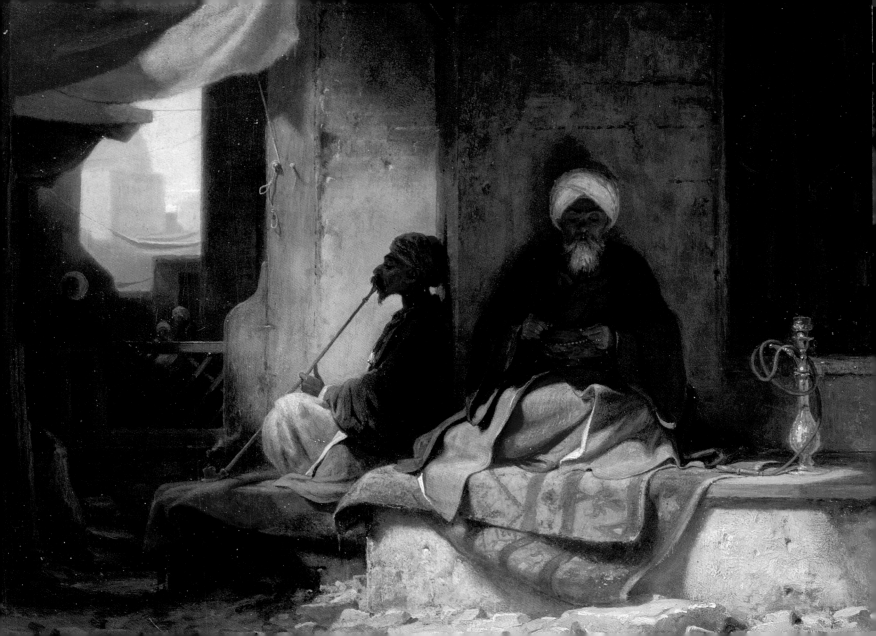

I wish I could write as mysterious as a cat.

Three Cats, 1913
Franz Marc
K20/K21, Düsseldorf

1 2 3 4 5 6 7 8 9 10 11 **12** 13 14 15 16 17 18 19 20 21 22 23 24 25 26 27 28 29 30

JUNE

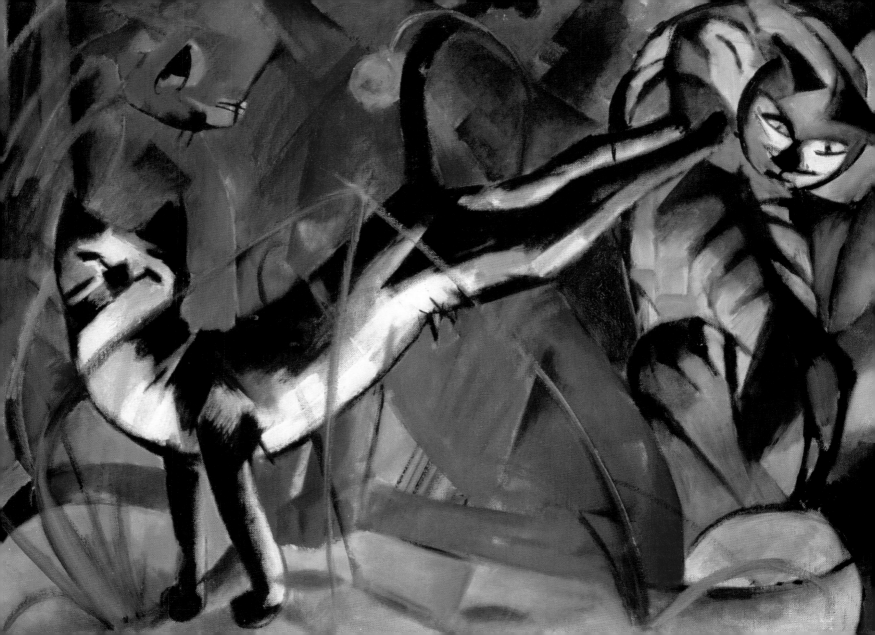

The man who has no inner life is a slave to his surroundings.

Henri-Frederic Amiel

Garden of Earthly Delights (center panel), 1480–90
Hieronymus Bosch
Museo Nacional del Prado, Madrid

1 2 3 4 5 6 7 8 9 10 11 12 **13** 14 15 16 17 18 19 20 21 22 23 24 25 26 27 28 29 30

JUNE

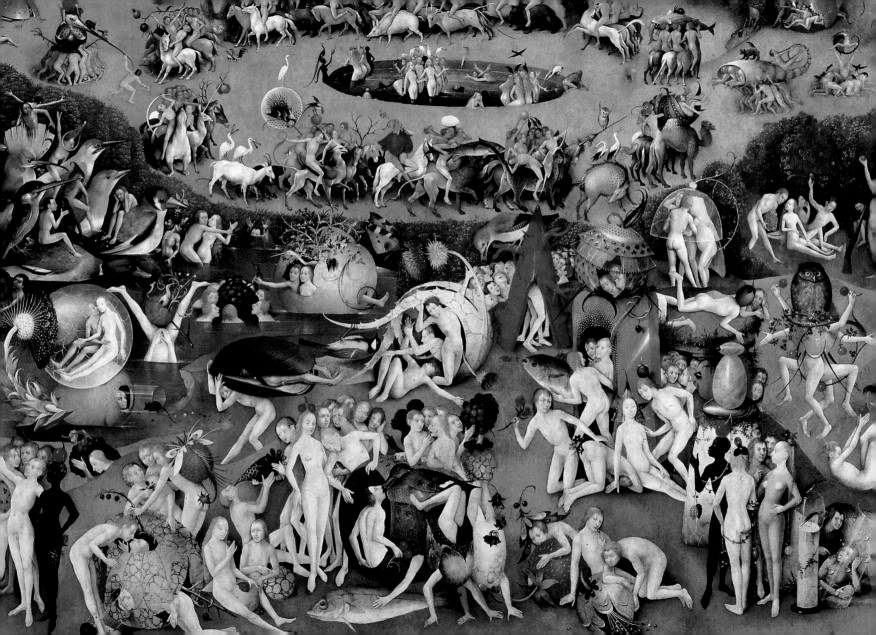

Of course you will say that I ought to be practical and ought to try to paint the way they want me to paint. Well, I will tell you a secret. I have tried and I have tried very hard, but I can't do it. I just can't do it! And that is why I am just a little crazy.

REMBRANDT VAN RIJN

Susanne and the Old Man, *c.* 1636
Rembrandt van Rijn
Mauritshuis, The Hague

1 2 3 4 5 6 7 8 9 10 11 12 13 **14** 15 16 17 18 19 20 21 22 23 24 25 26 27 28 29 30

JUNE

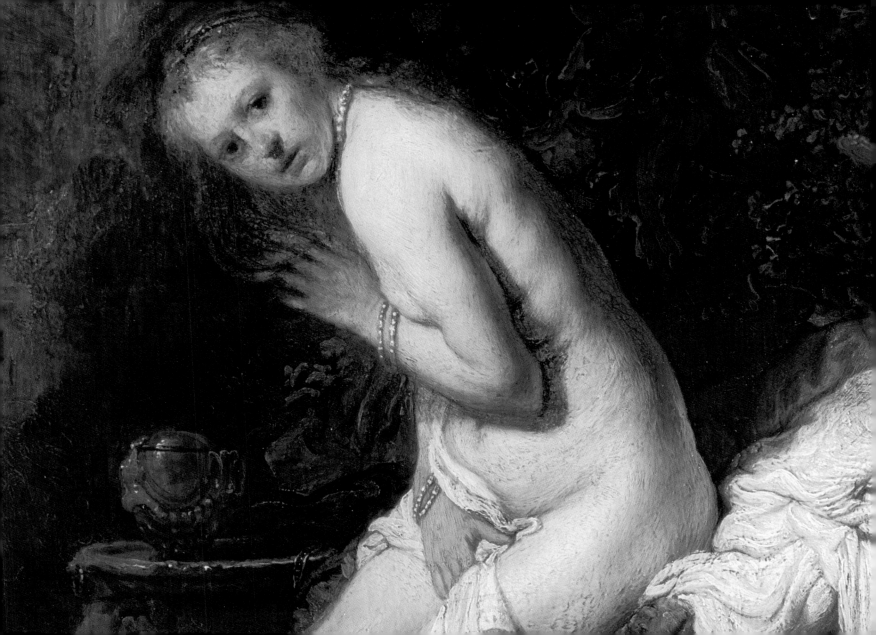

Art is nothing but the expression of our dream;
the more we surrender to it the closer we get
to the inner truth of things.

FRANZ MARC

Paradise, early 17th century
Paul de Vos
Kunsthistorisches Museum, Vienna

1 2 3 4 5 6 7 8 9 10 11 12 13 14 **15** 16 17 18 19 20 21 22 23 24 25 26 27 28 29 30

JUNE

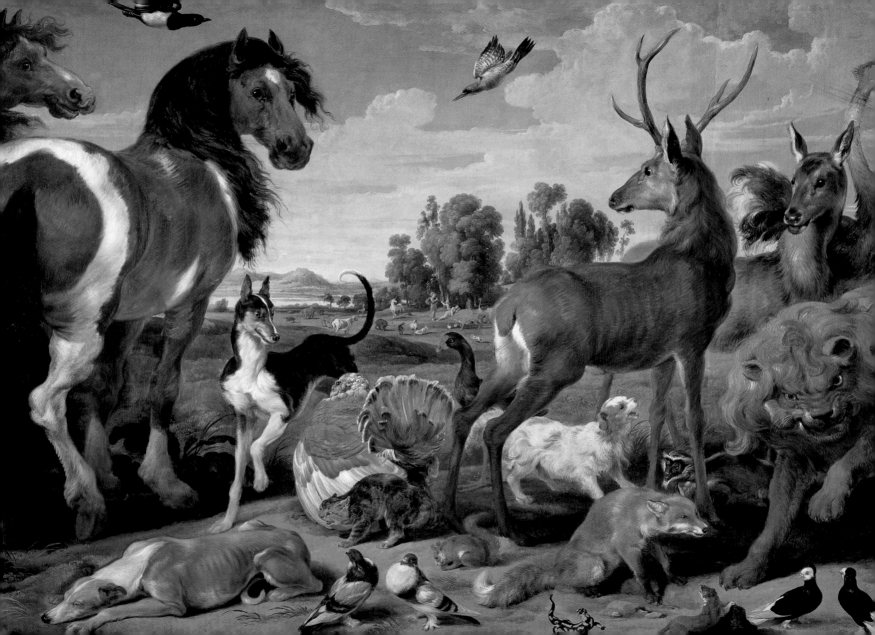

*An art which isn't based on feeling
isn't an art at all ... feeling is the principle,
the beginning and the end; craft, objective,
technique—all these are in the middle.*

PAUL CÉZANNE

The Château at Medan, *c.* 1880
Paul Cézanne
Art Gallery, Glasgow

1 2 3 4 5 6 7 8 9 10 11 12 13 14 15 **16** 17 18 19 20 21 22 23 24 25 26 27 28 29 30

JUNE

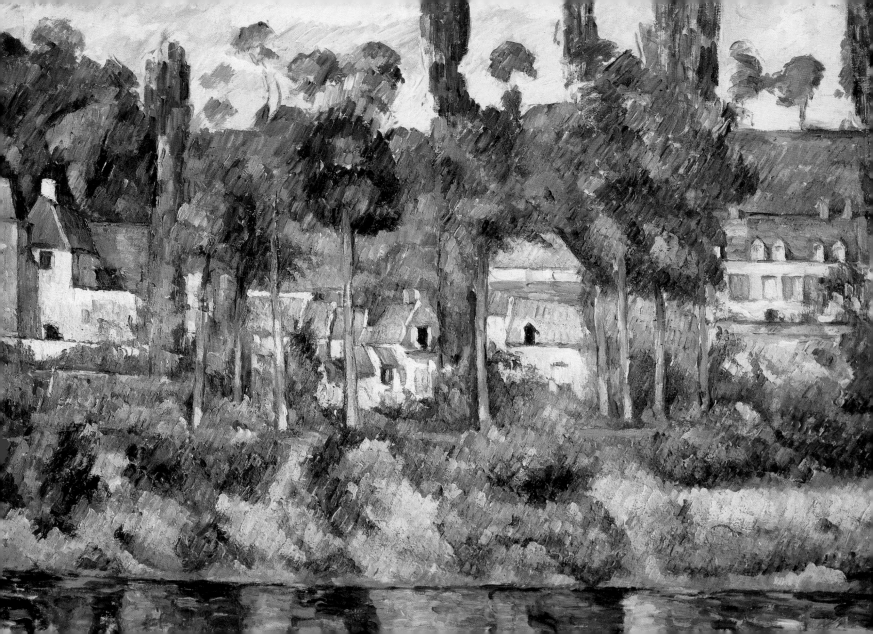

Music is a moral law. It gives soul to the universe,
wings to the mind, flight to the imagination,
and charm and gaiety to life and to everything.

<small>PLATO</small>

The Concert in the Garden, 18th century
Peter Jakob Horemans
Lenbachhaus, Munich

1 2 3 4 5 6 7 8 9 10 11 12 13 14 15 16 **17** 18 19 20 21 22 23 24 25 26 27 28 29 30

JUNE

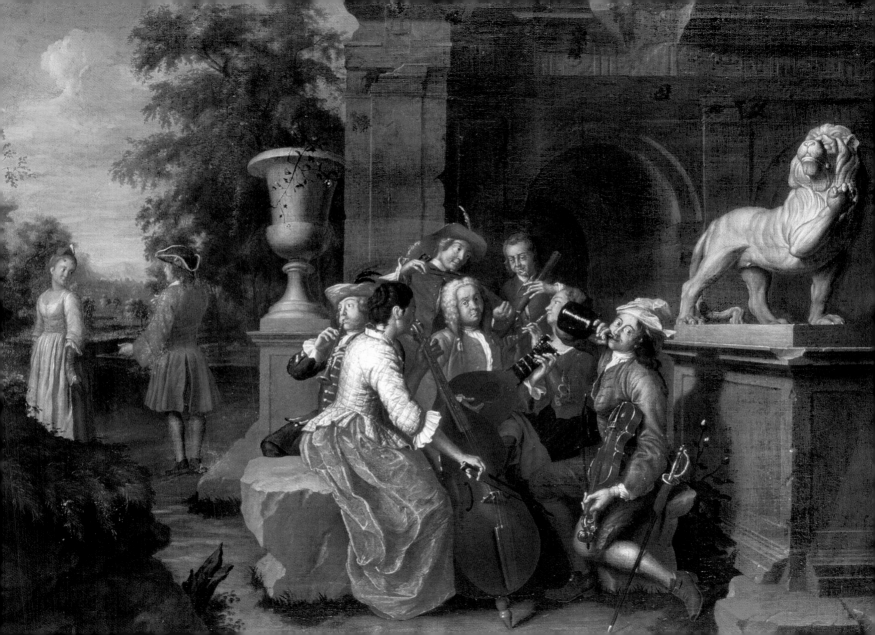

Color exists simultaneously with form.
Both elements are constantly associated
but color strikes you more.

FERDINAND HODLER

Lake Thun and the Stockhorn Chain, 1910
Ferdinand Hodler
Kunsthalle, Mannheim

1 2 3 4 5 6 7 8 9 10 11 12 13 14 15 16 17 **18** 19 20 21 22 23 24 25 26 27 28 29 30

JUNE

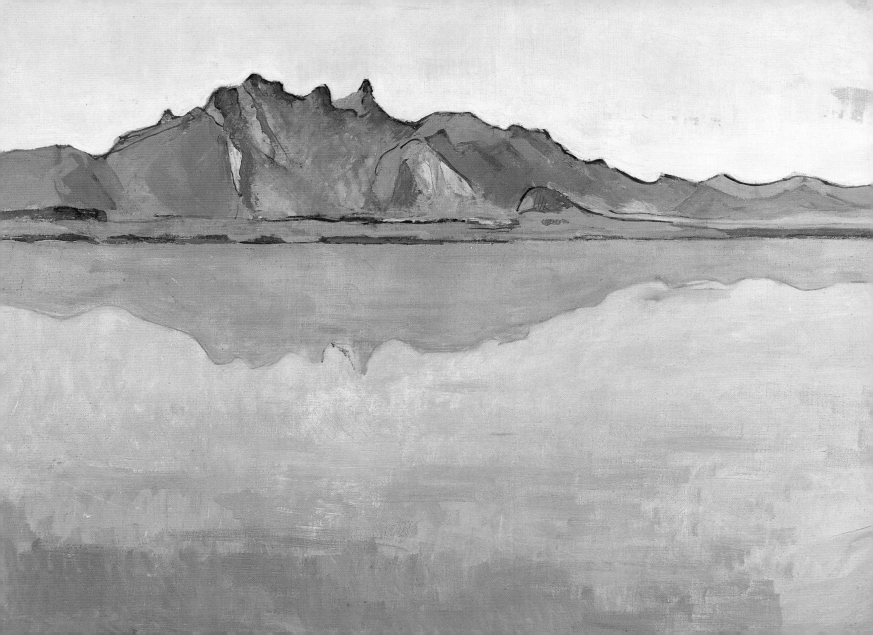

O Holy Spirit, descend plentifully into my heart.
Enlighten the dark corners of this neglected
dwelling and scatter there Thy cheerful beams.

<small>SAINT AUGUSTINE</small>

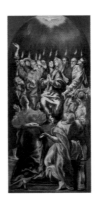

Pentecost, *c.* 1605–10
El Greco
Museo Nacional del Prado, Madrid

1 2 3 4 5 6 7 8 9 10 11 12 13 14 15 16 17 18 **19** 20 21 22 23 24 25 26 27 28 29 30

JUNE

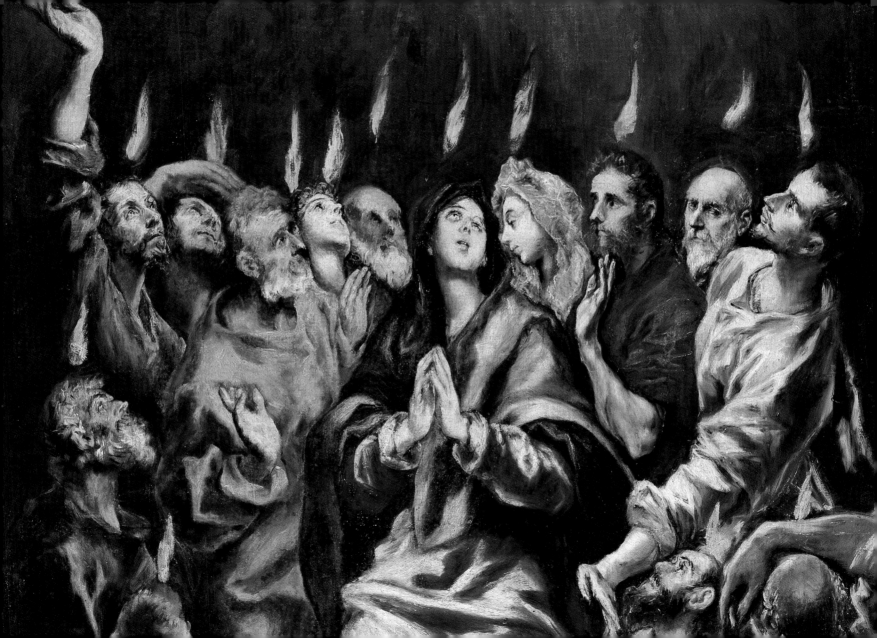

*He put so much mystery
in so much brightness.*

Ford (Running Away), 1901
Paul Gauguin
The Pushkin Museum of Fine Arts, Moscow

1 2 3 4 5 6 7 8 9 10 11 12 13 14 15 16 17 18 19 **20** 21 22 23 24 25 26 27 28 29 30

JUNE

The beautiful is in nature, and it is encountered under the most diverse forms of reality. Once it is found, it belongs to art, or rather to the artist who discovers it.

Gustave Courbet

The Hammock, 1844
Gustave Courbet
Oskar Reinhart Collection, Winterthur

1 2 3 4 5 6 7 8 9 10 11 12 13 14 15 16 17 18 19 20 **21** 22 23 24 25 26 27 28 29 30

JUNE

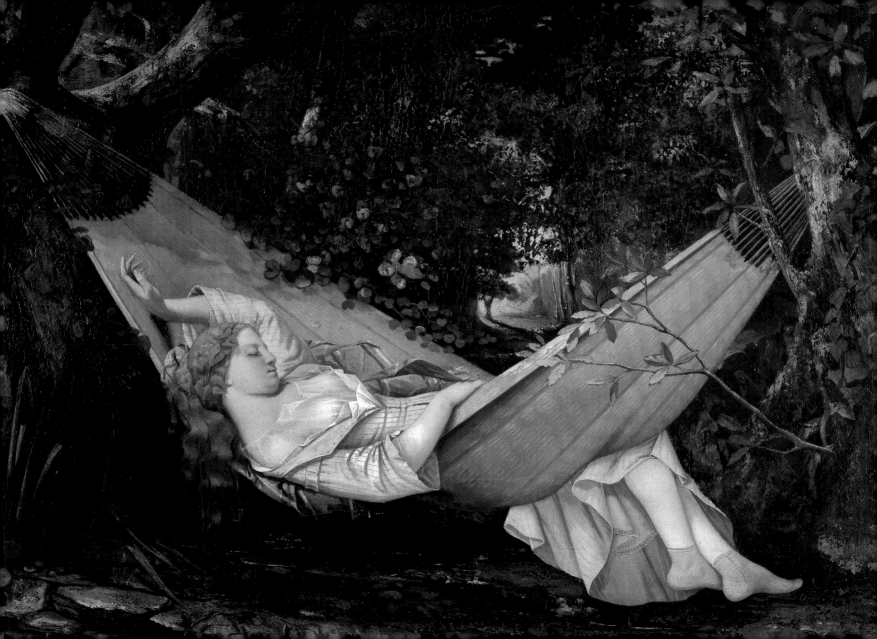

The important thing is this:
To be able at any moment
to sacrifice what we are
for what we could become.

CHARLES DUBOIS

The Sacrifice of Issac, 1601
Agnolo Bronzino
Uffizi Gallery, Florence

1 2 3 4 5 6 7 8 9 10 11 12 13 14 15 16 17 18 19 20 21 **22** 23 24 25 26 27 28 29 30

JUNE

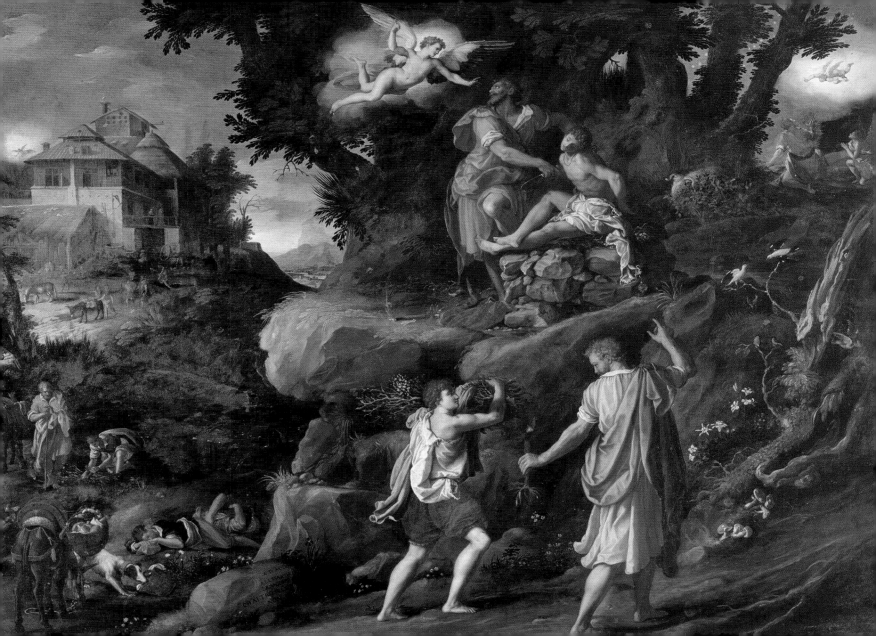

Her love was entire as a child's,
and though warm as summer
it was fresh as spring.

Thomas Hardy

Henriette of France as Flora, 1742
Jean-Marc Nattier
Uffizi Gallery, Florence

1 2 3 4 5 6 7 8 9 10 11 12 13 14 15 16 17 18 19 20 21 22 **23** 24 25 26 27 28 29 30

JUNE

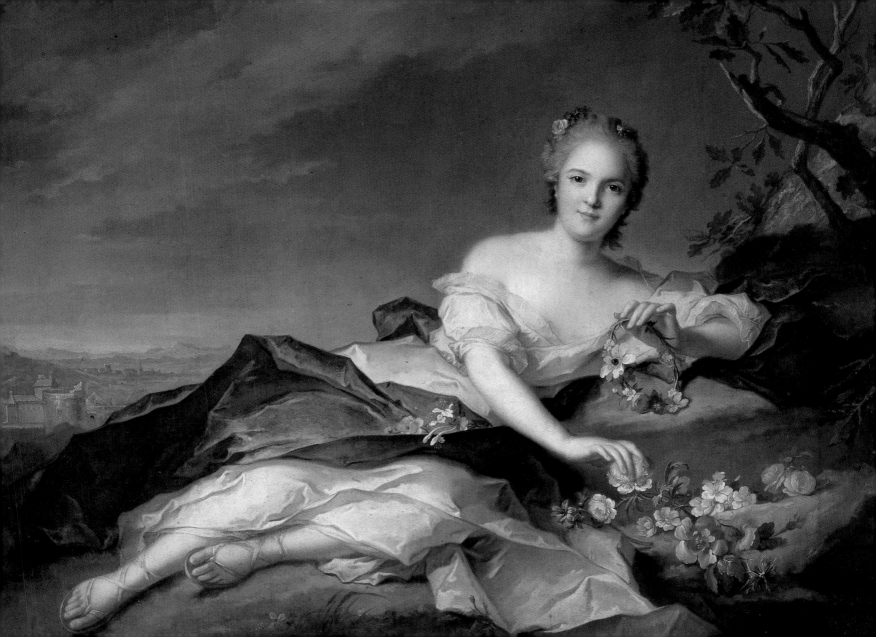

I would rather that my spark should burn out in a brilliant blaze than it should be stifled by dry-rot. I would rather be a superb meteor, every atom of me in magnificent glow, than a sleepy and permanent planet. The function of man is to live, not to exist …

JACK LONDON

Fireworks over Carraia Bridge in Florence during the Festival of John the Baptist, 19th century
Giovanni Signorini
Uffizi Gallery, Florence

1 2 3 4 5 6 7 8 9 10 11 12 13 14 15 16 17 18 19 20 21 22 23 **24** 25 26 27 28 29 30

JUNE

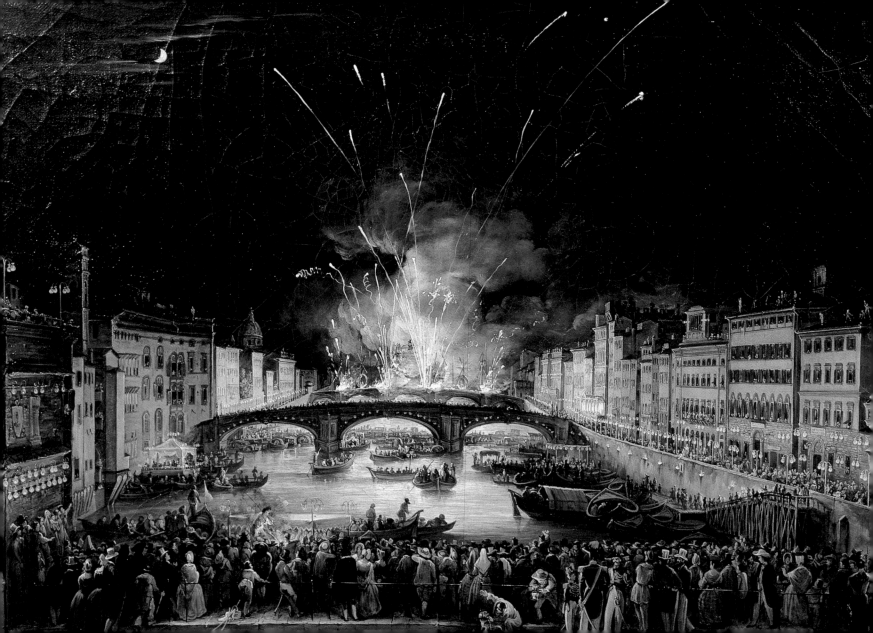

These things I warmly wish for you:
someone to love, some work to do,
a bit o' sun, a bit o' cheer,
and a guardian angel always near.

IRISH BLESSING

The Parasol, 1777
Francisco José de Goya
Museo Nacional del Prado, Madrid

1 2 3 4 5 6 7 8 9 10 11 12 13 14 15 16 17 18 19 20 21 22 23 24 **25** 26 27 28 29 30

JUNE

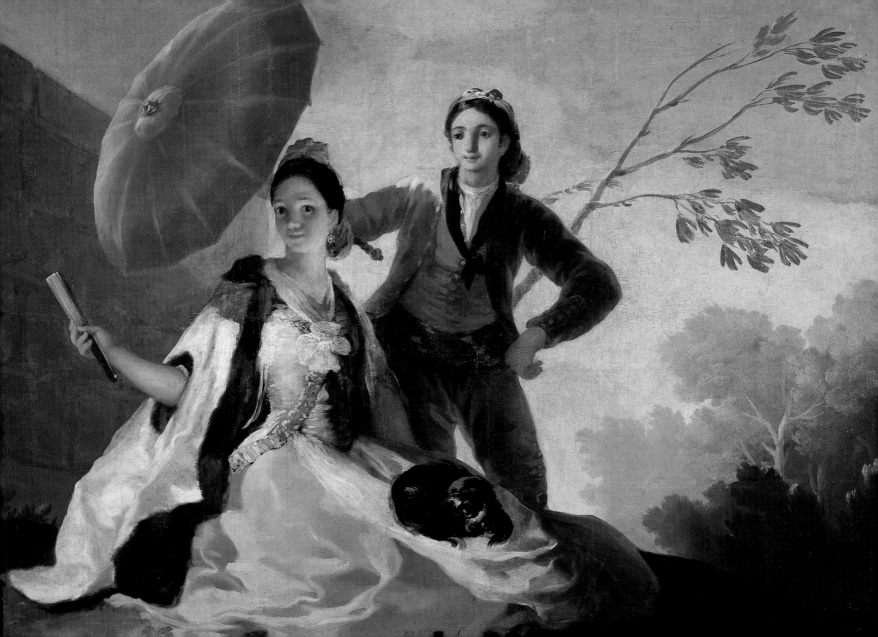

In my opinion, I am often rich—not in money, but rich—because I have found in my work something which I can devote myself to heart and soul, and which inspires me and gives a meaning to life.

<small>Vincent van Gogh</small>

The Langlois Bridge at Arles with Women Washing, 1888
Vincent van Gogh
Kröller-Müller Museum, Otterlo

1 2 3 4 5 6 7 8 9 10 11 12 13 14 15 16 17 18 19 20 21 22 23 24 25 **26** 27 28 29 30

JUNE

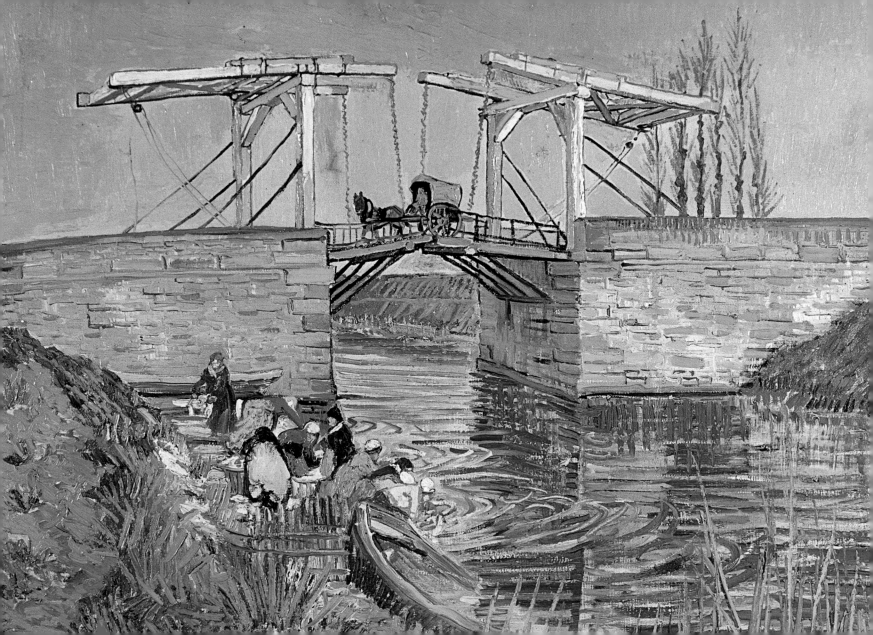

But mighty Nature bounds as from her birth;
The sun is in the heavens, and life on earth:
Flowers in the valley, splendor in the beam,
Health on the gale, and freshness in the stream.

<small>LORD BYRON</small>

Landscape with Hagar and the Angel, c. 1654
Claude Lorrain
Oskar Reinhart Collection, Winterthur

1 2 3 4 5 6 7 8 9 10 11 12 13 14 15 16 17 18 19 20 21 22 23 24 25 26 **27** 28 29 30

JUNE

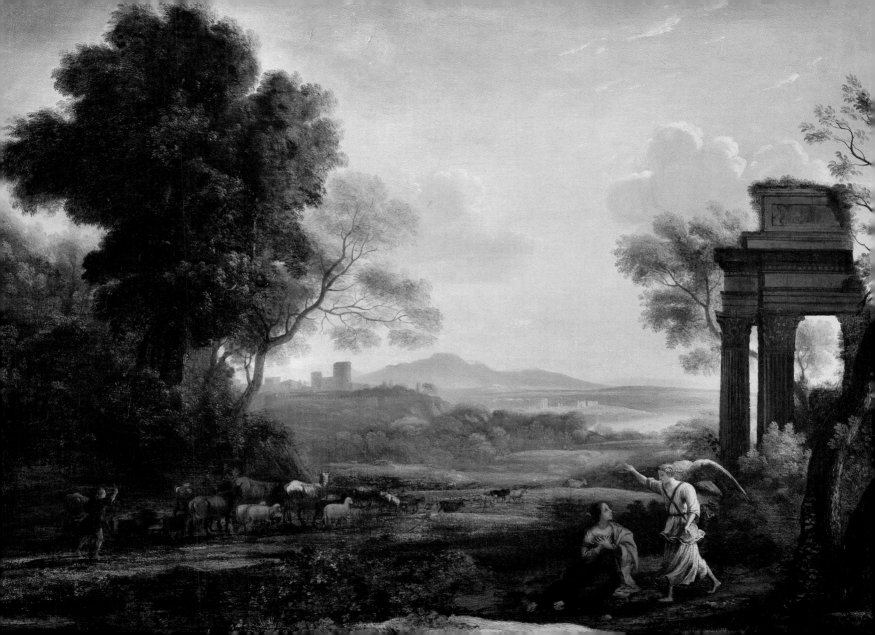

Don't part with your illusions.
When they are gone you may still exist,
but you have ceased to live.

MARK TWAIN

Joyride, 1903
Franz von Stuck
Georg Schäfer Collection

1 2 3 4 5 6 7 8 9 10 11 12 13 14 15 16 17 18 19 20 21 22 23 24 25 26 27 **28** 29 30

JUNE

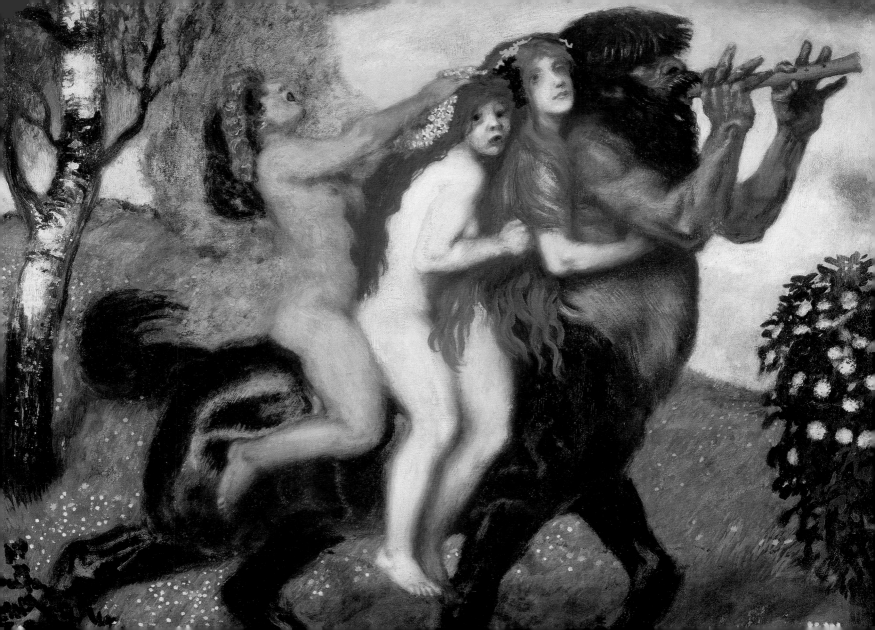

My talent is such that no undertaking has ever surpassed my courage.

PETER PAUL RUBENS

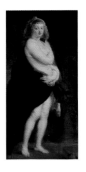

**Helene Fourment,
the Second Wife of the Artist,** *c.* 1638
Peter Paul Rubens
Kunsthistorisches Museum, Vienna

1 2 3 4 5 6 7 8 9 10 11 12 13 14 15 16 17 18 19 20 21 22 23 24 25 26 27 28 **29** 30

JUNE

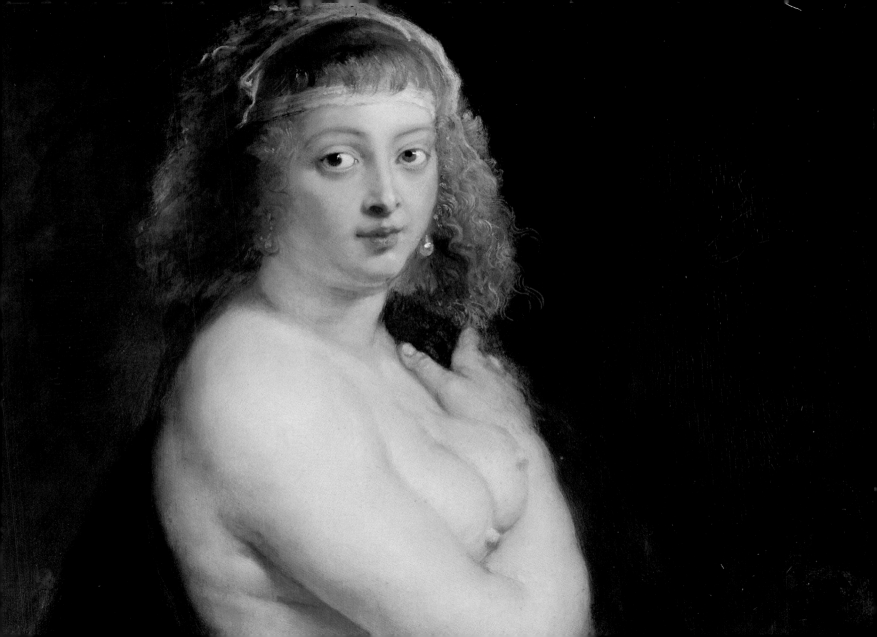

*Let food be your medicine
and medicine be your food.*

Hippocrates

Cabbage Garden in Schrobenhausen, 19th century
Franz von Lenbach
Lenbach-Museum, Schrobenhausen

1 2 3 4 5 6 7 8 9 10 11 12 13 14 15 16 17 18 19 20 21 22 23 24 25 26 27 28 29 **30**

JUNE

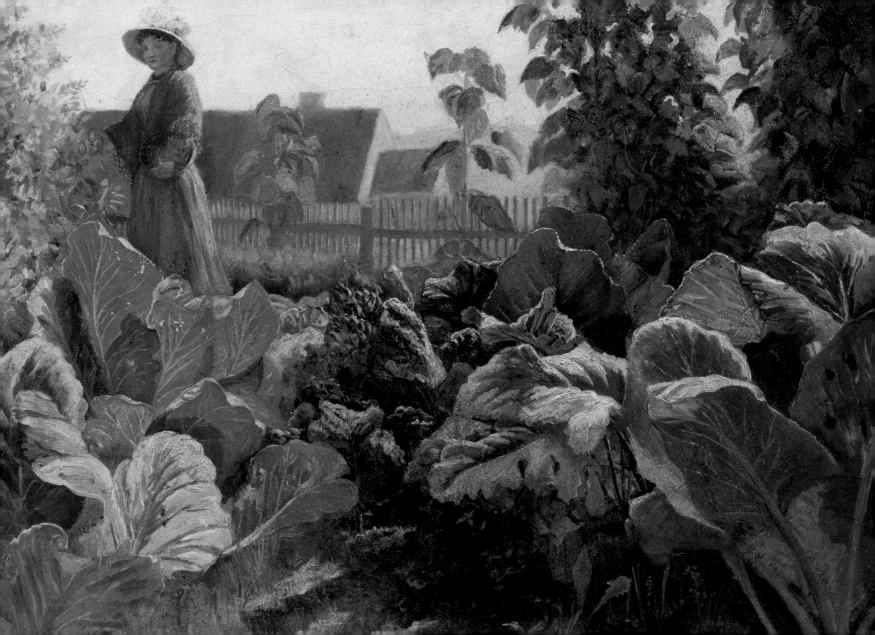

... painting holds no secrets,
but depends only on natural talent,
study and intuition which, together,
produce the greatest achievements in art ...

Francisco José de Goya

The Puppet, 1791–92
Francisco José de Goya
Museo Nacional del Prado, Madrid

1 2 3 4 5 6 7 8 9 10 11 12 13 14 15 16 17 18 19 20 21 22 23 24 25 26 27 28 29 30 31

JULY

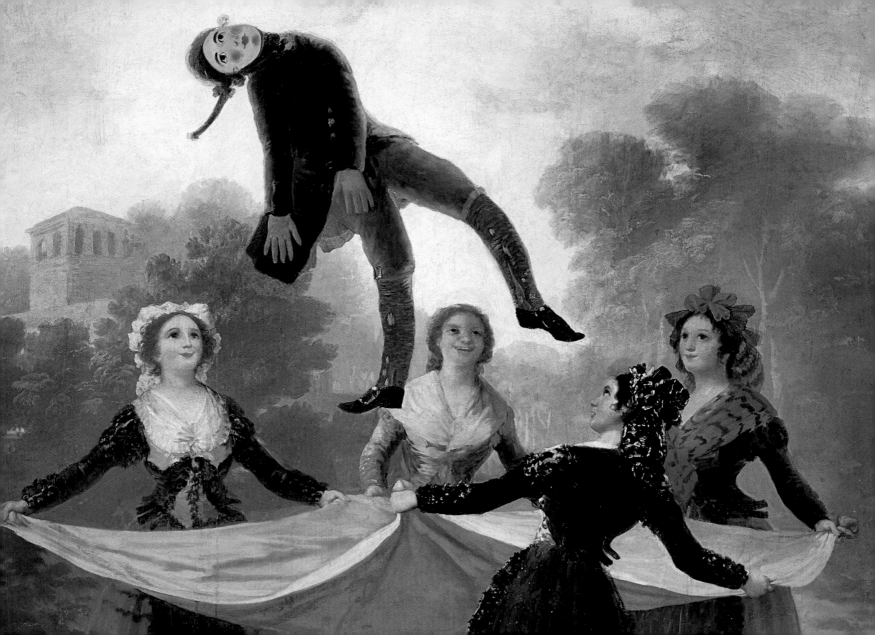

A lion sleeps in the heart of every brave man.

Lion at Rest, *c.* 1585
Miniature Painting from the Mughal Era
Nasli and Alice Heeramaneck Collection, New Haven

2 1 3 4 5 6 7 8 9 10 11 12 13 14 15 16 17 18 19 20 21 22 23 24 25 26 27 28 29 30 31

JULY

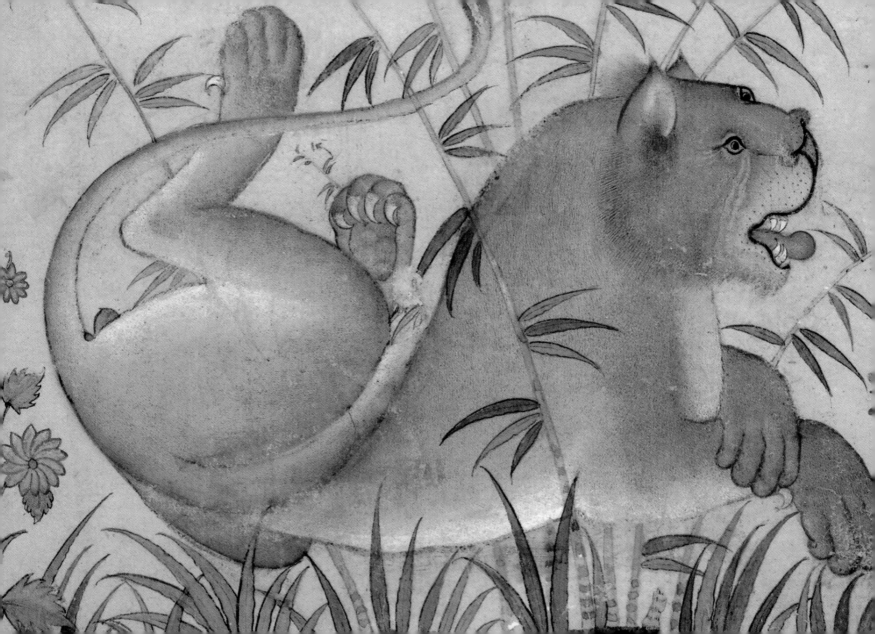

We are all travelers in the wilderness of this world, and the best we can find in our travels is an honest friend.

ROBERT LOUIS STEVENSON

The Childhood Friends, *c.* 1855
Carl Spitzweg
Lenbachhaus, Munich

1 2 **3** 4 5 6 7 8 9 10 11 12 13 14 15 16 17 18 19 20 21 22 23 24 25 26 27 28 29 30 31

JULY

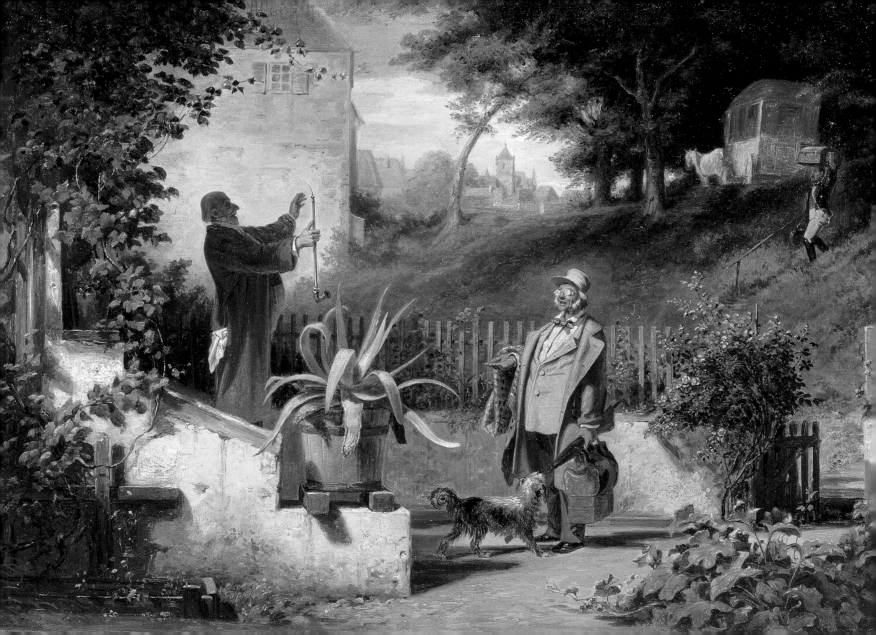

*'Tis the star-spangled banner: O, long
may it wave O'er the land of the free and
the home of the brave!*

Francis Scott Key

Flag, 1954–55
Jasper Johns
Museum of Modern Art, New York,
Gift of Philipp Johnson in honor of Alfred H. Baar Jr.

1 2 3 **4** 5 6 7 8 9 10 11 12 13 14 15 16 17 18 19 20 21 22 23 24 25 26 27 28 29 30 31

July

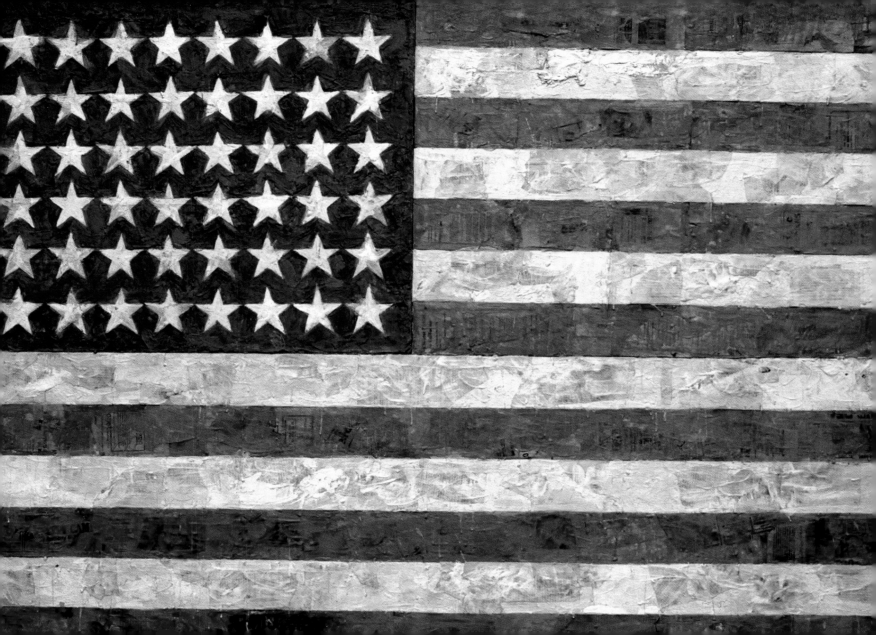

*The purest and most thoughtful minds
are those which love color the most.*

<small>John Ruskin</small>

Garden Restaurant, 1912
August Macke
Kunstmuseum, Bern

1 2 3 4 **5** 6 7 8 9 10 11 12 13 14 15 16 17 18 19 20 21 22 23 24 25 26 27 28 29 30 31

JULY

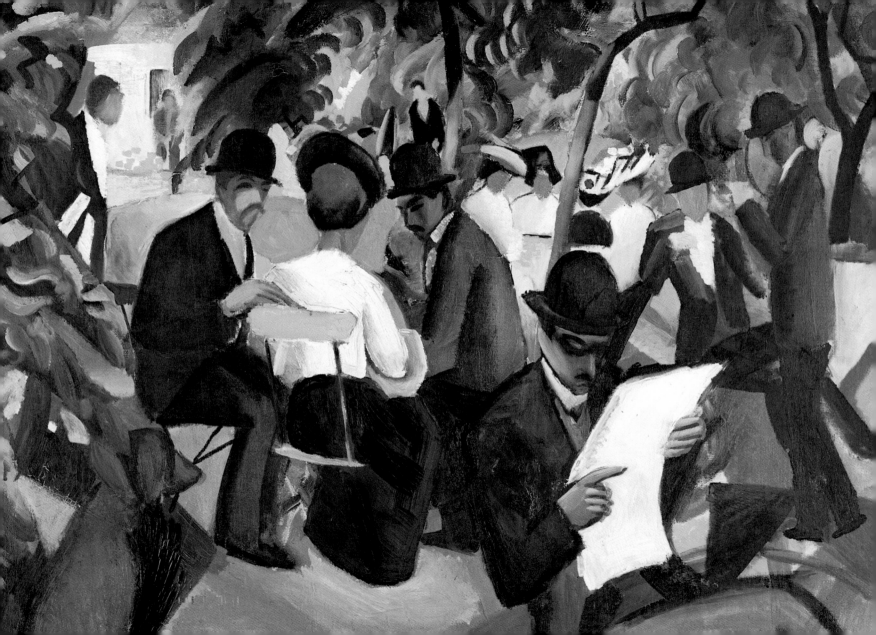

I've caught this magical landscape
and it's the enchantment of it that I'm
so keen to render. Of course lots of people
will protest that it's quite unreal,
but that's just too bad.

<small>Claude Monet</small>

Field of Poppies, 1880
Claude Monet
The State Hermitage Museum, St. Petersburg

6

1 2 3 4 5 **6** 7 8 9 10 11 12 13 14 15 16 17 18 19 20 21 22 23 24 25 26 27 28 29 30 31

July

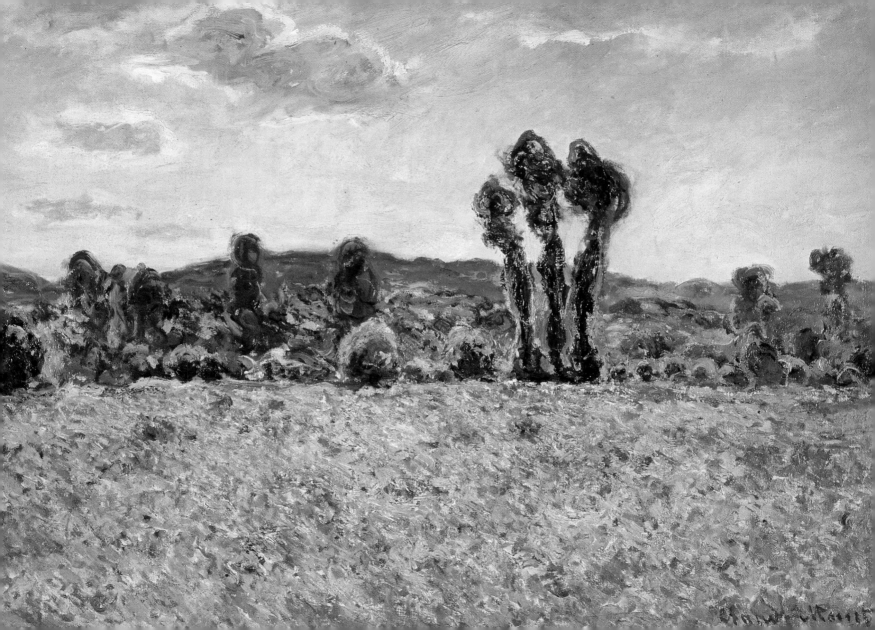

Eve was not taken out of Adam's head to top him,
neither out of his feet to be trampled on by him,
but out of his side to be equal with him, under
his arm to be protected by him, and near his heart
to be loved by him.

<small>MATTHEW HENRY</small>

Paradise (Adam and Eve), *c.* 1616
Peter Paul Rubens
Mauritshuis, The Hague

1 2 3 4 5 6 **7** 8 9 10 11 12 13 14 15 16 17 18 19 20 21 22 23 24 25 26 27 28 29 30 31

JULY

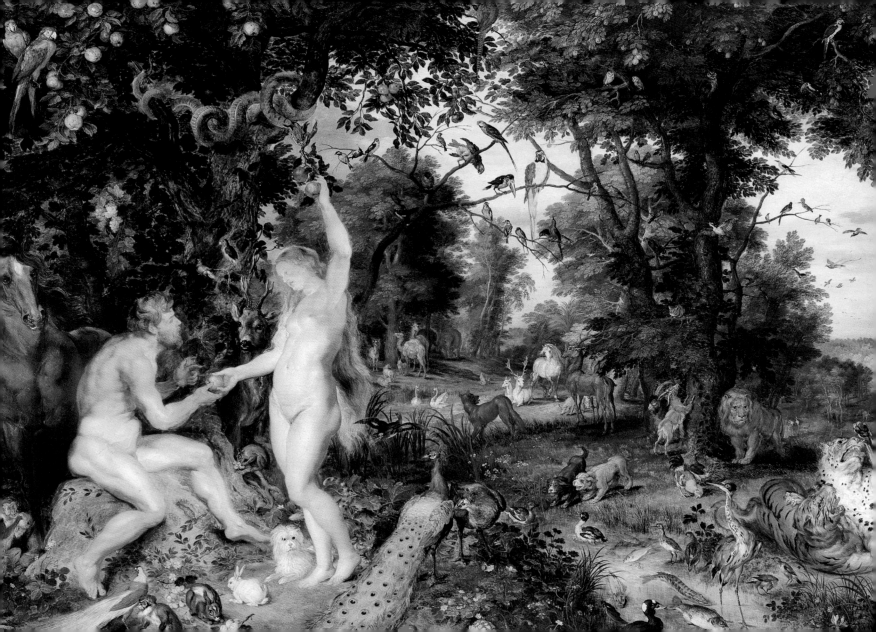

*I have touched some people with a sense
of art—they felt the love
and the life. Can you offer me anything
to compare to that joy for an artist?*

<small>MARY CASSATT</small>

The Boating Party, c. 1893–94
Mary Cassatt
National Gallery of Art, Washington D.C.

1 2 3 4 5 6 7 **8** 9 10 11 12 13 14 15 16 17 18 19 20 21 22 23 24 25 26 27 28 29 30 31

JULY

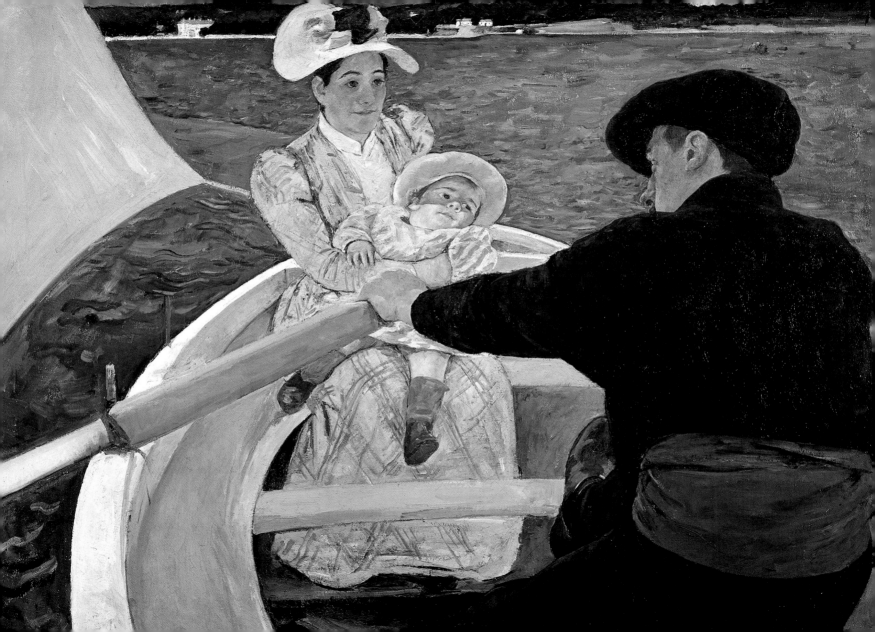

Go to the country—
The muse is in the woods.

Jean-Baptiste-Camille Corot

Les Champs-Elysées, 1716–17
Jean-Antoine Watteau
Wallace Collection, London

1 2 3 4 5 6 7 8 **9** 10 11 12 13 14 15 16 17 18 19 20 21 22 23 24 25 26 27 28 29 30 31

JULY

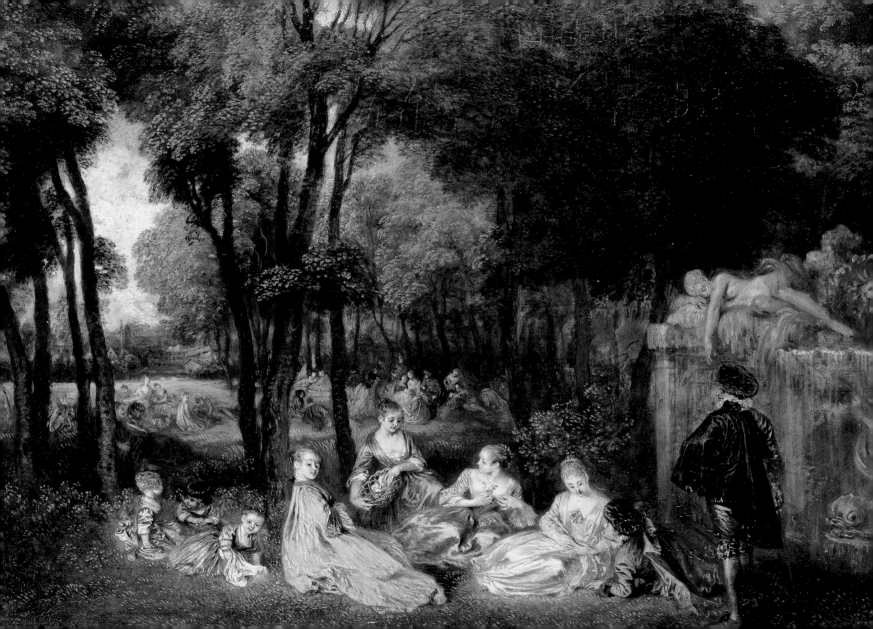

Blessed are they who see beautiful things in humble places where other people see nothing.

<small>CAMILLE PISSARRO</small>

Landscape near Pontoise, 1878
Camille Pissarro
Oskar Reinhart Collection, Winterthur

1 2 3 4 5 6 7 8 9 **10** 11 12 13 14 15 16 17 18 19 20 21 22 23 24 25 26 27 28 29 30 31

JULY

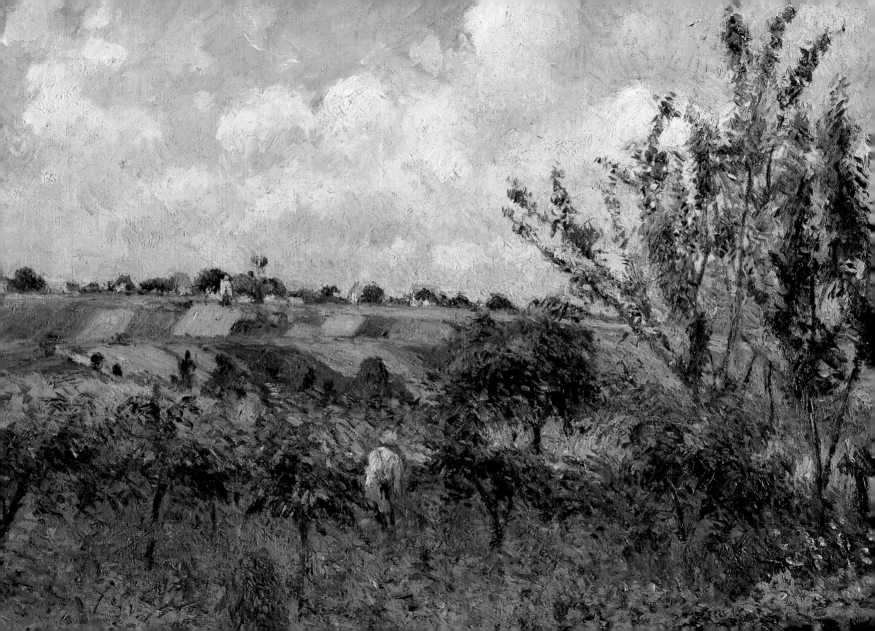

*I've never let my school
interfere with my education.*

MARK TWAIN

On the Way to School in Edam, early 20th century
Max Liebermann
The Pushkin Museum of Fine Arts, Moscow

1 2 3 4 5 6 7 8 9 10 **11** 12 13 14 15 16 17 18 19 20 21 22 23 24 25 26 27 28 29 30 31

JULY

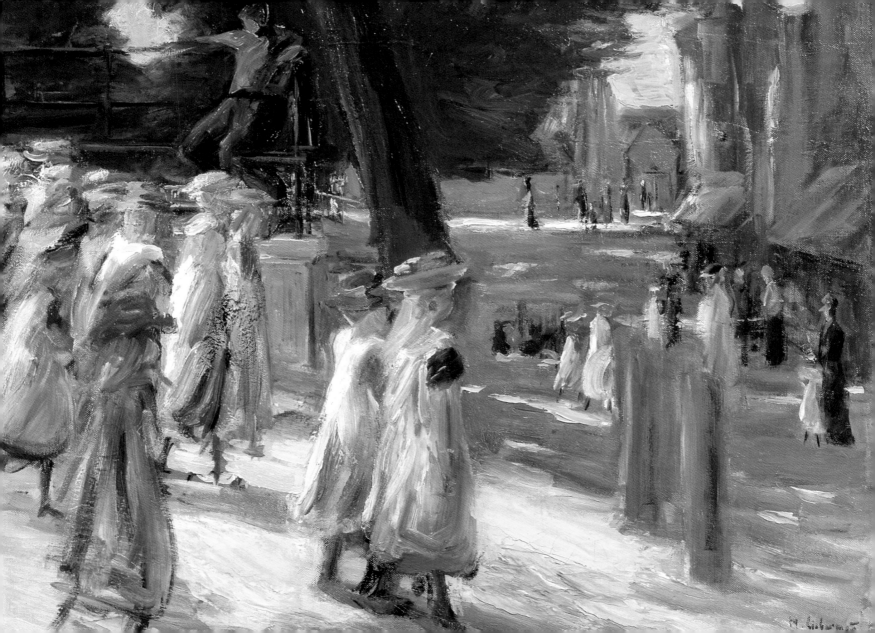

*What I am seeking is not the real
and not the unreal but rather the
unconscious, the mystery of the
instinctive in the human race.*

<small>AMEDEO MODIGLIANI</small>

Reclining Nude, *c.* 1919
Amedeo Modigliani
Museum of Modern Art, New York

1 2 3 4 5 6 7 8 9 10 11 **12** 13 14 15 16 17 18 19 20 21 22 23 24 25 26 27 28 29 30 31

JULY

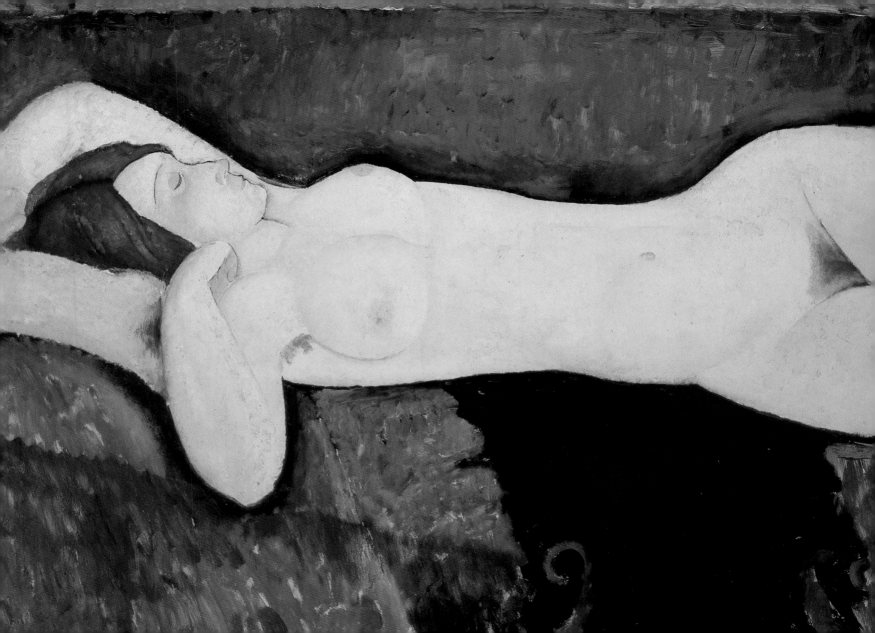

Luck never gives;
it only lends.

**The Cardsharper with
the Ace of Diamonds,** *c.* 1603
Georges de la Tour
Musée du Louvre, Paris

1 2 3 4 5 6 7 8 9 10 11 12 **13** 14 15 16 17 18 19 20 21 22 23 24 25 26 27 28 29 30 31

JULY

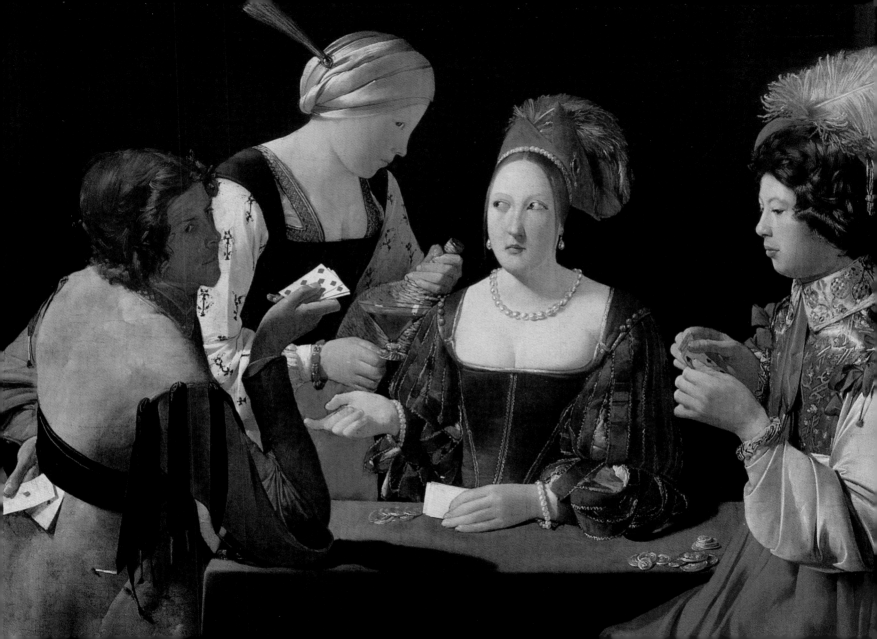

*Earth and sky, woods and fields,
lakes and rivers, the mountain and the sea,
are excellent schoolmasters, and teach
some of us more than we can ever learn
from books.*

JOHN LUBBOCK

At Lake Atter, 1915
Gustav Klimt
Rupertinum, Salzburg

1 2 3 4 5 6 7 8 9 10 11 12 13 **14** 15 16 17 18 19 20 21 22 23 24 25 26 27 28 29 30 31

JULY

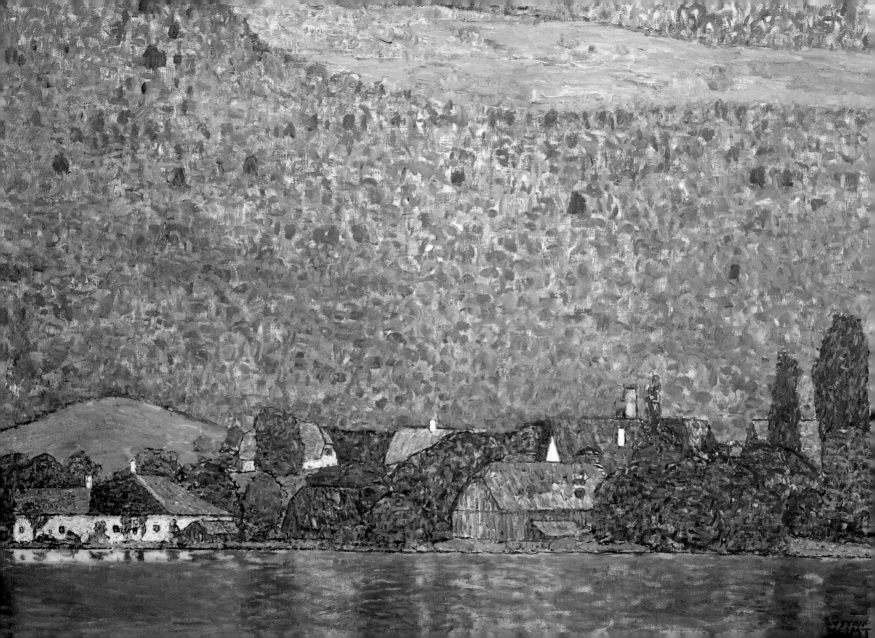

There is a passion for hunting something deeply implanted in the human breast.

The Hunt of Meleager and Atalante, *c.* 1615–20
Peter Paul Rubens
Kunsthistorisches Museum, Vienna

1 2 3 4 5 6 7 8 9 10 11 12 13 14 **15** 16 17 18 19 20 21 22 23 24 25 26 27 28 29 30 31

JULY

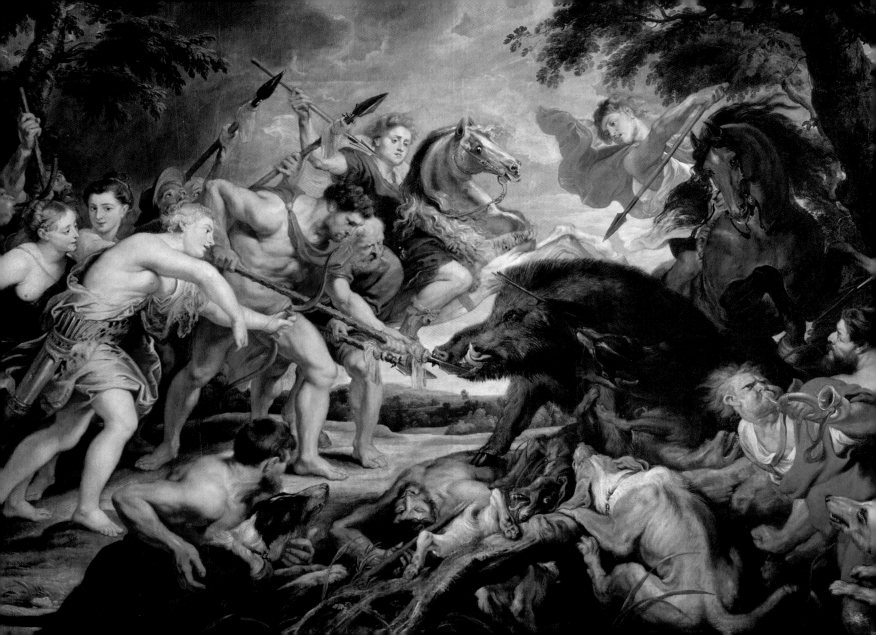

*And think not you can guide
the course of love. For love,
if it finds you worthy,
shall guide your course.*

KAHLIL GIBRAN

Rinaldo and Armida in Her Garden, 1742–45
Giovanni Battista Tiepolo
The Art Institute of Chicago

1 2 3 4 5 6 7 8 9 10 11 12 13 14 15 **16** 17 18 19 20 21 22 23 24 25 26 27 28 29 30 31

JULY

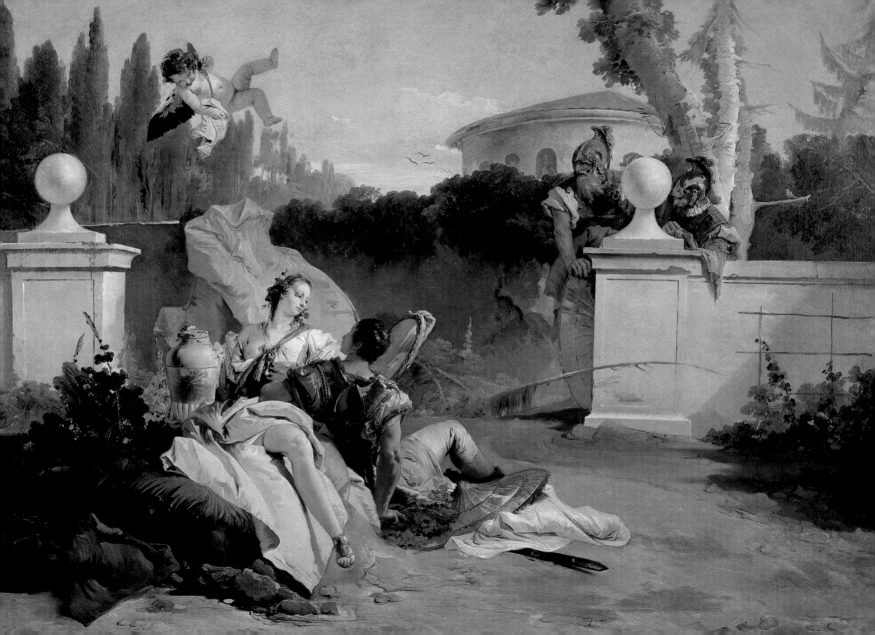

*It is often said that my heart
is too open for my own good.*

<small>Henri Rousseau</small>

The Dream, 1910
Henri Rousseau
Museum of Modern Art, New York

1 2 3 4 5 6 7 8 9 10 11 12 13 14 15 16 **17** 18 19 20 21 22 23 24 25 26 27 28 29 30 31

JULY

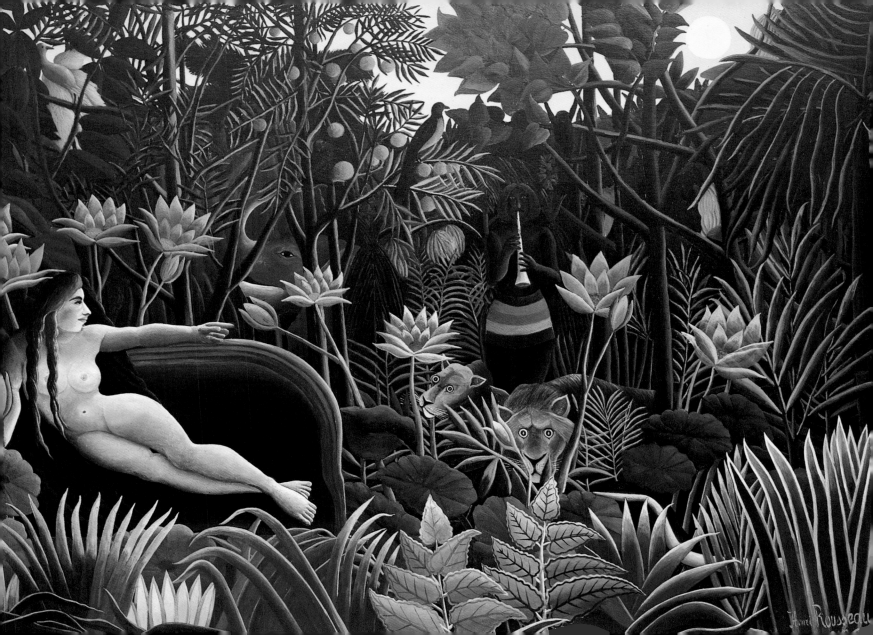

*May your joys be as bright as the morning,
and your sorrows merely be shadows that fade
in the sunlight of love. May you have enough
happiness to keep you sweet, enough trials
to keep you strong, enough sorrow to keep you
human, enough hope to keep you happy.*

IRISH BLESSING

Morning, 1808
*Philipp Otto Runge
Kunsthalle, Hamburg*

1 2 3 4 5 6 7 8 9 10 11 12 13 14 15 16 17 **18** 19 20 21 22 23 24 25 26 27 28 29 30 31

JULY

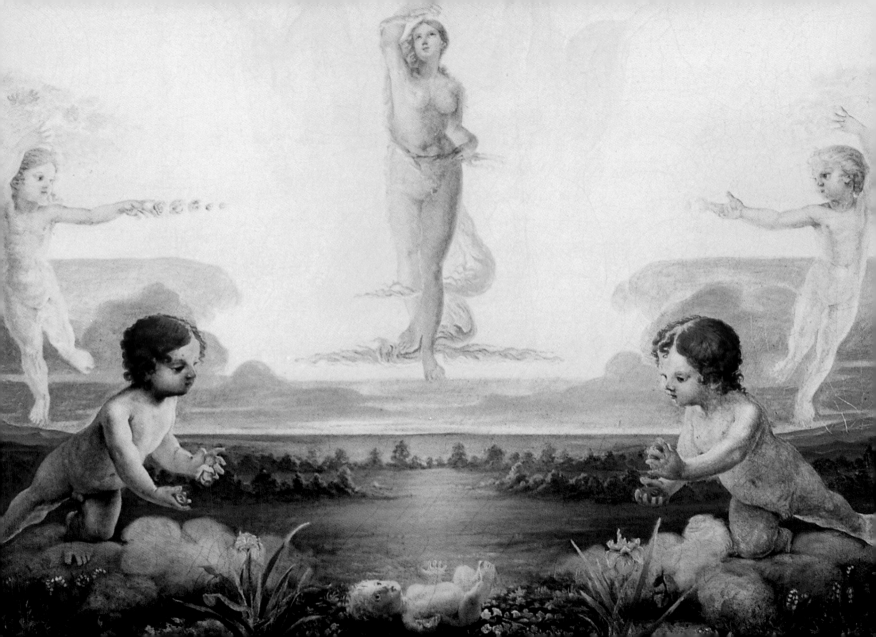

To desire and strive to be of some service
to the world, to aim at doing something
which shall really increase the happiness
and welfare and virtue of mankind—
this is a choice which is possible for all of us;
and surely it is a good haven to sail for.

Henry Van Dyke

Regatta of Concarneau, 1891
Paul Signac
Sir Charles Clore Collection

1 2 3 4 5 6 7 8 9 10 11 12 13 14 15 16 17 18 **19** 20 21 22 23 24 25 26 27 28 29 30 31

July

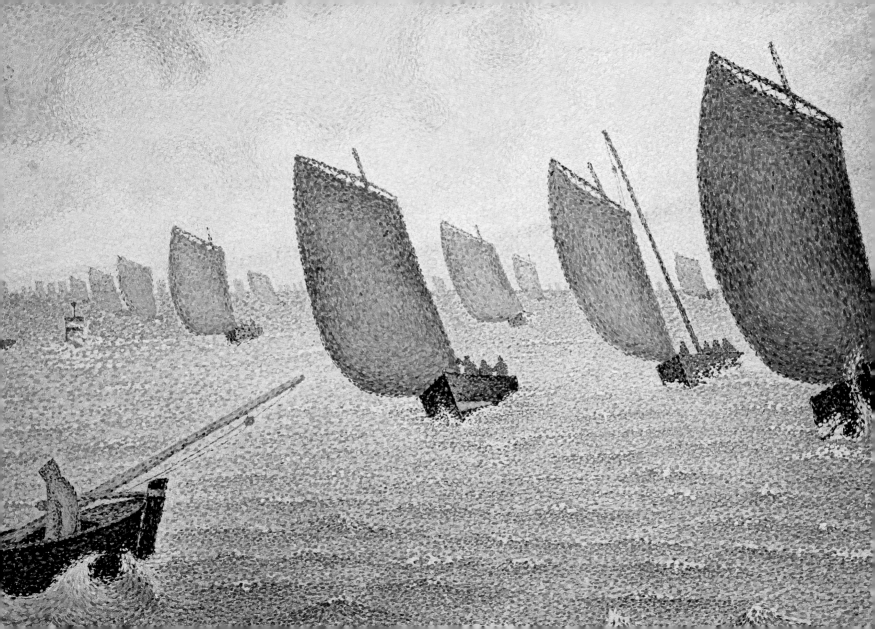

Surprises are foolish things. The pleasure is not enhanced, and the inconvenience is often considerable.

<small>JANE AUSTEN</small>

The Surprised Bather, 1736
François Boucher
Archangelsk Museum

1 2 3 4 5 6 7 8 9 10 11 12 13 14 15 16 17 18 19 **20** 21 22 23 24 25 26 27 28 29 30 31

JULY

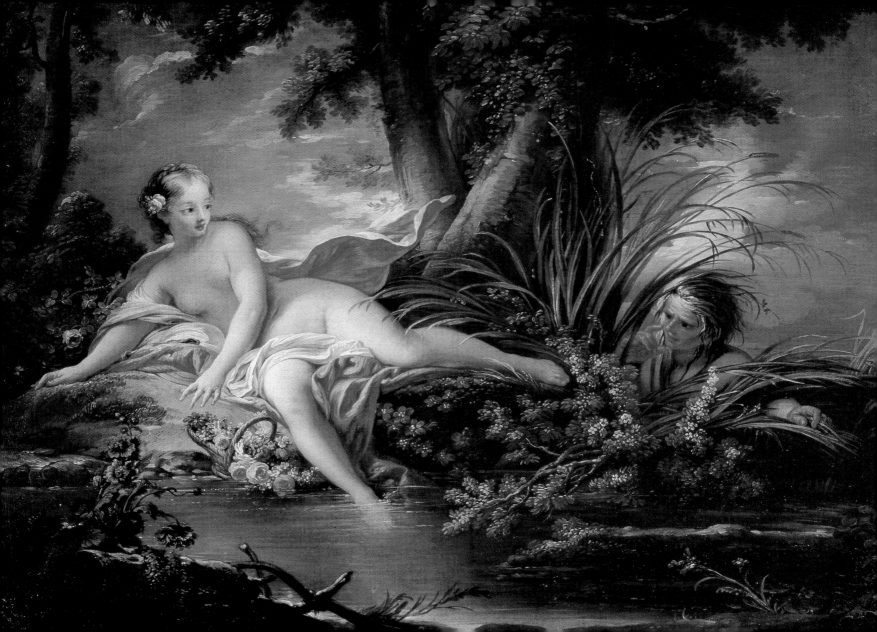

What a piece of work is man!
How noble in reason! How infinite
in faculty! In form, in moving,
how express and admirable!
In action how like an angel!
In apprehension how like a god!

WILLIAM SHAKESPEARE

Self-Portrait with Skeleton, 1896
Lovis Corinth
Lenbachhaus, Munich

1 2 3 4 5 6 7 8 9 10 11 12 13 14 15 16 17 18 19 20 **21** 22 23 24 25 26 27 28 29 30 31

JULY

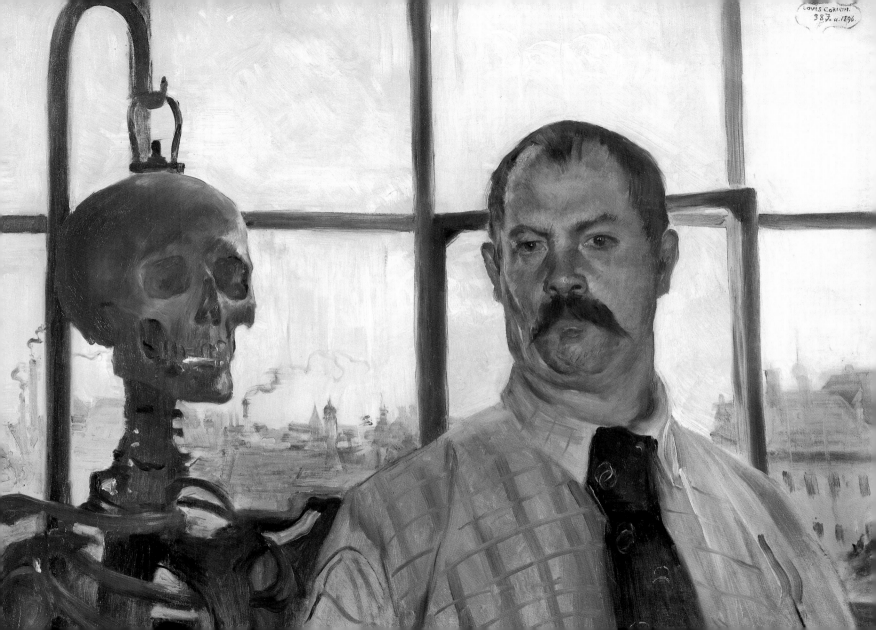

Townfolk know pleasures,
country people joys.

<small>MINNA THOMAS ANTRIM</small>

Country Wedding, c. 1568
Pieter Brueghel the Elder
Kunsthistorisches Museum, Vienna

1 2 3 4 5 6 7 8 9 10 11 12 13 14 15 16 17 18 19 20 21 **22** 23 24 25 26 27 28 29 30 31

JULY

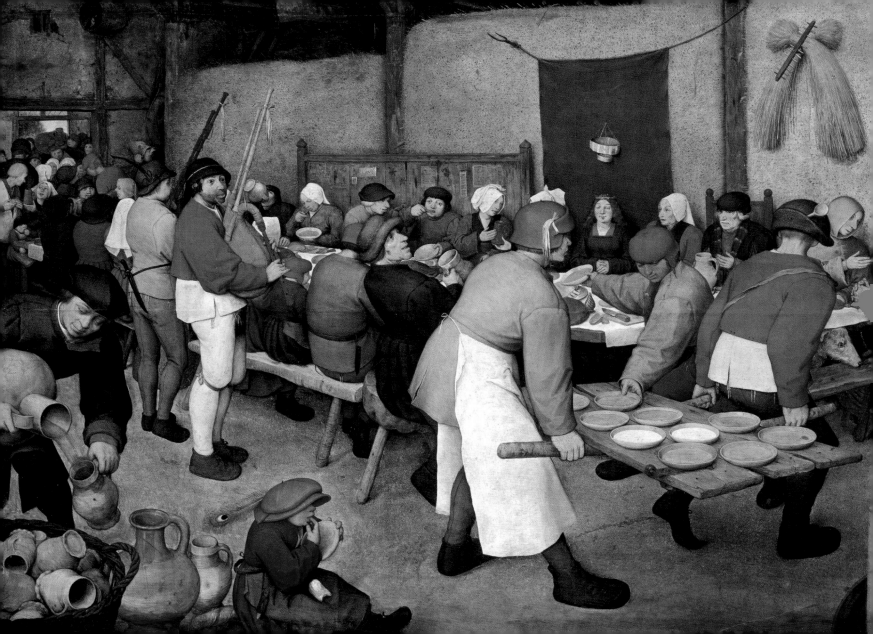

The greater part of our happiness or misery depends on our dispositions and not our circumstances.

Martha Washington

Self-Portrait with Saskia, *c.* 1635
Rembrandt van Rijn
Gemäldegalerie, Dresden

1 2 3 4 5 6 7 8 9 10 11 12 13 14 15 16 17 18 19 20 21 22 **23** 24 25 26 27 28 29 30 31

JULY

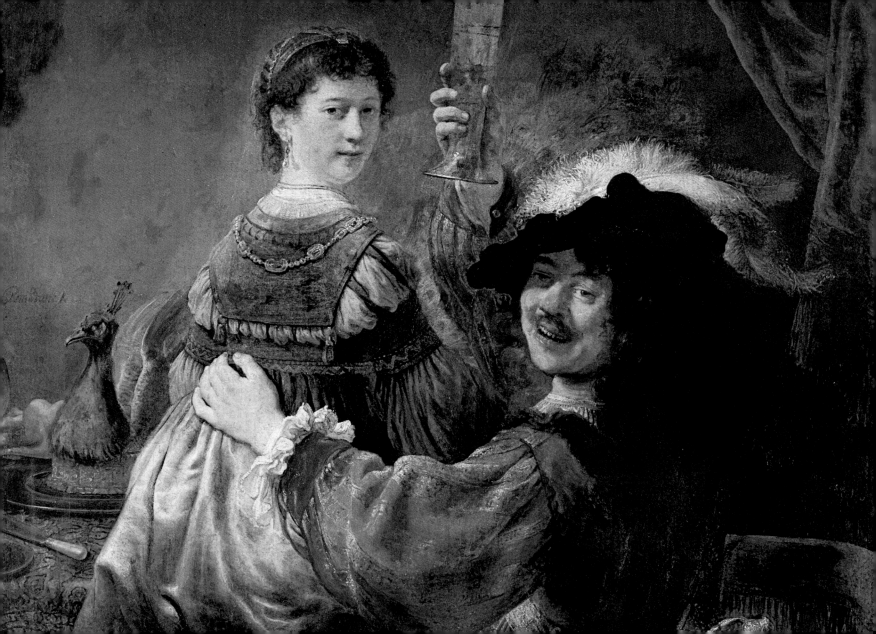

The song of the river ends not at her banks but in the hearts of those who have loved her.

Buffalo Joe

Riverbank, 1649
Jacob van Ruisdael
National Gallery of Scotland, Edinburgh

1 2 3 4 5 6 7 8 9 10 11 12 13 14 15 16 17 18 19 20 21 22 23 **24** 25 26 27 28 29 30 31

JULY

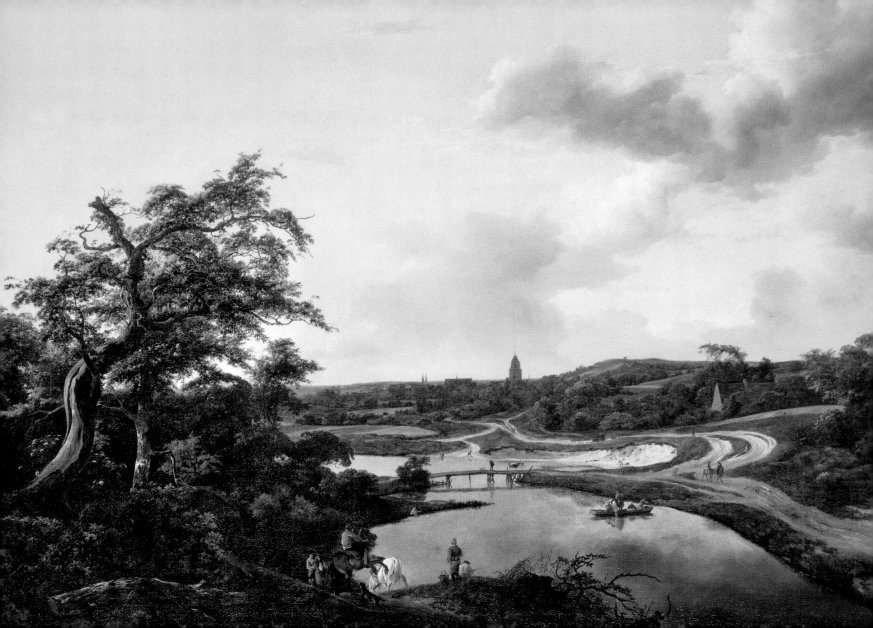

Titian is loved by all the world
because his style breathes life
into the portraits and is hated by
nature for the spirits conjured
by his art put the living to shame.

<small>PIETRO ARETINO</small>

Bacchanal of the Andrians, 1518–20
Titian
Museo Nacional del Prado, Madrid

1 2 3 4 5 6 7 8 9 10 11 12 13 14 15 16 17 18 19 20 21 22 23 24 **25** 26 27 28 29 30 31

JULY

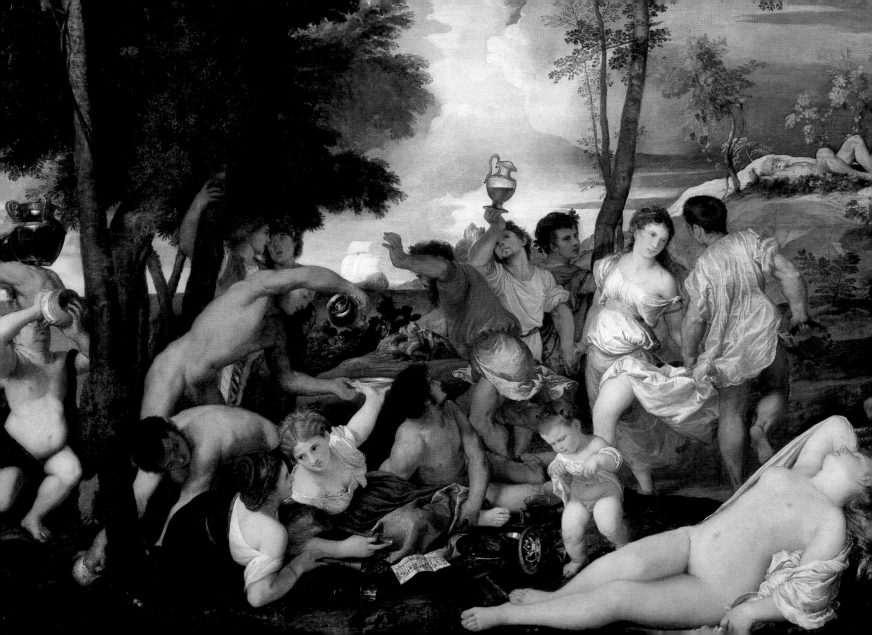

The people of Tahiti have invented a word:
"No artu," which means "I couldn't care less!"
Here it means pretty much the same as complete
serenity and naturalness. You cannot imagine
how I have grown accustomed to this word.
I often say it—and I understand it.

PAUL GAUGUIN

The King's Wife, 1896
Paul Gauguin
The Pushkin Museum of Fine Arts, Moscow

1 2 3 4 5 6 7 8 9 10 11 12 13 14 15 16 17 18 19 20 21 22 23 24 25 **26** 27 28 29 30 31

JULY

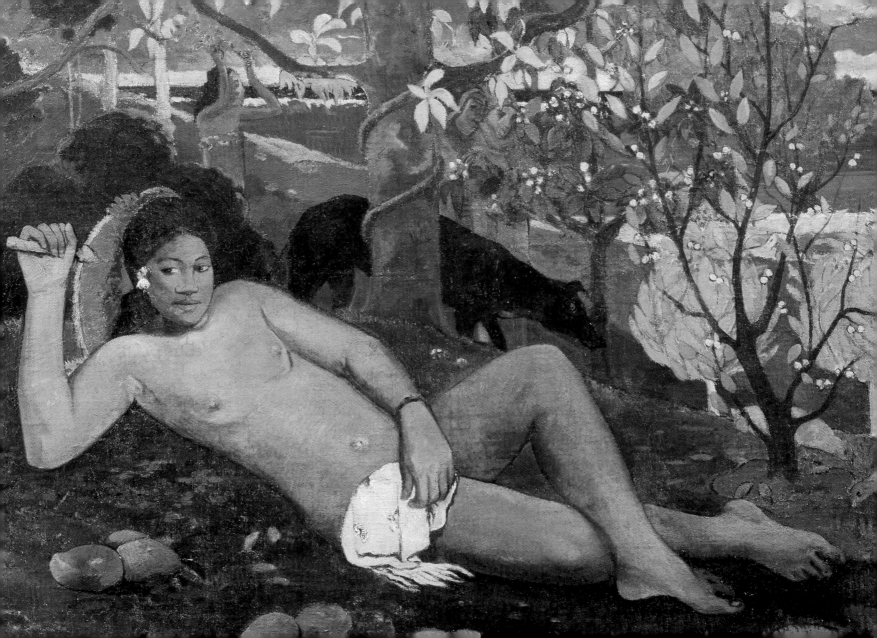

*The Louvre is the book
in which we learn to read.*

Paul Cézanne

The Rape of Europa, 1747
François Boucher
Musée du Louvre, Paris

27

1 2 3 4 5 6 7 8 9 10 11 12 13 14 15 16 17 18 19 20 21 22 23 24 25 26 **27** 28 29 30 31

July

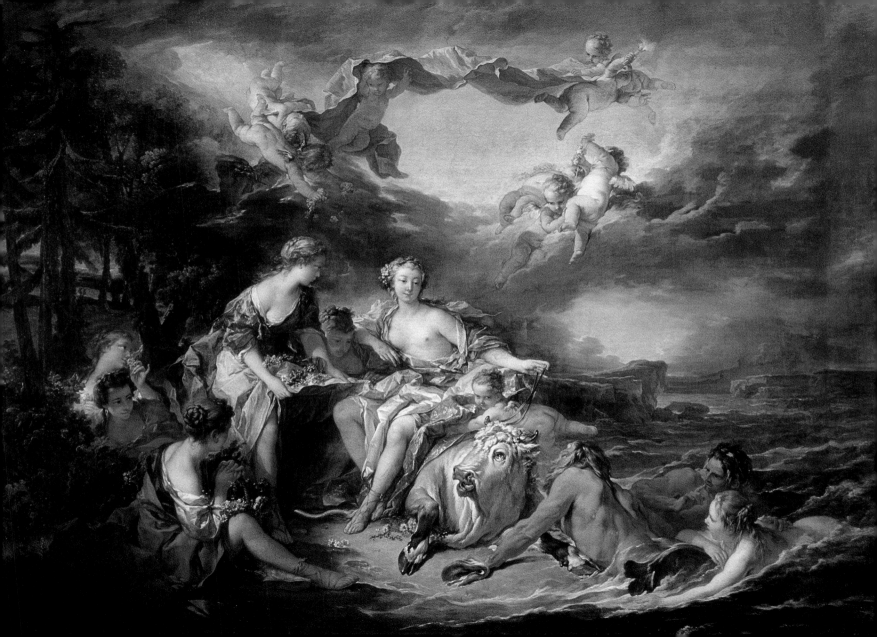

*I know not what course others
may take; but as for me,
give me liberty or give me death!*

<small>PATRICK HENRY</small>

Liberty Leading the People, 1830
Eugène Delacroix
Musée du Louvre, Paris

1 2 3 4 5 6 7 8 9 10 11 12 13 14 15 16 17 18 19 20 21 22 23 24 25 26 27 **28** 29 30 31

JULY

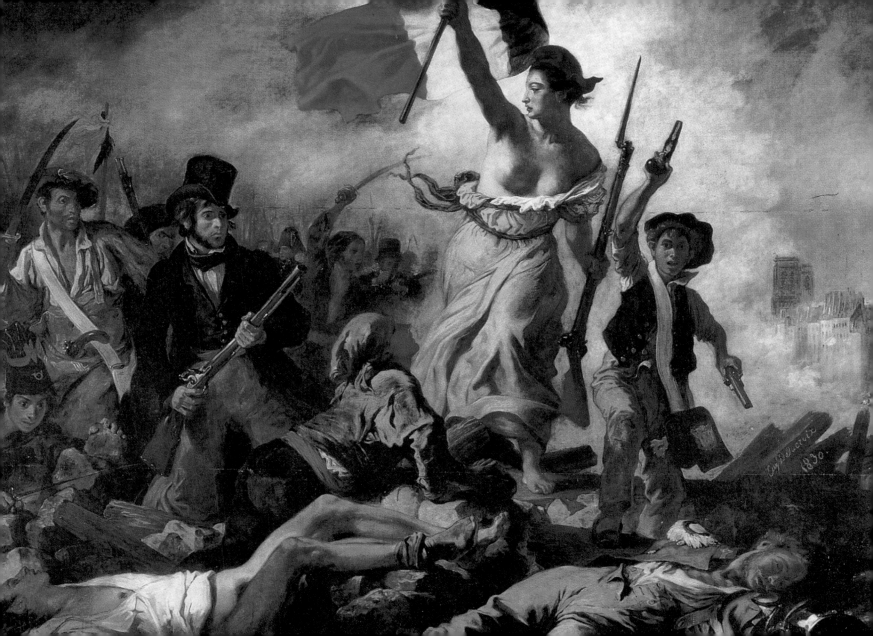

Every picture shows a spot
with which the artist
has fallen in love …

<small>ALFRED SISLEY</small>

At the Foot of the Aqueduct
in Louveciennes, 1876
Alfred Sisley
Oskar Reinhart Collection, Winterthur

1 2 3 4 5 6 7 8 9 10 11 12 13 14 15 16 17 18 19 20 21 22 23 24 25 26 27 28 **29** 30 31

JULY

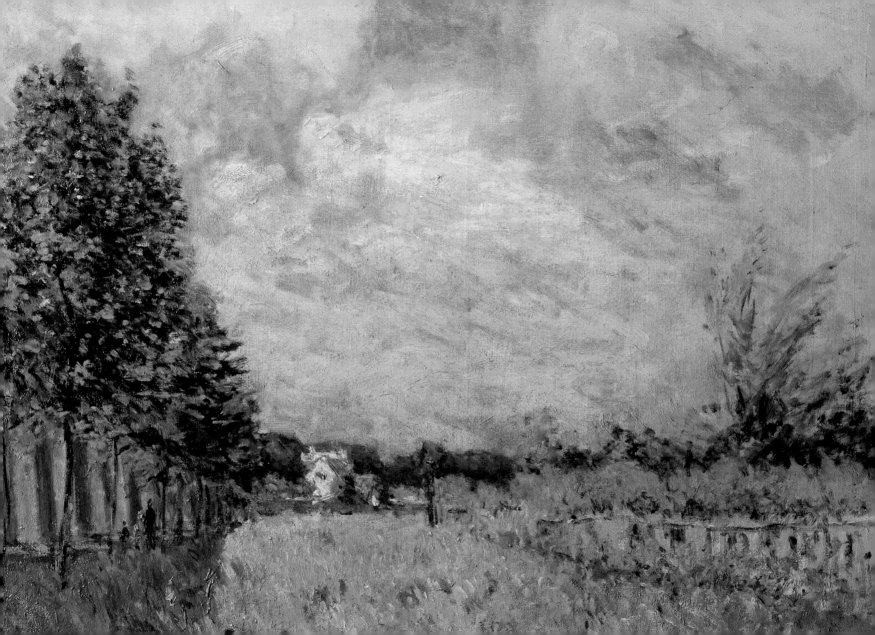

*For an Impressionist
to paint from nature
is not to paint the subject,
but to realize sensations.*

Paul Cézanne

The Bathers, 1900–06
Paul Cézanne
National Gallery, London

1 2 3 4 5 6 7 8 9 10 11 12 13 14 15 16 17 18 19 20 21 22 23 24 25 26 27 28 29 30 31

JULY

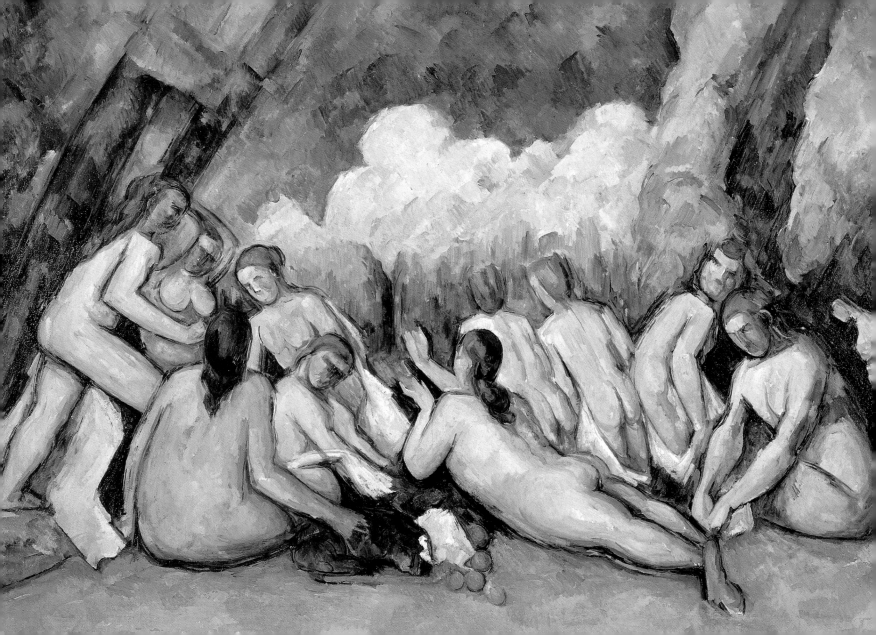

*Sir, I do not believe that I shall ever achieve
the tenderness or skill of Michelangelo or the man
from Urbino [Raphael], nor of Correggio and
Parmigianino; but the natural talent I possess,
which is no less than theirs, allows me to take
a new direction that makes me famous for
something in the same way that the others
became famous for what they did.*

TITIAN

Diana and Actaeon, 1559
Titian
On loan from the Duke of Sutherland, National Gallery of Scotland, Edinburgh

1 2 3 4 5 6 7 8 9 10 11 12 13 14 15 16 17 18 19 20 21 22 23 24 25 26 27 28 29 30 31

JULY

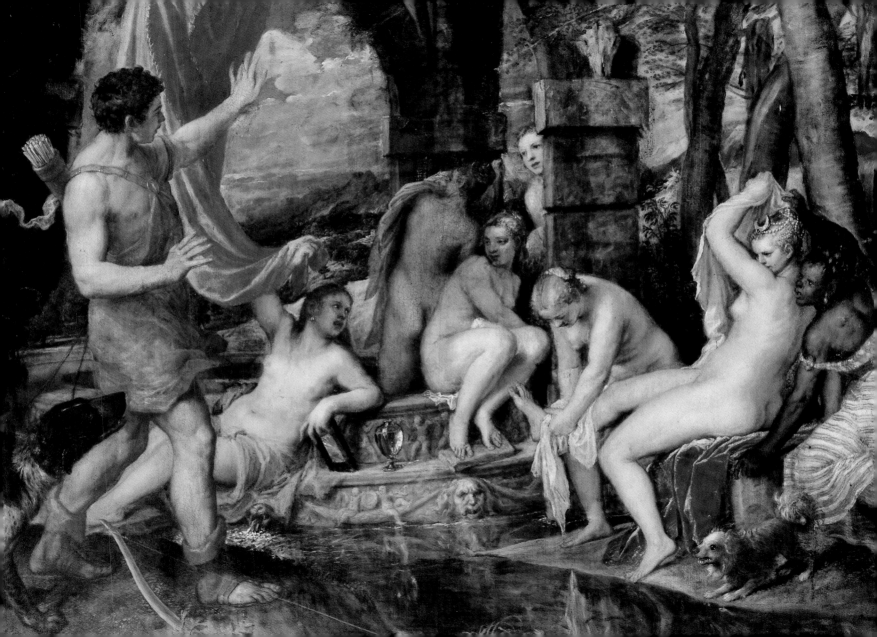

*The artist must create a spark
before he can make a fire
and before art is born,
the artist must be ready
to be consumed by the fire
of his own creation.*

Auguste Rodin

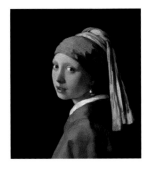

The Girl with the Pearl Earring, c. 1665
Johannes Vermeer
Mauritshuis, The Hague

1 2 3 4 5 6 7 8 9 10 11 12 13 14 15 16 17 18 19 20 21 22 23 24 25 26 27 28 29 30 31

AUGUST

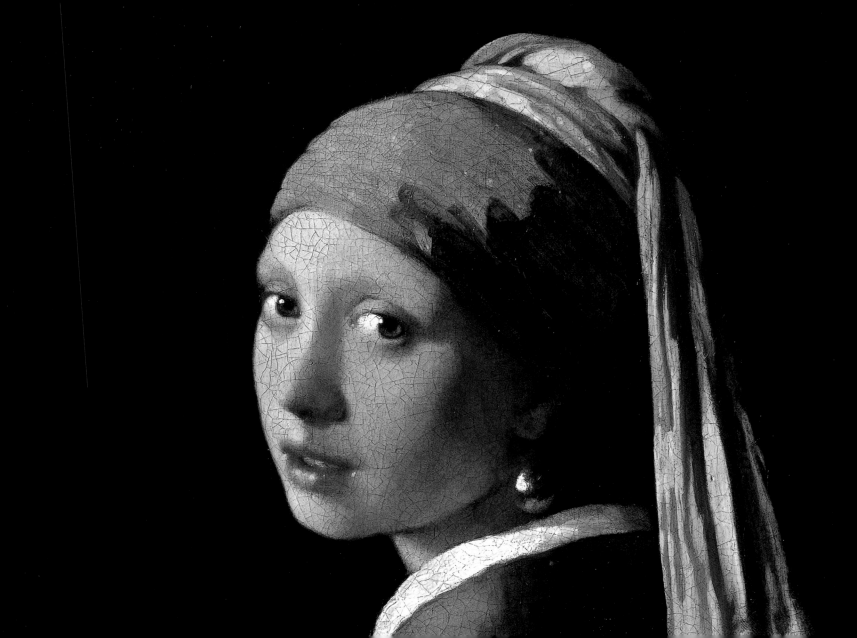

Whilst August yet wears her golden crown,
Ripening fields lush-bright with promise;
Summer waxes long, then wanes, quietly passing
Her fading green glory on to riotous Autumn.

MICHELLE L. THIEME

The Month of August, 1413–16
The Limburg Brothers
Musée Condé, Chantilly

1 2 3 4 5 6 7 8 9 10 11 12 13 14 15 16 17 18 19 20 21 22 23 24 25 26 27 28 29 30 31

AUGUST

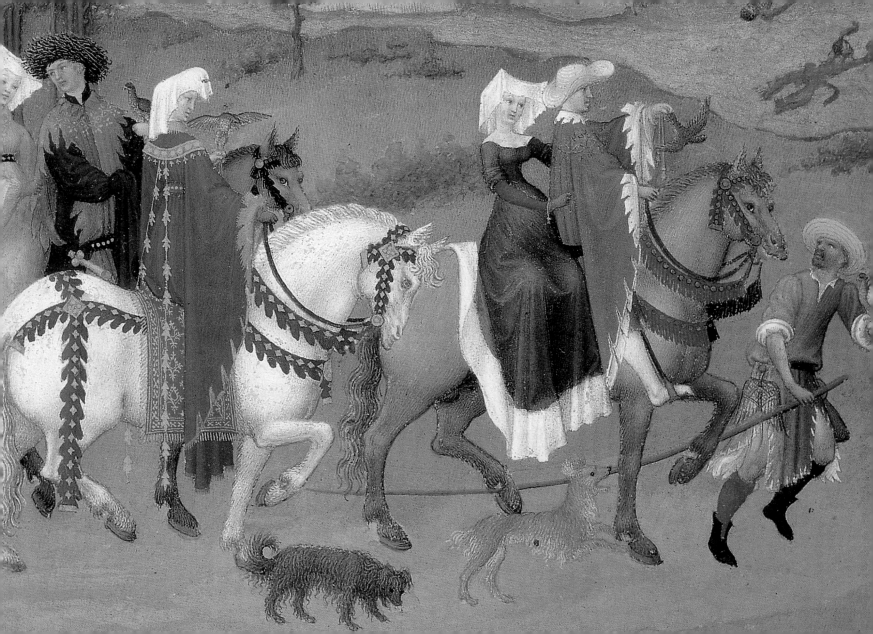

*Who loves a garden
still his Eden keeps,
Perennial pleasures plants,
and wholesome harvest reaps.*

AMOS BRONSON ALCOTT

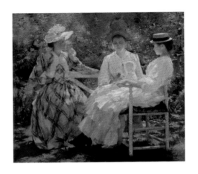

In a Garden, 1890
Edmund C. Tarbell
Milwaukee Art Museum

1 2 **3** 4 5 6 7 8 9 10 11 12 13 14 15 16 17 18 19 20 21 22 23 24 25 26 27 28 29 30 31

AUGUST

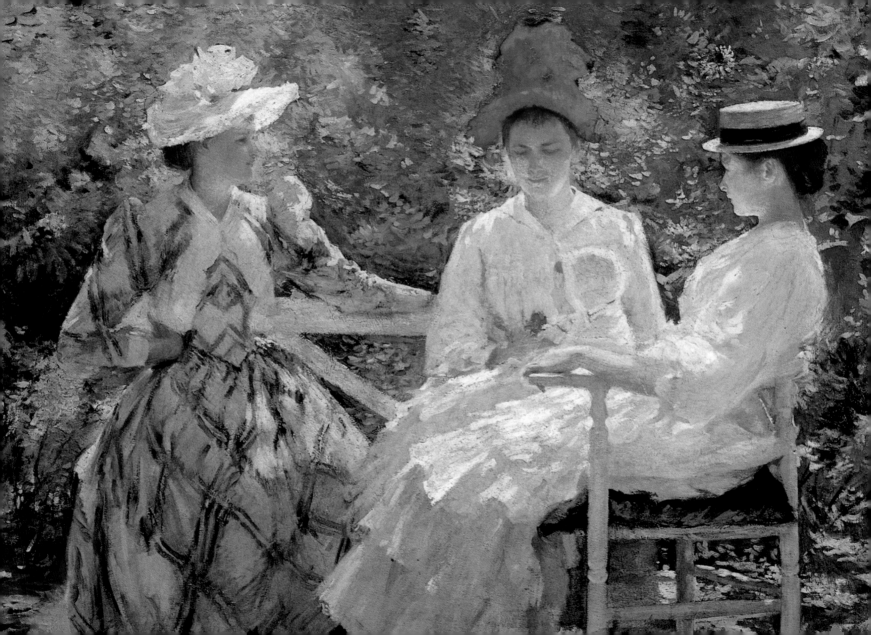

The difficult art of painting comes closer to the divine than any other, since it enables everything to be experienced that God created.

Francisco José de Goya

The Village Wedding, c. 1791
Francisco José de Goya
Museeo Nacional del Prado, Madrid

1 2 3 **4** 5 6 7 8 9 10 11 12 13 14 15 16 17 18 19 20 21 22 23 24 25 26 27 28 29 30 31

AUGUST

My garden is my most beautiful masterpiece.

Path through Monet's Garten in Giverny, 1902
Claude Monet
Kunsthistorisches Museum, Vienna

5

1 2 3 4 5 6 7 8 9 10 11 12 13 14 15 16 17 18 19 20 21 22 23 24 25 26 27 28 29 30 31

AUGUST

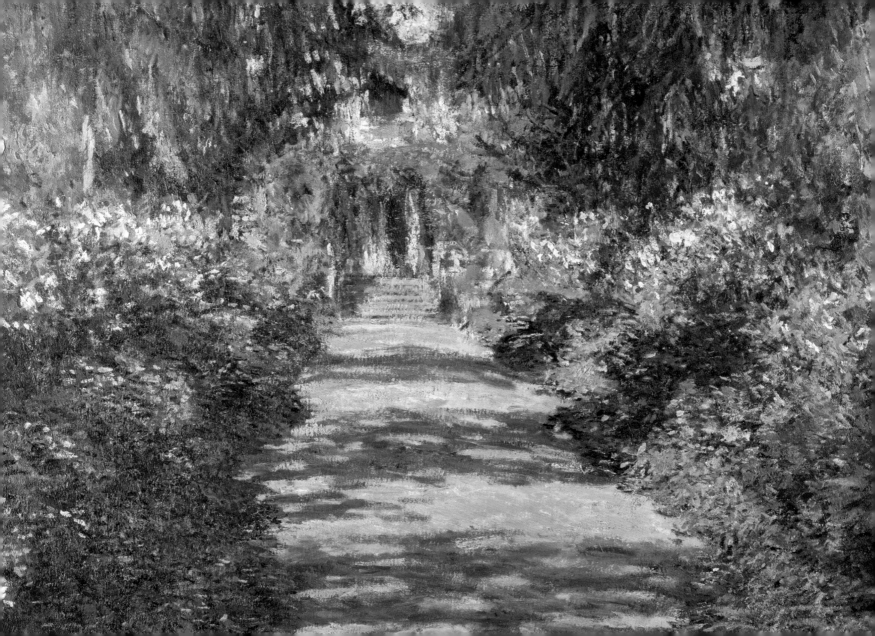

It is art that makes life, makes interest,
makes importance, and I know of no
substitute whatever for the force
and beauty of its process.

<small>HENRY JAMES</small>

Sleeping Venus, c. 1510
Giorgione
Gemäldegalerie, Dresden

1 2 3 4 5 **6** 7 8 9 10 11 12 13 14 15 16 17 18 19 20 21 22 23 24 25 26 27 28 29 30 31

AUGUST

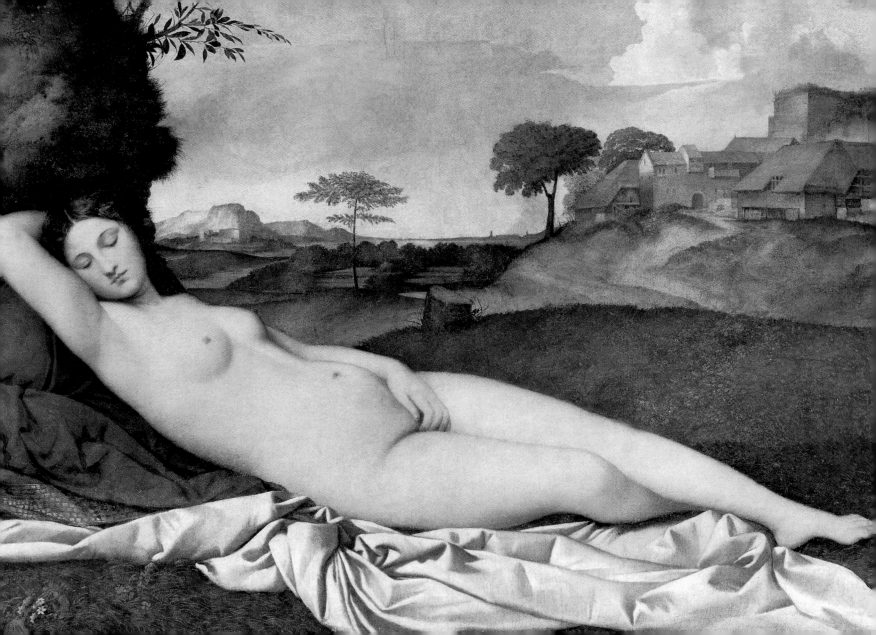

As an artist, a man has no home in Europe save in Paris.

A Sunday on La Grande Jatte, 1884–86
Georges Seurat
The Art Institute of Chicago

1 2 3 4 5 6 **7** 8 9 10 11 12 13 14 15 16 17 18 19 20 21 22 23 24 25 26 27 28 29 30 31

AUGUST

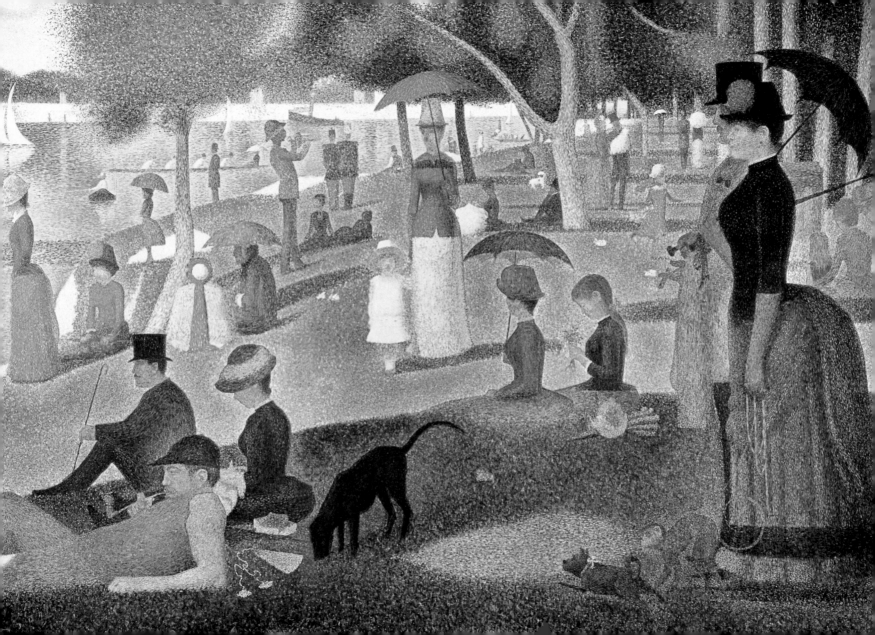

There is an eternal landscape,
a geography of the soul;
we search for its outlines
all our lives.

Josephine Hart

**Penitent Mary Magdalene
in a Landscape,** late 17th century
Claude Lorrain
Museo Nacional del Prado, Madrid

1 2 3 4 5 6 7 **8** 9 10 11 12 13 14 15 16 17 18 19 20 21 22 23 24 25 26 27 28 29 30 31

AUGUST

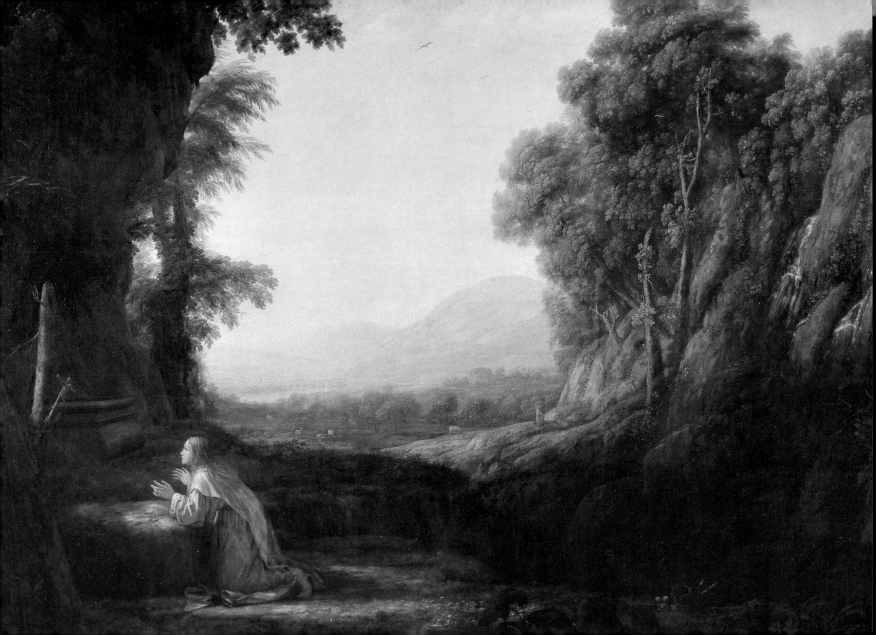

The world goes up and the world goes down,
And the sunshine follows the rain;
And yesterday's sneer and yesterday's frown
can never come over again.

CHARLES KINGSLEY

Lady with a Parasol, 1904
Karel Spillar
National Gallery, Prague

1 2 3 4 5 6 7 8 **9** 10 11 12 13 14 15 16 17 18 19 20 21 22 23 24 25 26 27 28 29 30 31

AUGUST

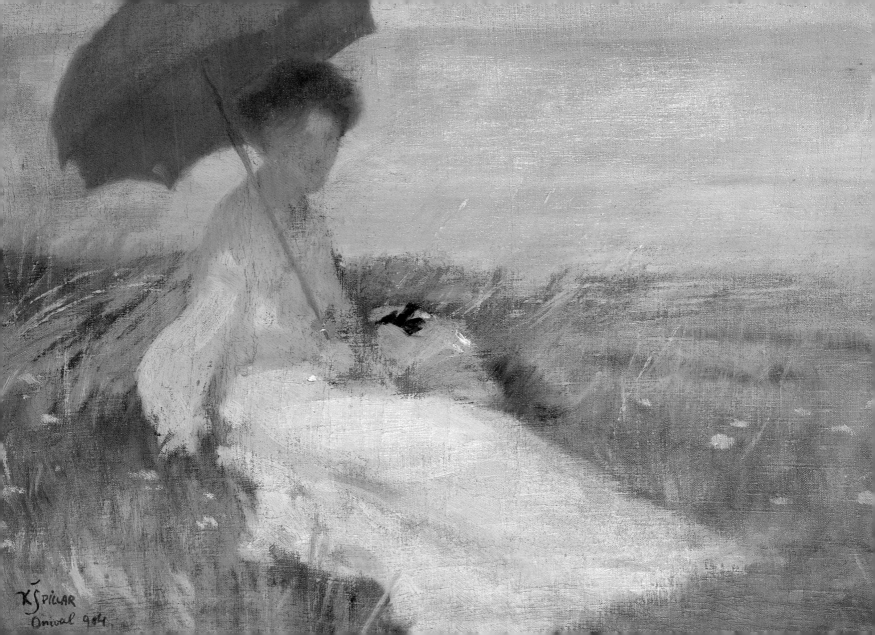

No bird soars too high
if he soars with his own wings.

WILLIAM BLAKE

Landscape with Birds, 1628
Roelant Jakobsz Savery
Kunsthistorisches Museum, Vienna

1 2 3 4 5 6 7 8 9 **10** 11 12 13 14 15 16 17 18 19 20 21 22 23 24 25 26 27 28 29 30 31

AUGUST

The dancer's body is simply the luminous manifestation of the soul.

Isadora Duncan

Dancer in a Blue Costume, *c.* 1898
Edgar Degas
The Pushkin Museum of Fine Arts, Moscow

1 2 3 4 5 6 7 8 9 10 **11** 12 13 14 15 16 17 18 19 20 21 22 23 24 25 26 27 28 29 30 31

AUGUST

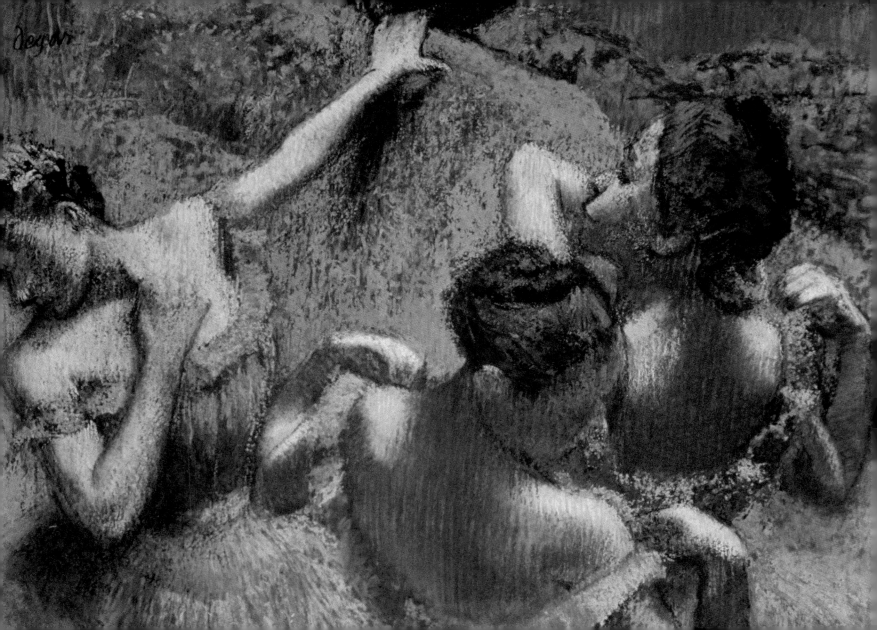

Art can never exist without naked beauty displayed.

<small>WILLIAM BLAKE</small>

Nude on the Beach at Portici, mid-19th century
Mariano Fortuny
Casón del Buen Retiro, Madrid

1 2 3 4 5 6 7 8 9 10 11 **12** 13 14 15 16 17 18 19 20 21 22 23 24 25 26 27 28 29 30 31

AUGUST

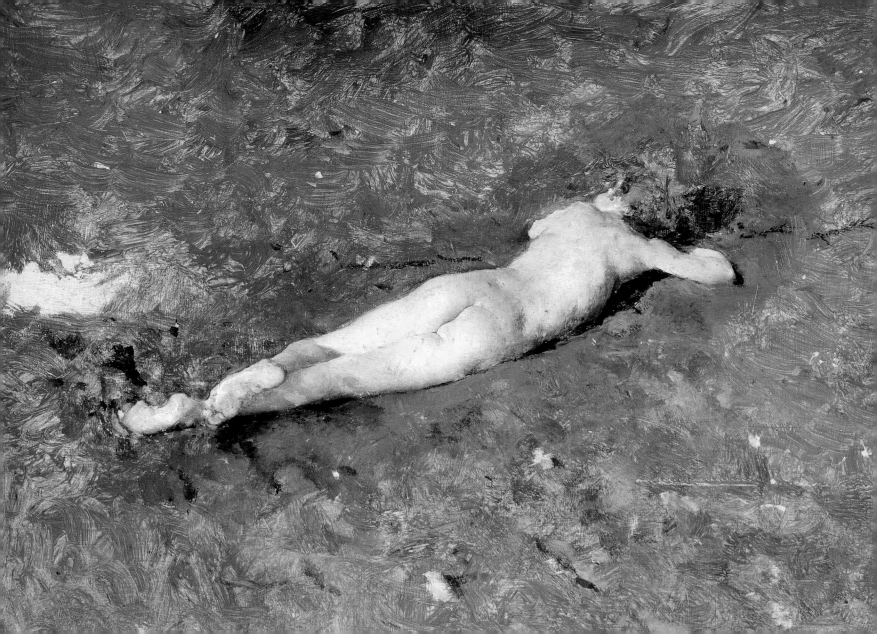

*The gods help them
that help themselves.*

Aesop

Feast of the Gods, early 17th century
Flemish
Kunsthistorisches Museum, Vienna

13

1 2 3 4 5 6 7 8 9 10 11 12 **13** 14 15 16 17 18 19 20 21 22 23 24 25 26 27 28 29 30 31

AUGUST

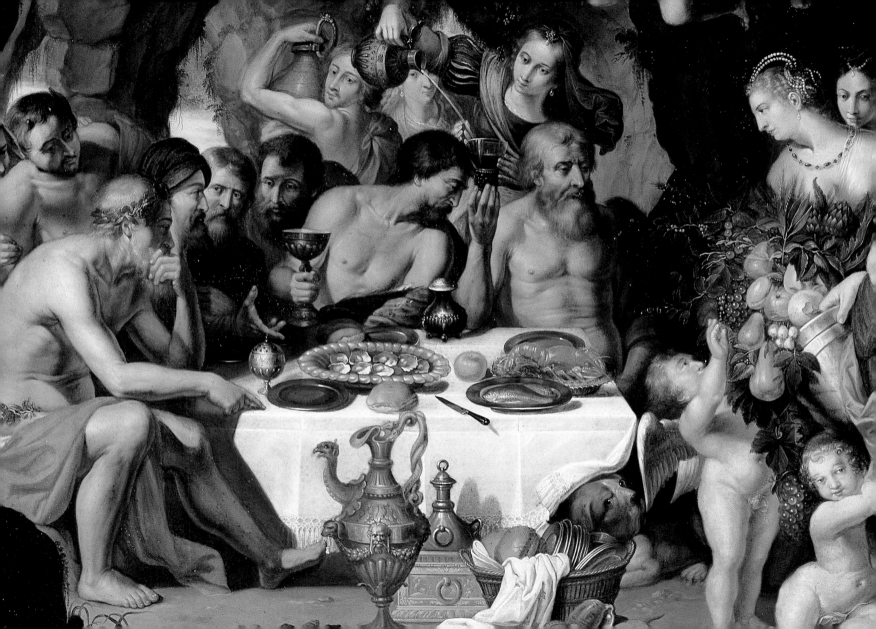

*How rich art is; if one can only
remember what one has seen,
one is never without food
for thought or truly lonely.*

VINCENT VAN GOGH

Country Road with Cypress and Star, 1890
Vincent van Gogh
Kröller-Müller Museum, Otterlo

1 2 3 4 5 6 7 8 9 10 11 12 13 **14** 15 16 17 18 19 20 21 22 23 24 25 26 27 28 29 30 31

AUGUST

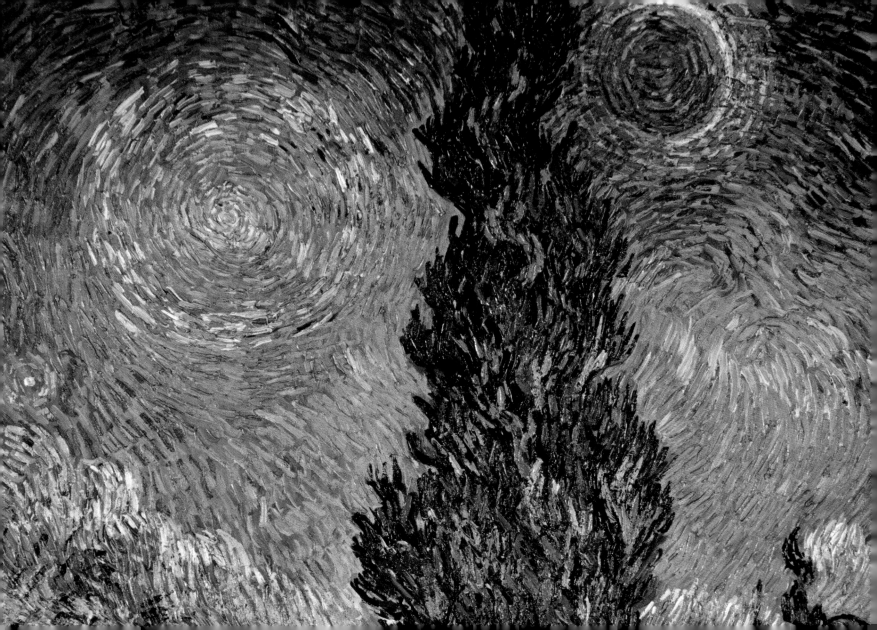

Sleep sweetly, tender heart, in peace!
Sleep, holy spirit, blessed soul,
While the stars burn, the moons increase,
And the great ages onward roll.

ALFRED LORD TENNYSON

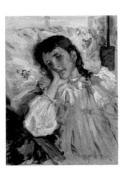

Sleepy (Portrait of the Artist's Daughter), *c.* 1894
William Merritt Chase
Jordan Volpe Gallery, New York

1 2 3 4 5 6 7 8 9 10 11 12 13 14 **15** 16 17 18 19 20 21 22 23 24 25 26 27 28 29 30 31

AUGUST

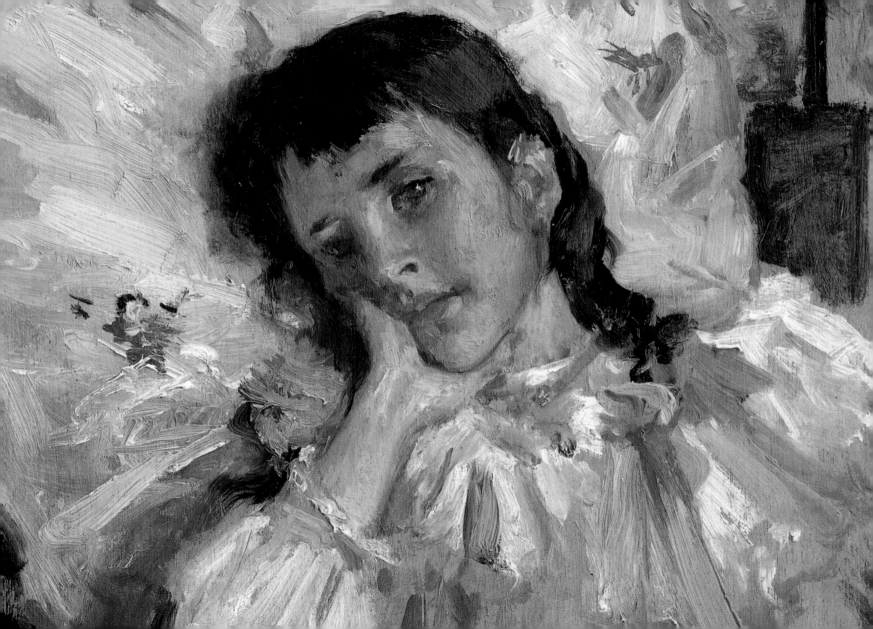

Live each season as it passes;
breathe the air, drink the drink,
taste the fruit, and resign yourself
to the influences of each.

HENRY DAVID THOREAU

Still-Life with Various Fruits, Golden Cup
and Nautilus Shell, mid-17th century
Jan Davidsz de Heem
Uffizi Gallery, Florence

1 2 3 4 5 6 7 8 9 10 11 12 13 14 15 **16** 17 18 19 20 21 22 23 24 25 26 27 28 29 30 31

AUGUST

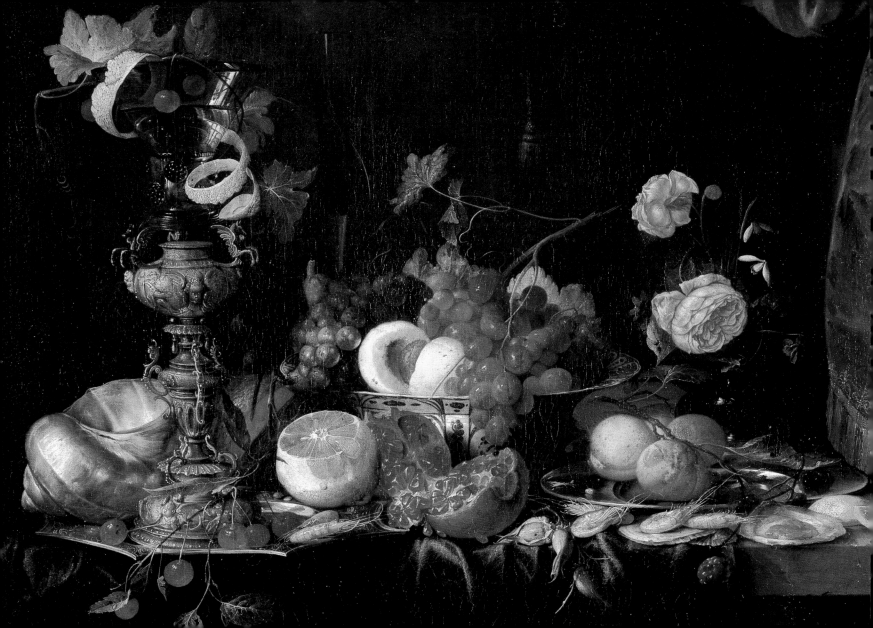

In order to do something new
we must go back to the source,
to humanity in its infancy.

PAUL GAUGUIN

Two Women from Tahiti, 1892
Paul Gauguin
Gemäldegalerie, Dresden

1 2 3 4 5 6 7 8 9 10 11 12 13 14 15 16 **17** 18 19 20 21 22 23 24 25 26 27 28 29 30 31

AUGUST

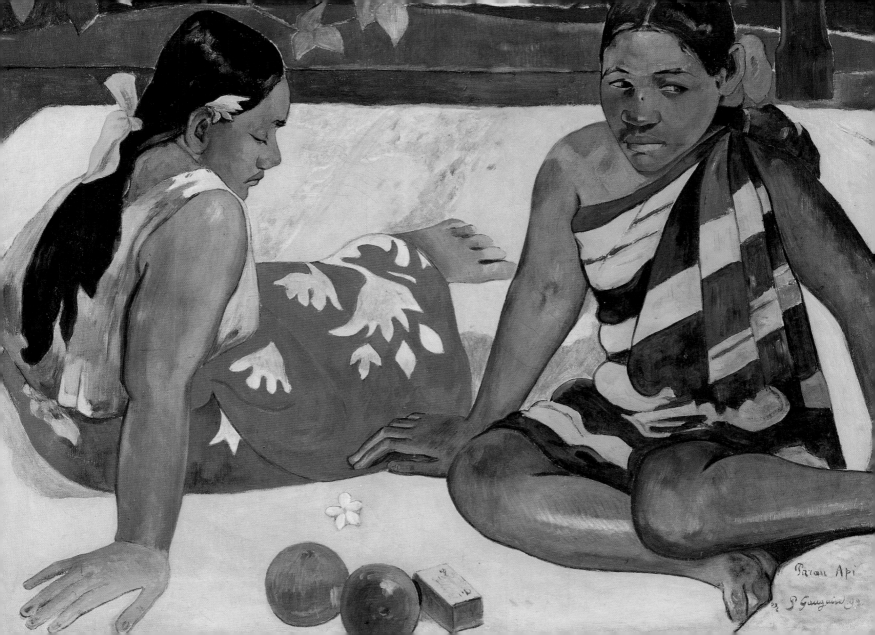

Parau Api

P Gauguin 92

Quodlibet, 1666
Samuel van Hoogstraten
Staatliche Kunsthalle, Karlsruhe

Illusion is the first of the pleasures.

VOLTAIRE

1 2 3 4 5 6 7 8 9 10 11 12 13 14 15 16 17 **18** 19 20 21 22 23 24 25 26 27 28 29 30 31

AUGUST

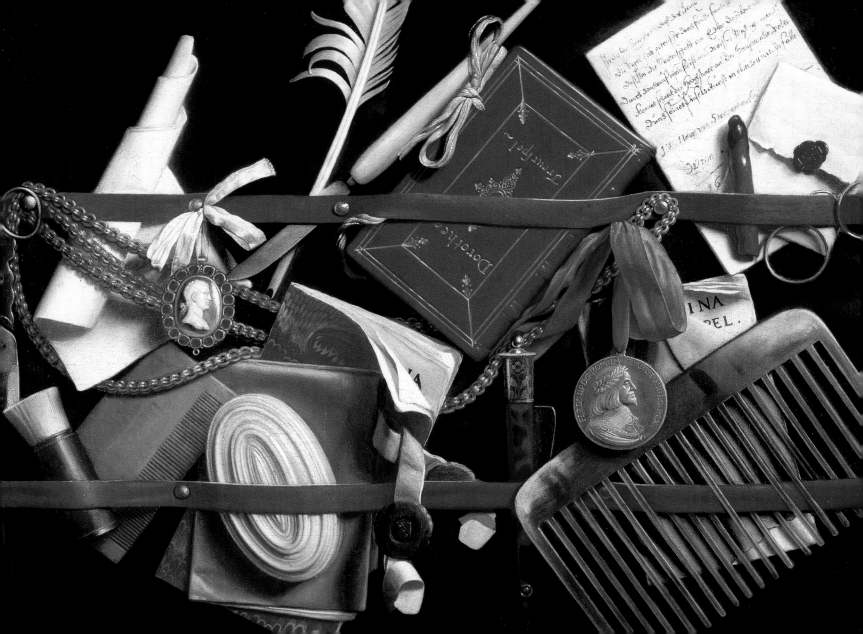

Learn diligence before speedy execution.

<small>LEONARDO DA VINCI</small>

The Floor Scrapers, 1875
Gustave Caillebotte
Musée d'Orsay, Paris

1 2 3 4 5 6 7 8 9 10 11 12 13 14 15 16 17 18 **19** 20 21 22 23 24 25 26 27 28 29 30 31

AUGUST

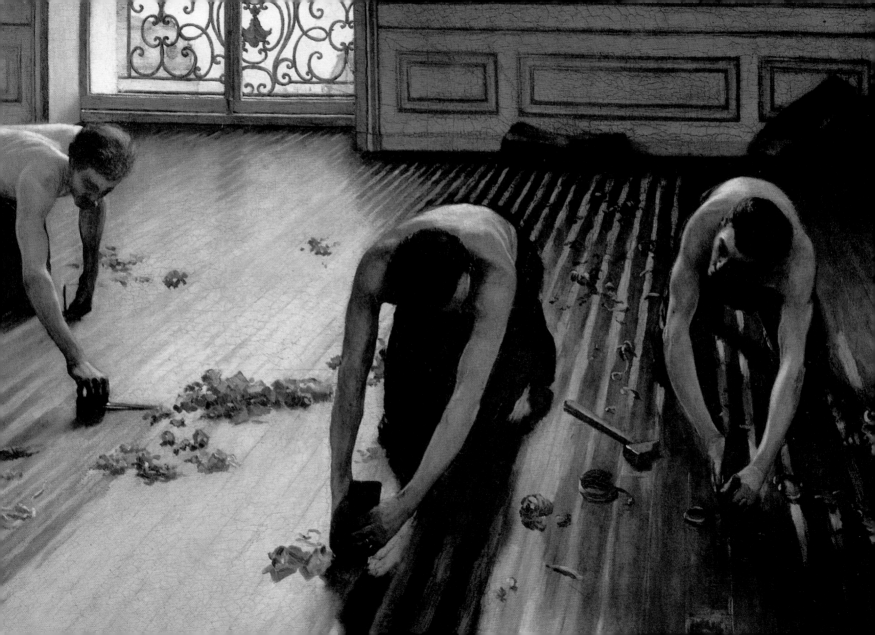

Another age shall see the golden ear
Imbrown the slope, and nod on the parterre,
Deep harvests bury all his pride has plann'd,
And laughing Ceres re-assume the land.

<small>ALEXANDER POPE</small>

Ceres and the Four Elements,
late 16th century
Jan Brueghel the Elder
Kunsthistorisches Museum, Vienna

1 2 3 4 5 6 7 8 9 10 11 12 13 14 15 16 17 18 19 **20** 21 22 23 24 25 26 27 28 29 30 31

AUGUST

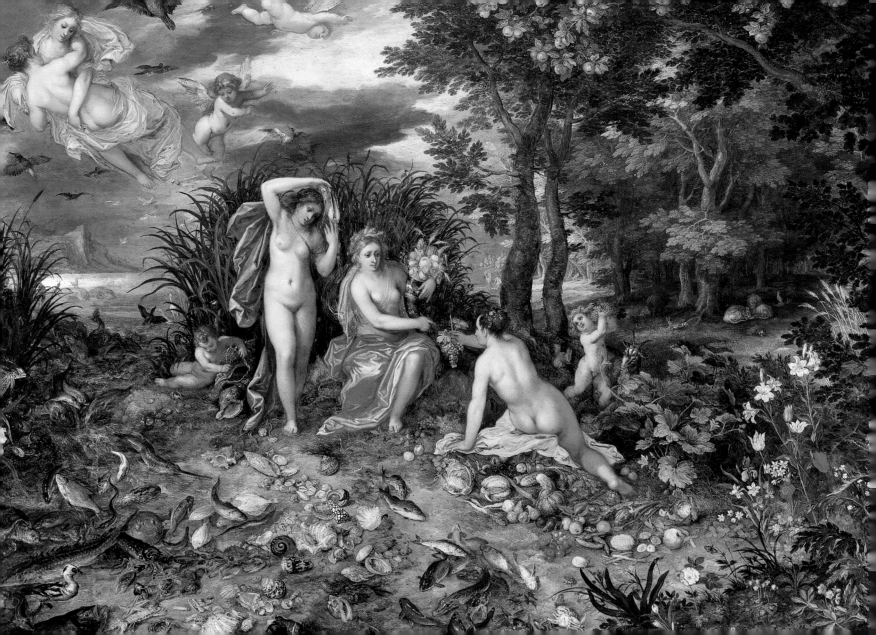

*Genius is the ability to renew
one's emotions in daily experience.*

<small>PAUL CÉZANNE</small>

Mont Saint-Victoire, 1896–98
Paul Cézanne
The State Hermitage Museum, St. Petersburg

1 2 3 4 5 6 7 8 9 10 11 12 13 14 15 16 17 18 19 20 **21** 22 23 24 25 26 27 28 29 30 31

AUGUST

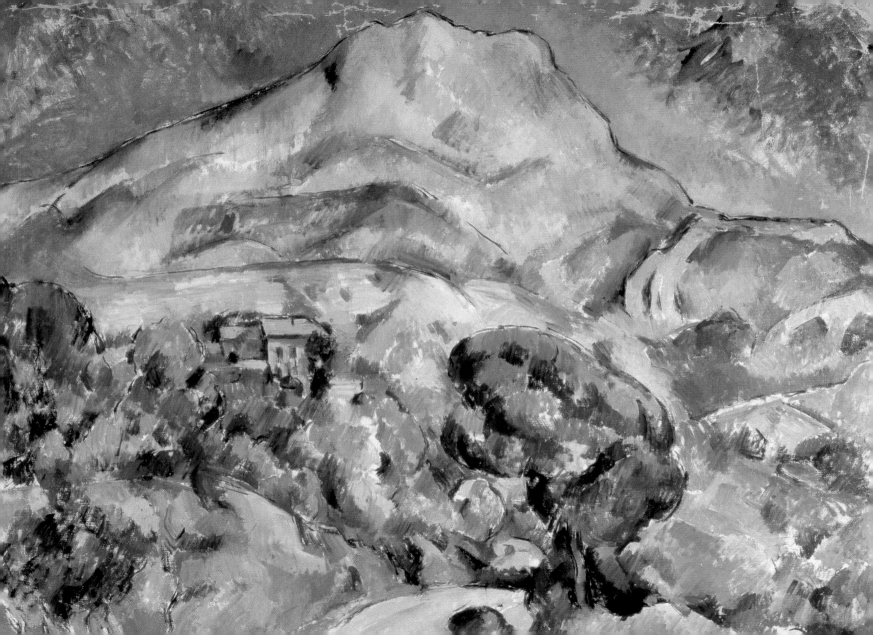

All art is an imitation of nature.

Lucius Annaeus Seneca

The Summer, 1563
Giuseppe Arcimboldo
Kunsthistorisches Museum, Vienna

1 2 3 4 5 6 7 8 9 10 11 12 13 14 15 16 17 18 19 20 21 **22** 23 24 25 26 27 28 29 30 31

AUGUST

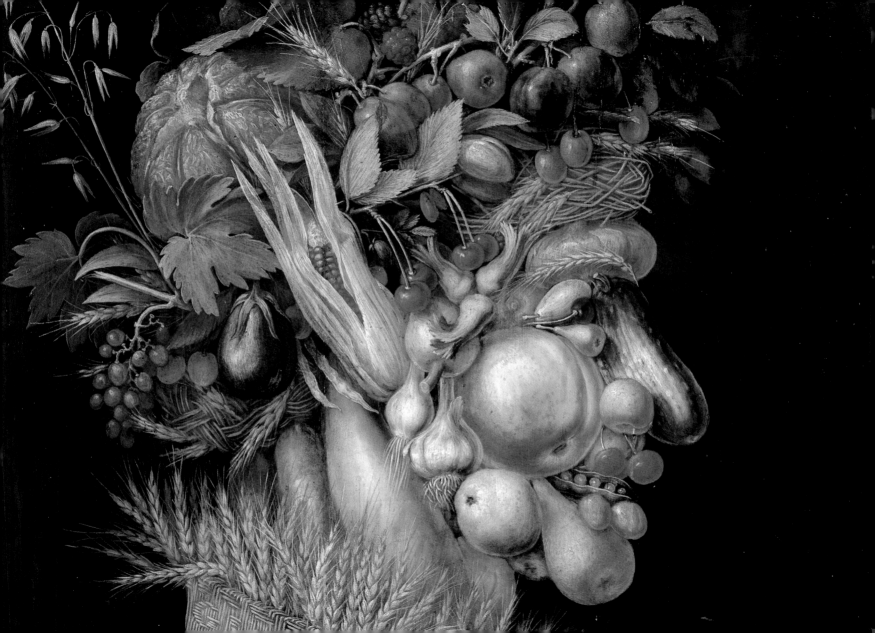

Art is unquestionably one of the purest and highest elements in human happiness. It trains the mind through the eye, and the eye through the mind. As the sun colors flowers, so does art color life.

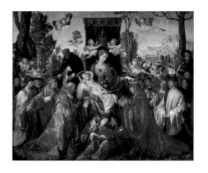

The Altarpeice of the Rose Garlands, 1506
Albrecht Dürer
National Gallery, Prague

1 2 3 4 5 6 7 8 9 10 11 12 13 14 15 16 17 18 19 20 21 22 **23** 24 25 26 27 28 29 30 31

AUGUST

Come forth into the light of things,
Let Nature be your teacher.

WILLIAM WORDSWORTH

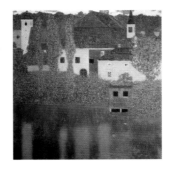

Schloss Kammer on Lake Atter, 1908
Gustav Klimt
National Gallery, Prague

1 2 3 4 5 6 7 8 9 10 11 12 13 14 15 16 17 18 19 20 21 22 23 **24** 25 26 27 28 29 30 31

AUGUST

There is nothing truer than truth. All the mistakes committed by great artists are due to their having separated themselves from truth, believing that their imagination is stronger. There is nothing stronger than nature. With nature in front of us we can do everything well.

JOAQUIN SOROLLA

Boys on the Beach, 1910
Joaquin Sorolla
Casón del Buen Retiro, Madrid

1 2 3 4 5 6 7 8 9 10 11 12 13 14 15 16 17 18 19 20 21 22 23 24 **25** 26 27 28 29 30 31

AUGUST

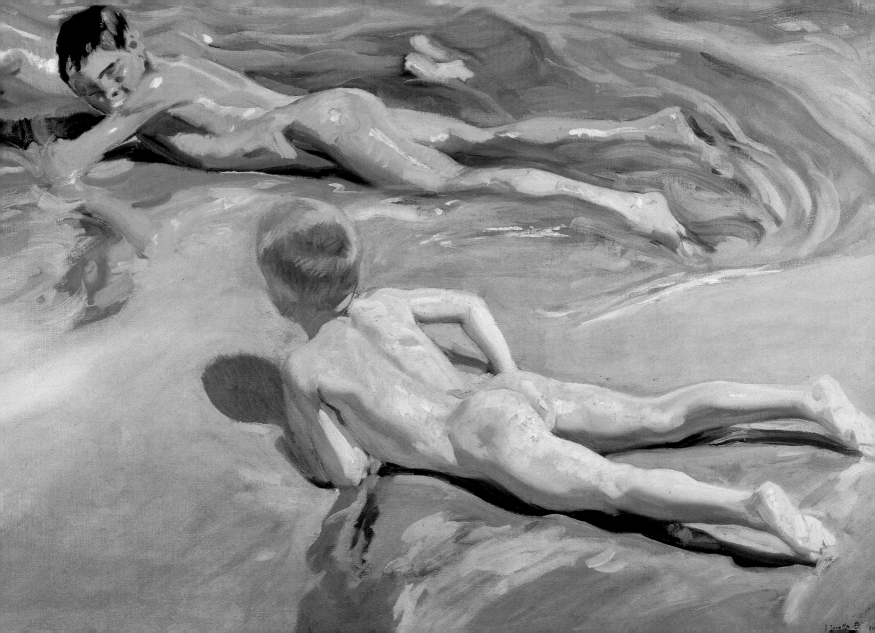

Somewhere over the rainbow,
skies are blue, and the dreams
that you dare to dream
really do come true.

L. FRANK BAUM

Landscape with Rainbow, 1632–35
Peter Paul Rubens
The State Hermitage Museum, St. Petersburg

1 2 3 4 5 6 7 8 9 10 11 12 13 14 15 16 17 18 19 20 21 22 23 24 25 **26** 27 28 29 30 31

AUGUST

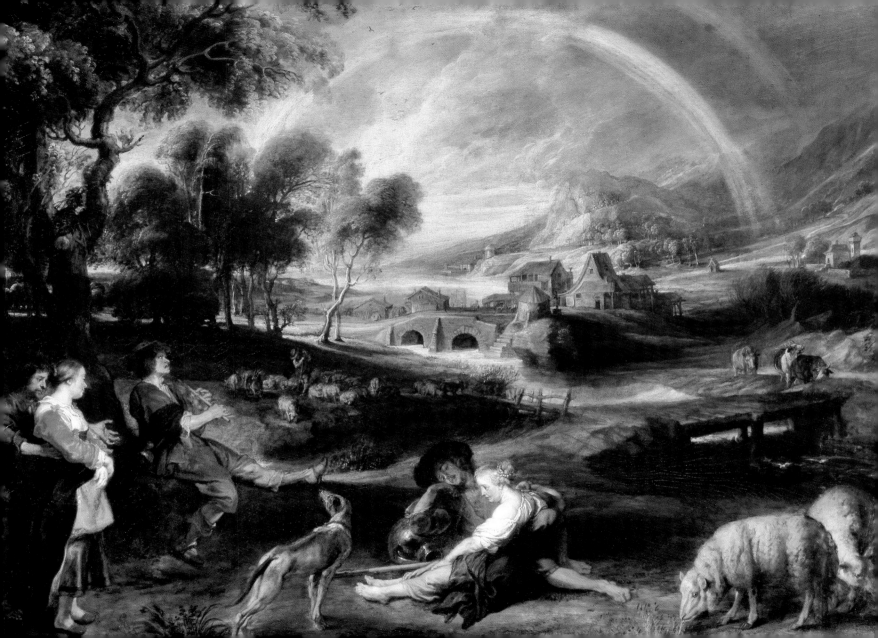

Art is not what you see,
but what you make others see.

EDGAR DEGAS

At the Races, Amateur Jockeys, 1877–78
Edgar Degas
Musée du Louvre, Paris

1 2 3 4 5 6 7 8 9 10 11 12 13 14 15 16 17 18 19 20 21 22 23 24 25 26 **27** 28 29 30 31

AUGUST

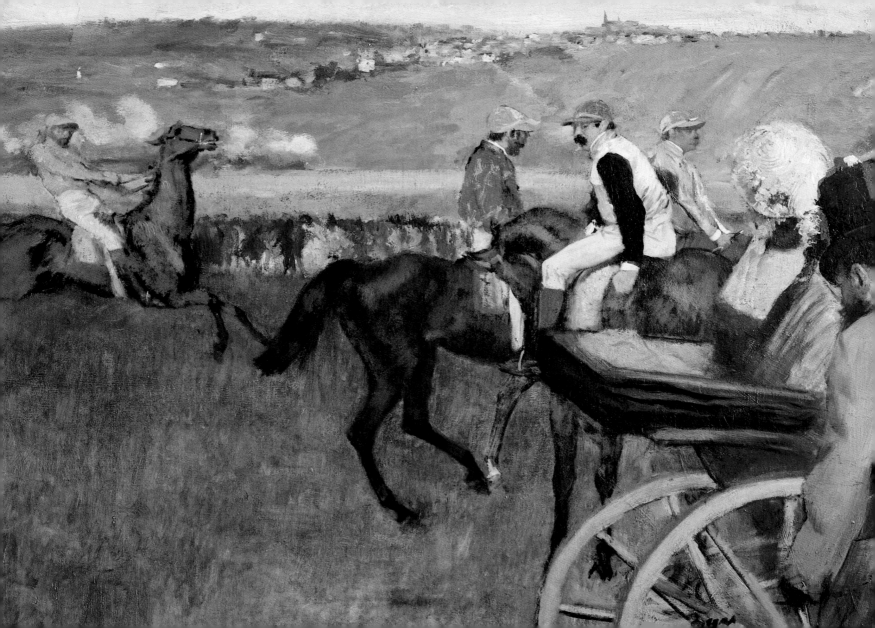

Art, to me, is the interpretation
of the impression which nature makes
upon the eye and brain.

CHILDE HASSAM

Sunset at the Ocean, 1895
Childe Hassam
Rose Art Museum, Brandeis University, Waltham
Gift of Mr. and Mrs. Monroe Geller, New York

1 2 3 4 5 6 7 8 9 10 11 12 13 14 15 16 17 18 19 20 21 22 23 24 25 26 27 **28** 29 30 31

AUGUST

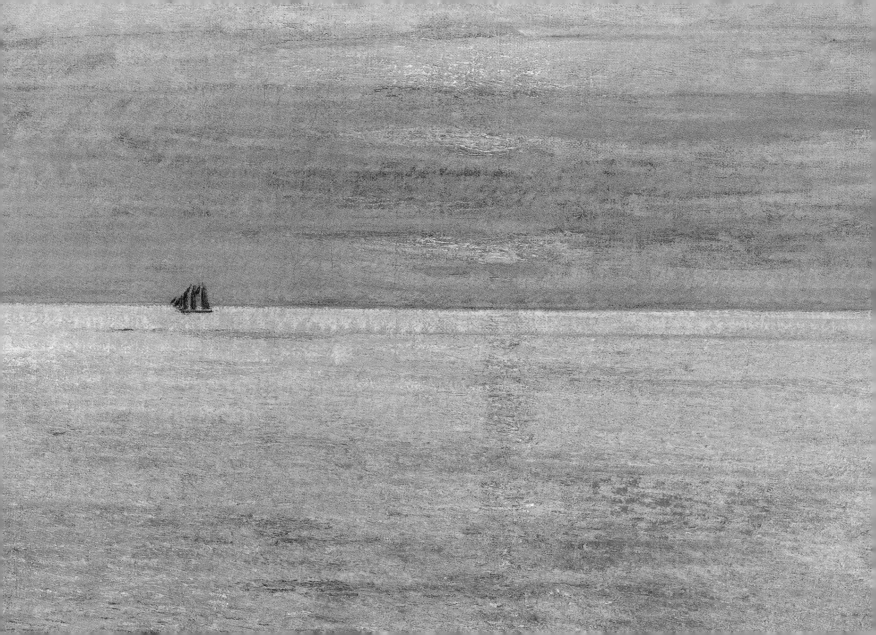

That beautiful season the Summer!
Filled was the air with a dreamy
and magical light; and the landscape
Lay as if new created in all the freshness
of childhood.

HENRY WADSWORTH LONGFELLOW

Summer Landscape, 1585
Lucas I van Valckenborch
Kunsthistorisches Museum, Vienna

1 2 3 4 5 6 7 8 9 10 11 12 13 14 15 16 17 18 19 20 21 22 23 24 25 26 27 28 **29** 30 31

AUGUST

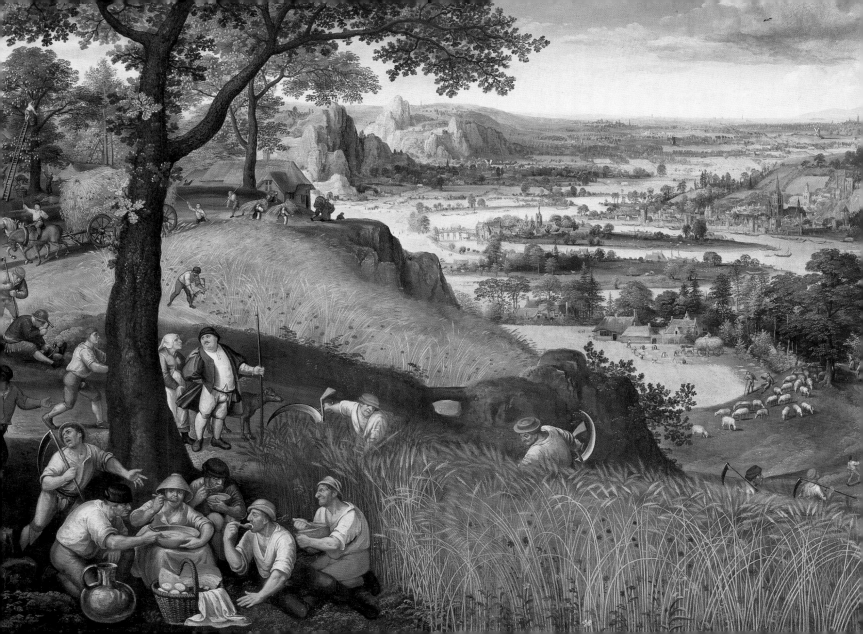

The soul becomes dyed with the color of its thoughts.

Marcus Aurelius

Cows Yellow-Red-Green, 1912
Franz Marc
Lenbachhaus, Munich

1 2 3 4 5 6 7 8 9 10 11 12 13 14 15 16 17 18 19 20 21 22 23 24 25 26 27 28 29 **30** 31

AUGUST

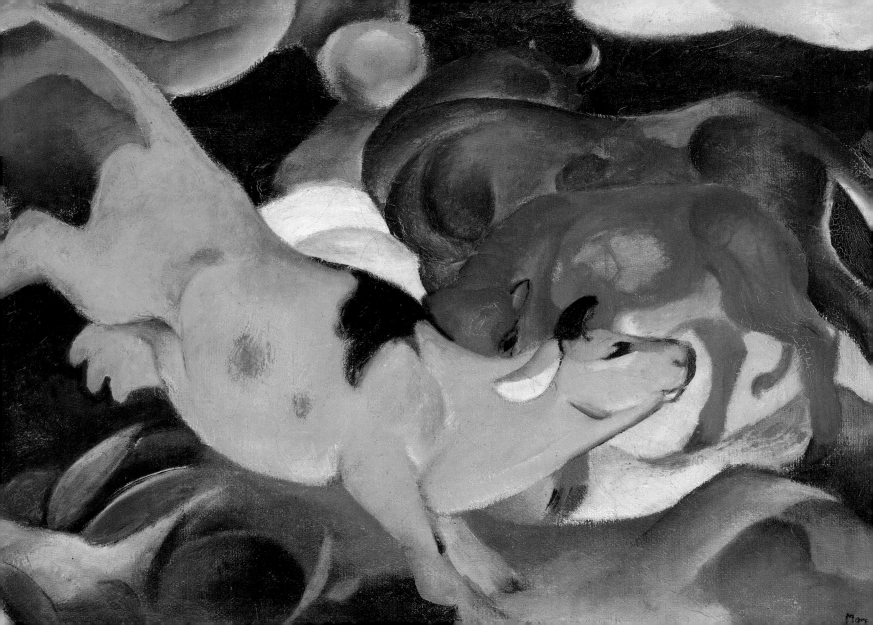

Climb the mountains and get their good tidings.
Nature's peace will flow into you as sunshine
flows into trees. The winds will blow their own
freshness into you while cares will drop off
like autumn leaves.

JOHN MUIR

Mountain Landscape
with Lumberjacks, 1601
Roelant Jakobsz Savery
Kunsthistorisches Museum, Vienna

1 2 3 4 5 6 7 8 9 10 11 12 13 14 15 16 17 18 19 20 21 22 23 24 25 26 27 28 29 30 **31**

AUGUST

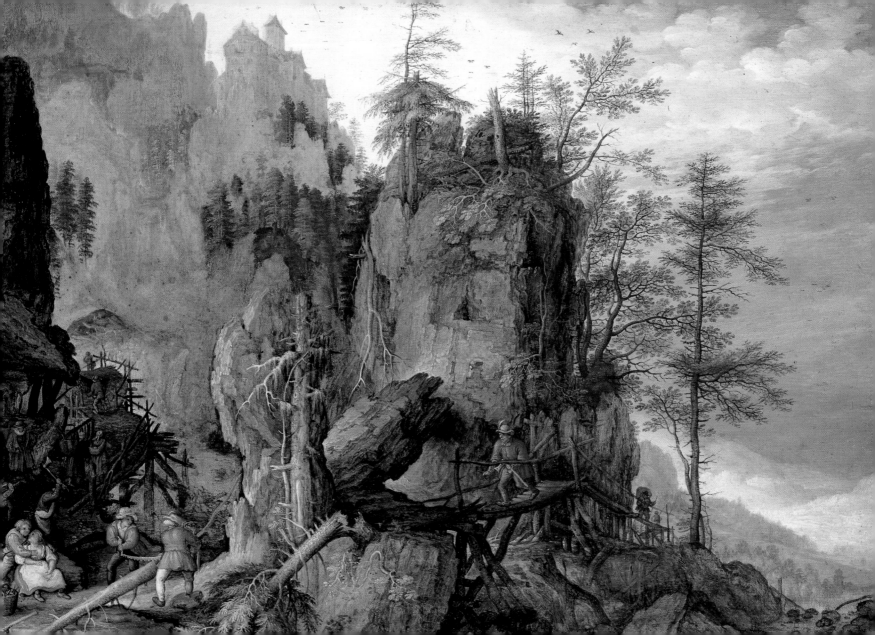

Tiger, tiger, burning bright
In the forests of the night,
What immortal hand or eye
Dare frame thy fearful symmetry?

WILLIAM BLAKE

Combat of a Tiger and a Buffalo, 1908
Henri Rousseau
The State Hermitage Museum, St. Petersburg

1 2 3 4 5 6 7 8 9 10 11 12 13 14 15 16 17 18 19 20 21 22 23 24 25 26 27 28 29 30

SEPTEMBER

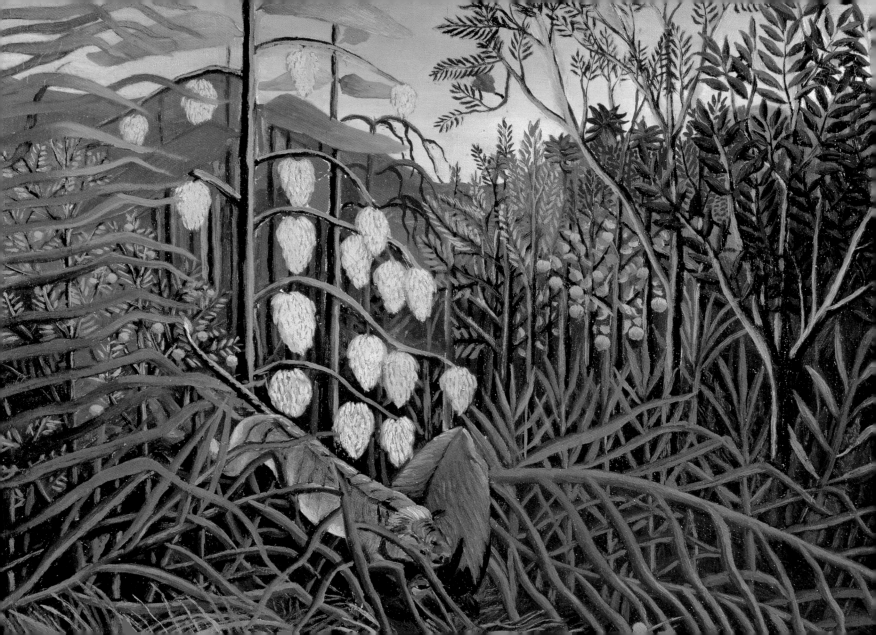

The sail, the play of its pulse so like our own lives: so thin and yet so full of life, so noiseless when it labors hardest, so noisy and impatient when least effective.

HENRY DAVID THOREAU

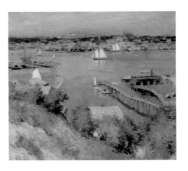

Gloucester Harbor, 1895
Willard Metcalf
Amherst College, Mead Art Museum, Gift of George D. Pratt

1 2 3 4 5 6 7 8 9 10 11 12 13 14 15 16 17 18 19 20 21 22 23 24 25 26 27 28 29 30

SEPTEMBER

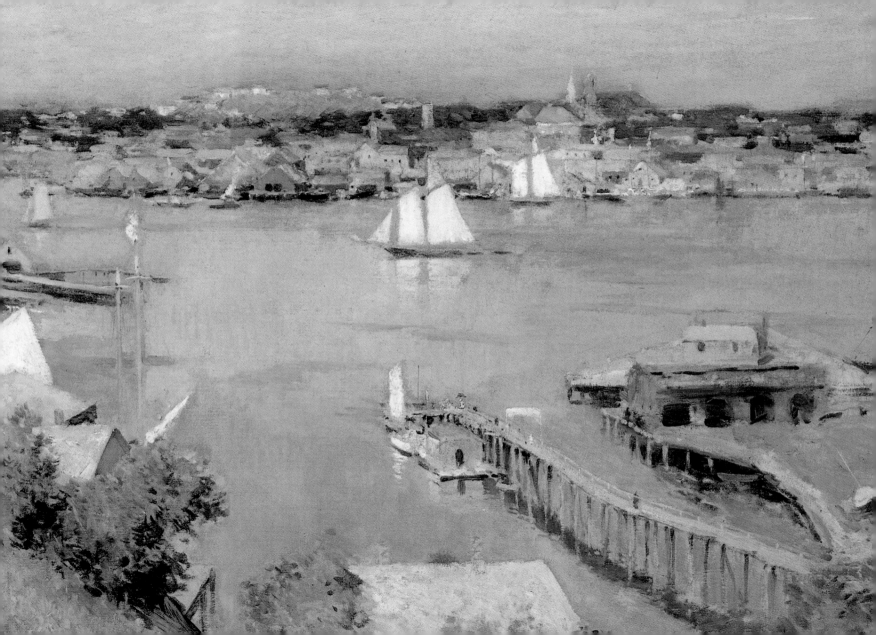

Only those who look with the eyes of children can lose themselves in the object of their wonder.

Eberhard Arnold

Young Girl in a Window, early 19th century
Ferdinand Georg Waldmüller
Georg Schäfer Collection

1 2 **3** 4 5 6 7 8 9 10 11 12 13 14 15 16 17 18 19 20 21 22 23 24 25 26 27 28 29 30

SEPTEMBER

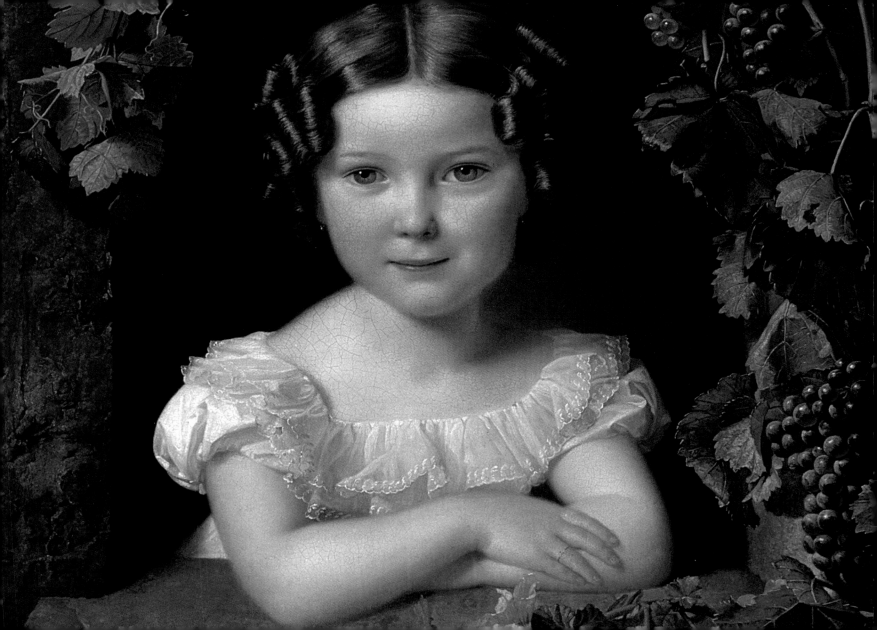

The real voyage of discovery consists not in seeking new landscapes but in having new eyes.

Marcel Proust

The Retrieval of Moses, 1738–40
Giovanni Battista Tiepolo
National Gallery of Scotland, Edinburgh

1 2 3 **4** 5 6 7 8 9 10 11 12 13 14 15 16 17 18 19 20 21 22 23 24 25 26 27 28 29 30

SEPTEMBER

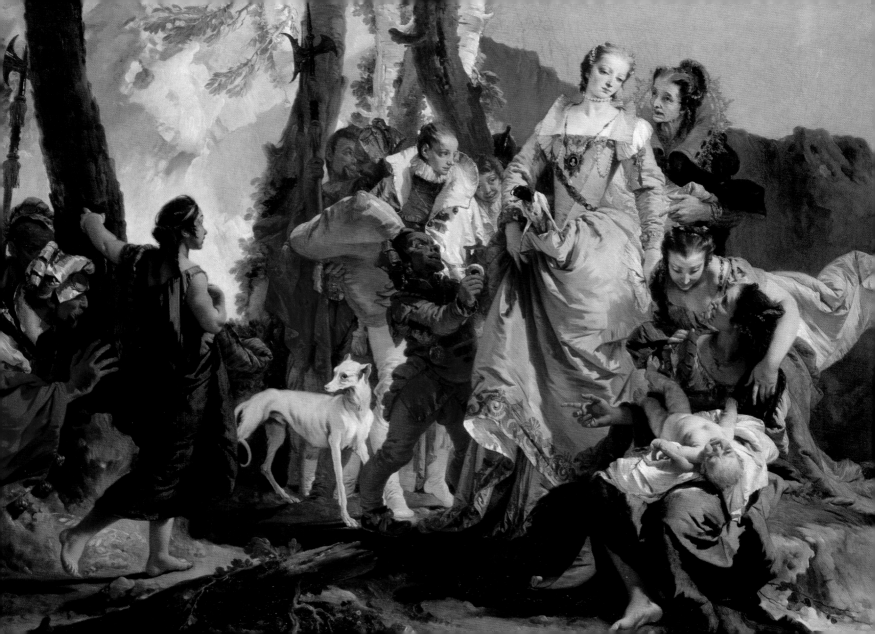

Of all the arts, abstract painting is the most difficult. It demands that you know how to draw well, that you have a heightened sensitivity for composition and for colors, and that you be a true poet. This last part is essential.

WASSILY KANDINSKY

Gorge Improvisation, 1914
Wassily Kandinsky
Lenbachhaus, Munich

5

1 2 3 4 **5** 6 7 8 9 10 11 12 13 14 15 16 17 18 19 20 21 22 23 24 25 26 27 28 29 30

SEPTEMBER

The good physician treats the disease;
the great physician treats the patient
who has the disease.

<small>WILLIAM OSLER</small>

The Doctor, 1780
Francisco José de Goya
National Gallery of Scotland, Edinburgh

1 2 3 4 5 **6** 7 8 9 10 11 12 13 14 15 16 17 18 19 20 21 22 23 24 25 26 27 28 29 30

SEPTEMBER

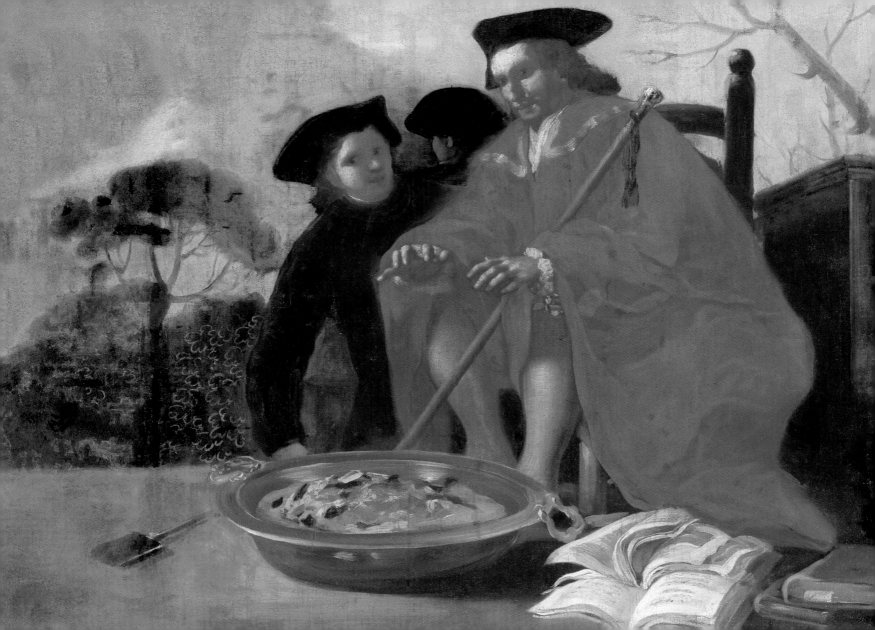

Water is the driving force of all nature.

Leonardo Da Vinci

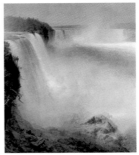

Niagara Falls, from the American Side, 1867
Frederic Edwin Church
National Gallery of Scotland, Edinburgh

1 2 3 4 5 6 **7** 8 9 10 11 12 13 14 15 16 17 18 19 20 21 22 23 24 25 26 27 28 29 30

SEPTEMBER

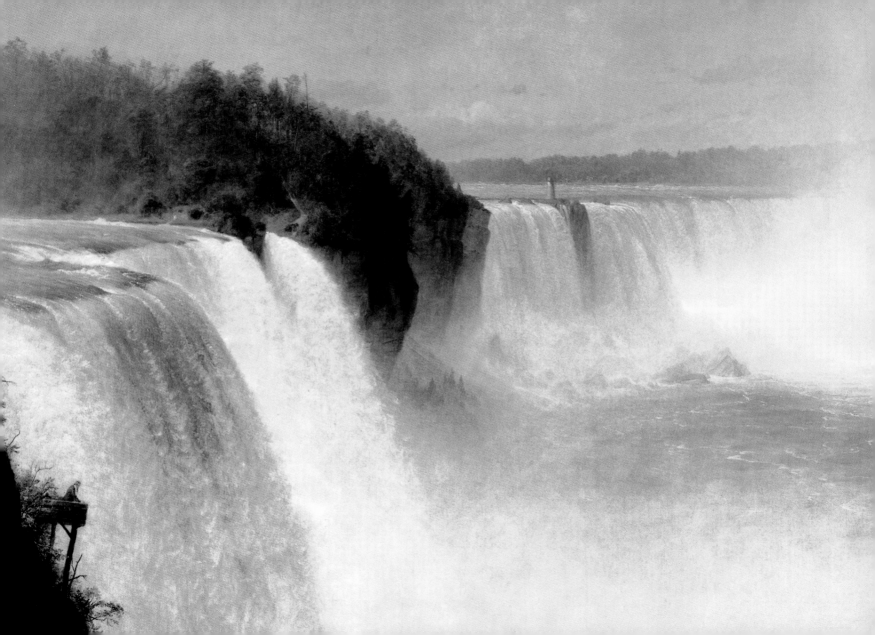

*The mind loves the unknown.
It loves images whose meaning
is unknown, since the meaning
of the mind itself is unknown.*

Rene Magritte

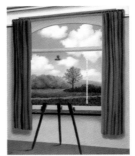

The Human Condition, 1934
René Magritte
National Gallery of Art, Washington D.C.
Gift of the Collector's Committee

1 2 3 4 5 6 7 **8** 9 10 11 12 13 14 15 16 17 18 19 20 21 22 23 24 25 26 27 28 29 30

SEPTEMBER

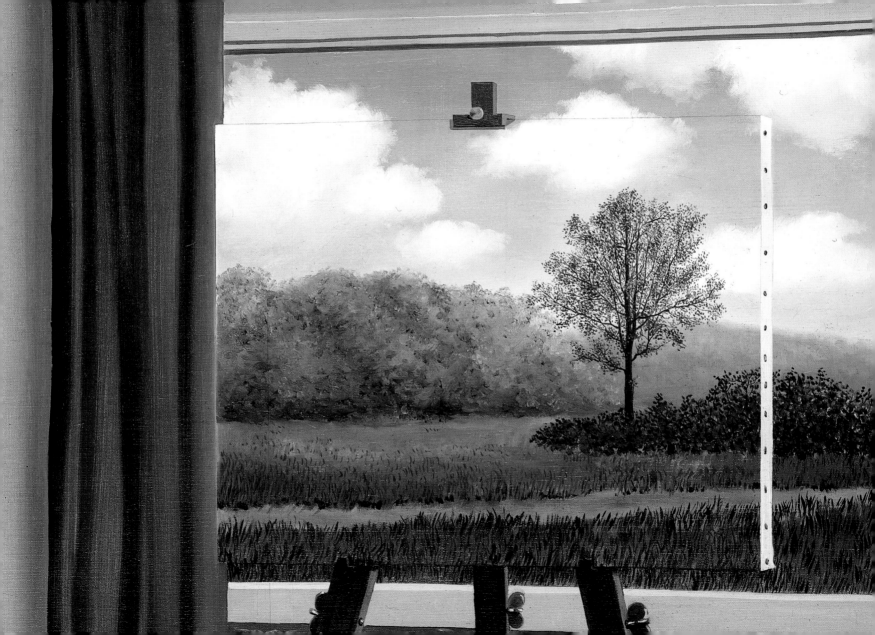

Absence of occupation is not rest;
a mind quite vacant is a mind distressed.

WILLIAM COWPER

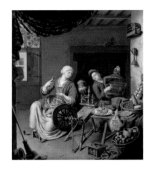

A Tradeswoman, 1734
Willem van Mieris
Residenzgalerie, Salzburg

1 2 3 4 5 6 7 8 **9** 10 11 12 13 14 15 16 17 18 19 20 21 22 23 24 25 26 27 28 29 30

SEPTEMBER

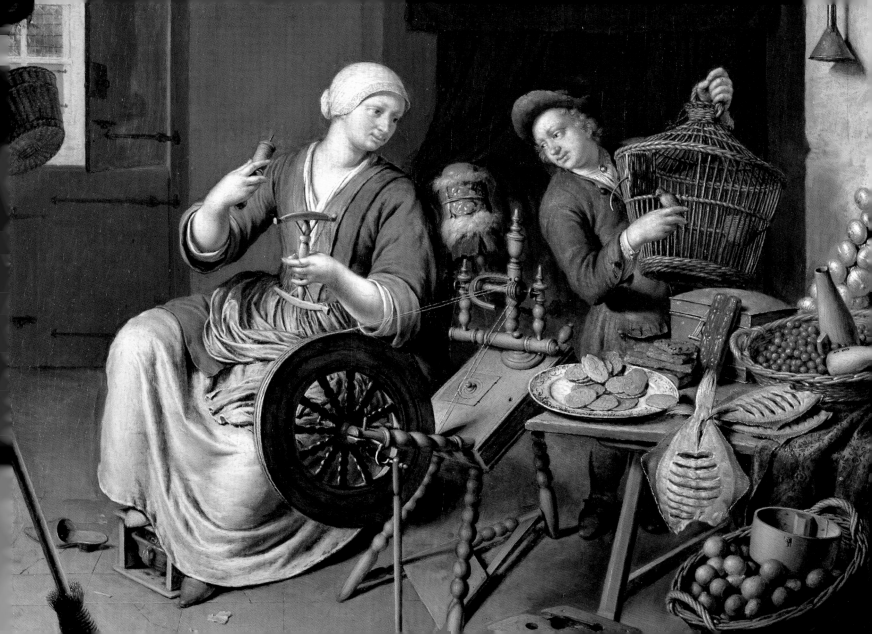

*More grows in the garden
than the gardener sows.*

In the Vegetable Garden, 1881
Camille Pissarro
National Gallery, Prague

1 2 3 4 5 6 7 8 9 **10** 11 12 13 14 15 16 17 18 19 20 21 22 23 24 25 26 27 28 29 30

SEPTEMBER

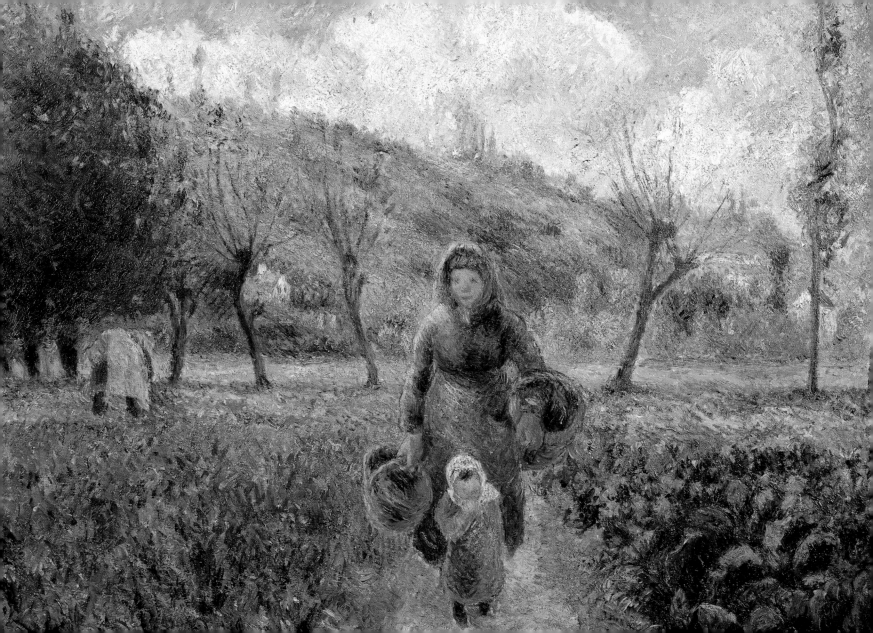

I think that if you shake the tree,
you ought to be around when the fruit
falls to pick it up.

<small>MARY CASSATT</small>

Fruit Bowl with Apples and Pears,
17th century
Maestro della Fruttiera Lombarda
Silvano Lodi Collection, Campione d.I.

1 2 3 4 5 6 7 8 9 10 **11** 12 13 14 15 16 17 18 19 20 21 22 23 24 25 26 27 28 29 30

SEPTEMBER

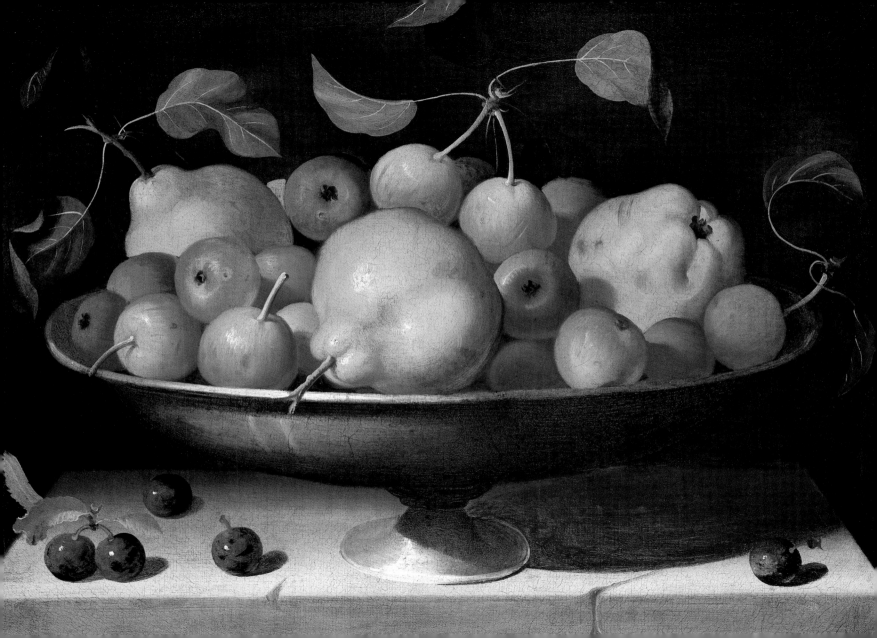

*Don't judge each day
by the harvest you reap
but by the seeds that you plant.*

<small>ROBERT LOUIS STEVENSON</small>

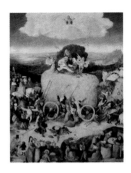

The Hay Wagon (center panel), c. 1500
Hieronymus Bosch
Museo Nacional del Prado, Madrid

1 2 3 4 5 6 7 8 9 10 11 **12** 13 14 15 16 17 18 19 20 21 22 23 24 25 26 27 28 29 30

SEPTEMBER

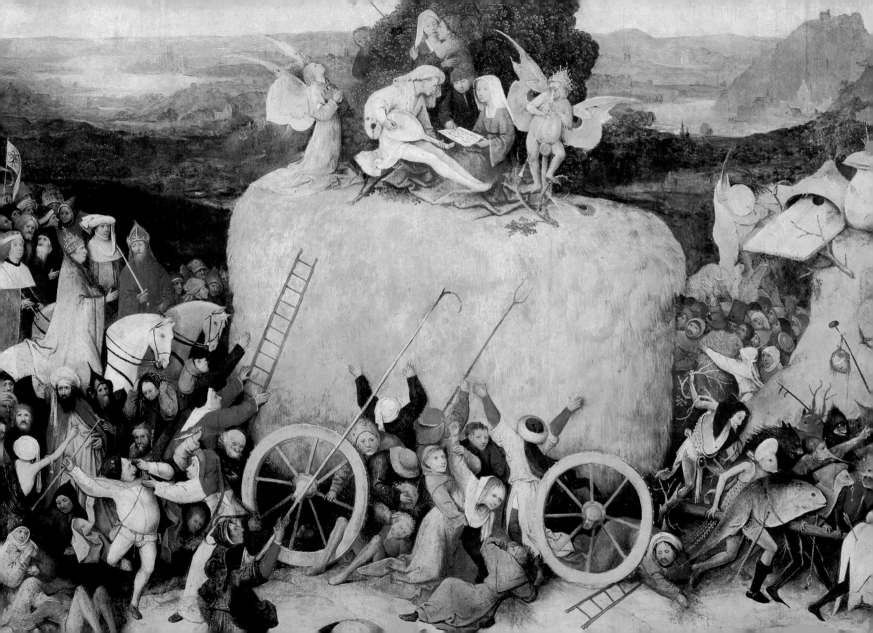

What moves those of genius,
what inspires their work is not
new ideas, but their obsession with
the idea that what has already been
said is still not enough.

EUGÈNE DELACROIX

Abduction of the Turks, *c.* 1852
Eugène Delacroix
Kunsthalle, Mannheim

1 2 3 4 5 6 7 8 9 10 11 12 **13** 14 15 16 17 18 19 20 21 22 23 24 25 26 27 28 29 30

SEPTEMBER

The painter should paint not only what he has in front of him, but also what he sees inside himself. If he sees nothing within, then he should stop painting what is in front of him.

CASPAR DAVID FRIEDRICH

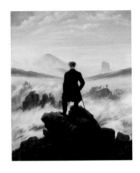

Wanderer Above the Sea of Fog, c. 1818
Caspar David Friedrich
Kunsthalle, Hamburg

1 2 3 4 5 6 7 8 9 10 11 12 13 **14** 15 16 17 18 19 20 21 22 23 24 25 26 27 28 29 30

SEPTEMBER

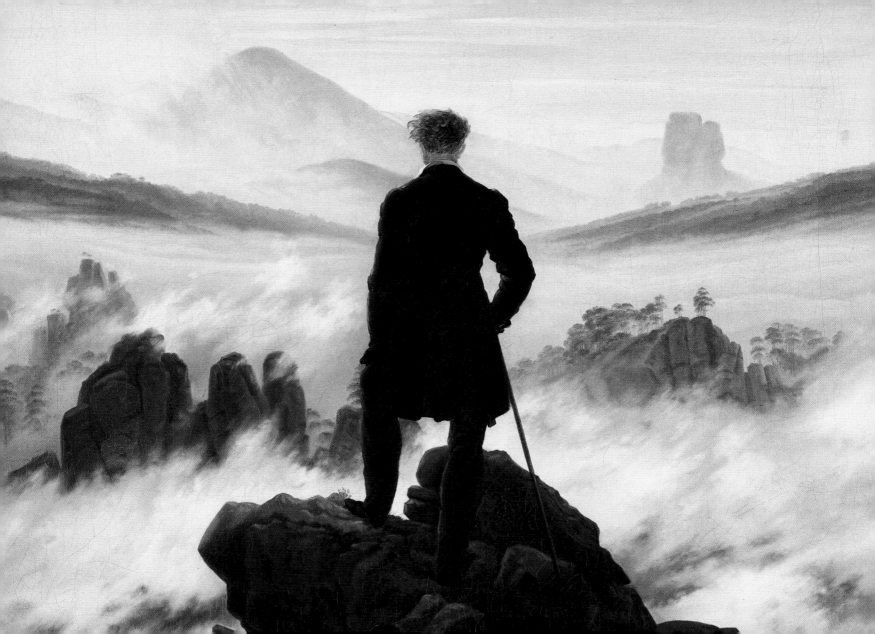

*The will is free; Strong is the soul, and wise,
and beautiful; The seeds of godlike power are
in us still; Gods are we, bards, saints, heroes,
if we will!*

<small>MATTHEW ARNOLD</small>

The Calling of St. Matthew, 1599–1600
Caravaggio
San Luigi die Francesi, Rome

1 2 3 4 5 6 7 8 9 10 11 12 13 14 **15** 16 17 18 19 20 21 22 23 24 25 26 27 28 29 30

SEPTEMBER

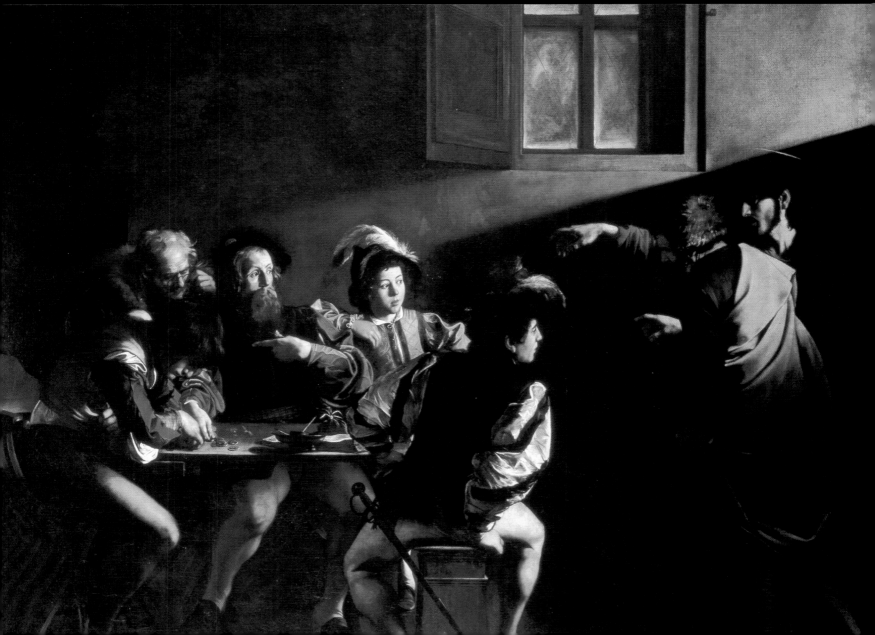

*When you paint, try to put down
exactly what you see.
Whatever else you have to offer
will come out anyway.*

WINSLOW HOMER

Croquet Players, 1875
Winslow Homer
Delaware Art Museum, Wilmington, Gift of the Friends of Art and other supporters

1 2 3 4 5 6 7 8 9 10 11 12 13 14 15 **16** 17 18 19 20 21 22 23 24 25 26 27 28 29 30

SEPTEMBER

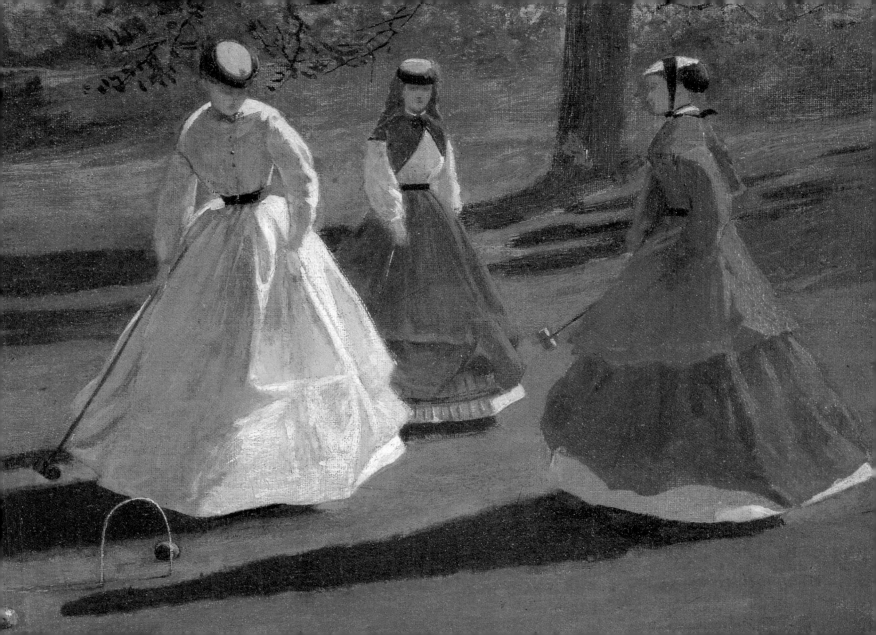

*Be noble! And the nobleness that lies
in other men, sleeping, but never dead,
will rise in majesty to meet thine own.*

<small>James Russell Lowell</small>

John Pamplin, *c.* 1753–54
Thomas Gainsborough
National Gallery, London

1 2 3 4 5 6 7 8 9 10 11 12 13 14 15 16 **17** 18 19 20 21 22 23 24 25 26 27 28 29 30

SEPTEMBER

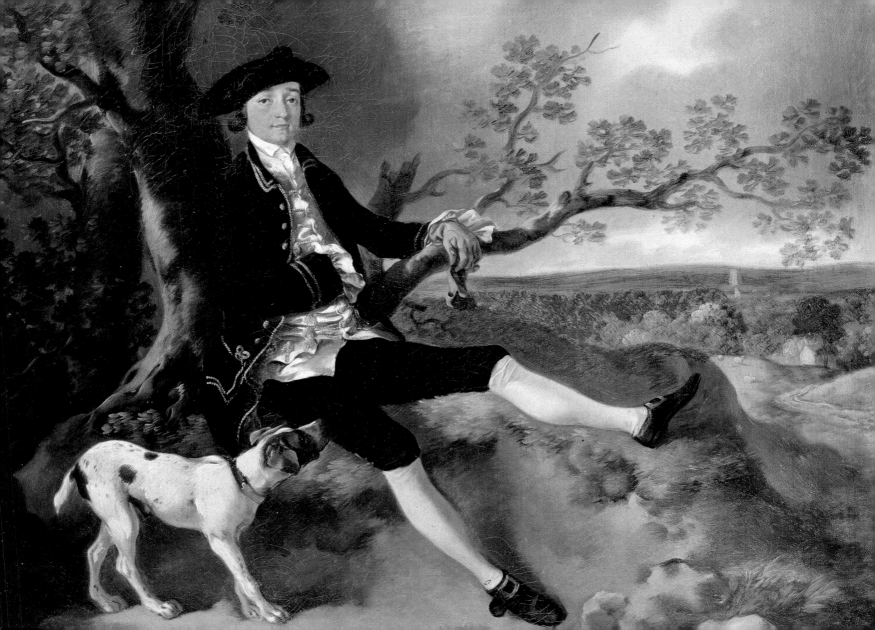

Above all, do not lose your desire to walk.
Every day I walk myself into a state of
well-being and walk away from every illness.
I have walked myself into my best thoughts,
and I know of no thought so burdensome that
one cannot walk away from it.

SØREN KIERKEGAARD

The Sunday Walk, 1841
Carl Spitzweg
Museum Carolino Augusteum, Salzburg

1 2 3 4 5 6 7 8 9 10 11 12 13 14 15 16 17 **18** 19 20 21 22 23 24 25 26 27 28 29 30

SEPTEMBER

*The only time I feel alive
is when I'm painting.*

Vincent van Gogh

Café Terrace at Night, 1888
Vincent van Gogh
Kröller-Müller Museum, Otterlo

1 2 3 4 5 6 7 8 9 10 11 12 13 14 15 16 17 18 **19** 20 21 22 23 24 25 26 27 28 29 30

SEPTEMBER

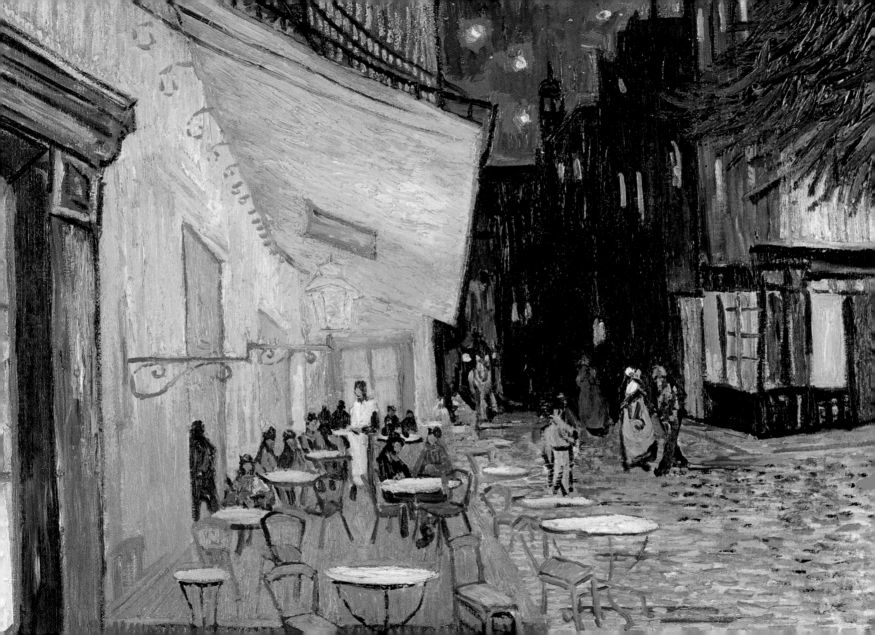

It is good to be without vices, but it is not good to be without temptations.

WALTER BAGEHOT

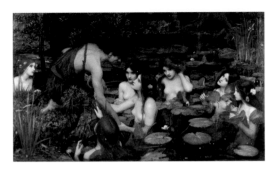

Hylas and the Nymphs, 1896
John William Waterhouse
Manchester Art Gallery

1 2 3 4 5 6 7 8 9 10 11 12 13 14 15 16 17 18 19 **20** 21 22 23 24 25 26 27 28 29 30

SEPTEMBER

Pearls lie not on the seashore.
If thou desirest one,
thou must dive for it.

CHINESE PROVERB

The Beach and Dunes at St. Briac, 1890
Paul Signac
The Pushkin Museum of Fine Arts, Moscow

1 2 3 4 5 6 7 8 9 10 11 12 13 14 15 16 17 18 19 20 **21** 22 23 24 25 26 27 28 29 30

SEPTEMBER

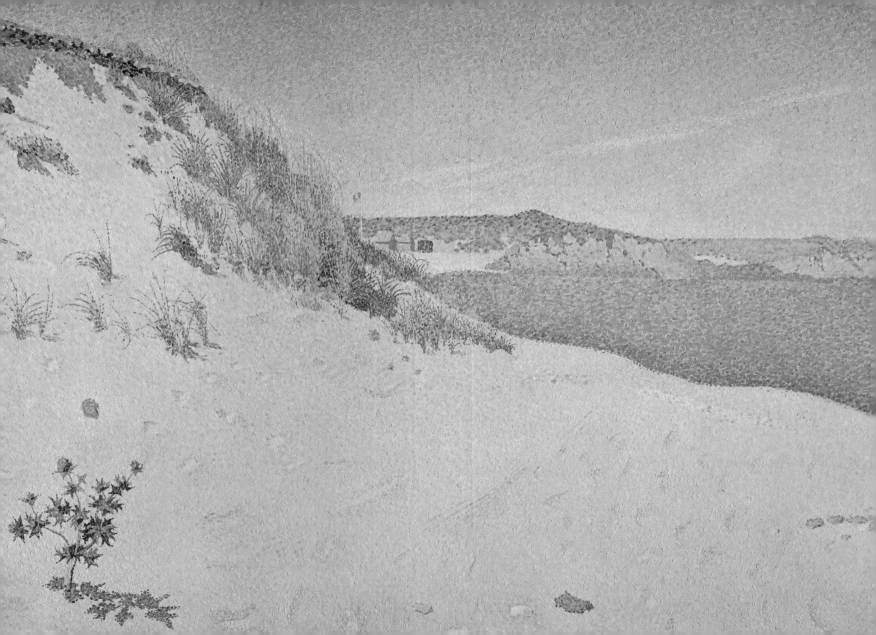

To err is human.
To loaf is Parisian.

Victor Hugo

In the Jardin de Luxembourg, 1876
Adolph von Menzel
The Pushkin Museum of Fine Arts, Moscow

1 2 3 4 5 6 7 8 9 10 11 12 13 14 15 16 17 18 19 20 21 **22** 23 24 25 26 27 28 29 30

SEPTEMBER

It's on the strength of observation and reflection that one finds a way.

Claude Monet

Wheatstacks near Giverny, 1884–89
Claude Monet
The Pushkin Museum of Fine Arts, Moscow

1 2 3 4 5 6 7 8 9 10 11 12 13 14 15 16 17 18 19 20 21 22 **23** 24 25 26 27 28 29 30

SEPTEMBER

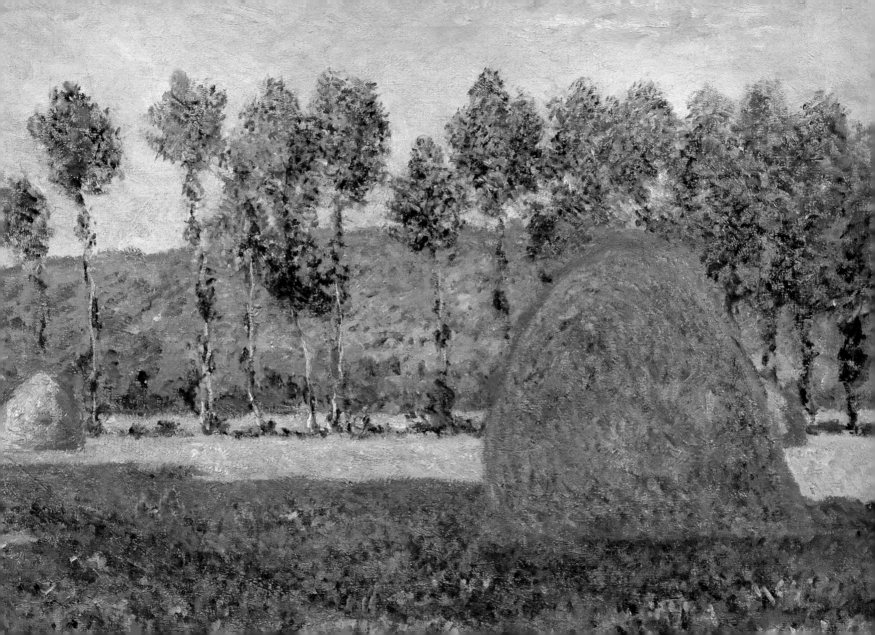

Poets have been mysteriously silent on the subject of cheese.

G. K. CHESTERTON

Breakfast-Piece, 1613
Floris van Dyck
Frans Hals Museum, Haarlem

1 2 3 4 5 6 7 8 9 10 11 12 13 14 15 16 17 18 19 20 21 22 23 **24** 25 26 27 28 29 30

SEPTEMBER

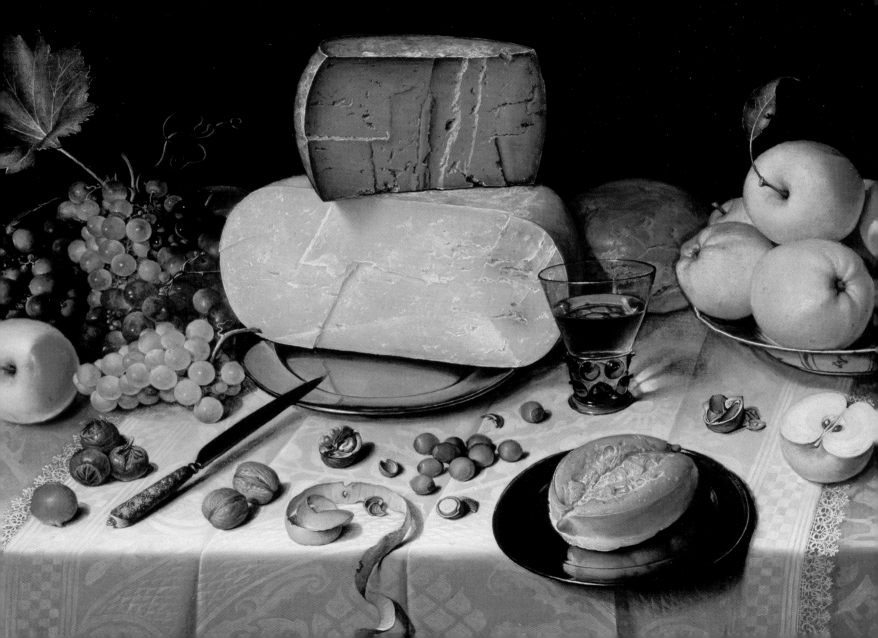

Brook! Whose society the poet seeks,
Intent his wasted spirits to renew;
And whom the curious painter doth pursue;
Through rocky passes, among flowery creeks,
And tracks thee dancing down thy water-breaks.

WILLIAM WORDSWORTH

Landscape in Normandy.
Arques-la-Bataille, 1903
Felix Vallotton
The State Hermitage Museum, St. Petersburg

1 2 3 4 5 6 7 8 9 10 11 12 13 14 15 16 17 18 19 20 21 22 23 24 **25** 26 27 28 29 30

SEPTEMBER

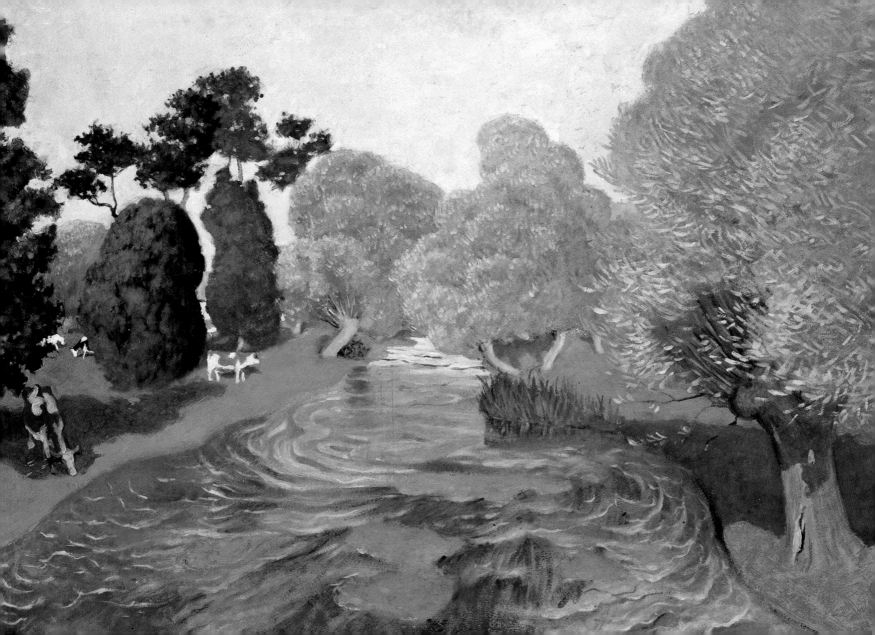

With the brush we merely tint, while the imagination alone produces color.

THÉODORE GÉRICAULT

A Horse Restrained by a Slave, 1816–17
Théodore Géricault
Musée des Beaux-Arts, Rouen

1 2 3 4 5 6 7 8 9 10 11 12 13 14 15 16 17 18 19 20 21 22 23 24 25 **26** 27 28 29 30

SEPTEMBER

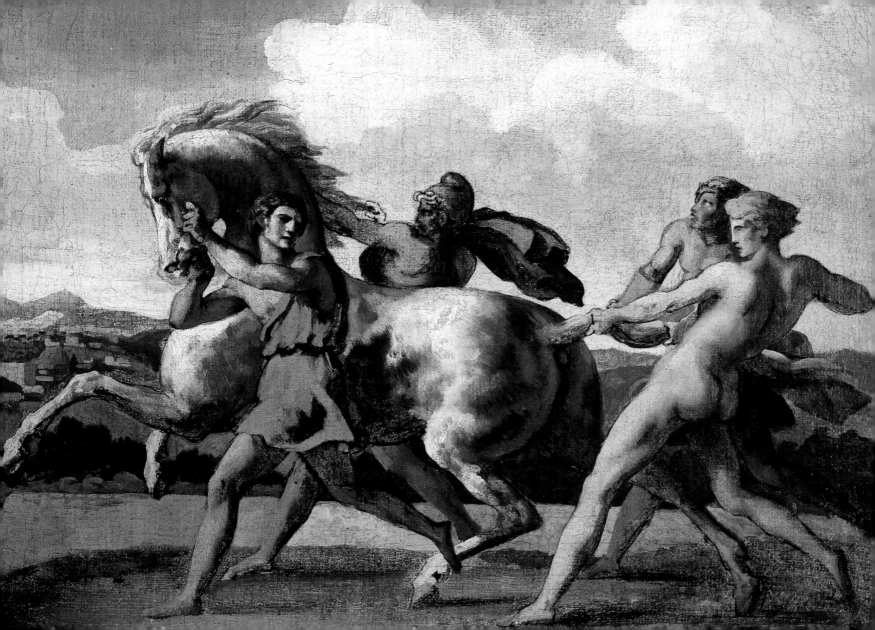

*Patience and perseverance
have a magical effect before
which difficulties disappear
and obstacles vanish.*

JOHN QUINCY ADAMS

Woman with a Water Jug, *c.* 1663
Johannes Vermeer
The Metropolitan Museum of Art, New York

1 2 3 4 5 6 7 8 9 10 11 12 13 14 15 16 17 18 19 20 21 22 23 24 25 26 **27** 28 29 30

SEPTEMBER

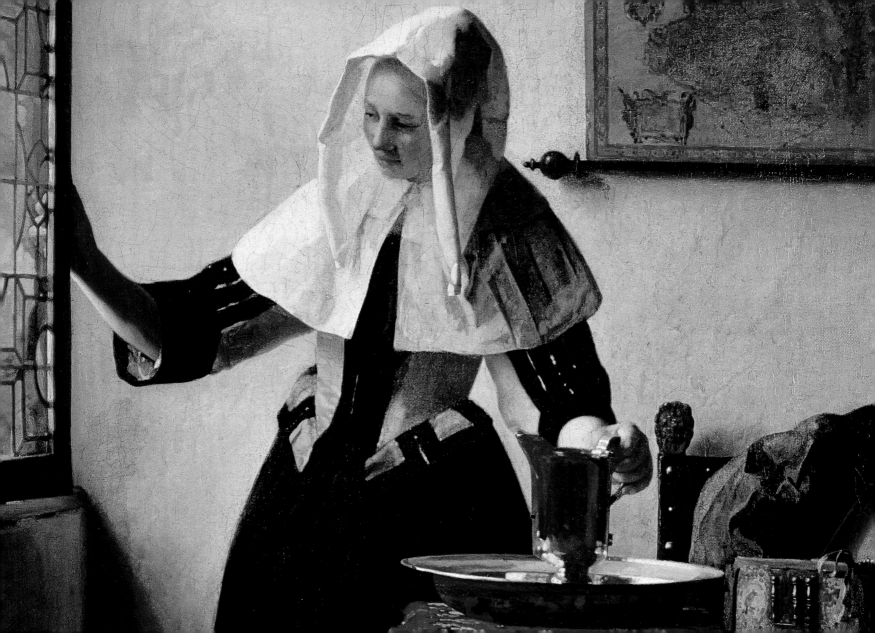

Bacchus we thank who gave us wine
Which warms the blood within our veins;
That nectar is itself divine.
The man who drinks not, yet attains
By godly grace to human rank
Would be an angel if he drank.

Fʀᴇɴᴄʜ ᴅʀɪɴᴋɪɴɢ ꜱᴏɴɢ

Bacchus, 1628
Diego Rodriguez de Velázquez
Museo Nacional del Prado, Madrid

1 2 3 4 5 6 7 8 9 10 11 12 13 14 15 16 17 18 19 20 21 22 23 24 25 26 27 **28** 29 30

SEPTEMBER

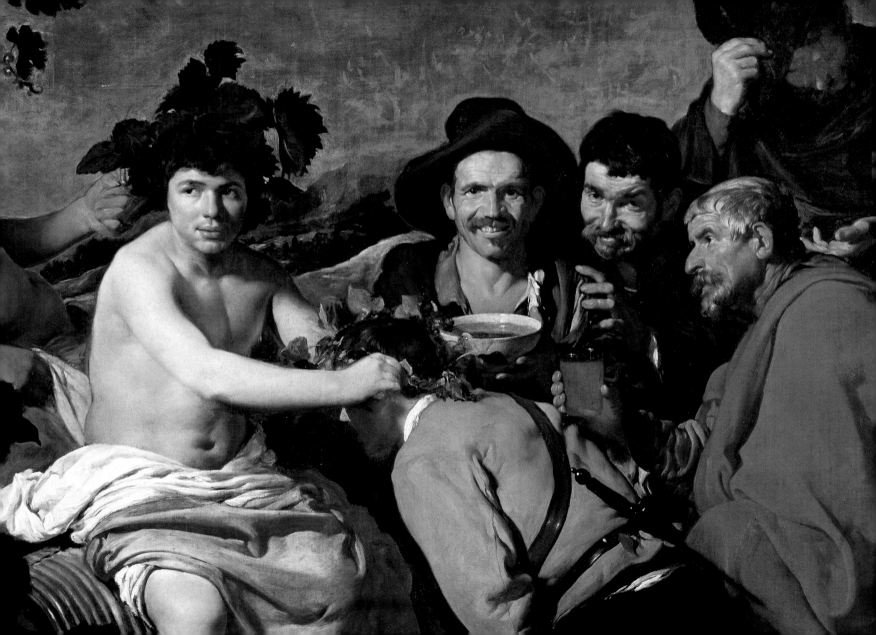

Love will not be constrained by mastery;
when mastery comes, the God of love at once
beats his wings, and farewell, he is gone.
Love is a thing as free as any spirit ...

<small>GEOFFREY CHAUCER</small>

Venus and Cupid, c. 1742
François Boucher
Gemäldegalerie, Berlin

1 2 3 4 5 6 7 8 9 10 11 12 13 14 15 16 17 18 19 20 21 22 23 24 25 26 27 28 **29** 30

SEPTEMBER

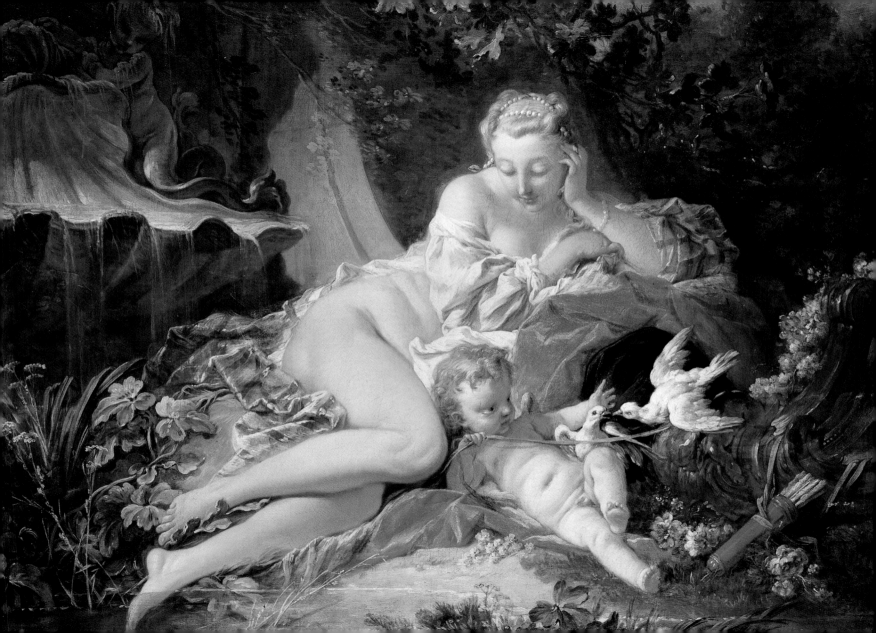

What is one to think of those fools who tell one that the artist is always subordinate to nature? Art is in harmony parallel with nature.

Paul Cézanne

The Banks of the Marne, 1888–95
Paul Cézanne
The Pushkin Museum of Fine Arts, Moscow

1 2 3 4 5 6 7 8 9 10 11 12 13 14 15 16 17 18 19 20 21 22 23 24 25 26 27 28 29 **30**

SEPTEMBER

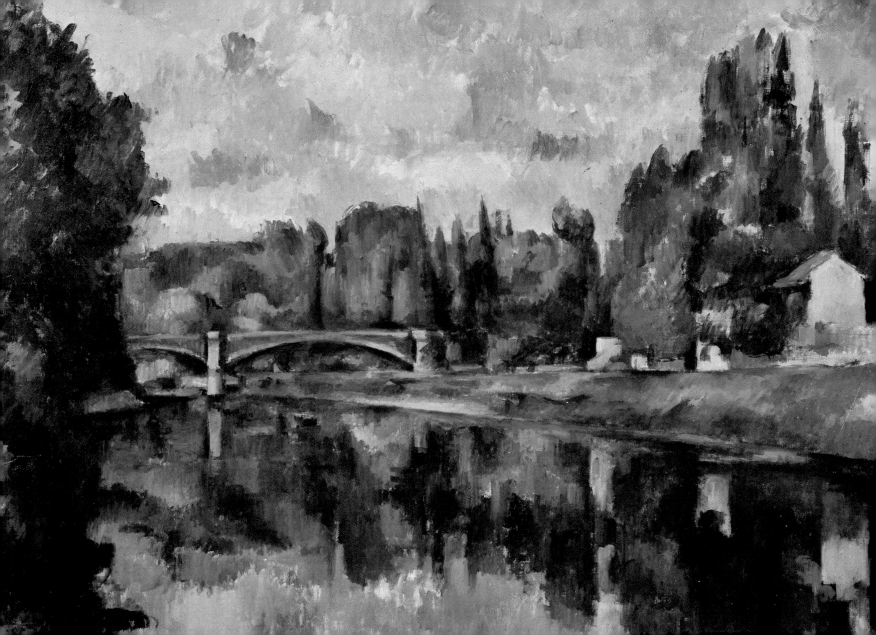

Whoever would overthrow the liberty of a nation must begin by subduing the freeness of speech.

<small>BENJAMIN FRANKLIN</small>

The Tower of Babel, 1563
Pieter Brueghel the Elder
Kunsthistorisches Museum, Vienna

1 2 3 4 5 6 7 8 9 10 11 12 13 14 15 16 17 18 19 20 21 22 23 24 25 26 27 28 29 30 31

OCTOBER

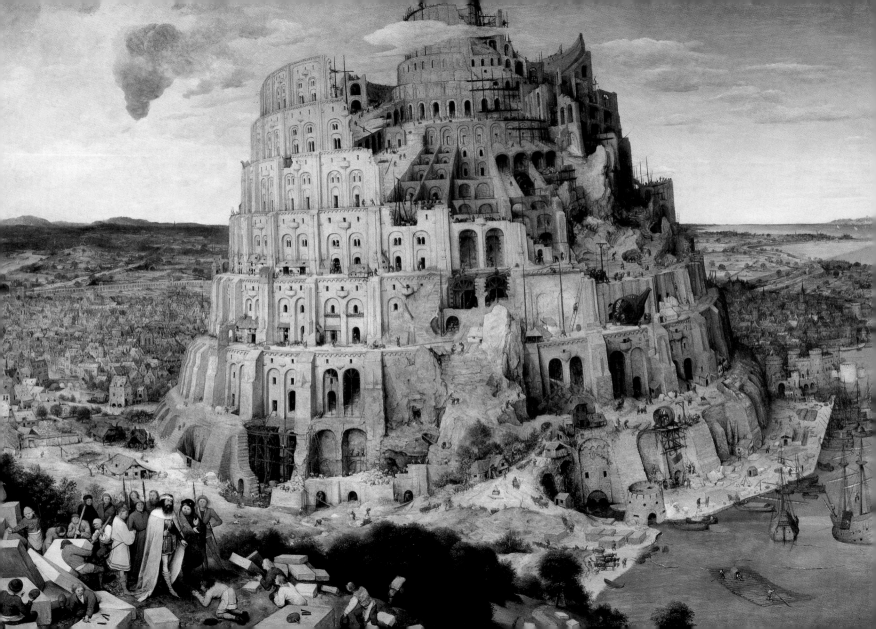

Twenty years from now you will be more dissapointed by the things you didn't do, than by the things you did. So throw off the bowlines, sail away from the safe harbor. Catch the trade winds in your sails. Explore. Dream.

On a Sailing Ship, 1819
Caspar David Friedrich
The State Hermitage Museum, St. Petersburg

1 2 3 4 5 6 7 8 9 10 11 12 13 14 15 16 17 18 19 20 21 22 23 24 25 26 27 28 29 30 31

OCTOBER

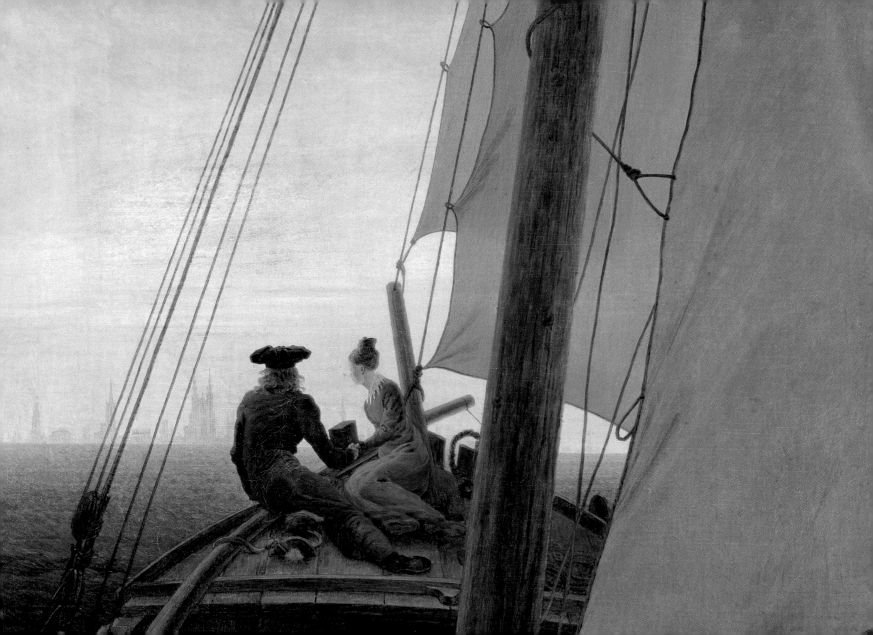

Some books are to be tasted, others to be swallowed, and some few to be chewed and digested.

Francis Bacon

The Open Missal, *c.* 1570
Ludger tom Ring the Younger
Frances Lehman Loeb Art Center, Vassar College, Poughkeepsie
Purchased by Mrs. John D. Rockefeller III (Blanchette Hooker, Class of 1931) Fund

1 2 **3** 4 5 6 7 8 9 10 11 12 13 14 15 16 17 18 19 20 21 22 23 24 25 26 27 28 29 30 31

OCTOBER

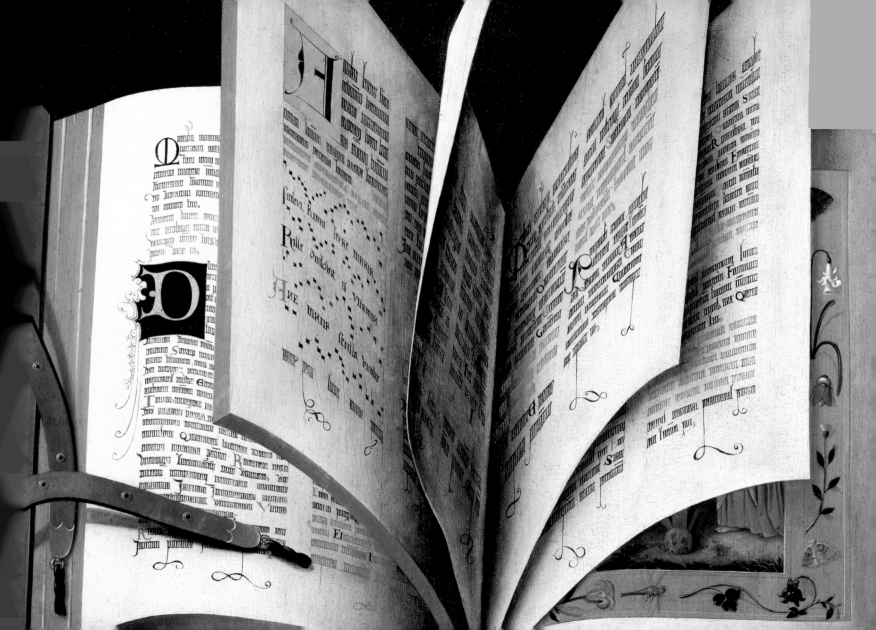

Art can only be erotic.

<small>PABLO PICASSO</small>

Reclining Nude, 1932
Pablo Picasso
Musée Picasso, Paris

<small>1 2 3</small> **4** <small>5 6 7 8 9 10 11 12 13 14 15 16 17 18 19 20 21 22 23 24 25 26 27 28 29 30 31</small>

OCTOBER

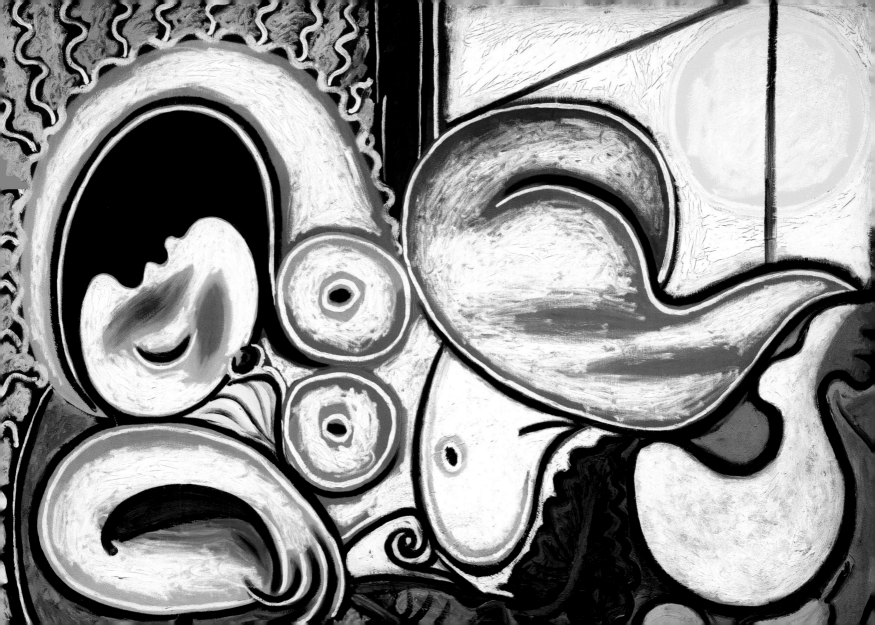

*Love is an ideal thing,
marriage a real thing.*

Portrait of a Married Couple, *c.* 1523
Lorenzo Lotto
The State Hermitage Museum, St. Petersburg

1 2 3 4 **5** 6 7 8 9 10 11 12 13 14 15 16 17 18 19 20 21 22 23 24 25 26 27 28 29 30 31

OCTOBER

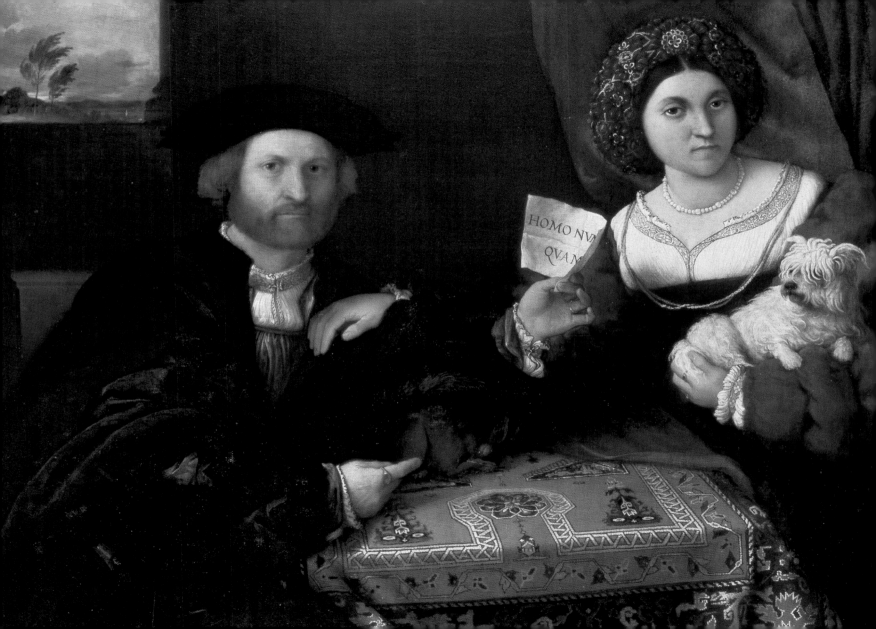

October gave a party; The leaves by hundreds
came—The Chestnuts, Oaks, and Maples,
And leaves of every name. The Sunshine spread
a carpet, And everything was grand,
Miss Weather led the dancing, Professor Wind
the band.

GEORGE COOPER

Overgrown Country House, 1909
Konstantin Bakhtin
Art Museum, Sumi

1 2 3 4 5 **6** 7 8 9 10 11 12 13 14 15 16 17 18 19 20 21 22 23 24 25 26 27 28 29 30 31

OCTOBER

The older the fiddle,
the sweeter the tune.

IRISH PROVERB

Fiddler in Front of the Farmhouse, 1673
Adriaen van Ostade
Mauritshuis, The Hague

1 2 3 4 5 6 **7** 8 9 10 11 12 13 14 15 16 17 18 19 20 21 22 23 24 25 26 27 28 29 30 31

OCTOBER

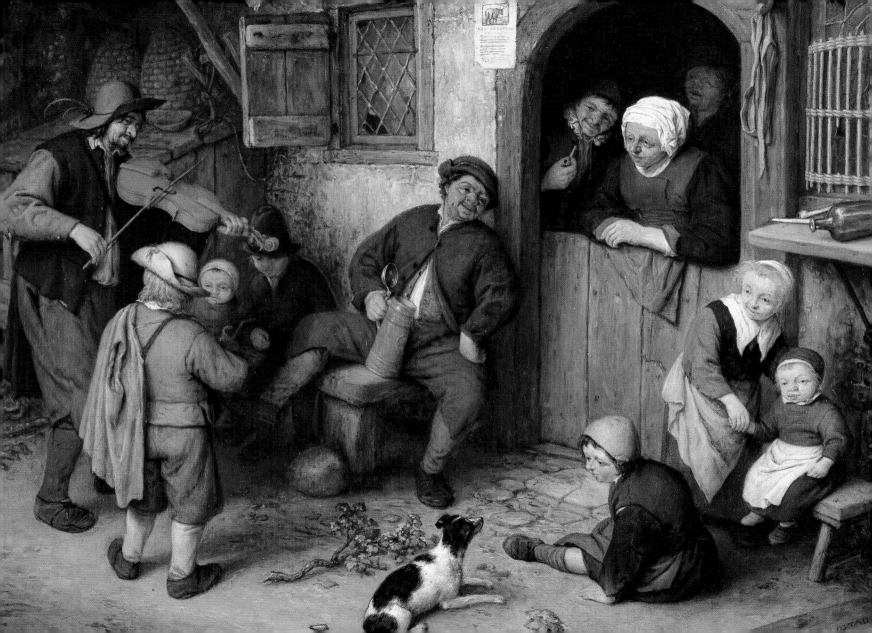

Come, thou monarch of the vine,
Plumpy Bacchus with pink eyne!
In thy fats our cares be drown'd,
With thy grapes our hairs be crown'd:
Cup us, till the world go round,
Cup us, till the world go round!

WILLIAM SHAKESPEARE

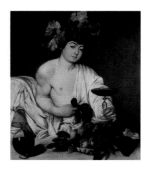

Young Bacchus, *c.* 1597
Caravaggio
Uffizi Gallery, Florence

1 2 3 4 5 6 7 **8** 9 10 11 12 13 14 15 16 17 18 19 20 21 22 23 24 25 26 27 28 29 30 31

OCTOBER

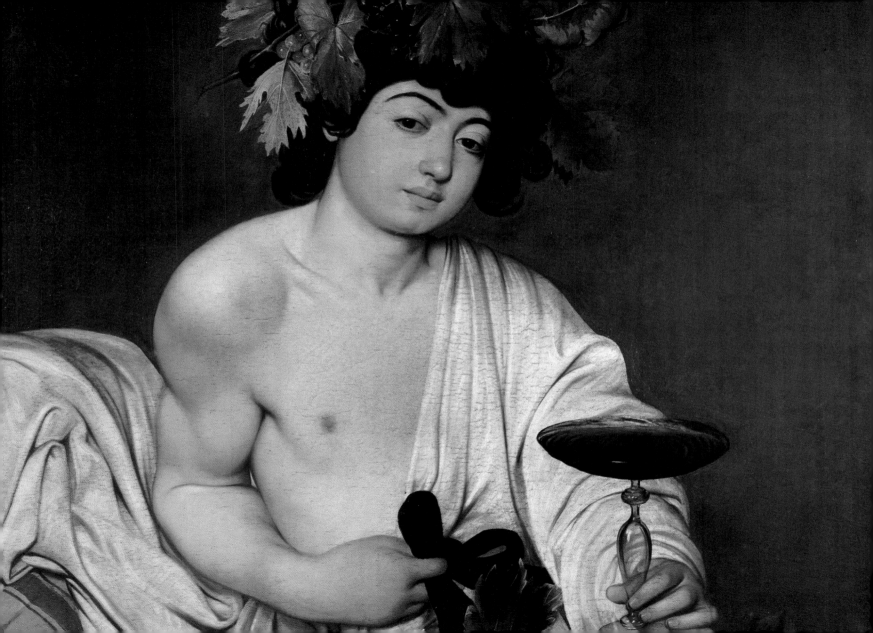

Rouse the lion from his lair.

Sir Walter Scott

Fight Between a Lion and a Tiger, c. 1860–63
Eugène Delacroix
Oskar Reinhart Collection, Winterthur

1 2 3 4 5 6 7 8 **9** 10 11 12 13 14 15 16 17 18 19 20 21 22 23 24 25 26 27 28 29 30 31

OCTOBER

Every season hath its pleasures;
Spring may boast her flowery prime,
Yet the vineyard's ruby treasures
Brighten Autumn's sob'rer time.

<small>THOMAS MOORE</small>

Autumn Landscape with Vineyards, 1585
Lucas I van Valckenborch
Kunsthistorisches Museum, Vienna

1 2 3 4 5 6 7 8 9 **10** 11 12 13 14 15 16 17 18 19 20 21 22 23 24 25 26 27 28 29 30 31

OCTOBER

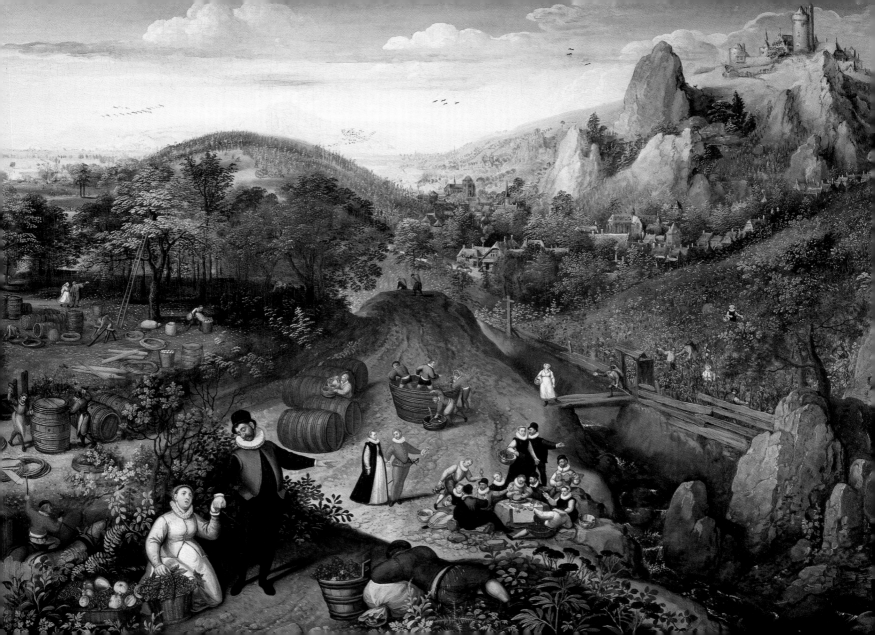

His high endeavors are an inward light
That makes the path before him always bright.

WILLIAM WORDSWORTH

The Coast of Fehmarn with Lighthouse, 1913
Ernst Ludwig Kirchner
Private Collection

1 2 3 4 5 6 7 8 9 10 **11** 12 13 14 15 16 17 18 19 20 21 22 23 24 25 26 27 28 29 30 31

OCTOBER

Horse thou art truly a creature without equal,
for thou fliest without wings and conquerest
without sword.

THE KORAN

The Dapple-Gray Horse, Sarramoc, *c.* 1725
Johann Georg Hamilton
Kunsthistorisches Museum, Vienna

1 2 3 4 5 6 7 8 9 10 11 **12** 13 14 15 16 17 18 19 20 21 22 23 24 25 26 27 **28 29 30 31**

OCTOBER

'Tis the little rift within the lute—
That by and by will make the music mute,
And, ever widening, slowly silence all.

ALFRED LORD TENNYSON

Lute Player, *c.* 1624–26
Hendrick ter Brugghen
Kunsthistorisches Museum, Vienna

1 2 3 4 5 6 7 8 9 10 11 12 **13** 14 15 16 17 18 19 20 21 22 23 24 25 26 27 28 29 30 31

OCTOBER

A journey of a thousand miles must begin with a single step.

Lao Tzu

Yoshiwara, Plate 15 from the Series
"Fifty-three Stations of the Tokaido," *c.* 1833–34
Utagawa Hiroshige
Private Collection

1 2 3 4 5 6 7 8 9 10 11 12 13 **14** 15 16 17 18 19 20 21 22 23 24 25 26 27 28 29 30 31

OCTOBER

A sister is a little bit of childhood that can never be lost.

MARION C. GARRETTY

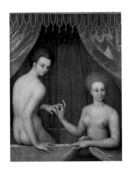

Gabrielle d'Estrées and Her Sister, *c.* 1594
School of Fontainebleau
Uffizi Gallery, Florence

1 2 3 4 5 6 7 8 9 10 11 12 13 14 **15** 16 17 18 19 20 21 22 23 24 25 26 27 28 29 30 31

OCTOBER

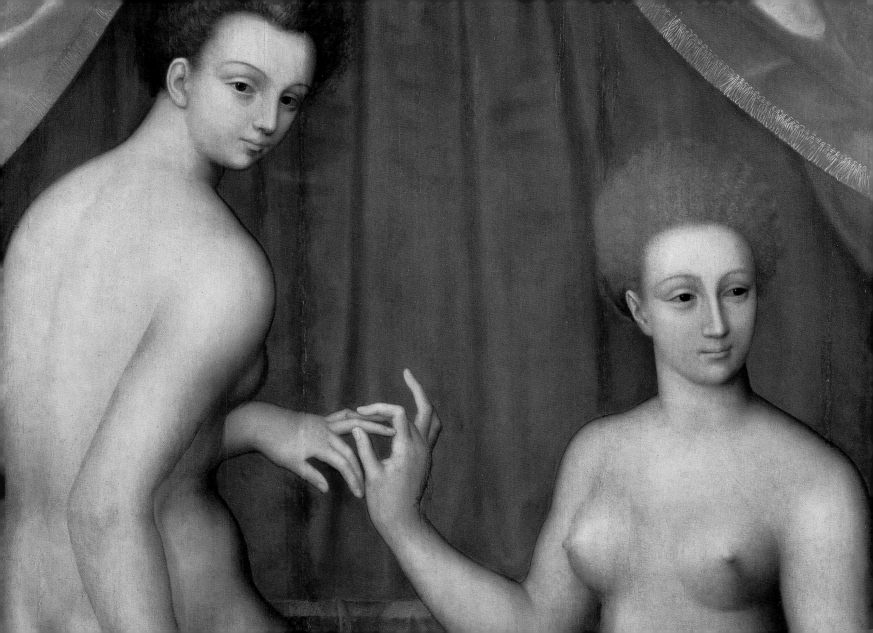

Divine nature gave the fields,
human art built the cities.

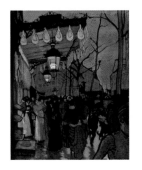

On the Street at Five in the Afternoon, 1887
Louis Anquetin
Wadsworth Antheneum, Hartford

1 2 3 4 5 6 7 8 9 10 11 12 13 14 15 **16** 17 18 19 20 21 22 23 24 25 26 27 28 29 30 31

OCTOBER

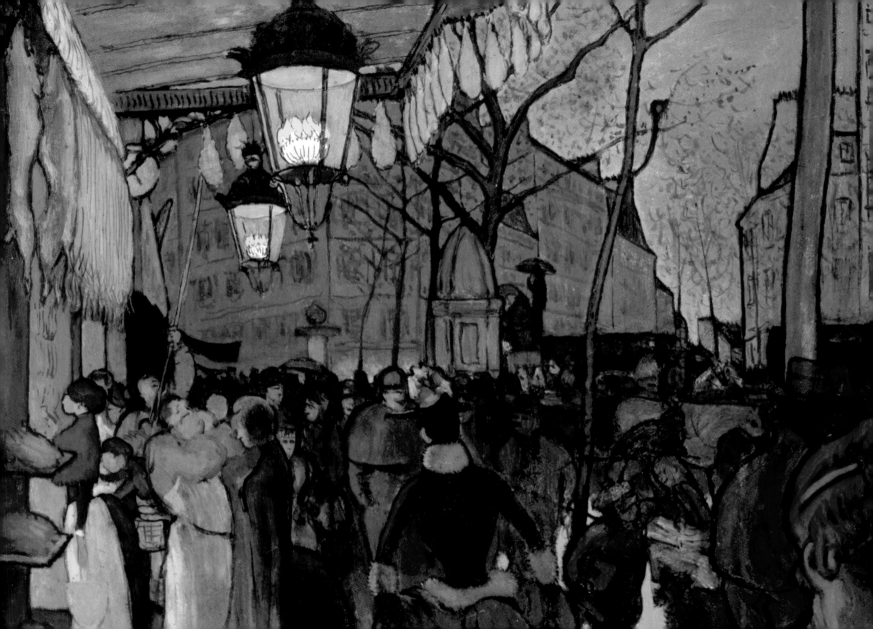

An artist's career
always begins tomorrow.

<small>JAMES McNEILL WHISTLER</small>

Portrait of the Artist's Mother, 1871
James McNeill Whistler
Musée d'Orsay, Paris

1 2 3 4 5 6 7 8 9 10 11 12 13 14 15 16 **17** 18 19 20 21 22 23 24 25 26 27 28 29 30 31

OCTOBER

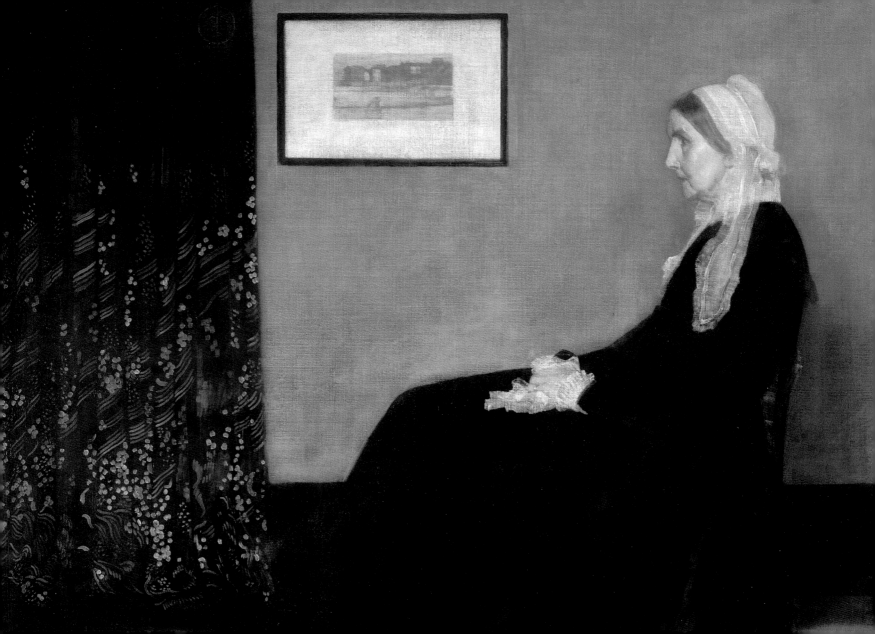

*The sun will not rise, or set,
without my notice and thanks.*

Winslow Homer

West Point, Prout's Neck, 1900
Winslow Homer
Sterling and Francine Clark Art Institute, Williamstown

1 2 3 4 5 6 7 8 9 10 11 12 13 14 15 16 17 **18** 19 20 21 22 23 24 25 26 27 28 29 30 31

OCTOBER

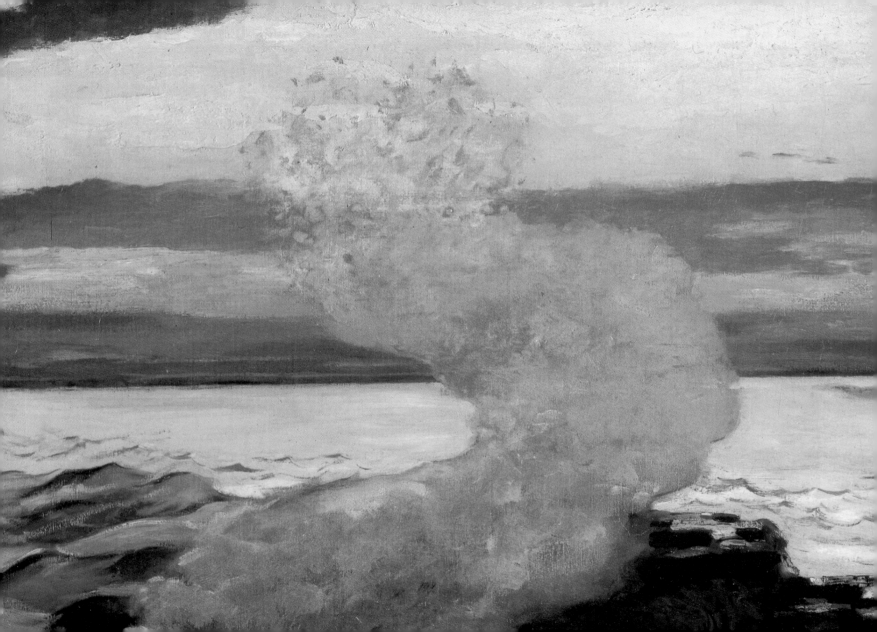

Luck affects everything;
let your hook always be cast;
in the stream where you least
expect it, there will be a fish.

Ovid

A Fish Market, *c.* 1620–30
Frans Snyders and Cornelis de Vos
Kunsthistorisches Museum, Vienna

1 2 3 4 5 6 7 8 9 10 11 12 13 14 15 16 17 18 **19** 20 21 22 23 24 25 26 27 28 29 30 31

OCTOBER

One must do the same subject
over again ten times, a hundred times.
In art nothing must resemble
an accident, not even movement.

<small>EDGAR DEGAS</small>

Ballet Scene, *c.* 1907
Edgar Degas
National Gallery of Art, Washington D.C.

1 2 3 4 5 6 7 8 9 10 11 12 13 14 15 16 17 18 19 **20** 21 22 23 24 25 26 27 28 29 30 31

OCTOBER

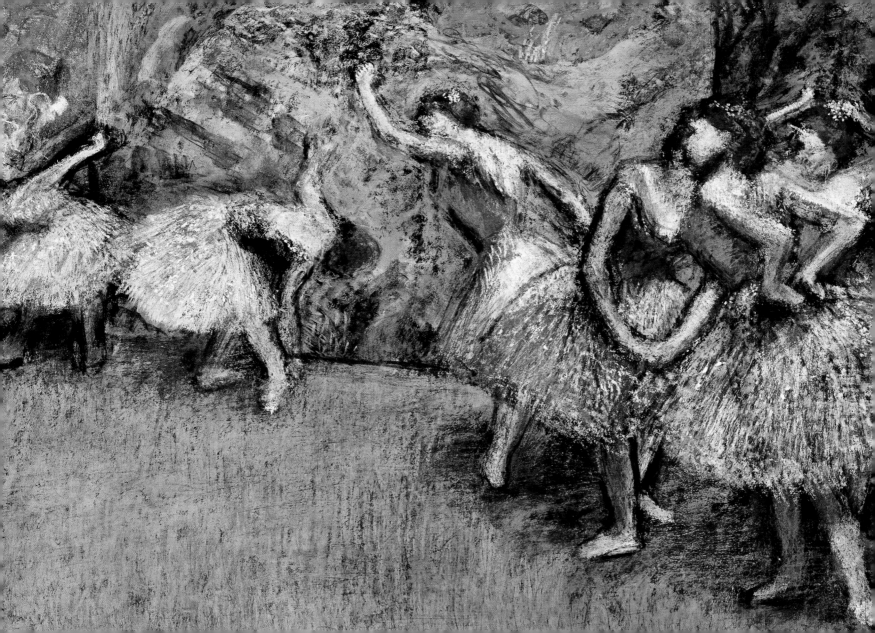

Pleasure in the job puts perfection in the work.

ARISTOTLE

Portrait of the Merchant Georg Gisze, 1532
Hans Holbein the Younger
Gemäldegalerie, Berlin

1 2 3 4 5 6 7 8 9 10 11 12 13 14 15 16 17 18 19 20 **21** 22 23 24 25 26 27 28 29 30 31

OCTOBER

... there was blond Ganymede,
whom Zeus abducted on account
of his beauty, so that he may be
together with the immortal ones,
as wine-pourer for the gods
in the palace of Zeus ...

HOMER

The Abduction of Ganymede, 1700
Anton Domenico Gabbiani
Uffizi Gallery, Florence

1 2 3 4 5 6 7 8 9 10 11 12 13 14 15 16 17 18 19 20 21 **22** 23 24 25 26 27 28 29 30 31

OCTOBER

Now I really feel the landscape,
I can be bold and include every tone
of blue and pink: it's enchanting,
it's delicious.

<small>CLAUDE MONET</small>

Cliffs near Dieppe, 1897
Claude Monet
The State Hermitage Museum, St. Petersburg

1 2 3 4 5 6 7 8 9 10 11 12 13 14 15 16 17 18 19 20 21 22 **23** 24 25 26 27 28 29 30 31

OCTOBER

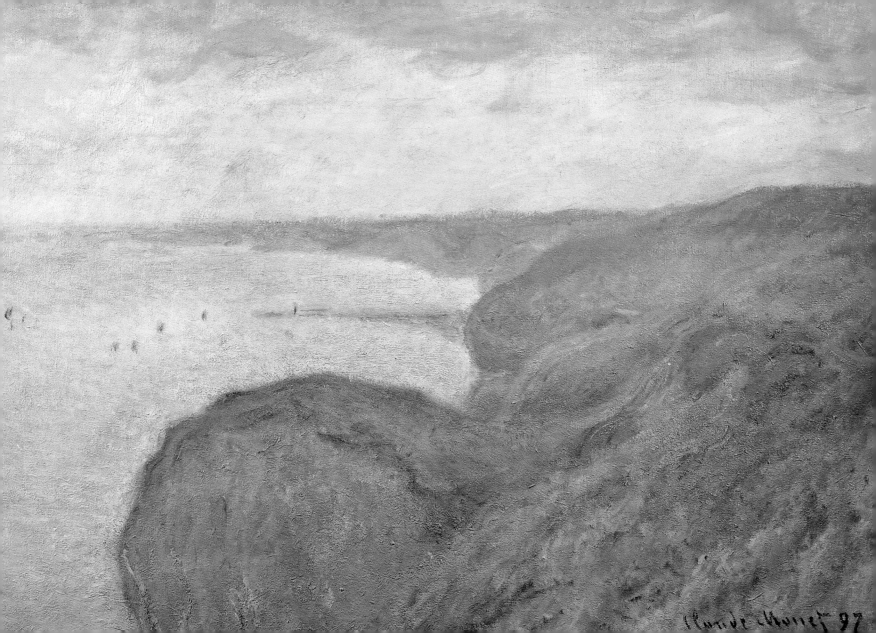

Claude Monet 97

Suffer little children,
and forbid them not,
to come unto me:
for of such is the
kingdom of heaven.

THE GOSPEL OF ST. MATTHEW 19:14

Let the Little Children
Come to Me, 16th century
Lucas Cranach the Elder
National Gallery, Prague

1 2 3 4 5 6 7 8 9 10 11 12 13 14 15 16 17 18 19 20 21 22 23 **24** 25 26 27 28 29 30 31

OCTOBER

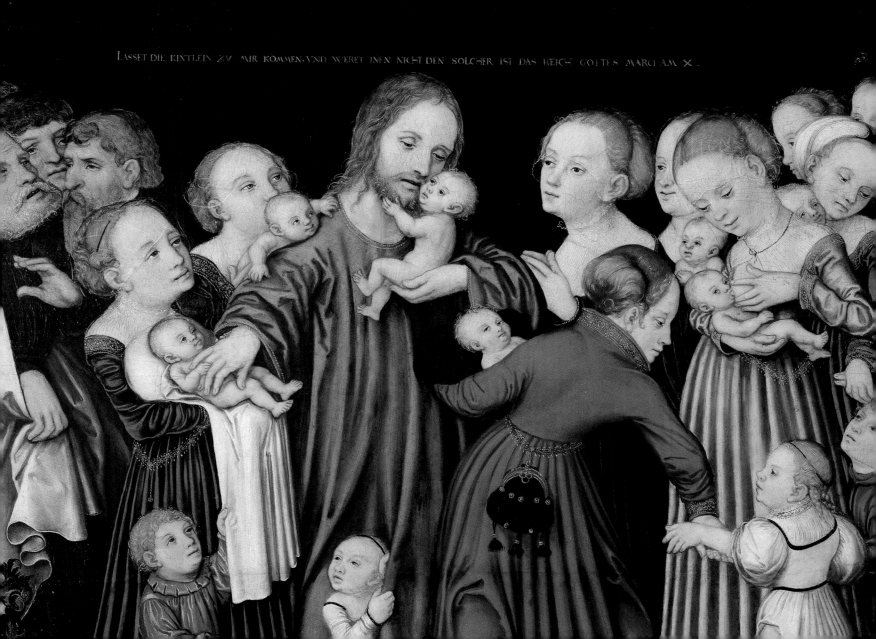

LASSET DIE KINTLEIN ZV MIR KÖMMEN VND WERET INEN NICHT DEN SOLCHER IST DAS REICH GOTTES MARCI AM X.

Nothing would be more tiresome
than eating and drinking
if God had not made them
a pleasure as well as a necessity.

<small>VOLTAIRE</small>

Still-Life, 1633
Pieter Claesz
Staatliche Kunstsammlungen, Kassel

1 2 3 4 5 6 7 8 9 10 11 12 13 14 15 16 17 18 19 20 21 22 23 24 **25** 26 27 28 29 30 31

OCTOBER

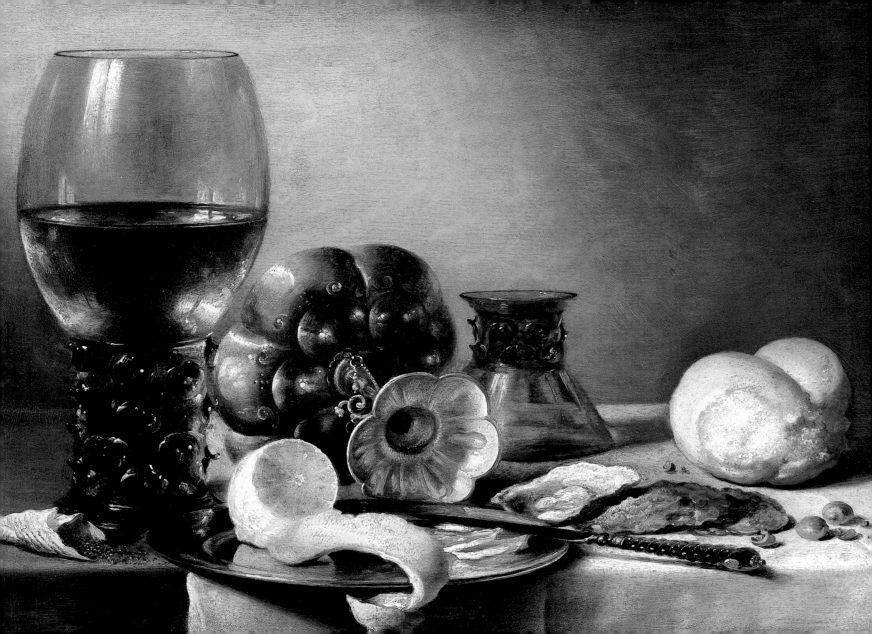

A community is like a ship;
everyone ought to be prepared
to take the helm.

Henrik Ibsen

The Directors of the Orphanage, 1663
Jean de Bray
Frans Hals Museum, Haarlem

1 2 3 4 5 6 7 8 9 10 11 12 13 14 15 16 17 18 19 20 21 22 23 24 25 **26** 27 28 29 30 31

OCTOBER

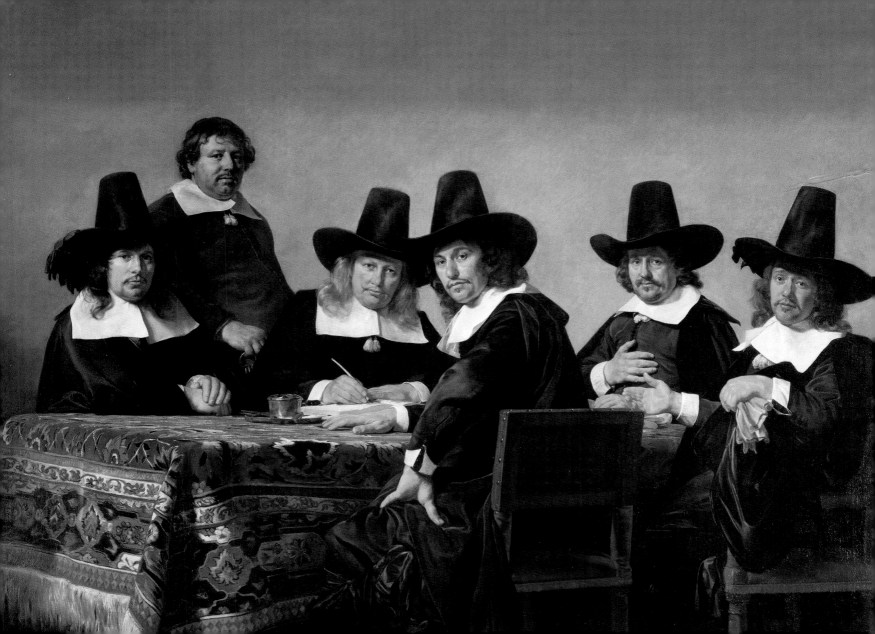

For one human being to love another;
that is perhaps the most difficult of all our tasks,
the ultimate, the last test and proof, the work
for which all other work is but preparation.

<small>RAINER MARIA RILKE</small>

**Evening Gathering
with Bridal Couple,** *c.* 1620
Gerrit van Honthorst
Uffizi Gallery, Florence

1 2 3 4 5 6 7 8 9 10 11 12 13 14 15 16 17 18 19 20 21 22 23 24 25 26 **27** 28 29 30 31

OCTOBER

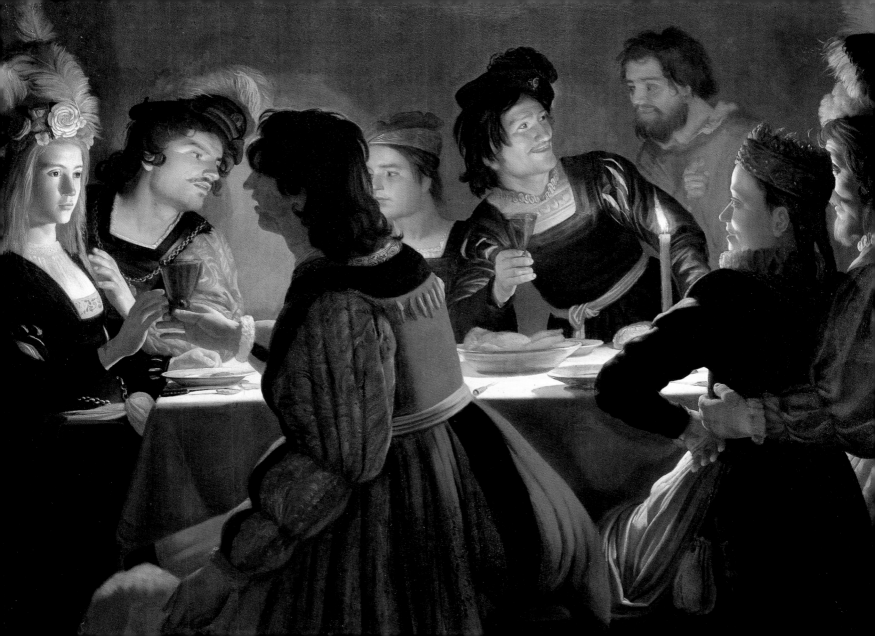

Delicious autumn! My very soul is wedded to it,
and if I were a bird I would fly about the earth
seeking the successive autumns.

GEORGE ELIOT

The Couple on the Bench, *c.* 1860–63
Carl Spitzweg
Lenbachhaus, Munich

1 2 3 4 5 6 7 8 9 10 11 12 13 14 15 16 17 18 19 20 21 22 23 24 25 26 27 **28** 29 30 31

OCTOBER

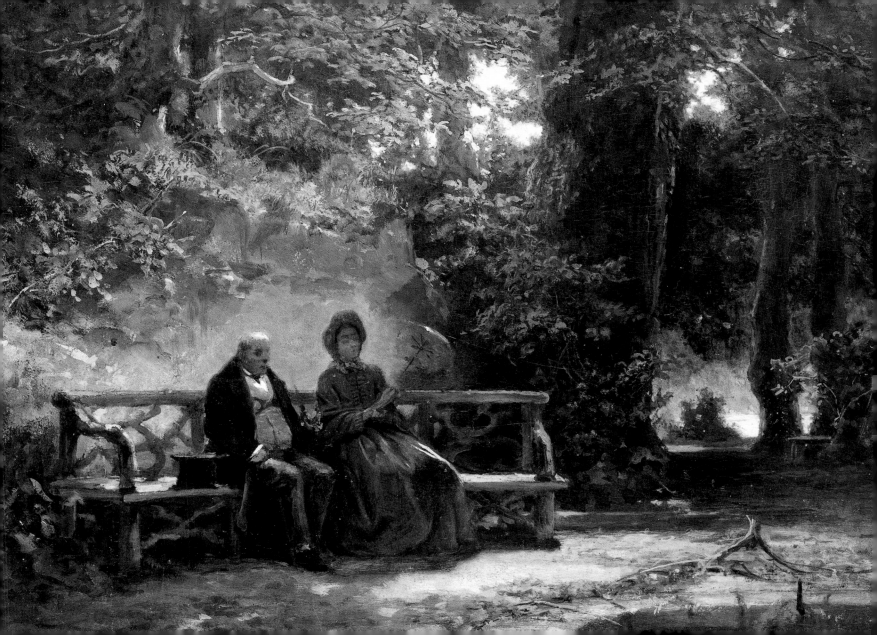

If the grand designs I have in my mind
and in my heart truly correspond
with what my hands and brushes
have created, then I think that I have
satisfied my wish to serve Your Excellency …

Titian

Venus with the Organ Player, 1548
Titian
Museo Nacional del Prado, Madrid

1 2 3 4 5 6 7 8 9 10 11 12 13 14 15 16 17 18 19 20 21 22 23 24 25 26 27 28 **29** 30 31

OCTOBER

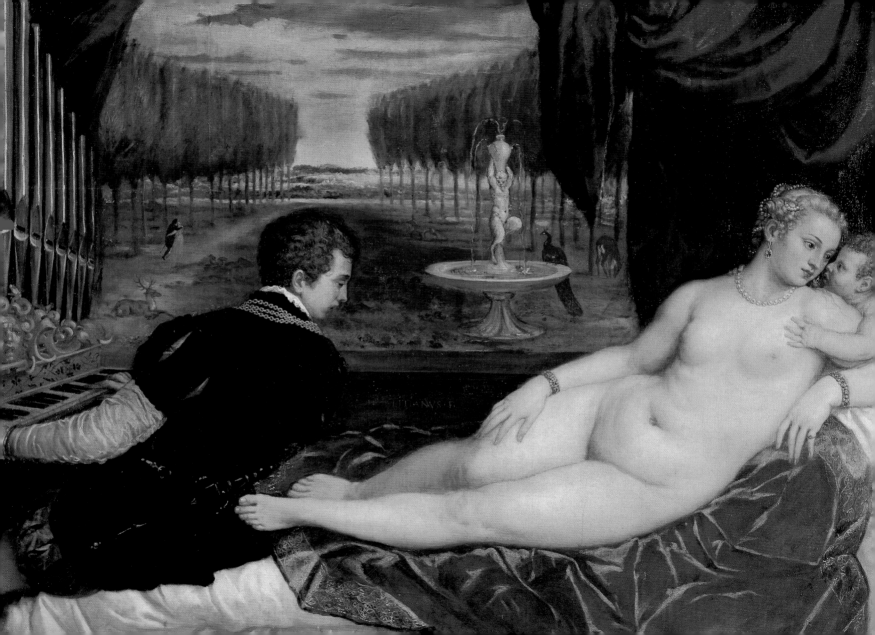

*He is the happiest,
be he king or peasant,
who finds peace in his home.*

Johann Wolfgang von Goethe

The Apple Peeler, *c.* 1661
Gerard ter Borch
Kunsthistorisches Museum, Vienna

1 2 3 4 5 6 7 8 9 10 11 12 13 14 15 16 17 18 19 20 21 22 23 24 25 26 27 28 29 **30** 31

OCTOBER

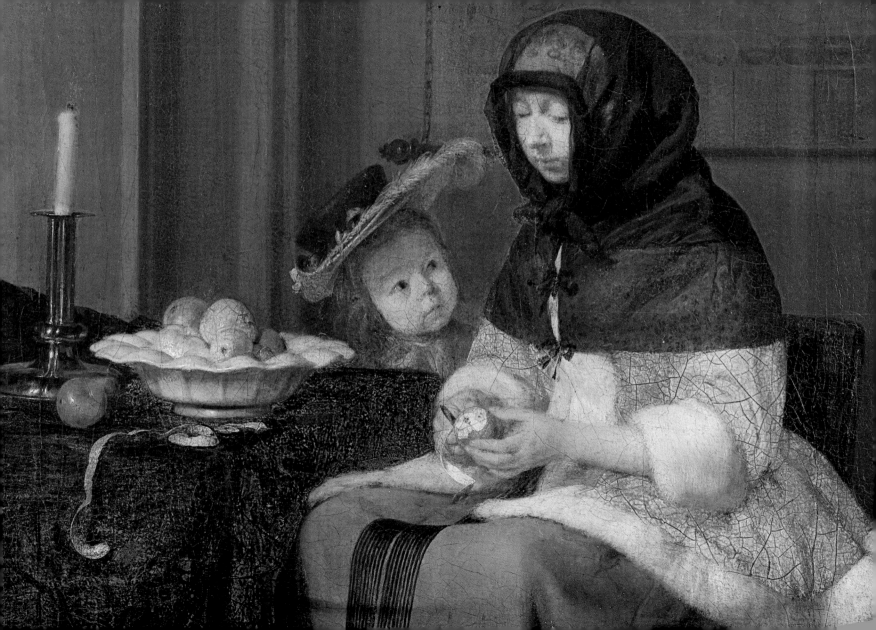

The man who will go down to posterity is the man who paints his own time and the scenes of everyday life around him.

<small>CHILDE HASSAM</small>

Union Square, 1892
Childe Hassam
The Artist Group Limited

1 2 3 4 5 6 7 8 9 10 11 12 13 14 15 16 17 18 19 20 21 22 23 24 25 26 27 28 29 30 **31**

OCTOBER

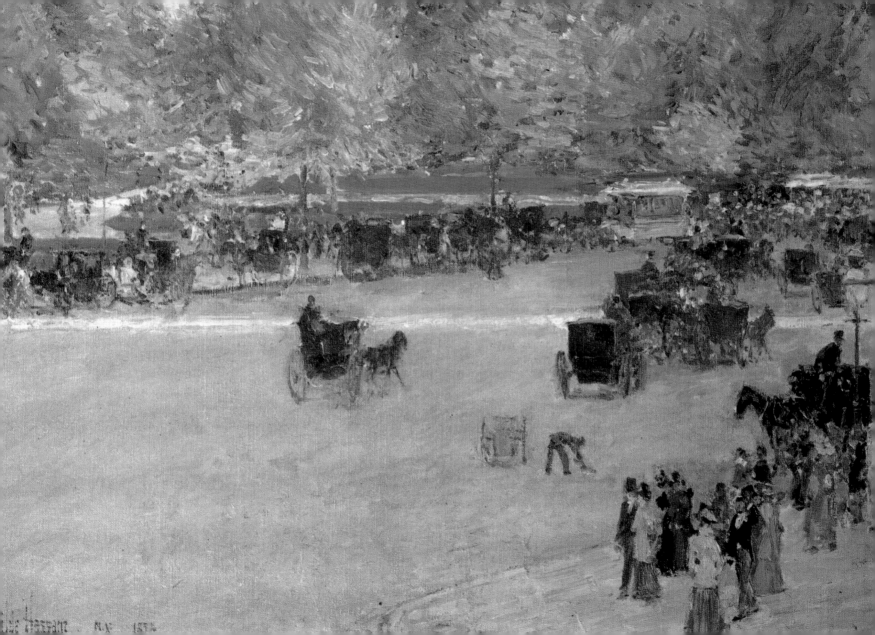

I hold that the perfection of form and beauty is contained in the sum of all men.

ALBRECHT DÜRER

The All Saints Painting, 1511
Albrecht Dürer
Kunsthistorisches Museum, Vienna

1 2 3 4 5 6 7 8 9 10 11 12 13 14 15 16 17 18 19 20 21 22 23 24 25 26 27 28 29 30

NOVEMBER

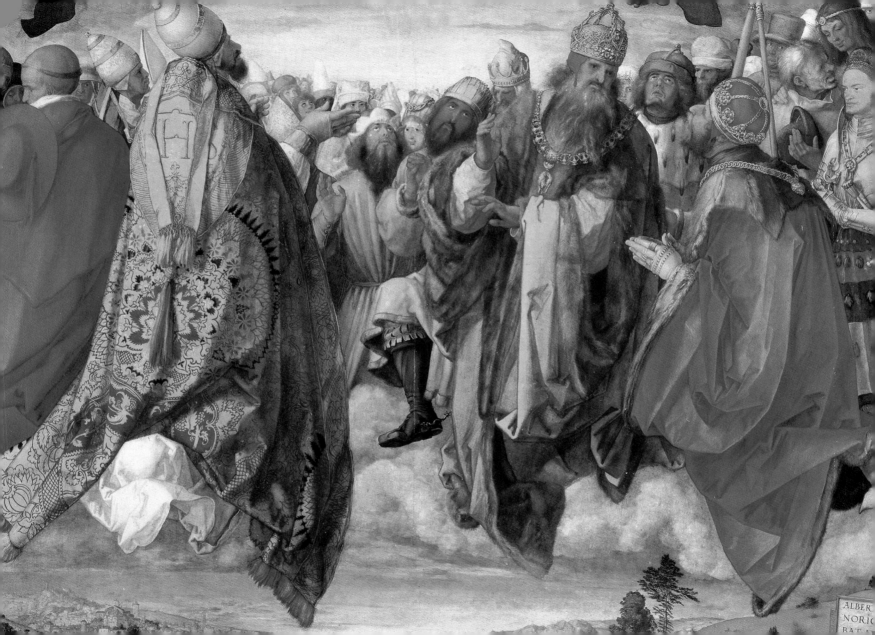

ALBER
NORIC
RAT

No person who is not a great sculptor
or painter can be an architect.
If he is not a sculptor or painter,
he can only be a builder.

<small>JOHN RUSKIN</small>

**The Marketplace and
Town Hall of Haarlem,** 1671
Gerrit Adriaensz Berckheyde
Frans Hals Museum, Haarlem

1 **2** 3 4 5 6 7 8 9 10 11 12 13 14 15 16 17 18 19 20 21 22 23 24 25 26 27 28 29 30

NOVEMBER

Come watch with me the shaft of fire that glows
In yonder West: the fair, frail palaces,
The fading Alps and archipelagoes,
And great cloud-continents of sunset-seas.

THOMAS BAILEY ALDRICH

Sunset (The Brothers), 1830–35
Caspar David Friedrich
The State Hermitage Museum, St. Petersburg

3
1 2 3 4 5 6 7 8 9 10 11 12 13 14 15 16 17 18 19 20 21 22 23 24 25 26 27 28 29 30

NOVEMBER

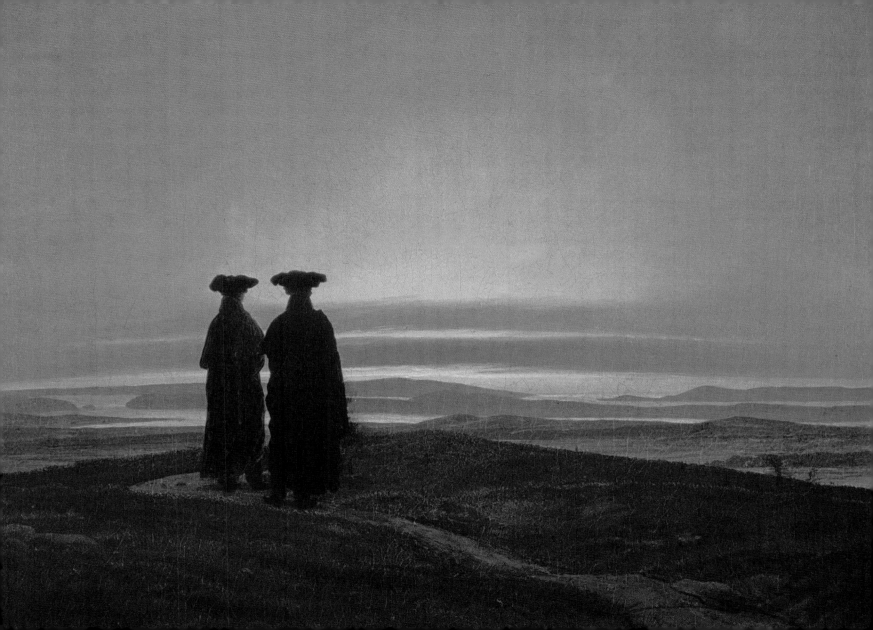

Double, double, toil and trouble,
fire burn and cauldron bubble.

Wᴉʟʟɪᴀᴍ Sʜᴀᴋᴇꜱᴘᴇᴀʀᴇ

Gathering of Witches, 1607
Frans Francken II
Kunsthistorisches Museum, Vienna

1 2 3 **4** 5 6 7 8 9 10 11 12 13 14 15 16 17 18 19 20 21 22 23 24 25 26 27 28 29 30

NOVEMBER

We live not according to reason,
but according to fashion.

Lucius Annaeus Seneca

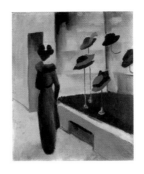

Hat Shop, 1913
August Macke
Lenbachhaus, Munich

1 2 3 4 **5** 6 7 8 9 10 11 12 13 14 15 16 17 18 19 20 21 22 23 24 25 26 27 28 29 30

NOVEMBER

Practise what you know,
and it will help to make clear
what now you do not know.

Rembrandt van Rijn

Parable of the Rich Man, 1627
Rembrandt van Rijn
Gemäldegalerie, Berlin

1 2 3 4 5 **6** 7 8 9 10 11 12 13 14 15 16 17 18 19 20 21 22 23 24 25 26 27 28 29 30

NOVEMBER

We do not quit playing because we grow old,
we grow old because we quit playing.

Children at Play, 1560
Pieter Brueghel the Elder
Kunsthistorisches Museum, Vienna

1 2 3 4 5 6 **7** 8 9 10 11 12 13 14 15 16 17 18 19 20 21 22 23 24 25 26 27 28 29 30

NOVEMBER

Temptations, when we meet them at first,
are as the lion that roared upon Samson;
but if we overcome them, the next time we see
them we shall find a nest of honey within.

JOHN BUNYAN

Samson in the Lion's Den, 17th century
Luca Giordano
Museo Nacional del Prado, Madrid

1 2 3 4 5 6 7 **8** 9 10 11 12 13 14 15 16 17 18 19 20 21 22 23 24 25 26 27 28 29 30

NOVEMBER

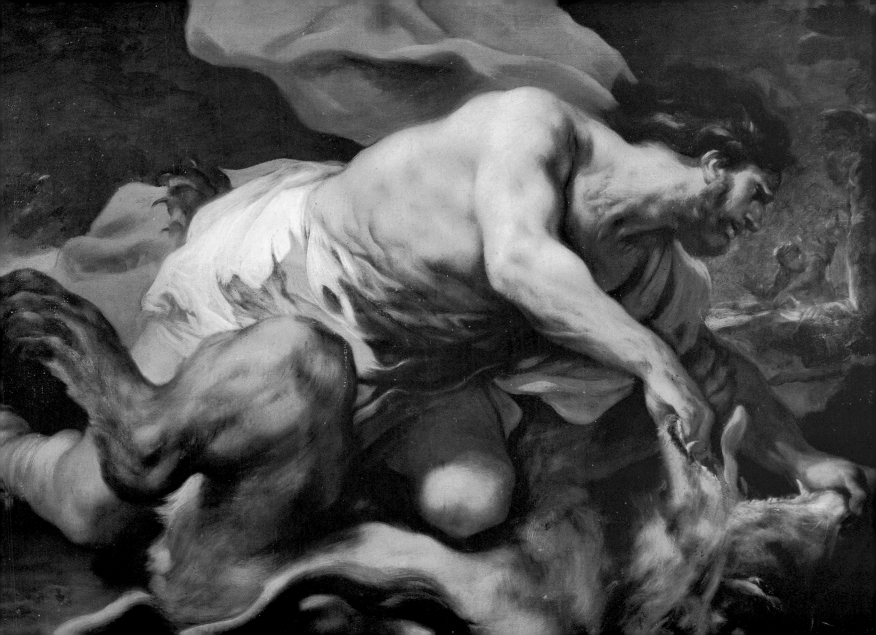

There are no fine tones in watercolor unless one makes play with the white of the paper ... Contrary to the rules, one must have no fear about leaving blank spaces.

PAUL SIGNAC

La Turballe, 1930
Paul Signac
The Pushkin Museum of Fine Arts, Moscow

1 2 3 4 5 6 7 8 **9** 10 11 12 13 14 15 16 17 18 19 20 21 22 23 24 25 26 27 28 29 30

NOVEMBER

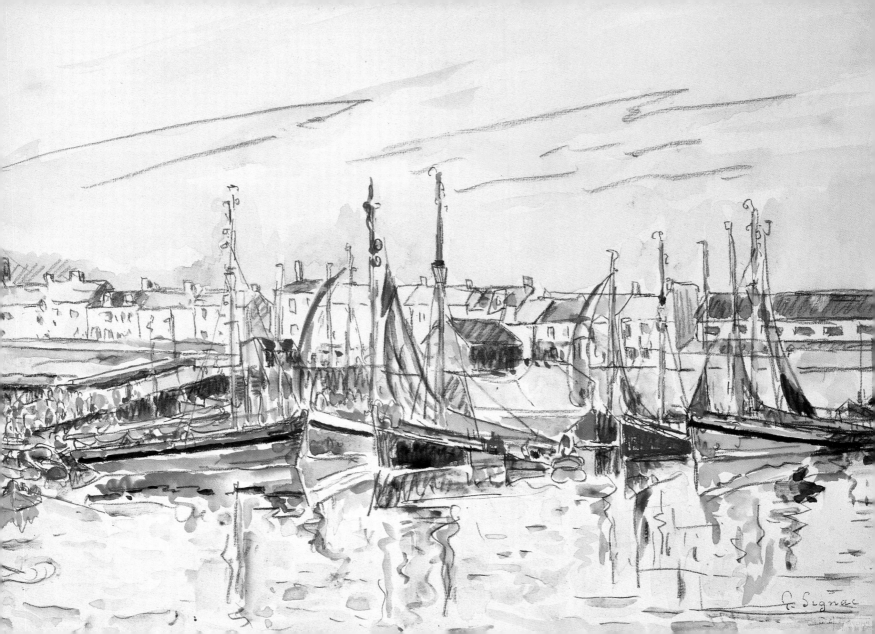

How sweet and gracious, even in common speech,
is that fine sense which men call courtesy!
Wholesome as air and genial as the light,
Welcome in every clime as the breath of flowers.

JAMES THOMAS FIELDS

Marriage A-la-Mode: 4. The Toilette, 1743–45
William Hogarth
National Gallery, London

1 2 3 4 5 6 7 8 9 **10** 11 12 13 14 15 16 17 18 19 20 21 22 23 24 25 26 27 28 29 30

NOVEMBER

The greatest good you can do for another is not just to share your riches but to reveal to him his own.

Benjamin Disraeli

St. Martin and the Beggar, *c.* 1597–99
El Greco
National Gallery of Art, Washington D.C.

1 2 3 4 5 6 7 8 9 10 **11** 12 13 14 15 16 17 18 19 20 21 22 23 24 25 26 27 28 29 30

NOVEMBER

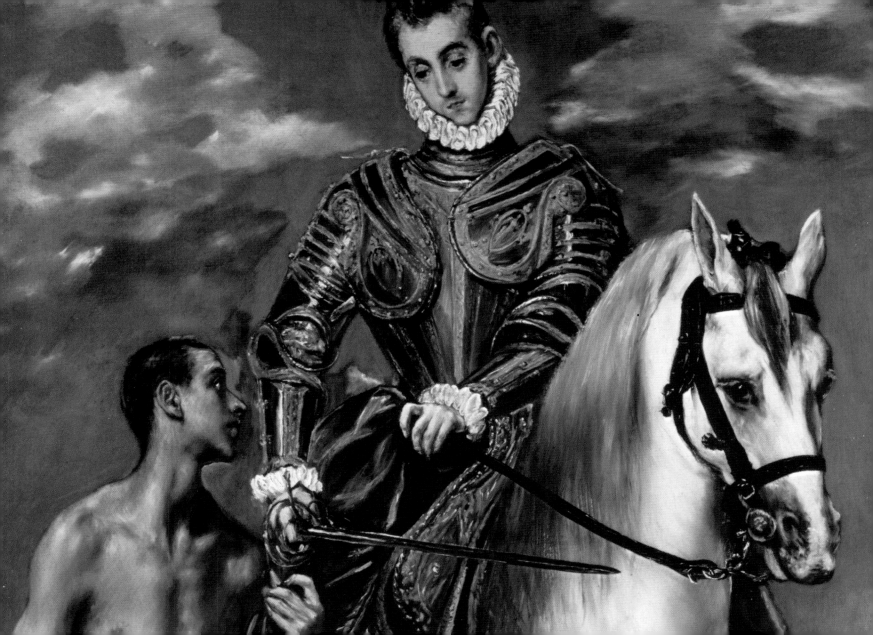

Neither a lofty degree of intelligence nor imagination nor both together go to the making of genius. Love, love, love, that is the soul of genius.

WOLFGANG AMADEUS MOZART

Cupid Unfastens the Belt of Venus, 1788
Sir Joshua Reynolds
The State Hermitage Museum, St. Petersburg

1 2 3 4 5 6 7 8 9 10 11 **12** 13 14 15 16 17 18 19 20 21 22 23 24 25 26 27 28 29 30

NOVEMBER

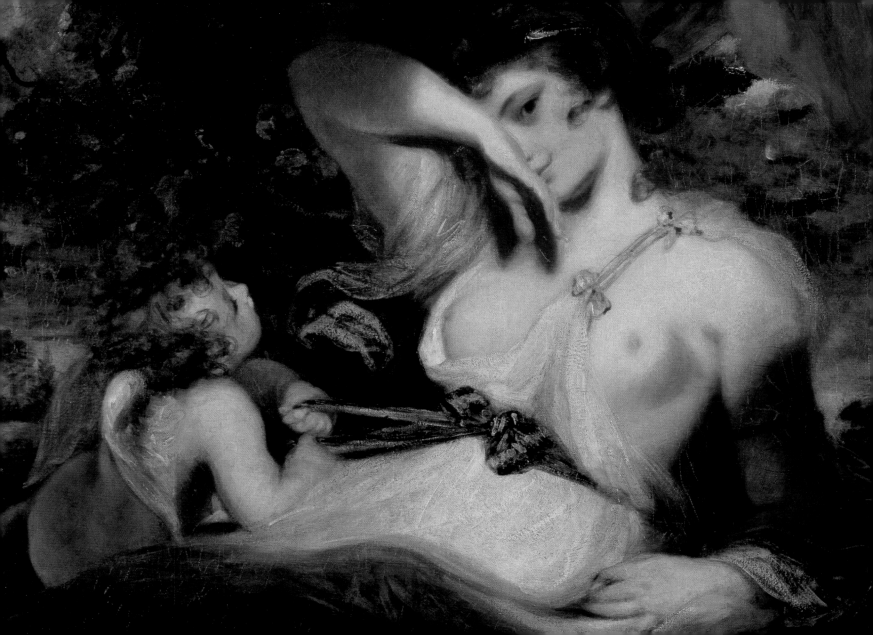

One of the most attractive things about the flowers is their beautiful reserve.

<small>HENRY DAVID THOREAU</small>

Basket of Flowers, *c.* 1640–50
Balthasar van der Ast
Nationalmuseum, Stockholm

1 2 3 4 5 6 7 8 9 10 11 12 **13** 14 15 16 17 18 19 20 21 22 23 24 25 26 27 28 29 30

NOVEMBER

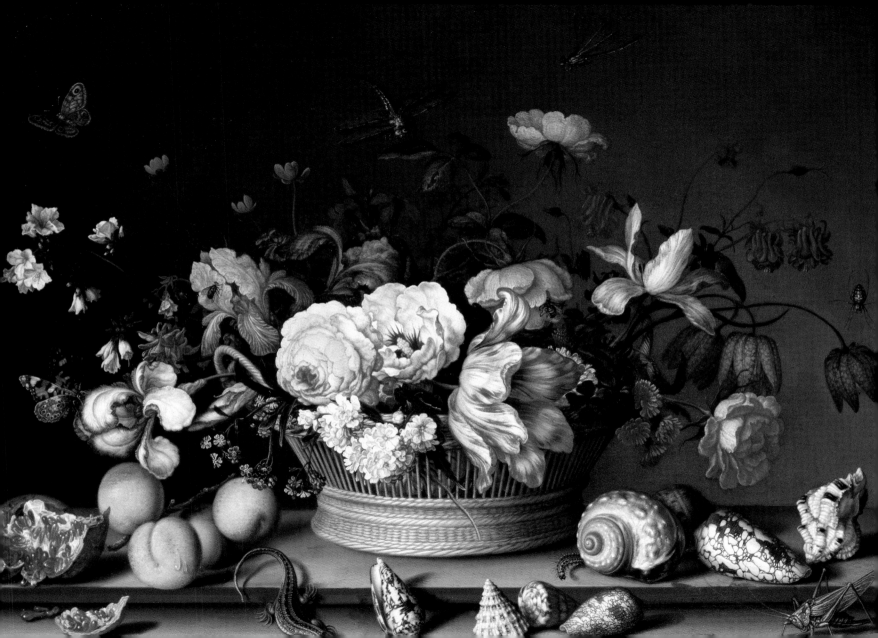

The Thames was all gold. God it was beautiful,
so fine that I began working a frenzy, following
the sun and its reflections on the water.

<small>CLAUDE MONET</small>

The Parliament in London at Sunset, 1903
Claude Monet
National Gallery of Art, Washington D.C.

1 2 3 4 5 6 7 8 9 10 11 12 13 **14** 15 16 17 18 19 20 21 22 23 24 25 26 27 28 29 30

NOVEMBER

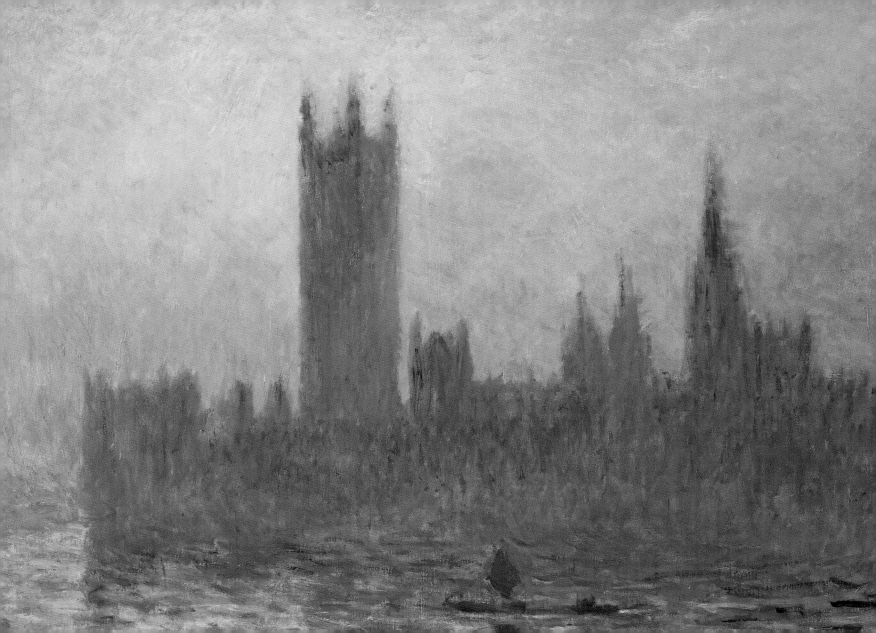

We must not let daylight in upon the magic.

<small>WALTER BAGEHOT</small>

The Magician, early 16th century
Dosso Dossi
The Pushkin Museum of Fine Arts, Moscow

1 2 3 4 5 6 7 8 9 10 11 12 13 14 **15** 16 17 18 19 20 21 22 23 24 25 26 27 28 29 30

NOVEMBER

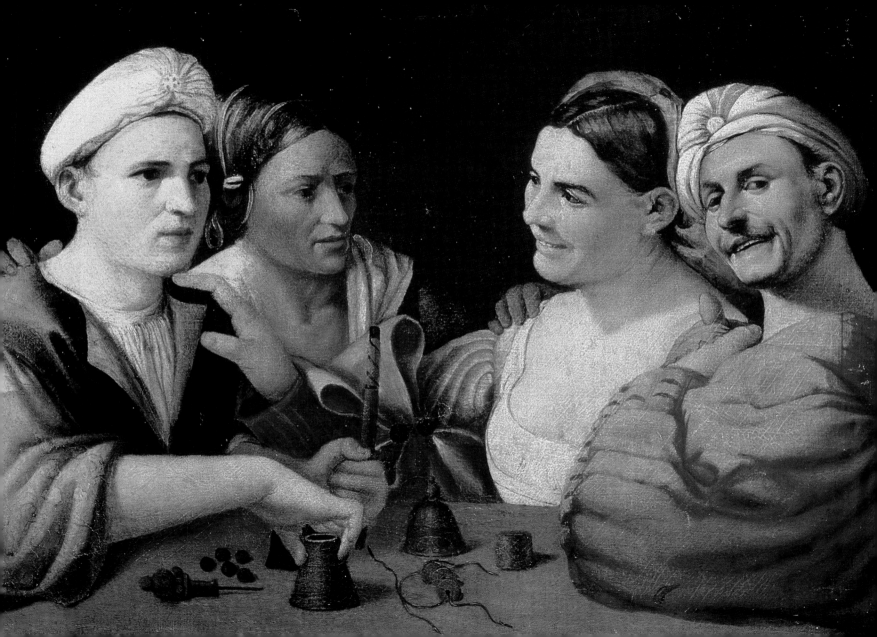

Music expresses that which cannot be put into words and that which cannot remain silent.

Victor Hugo

At the Piano, 1910
Herbert Masaryk
National Gallery, Prague

1 2 3 4 5 6 7 8 9 10 11 12 13 14 15 **16** 17 18 19 20 21 22 23 24 25 26 27 28 29 30

NOVEMBER

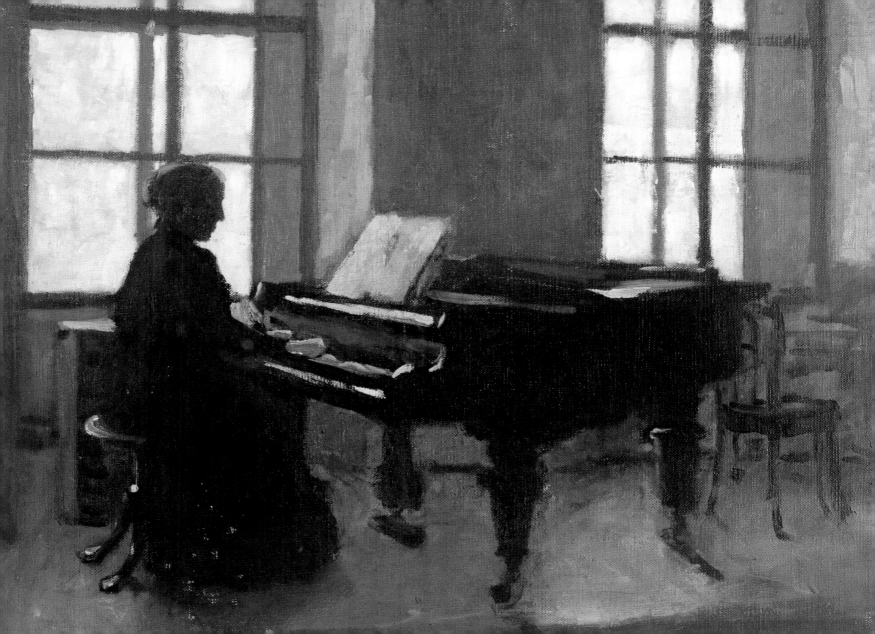

Remember those who are in bonds,
as bound with them;
and those who are ill-treated,
since you are also in the body.

HEBREWS, 13:3

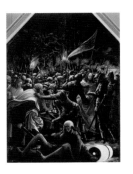

The Arrest of Christ. From the Saint Sebastian Altar, 1510–12
Albrecht Altdorfer
St. Florian Church, Linz

1 2 3 4 5 6 7 8 9 10 11 12 13 14 15 16 **17** 18 19 20 21 22 23 24 25 26 27 28 29 30

NOVEMBER

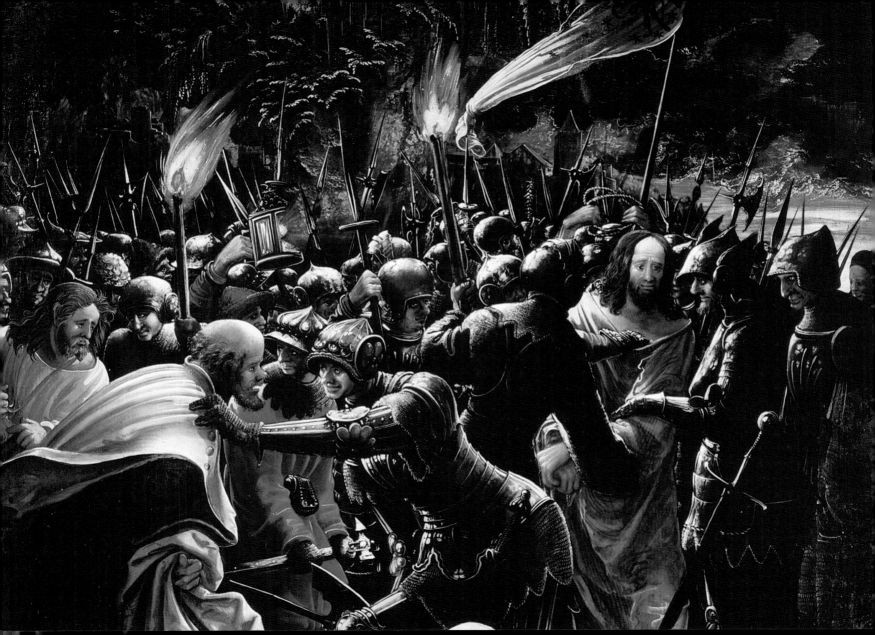

Love the animals, love the plants, love everything.
If you love everything, you will perceive the divine
mystery in things ... And you will come at last to
love the whole world with an all-embracing love.

Fyodor Dostoyevsky

Bison in Winter (Red Bison), 1913
Franz Marc
Private Collection of Dr. Hänggi, Basel

1 2 3 4 5 6 7 8 9 10 11 12 13 14 15 16 17 **18** 19 20 21 22 23 24 25 26 27 28 29 30

NOVEMBER

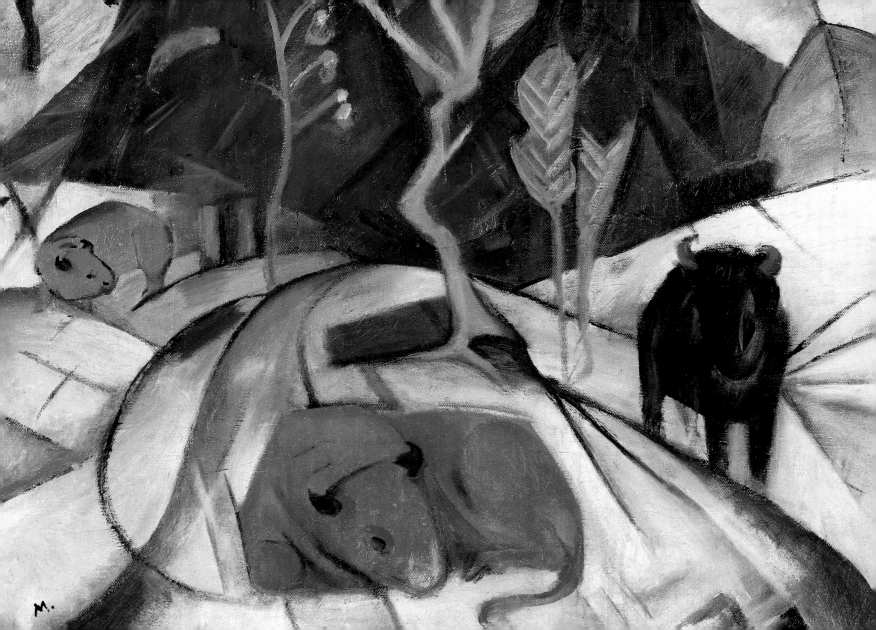

The creation continues incessantly through the media of man.

A NTONI G AUDI

Parting of the Water and the Creation of the Heavens and the Stars. Detail from the Altar of St. Petri, Hamburg, 1383
Master Bertram
Kunsthalle, Hamburg

1 2 3 4 5 6 7 8 9 10 11 12 13 14 15 16 17 18 **19** 20 21 22 23 24 25 26 27 28 29 30

NOVEMBER

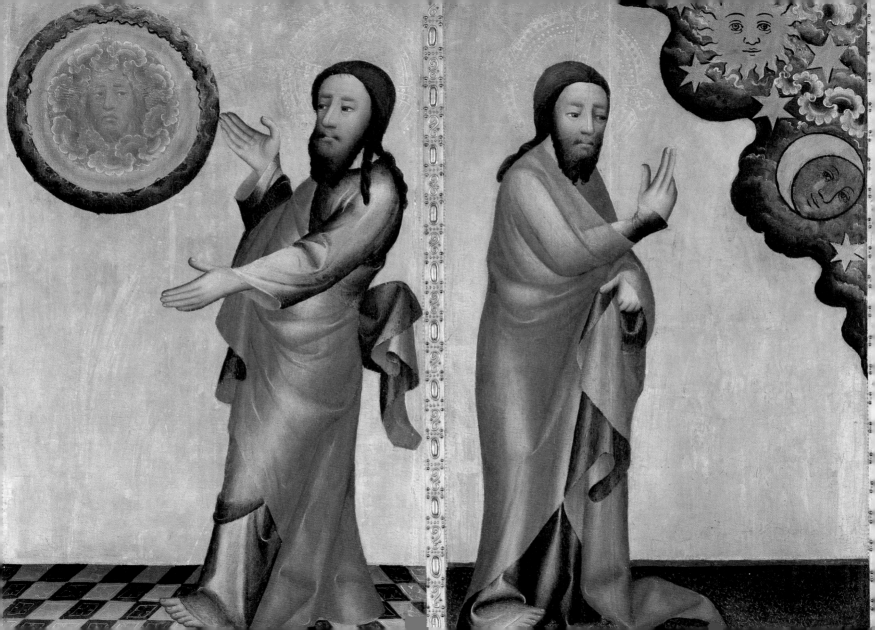

Whenever I see a Frans Hals
I feel like painting,
but when I see a Rembrandt
I feel like giving up!

<small>MAX LIEBERMANN</small>

David Plays Before Saul, 1658–59
Rembrandt van Rijn
Mauritshuis, The Hague

1 2 3 4 5 6 7 8 9 10 11 12 13 14 15 16 17 18 19 **20** 21 22 23 24 25 26 27 28 29 30

NOVEMBER

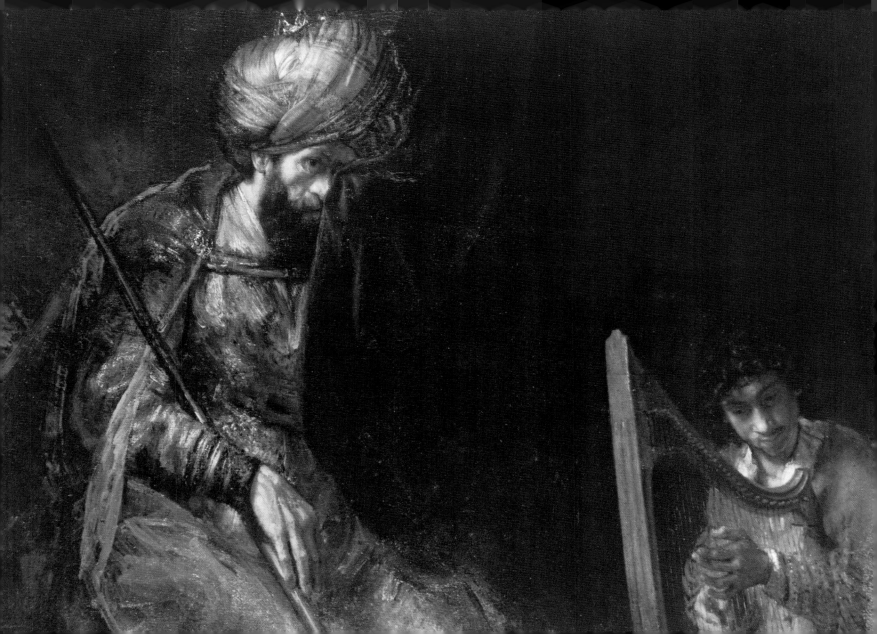

Art cannot be modern, art is timeless.

<small>EGON SCHIELE</small>

Edge of the City III, 1917–18
Egon Schiele
Neue Galerie (Joanneum), Graz

1 2 3 4 5 6 7 8 9 10 11 12 13 14 15 16 17 18 19 20 **21** 22 23 24 25 26 27 28 29 30

NOVEMBER

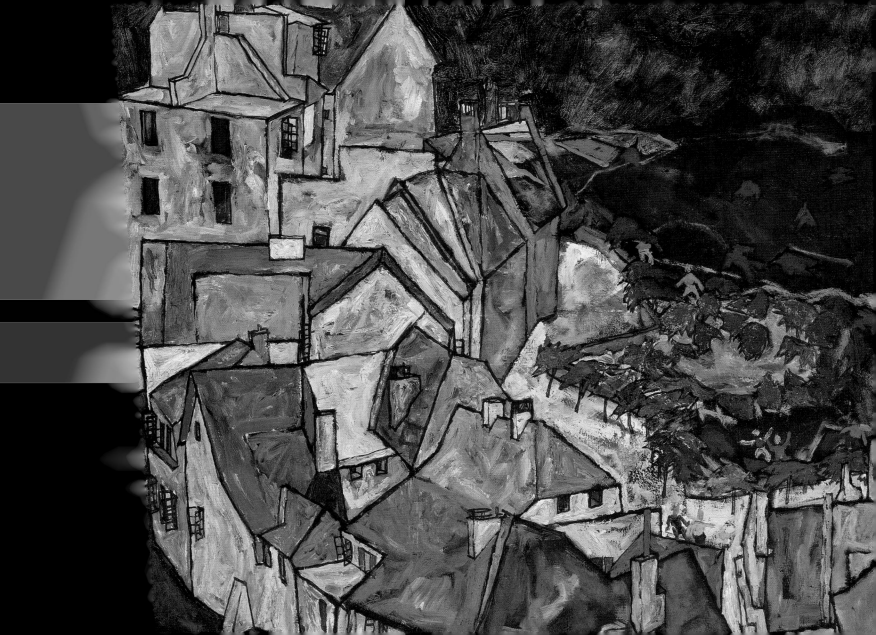

*There is no frigate like a book
To take us lands away,
Nor any coursers like a page
Of prancing poetry.*

Emily Dickinson

Girl Reading, 1776
Jean-Honoré Fragonard
National Gallery of Art, Washington D.C.

1 2 3 4 5 6 7 8 9 10 11 12 13 14 15 16 17 18 19 20 21 **22** 23 24 25 26 27 28 29 30

NOVEMBER

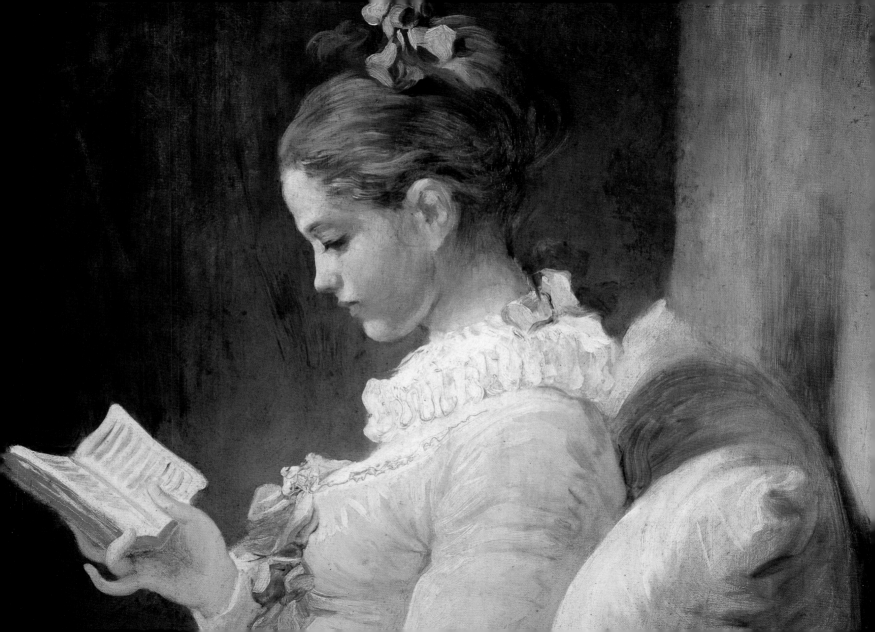

Yet all how beautiful! Pillars of pearl
Propping the cliffs above, stalactites bright
From the ice roof depending; and beneath,
Grottoes and temples with their crystal spires
And gleaming columns radiant in the sun.

WILLIAM HENRY BURLEIGH

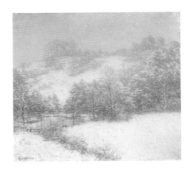

The Winter's Festival, 1913
Willard Metcalf
Fine Arts Museums of San Francisco

1 2 3 4 5 6 7 8 9 10 11 12 13 14 15 16 17 18 19 20 21 22 **23** 24 25 26 27 28 29 30

NOVEMBER

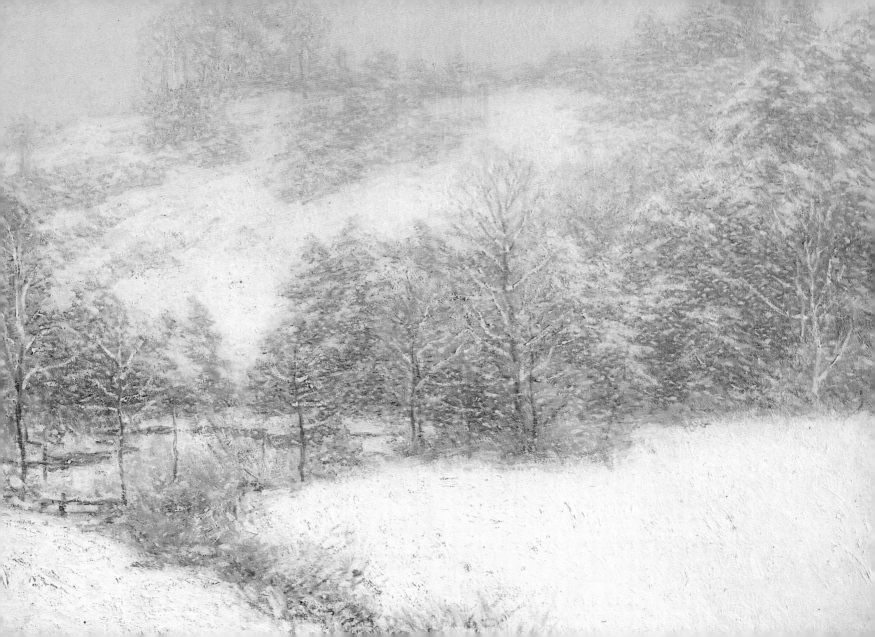

*A professional model
is like a stuffed owl.
These girls are alive.*

<small>Henri de Toulouse-Lautrec</small>

Quadrille in Moulin Rouge, 1885
Henri de Toulouse-Lautrec
National Gallery of Art, Washington D.C.

1 2 3 4 5 6 7 8 9 10 11 12 13 14 15 16 17 18 19 20 21 22 23 **24** 25 26 27 28 29 30

NOVEMBER

The sea! the sea! the open sea!
The blue, the fresh, the ever free!
Without a mark, without a bound,
It runneth the earth's wide regions round;
it plays with the clouds; it mocks the skies;
Or like a cradled creature lies.

BARRY CORNWALL

Oceanic Landscape with Sailboats, 1667
Ludolf Backhuyzen
Palazzo Pitti, Florence

1 2 3 4 5 6 7 8 9 10 11 12 13 14 15 16 17 18 19 20 21 22 23 24 **25** 26 27 28 29 30

NOVEMBER

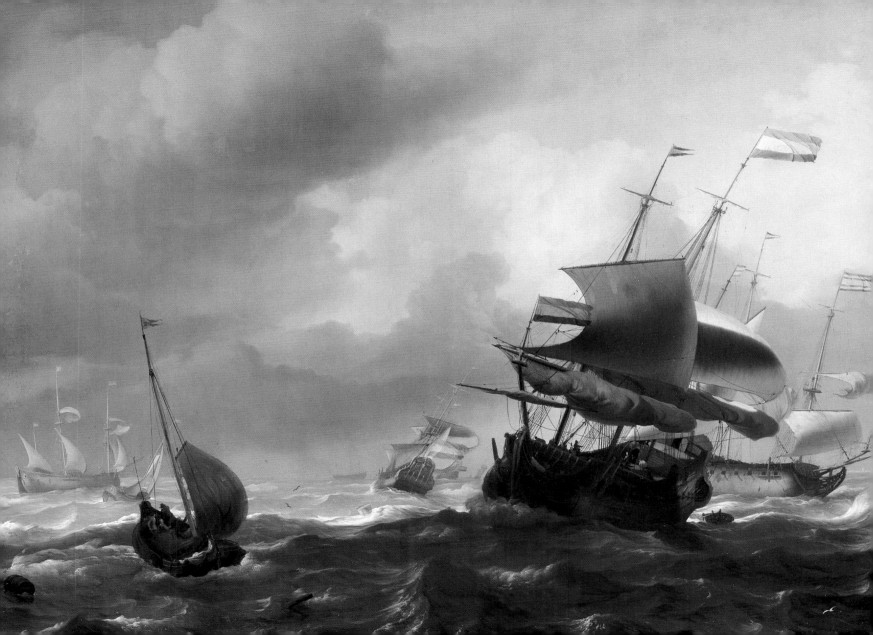

In the arts the way in which an idea is rendered, and the manner in which it is expressed, is much more important than the idea itself. To give a body and a perfect form to one's thought, this— and only this—is to be an artist.

Jacques-Louis David

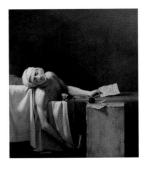

Death of Marat, 1793
Jacques-Louis David
The Pushkin Museum of Fine Arts, Moscow

1 2 3 4 5 6 7 8 9 10 11 12 13 14 15 16 17 18 19 20 21 22 23 24 25 **26** 27 28 29 30

NOVEMBER

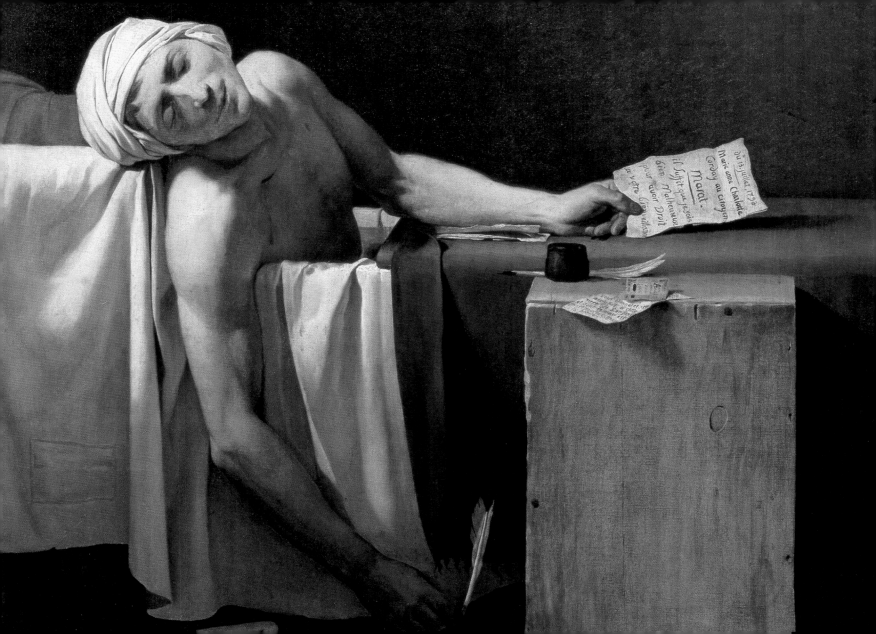

Du 13 juillet 1793
Marie anne Charlotte
Corday au citoyen
Marat.
il suffit que je sois
bien Malheureuse
pour avoir Droit
à votre bienveillance.

At Dresden on the Elbe, that handsome city,
Where straw hats, verses, and cigars are made,
They've built (it well may make us feel afraid,)
A music club and music warehouse pretty.

HEINRICH HEINE

View of the Old Town of Dresden
mid-18th century
Canaletto
Kunsthalle, Karlsruhe

1 2 3 4 5 6 7 8 9 10 11 12 13 14 15 16 17 18 19 20 21 22 23 24 25 26 **27** 28 29 30

NOVEMBER

And see the rivers how they run
Through woods and meads, in shade and sun,
Sometimes swift, sometimes slow,
Wave succeeding wave, they go
A various journey to the deep
Like human life to endless sleep!

JOHN DYER

View of Kymi River, 1902
Victor Westerholm
South Karelia Art Museum, Lapeenranta

1 2 3 4 5 6 7 8 9 10 11 12 13 14 15 16 17 18 19 20 21 22 23 24 25 26 27 **28** 29 30

NOVEMBER

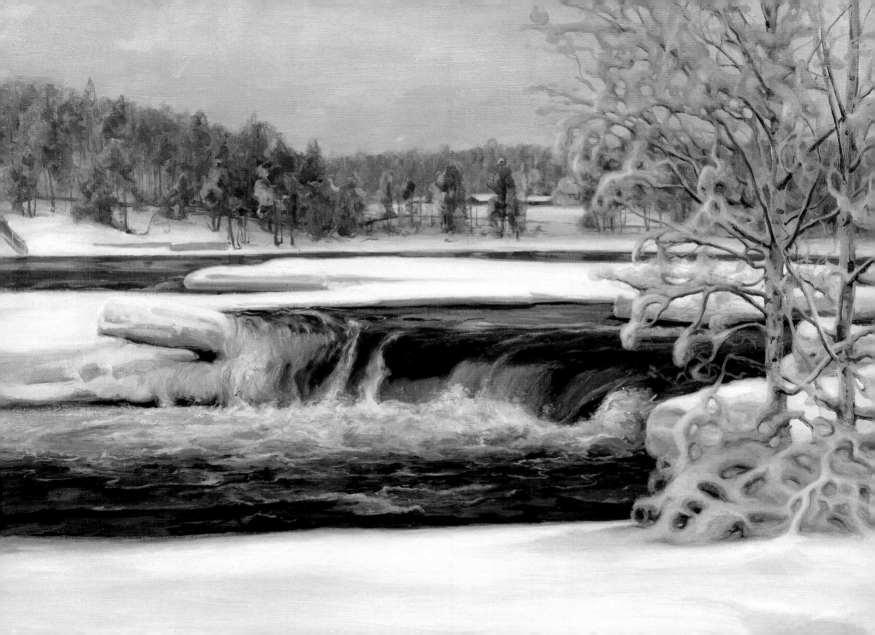

The "Kingdom of Heaven" is a condition of the heart—not something that comes "upon the earth" or "after death."

<small>Friedrich Nietzsche</small>

Virgin and Child with SS Donation and George and the Donor, 1436
Jan van Eyck
Musée des Beaux-Arts, Bruges

1 2 3 4 5 6 7 8 9 10 11 12 13 14 15 16 17 18 19 20 21 22 23 24 25 26 27 28 **29** 30

NOVEMBER

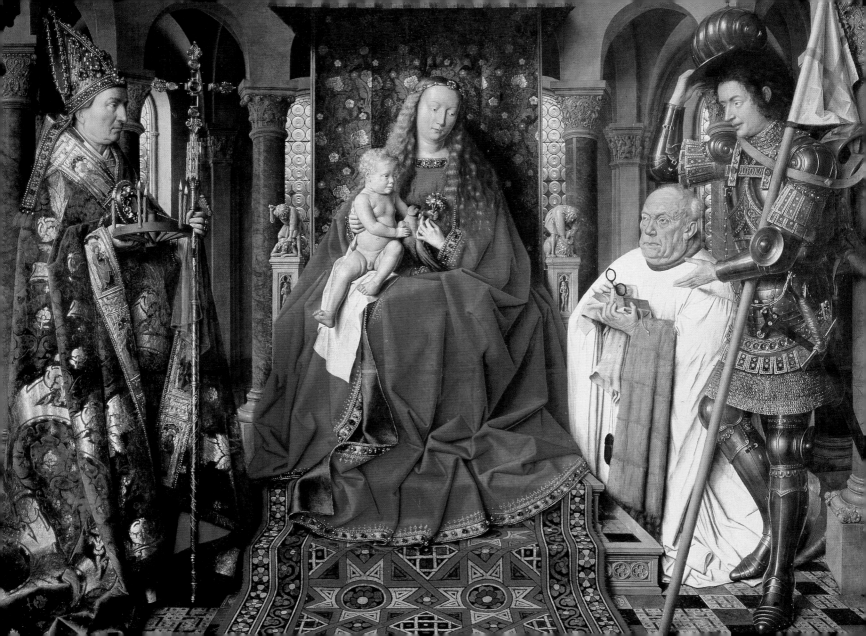

*There are no objects
and no colors in art,
only expressions.*

FRANZ MARC

Stables, 1913
Franz Marc
Guggenheim Museum, New York

1 2 3 4 5 6 7 8 9 10 11 12 13 14 15 16 17 18 19 20 21 22 23 24 25 26 27 28 29 **30**

NOVEMBER

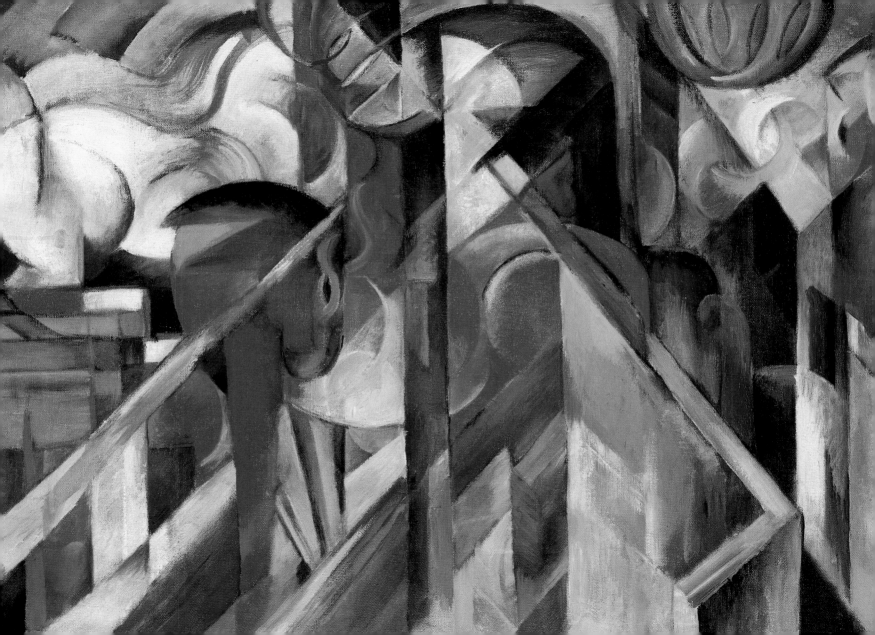

Angels bend to you in solemn ceremony and Saints pray where your foot steps: glorious Queen of Heaven! To you the lyre of the spheres resounds, which God has strung.

AUGUST WILHELM VON SCHLEGEL

The Assumption of Mary, 1519–20
Luca Signorelli
Museo Diocesano, Corona

1 2 3 4 5 6 7 8 9 10 11 12 13 14 15 16 17 18 19 20 21 22 23 24 25 26 27 28 29 30 31

DECEMBER

Some say they see
poetry in my paintings;
I see only science.

Georges Seurat

Models, 1886–88
Georges Seurat
Private Collection

1 2 3 4 5 6 7 8 9 10 11 12 13 14 15 16 17 18 19 20 21 22 23 24 25 26 27 28 29 30 31

DECEMBER

All religions must be tolerated, for every man must get to heaven his own way.

Frederick the Great

Madonna with the Parrots, c. 1525–28
Hans Baldung
Germanic National Museum, Nuremberg

1 2 **3** 4 5 6 7 8 9 10 11 12 13 14 15 16 17 18 19 20 21 22 23 24 25 26 27 28 29 30 31

DECEMBER

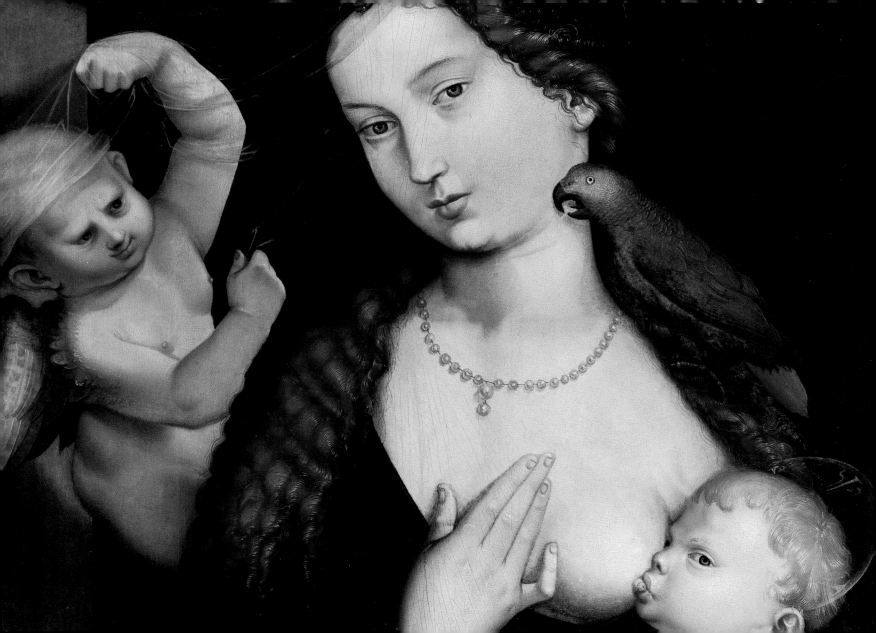

Every child is an artist.
The problem is how to remain
an artist once he grows up.

Pablo Picasso

Night Fishing at Antibes, 1939
Pablo Picasso
Museum of Modern Art, New York

1 2 3 **4** 5 6 7 8 9 10 11 12 13 14 15 16 17 18 19 20 21 22 23 24 25 26 27 28 29 30 31

DECEMBER

If the riches of the Indies, or the crowns of all the kingdoms of Europe, were laid at my feet in exchange for my love of reading, I would spurn them all.

FRANÇOIS FENELON

Maria Adelaide, Reading, 1753
Jean-Etienne Liotard
Uffizi Gallery, Florence

1 2 3 4 **5** 6 7 8 9 10 11 12 13 14 15 16 17 18 19 20 21 22 23 24 25 26 27 28 29 30 31

DECEMBER

I have to stay alone in order to fully contemplate and feel nature.

Caspar David Friedrich

Tree of Ravens, *c.* 1882
Caspar David Friedrich
Musée du Louvre, Paris

1 2 3 4 5 **6** 7 8 9 10 11 12 13 14 15 16 17 18 19 20 21 22 23 24 25 26 27 28 29 30 31

DECEMBER

*Music is well said
to be the speech of angels.*

Musician Angel, *c.* 1519
Rosso Fiorentino
Villa Farnesina, Rome

1 2 3 4 5 6 **7** 8 9 10 11 12 13 14 15 16 17 18 19 20 21 22 23 24 25 26 27 28 29 30 31

DECEMBER

*Paintings have a life of their own
that derives from the painter's soul.*

Vincent van Gogh

St. Luke Painting the Madonna, c. 1520
Mabuse
National Gallery, Prague

8 1 2 3 4 5 6 7 8 9 10 11 12 13 14 15 16 17 18 19 20 21 22 23 24 25 26 27 28 29 30 31

DECEMBER

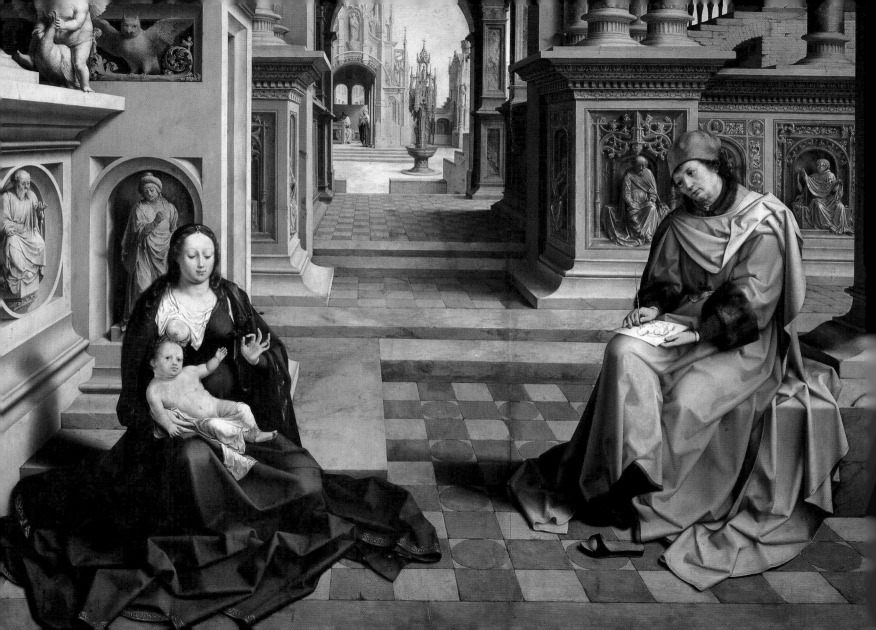

I do not wish them to have power over men, but over themselves.

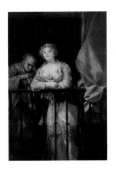

Maja and the Procuress on the Balcony, *c.* 1808–12
Francisco José de Goya
Museo Nacional del Prado, Madrid

9

1 2 3 4 5 6 7 8 **9** 10 11 12 13 14 15 16 17 18 19 20 21 22 23 24 25 26 27 28 29 30 31

DECEMBER

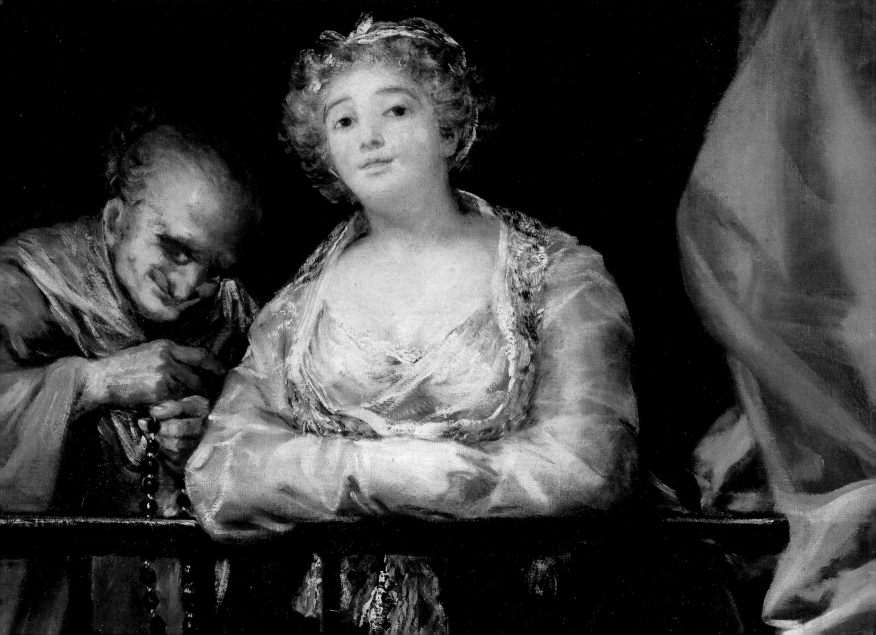

Let me sip from the goblet of worth.

Sean Kirkpatrick Clancy

Vanitas Still-Life with Nautilus Goblet, 1636
Pieter Claesz
Westphalia State Museum of Art and Cultural History, Münster

1 2 3 4 5 6 7 8 9 **10** 11 12 13 14 15 16 17 18 19 20 21 22 23 24 25 26 27 28 29 30 31

DECEMBER

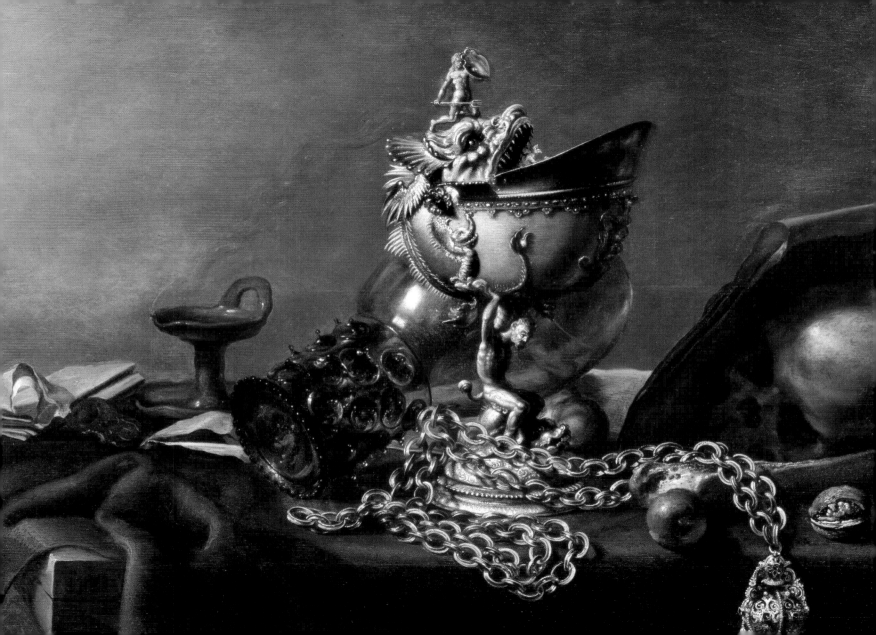

Nor need we power or splendor,
wide hall or lordly dome;
The good, the true, the tender—
these form the wealth of home.

<small>SARAH J. HALE</small>

The Holy Family with a
Painted Frame and Drapery, 1646
Rembrandt van Rijn
Staatliche Gemäldegalerie, Kassel

1 2 3 4 5 6 7 8 9 10 **11** 12 13 14 15 16 17 18 19 20 21 22 23 24 25 26 27 28 29 30 31

DECEMBER

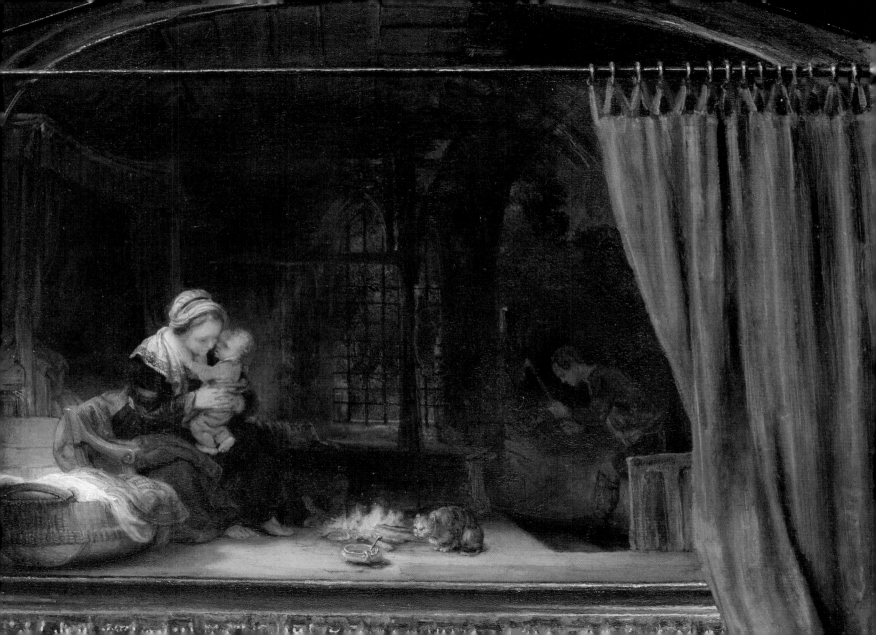

Happiness, that grand mistress
of the ceremonies in the dance of life,
impels us through all its mazes
and meanderings, but leads none of us
by the same route.

<small>CHARLES CALEB COLTON</small>

Madame Pompadour, 1758
François Boucher
National Gallery of Scotland, Edinburgh

1 2 3 4 5 6 7 8 9 10 11 **12** 13 14 15 16 17 18 19 20 21 22 23 24 25 26 27 28 29 30 31

DECEMBER

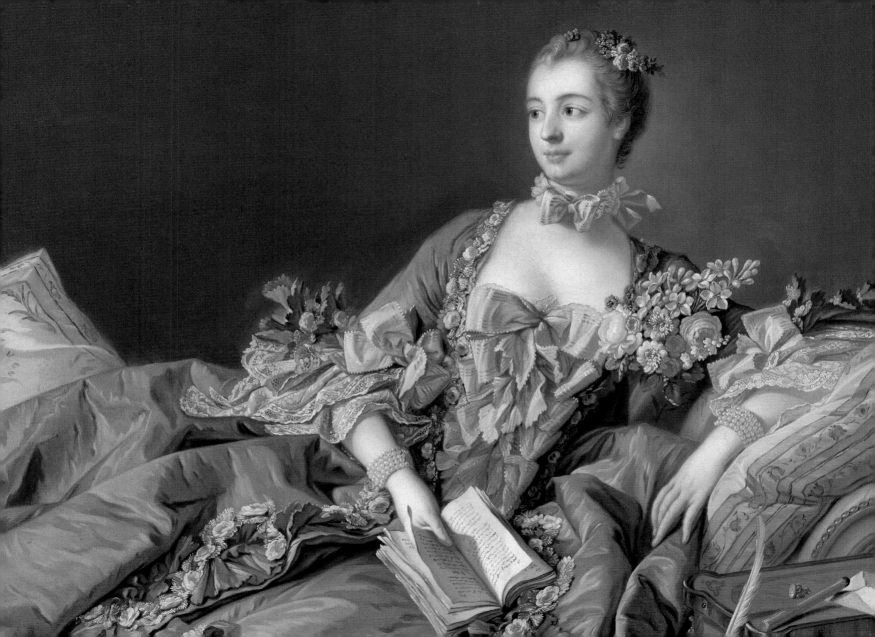

A painting requires a little mystery,
some vagueness, some fantasy.
When you always make your meaning
perfectly plain you end up boring people.

EDGAR DEGAS

Woman Combing her Hair and a Housemaid, *c.* 1894
Edgar Degas
Tate Gallery, London

1 2 3 4 5 6 7 8 9 10 11 12 **13** 14 15 16 17 18 19 20 21 22 23 24 25 26 27 28 29 30 31

DECEMBER

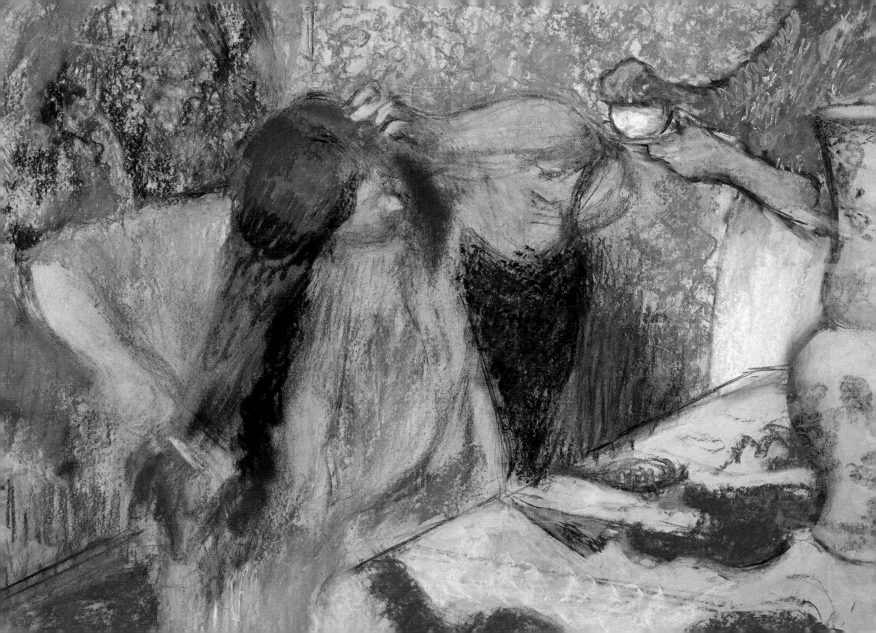

You may have the universe
if I may have Italy.

<small>GIUSEPPE VERDI</small>

Venice, The Dogana and San Giorgio Maggiore, 1834
Joseph Mallord William Turner
National Gallery of Art, Washington D.C.

1 2 3 4 5 6 7 8 9 10 11 12 13 **14** 15 16 17 18 19 20 21 22 23 24 25 26 27 28 29 30 31

DECEMBER

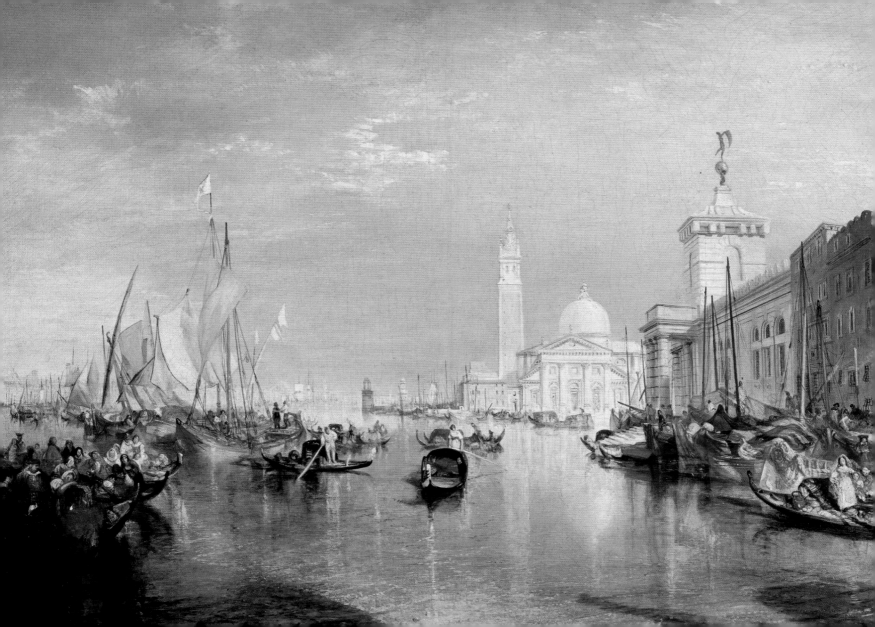

We may live without friends;
we may live without books.
But civilized men cannot live
without cooks.

OWEN MEREDITH

Interior of a Kitchen, 1644
David Teniers
Mauritshuis, The Hague

1 2 3 4 5 6 7 8 9 10 11 12 13 14 **15** 16 17 18 19 20 21 22 23 24 25 26 27 28 29 30 31

DECEMBER

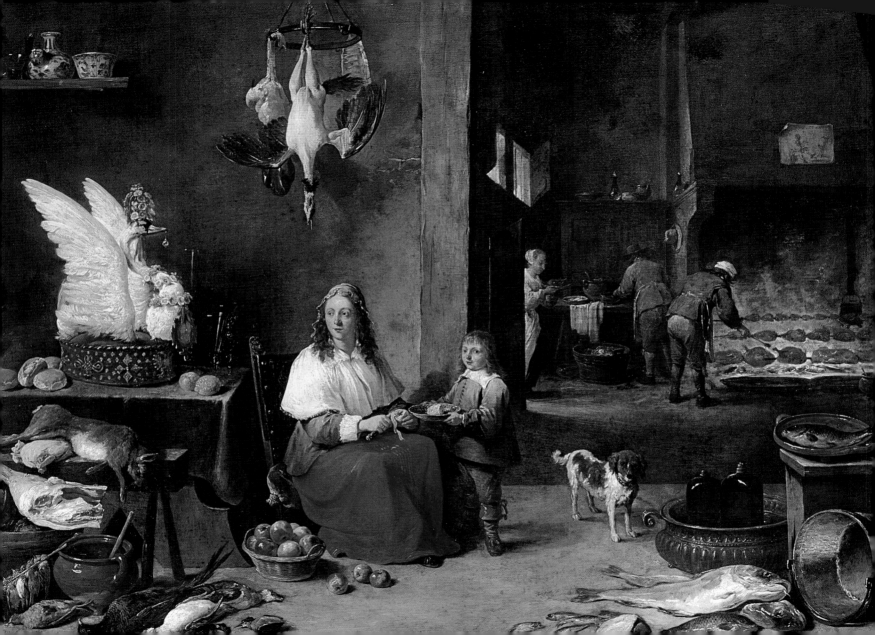

In wine there is truth.

Alkaios

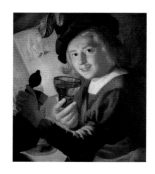

Young Drinker, 17th century
Gerrit van Honthorst
Residenzgalerie, Salzburg

1 2 3 4 5 6 7 8 9 10 11 12 13 14 15 **16** 17 18 19 20 21 22 23 24 25 26 27 28 29 30 31

DECEMBER

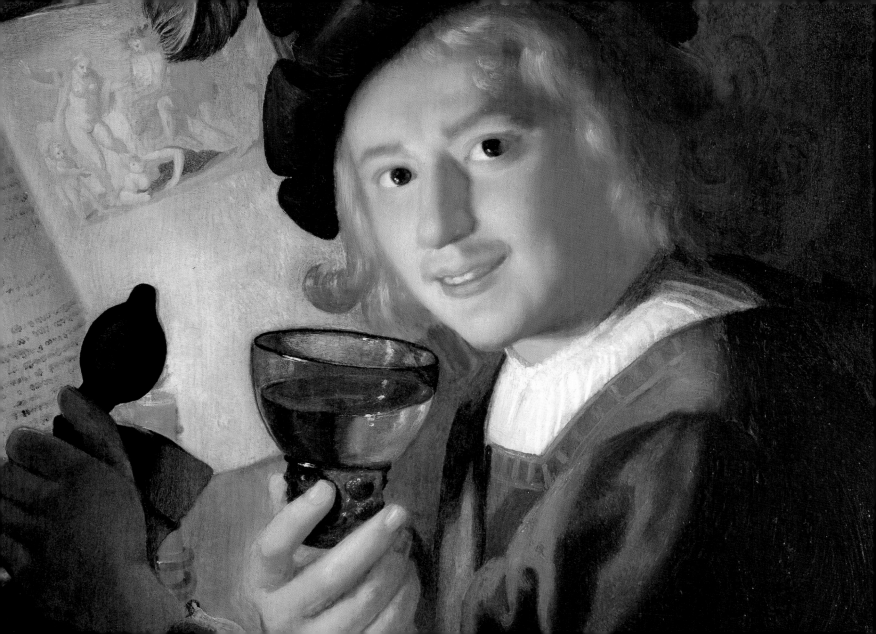

Fortune does not stand waiting at anyone's door.

The Dutch Proverbs, 1559
Pieter Brueghel the Elder
Gemäldegalerie, Berlin

1 2 3 4 5 6 7 8 9 10 11 12 13 14 15 16 **17** 18 19 20 21 22 23 24 25 26 27 28 29 30 31

DECEMBER

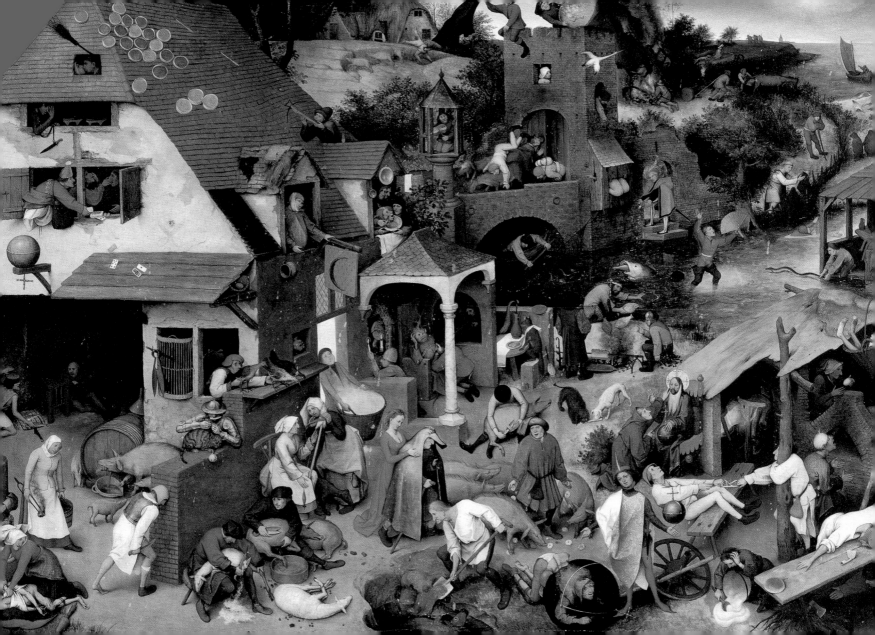

'Tis so much to be a king,
that he only is so by being so.

MICHEL DE MONTAIGNE

Edward, Prince of Wales, 1539
Hans Holbein the Younger
National Gallery of Art, Washington D.C.

18

1 2 3 4 5 6 7 8 9 10 11 12 13 14 15 16 17 18 19 20 21 22 23 24 25 26 27 28 29 30 31

DECEMBER

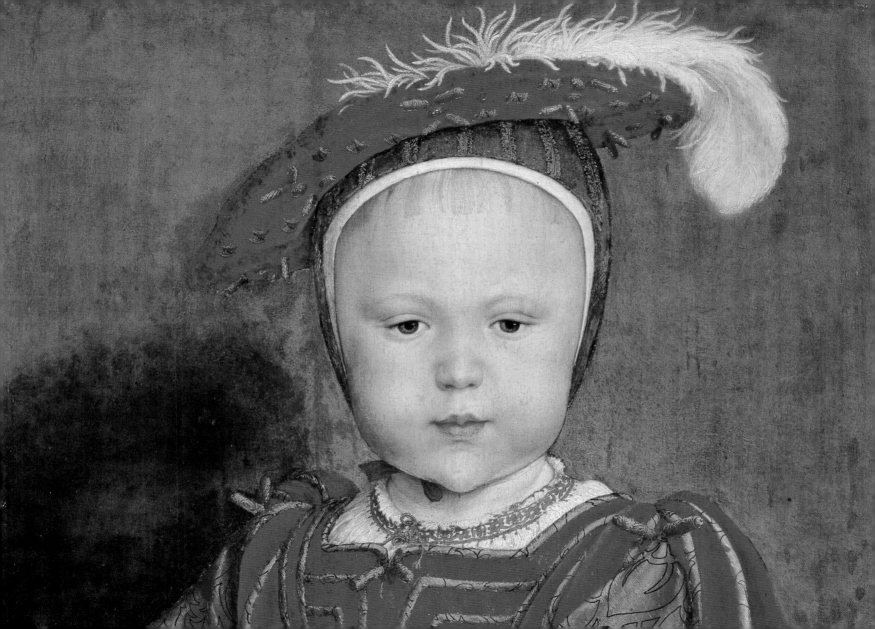

Beneath the transparent veil of black
We glimpse celestial angels made flesh.
Paint, O Titian, perfect master,
That others might see your great works.

PIETRO ARETINO

Danaë, 1546–53
Titian
The State Hermitage Museum, St. Petersburg

1 2 3 4 5 6 7 8 9 10 11 12 13 14 15 16 17 18 **19** 20 21 22 23 24 25 26 27 28 29 30 31

DECEMBER

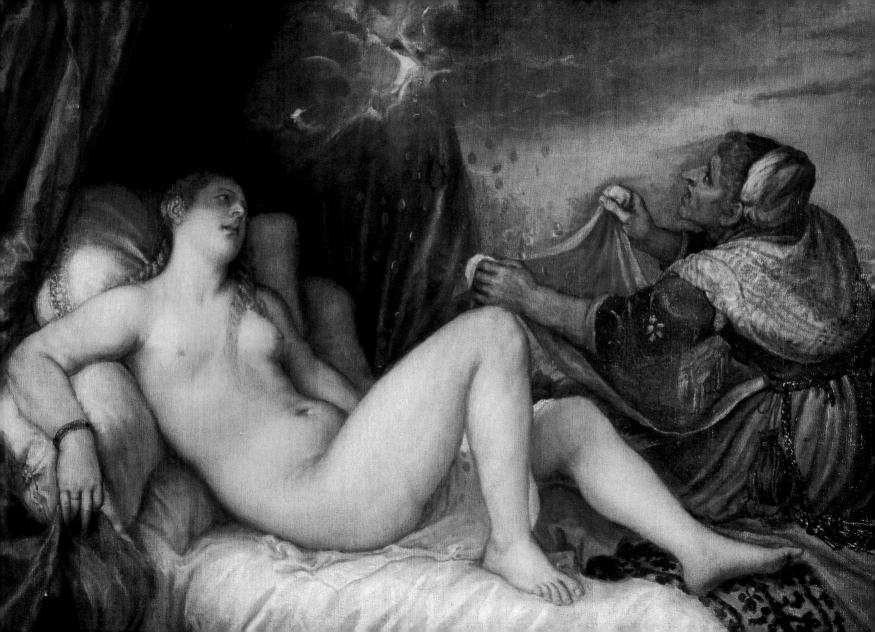

I shut my eyes in order to see.

<small>PAUL GAUGUIN</small>

Near the Sea, 1892
Paul Gauguin
National Gallery of Art, Washington D.C.

1 2 3 4 5 6 7 8 9 10 11 12 13 14 15 16 17 18 19 **20** 21 22 23 24 25 26 27 28 29 30 31

DECEMBER

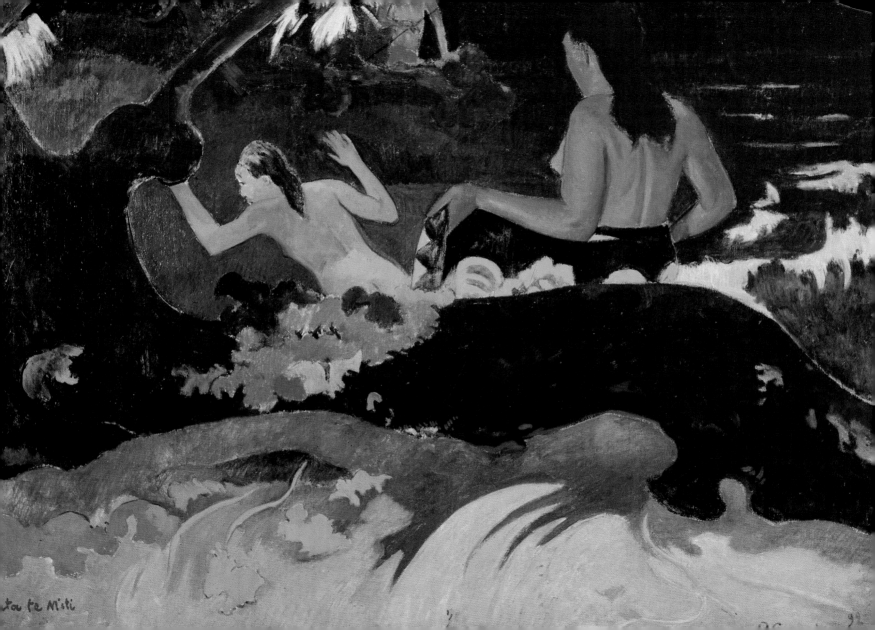

Fa te Miti

*Be careful to leave your sons
well instructed rather than rich,
for the hopes of the instructed
are better than the wealth
of the ignorant.*

Epictetus

**Eleonora of Toledo with
Her Son Giovanni,** 1544–45
Agnolo Bronzino
Uffizi Gallery, Florence

1 2 3 4 5 6 7 8 9 10 11 12 13 14 15 16 17 18 19 20 **21** 22 23 24 25 26 27 28 29 30 31

December

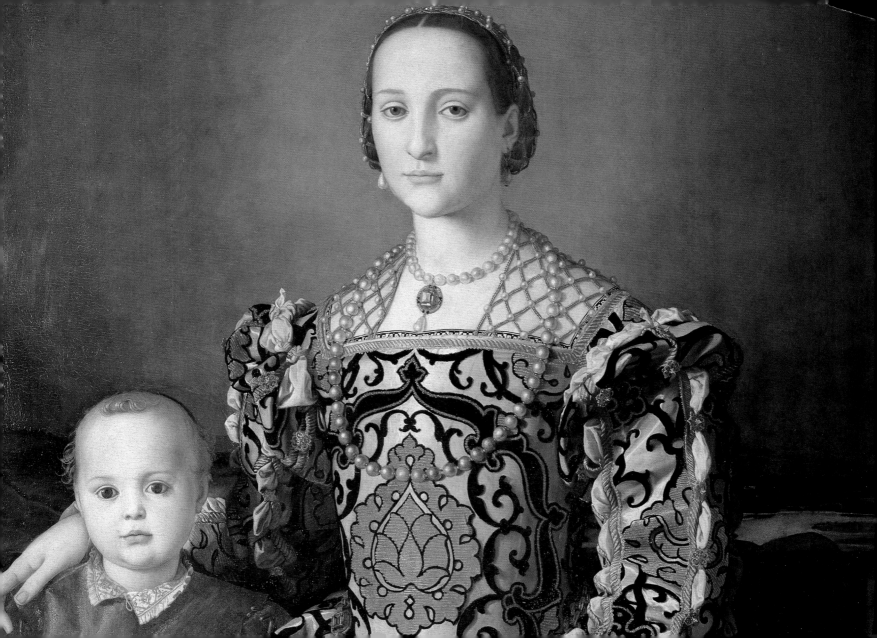

Saint Jerome. Thomas Altarpiece,
15th century
Pedro Berruguete
Saint Thomas Monastery, Avila

Language is the archive of history.

Ralph Waldo Emerson

1 2 3 4 5 6 7 8 9 10 11 12 13 14 15 16 17 18 19 20 21 **22** 23 24 25 26 27 28 29 30 31

DECEMBER

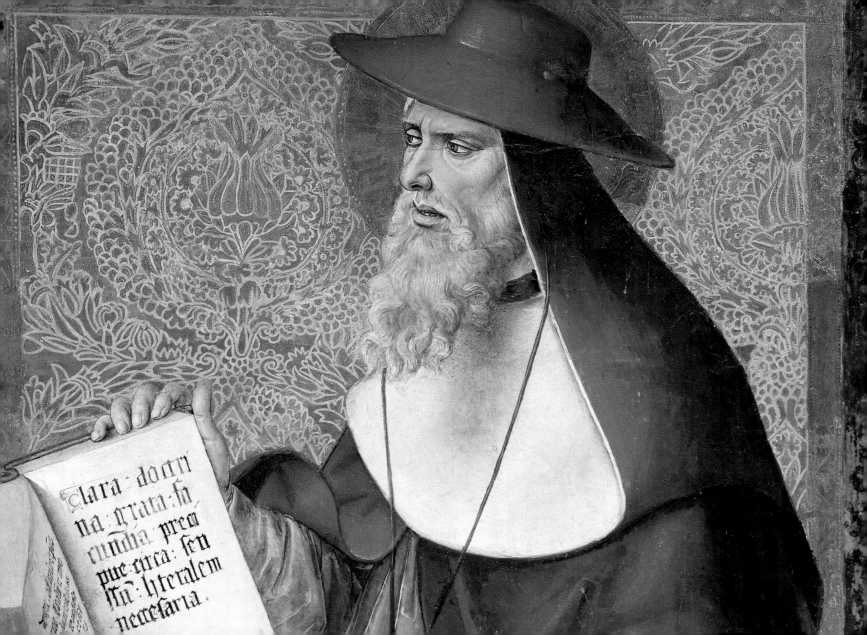

Clara doctri
na grata: fa
cunda preca
pue erica: sen
su: literalem
necessaria

... perfection is what I endeavor to attain ...

Raphael

The Sistine Madonna, c. 1513
Raphael
Gemäldegalerie, Dresden

1 2 3 4 5 6 7 8 9 10 11 12 13 14 15 16 17 18 19 20 21 22 **23** 24 25 26 27 28 29 30 31

DECEMBER

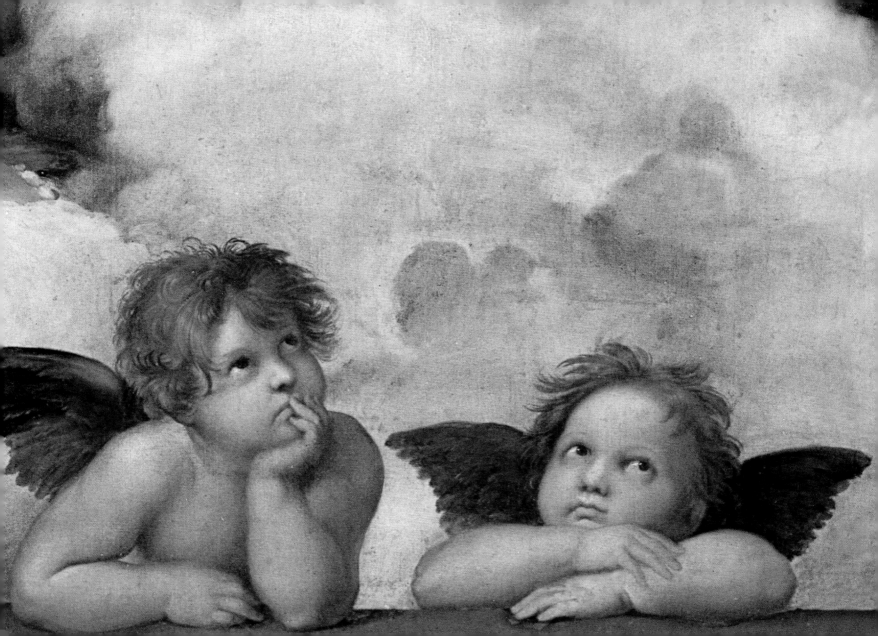

Angels can fly because they take themselves lightly.

G. K. CHESTERTON

Three Floating Angels, late 15th century
Master of the Housebook
Kunstmuseum Basel

1 2 3 4 5 6 7 8 9 10 11 12 13 14 15 16 17 18 19 20 21 22 23 **24** 25 26 27 28 29 30 31

DECEMBER

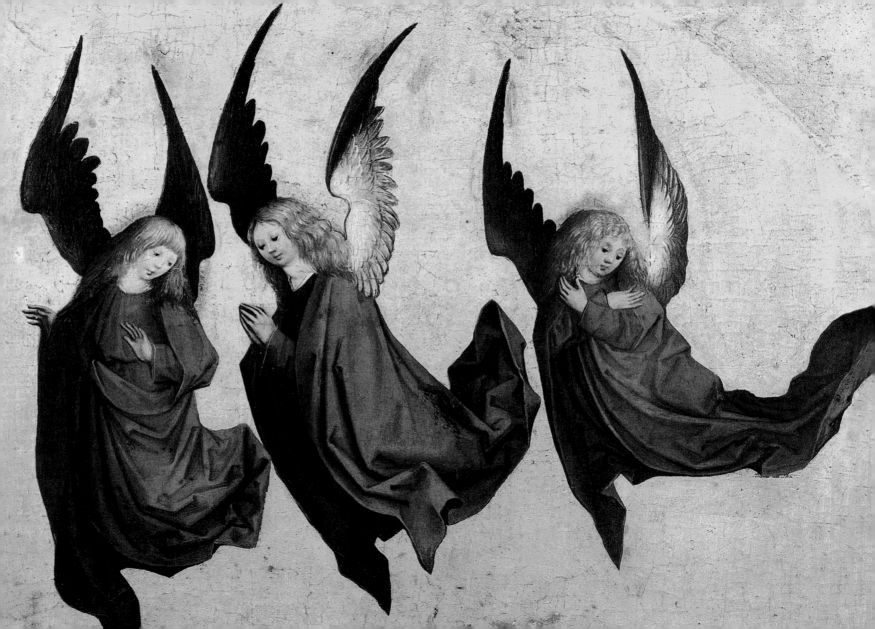

I heard the bells on Christmas Day
Their old, familiar carols play,
And wild and sweet the words repeat
Of peace on earth, good-will to men!

Henry Wadsworth Longfellow

Adoration of the Shepherds, 1622
Gerrit van Honthorst
Wallraf-Richartz-Museum, Cologne

1 2 3 4 5 6 7 8 9 10 11 12 13 14 15 16 17 18 19 20 21 22 23 24 **25** 26 27 28 29 30 31

DECEMBER

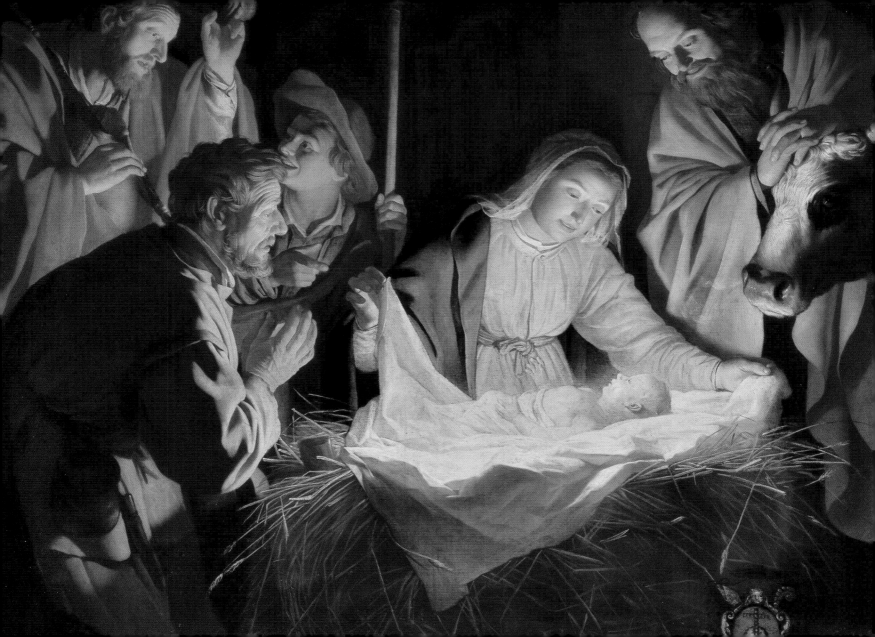

*It is impossible to imagine
a more complete fusion
with nature than that of the Gypsy.*

Franz Liszt

Winter Landscape with Gypsies,
early 17th century
Gysbrecht Lytens
Kunsthistorisches Museum, Vienna

1 2 3 4 5 6 7 8 9 10 11 12 13 14 15 16 17 18 19 20 21 22 23 24 25 **26** 27 28 29 30 31

DECEMBER

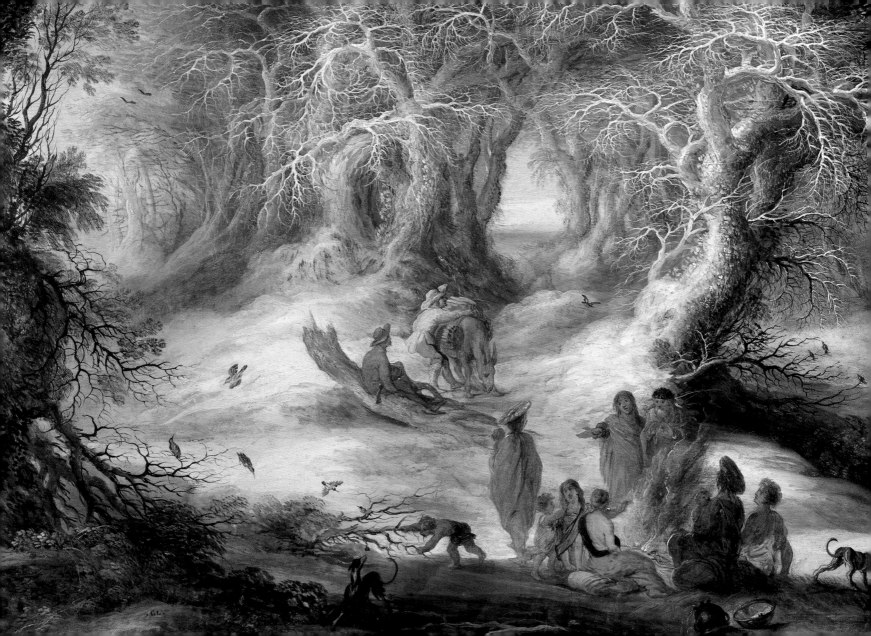

If you must play, decide upon
three things at the start:
the rules of the game,
the stakes, and the quitting time.

<small>CHINESE PROVERB</small>

Two Men Playing Cards
in the Kitchen of an Inn, 17th century
David Teniers
National Gallery, London

1 2 3 4 5 6 7 8 9 10 11 12 13 14 15 16 17 18 19 20 21 22 23 24 25 26 **27** 28 29 30 31

DECEMBER

In seed time learn,
in harvest teach,
in winter enjoy.

WILLIAM BLAKE

Ice Scene, early 17th century
Hendrik Avercamp
Mauritshuis, The Hague

1 2 3 4 5 6 7 8 9 10 11 12 13 14 15 16 17 18 19 20 21 22 23 24 25 26 27 **28** 29 30 31

DECEMBER

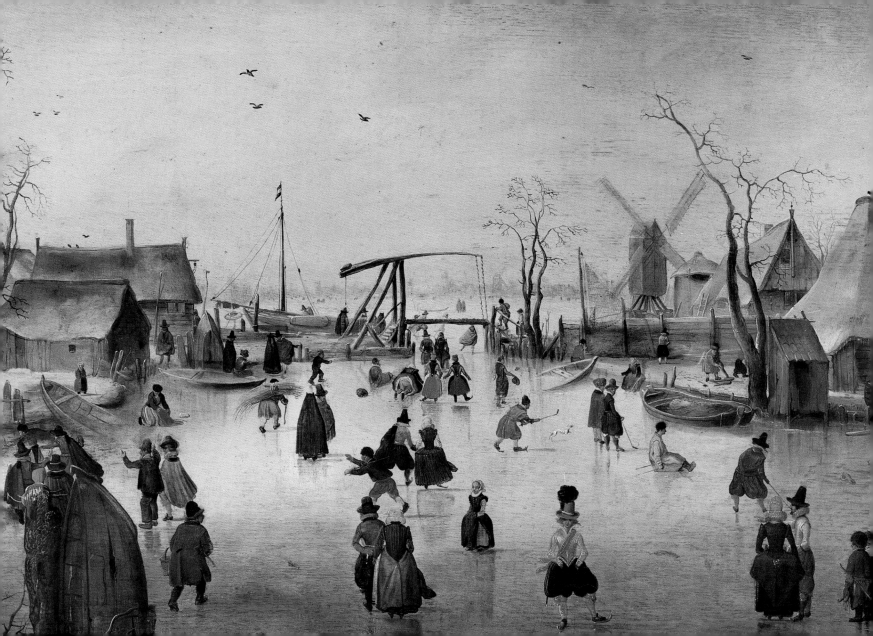

I paint things as they are.
I don't comment. I record.

Henri de Toulouse-Lautrec

At the Races, 1899
Henri de Toulouse-Lautrec
Musée Toulouse-Lautrec, Albi

1 2 3 4 5 6 7 8 9 10 11 12 13 14 15 16 17 18 19 20 21 22 23 24 25 26 27 28 **29** 30 31

DECEMBER

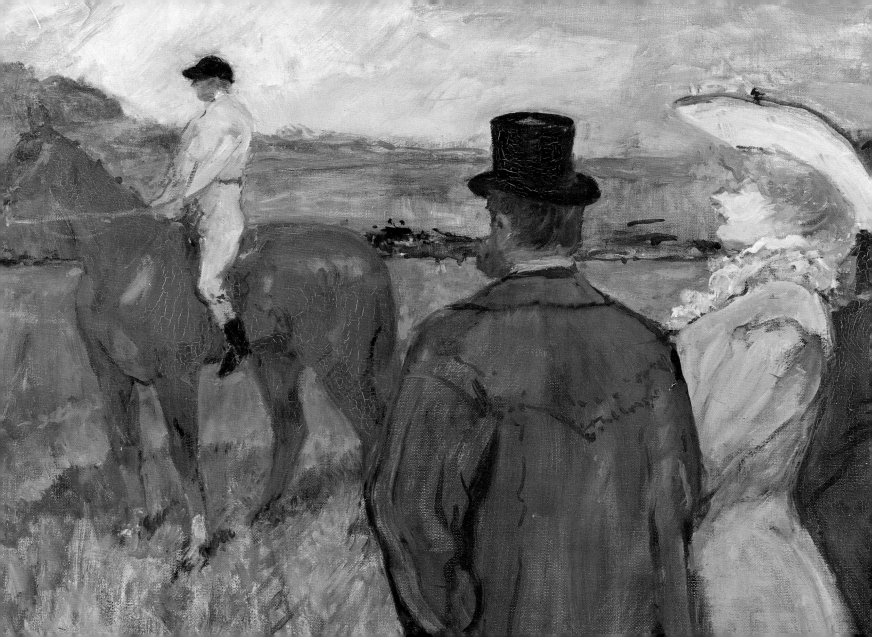

*Music is the universal language
of mankind.*

Henry Wadsworth Longfellow

A Concert, *c.* 1623
Dirck van Baburen
The State Hermitage Museum, St. Petersburg

1 2 3 4 5 6 7 8 9 10 11 12 13 14 15 16 17 18 19 20 21 22 23 24 25 26 27 28 29 **30** 31

December

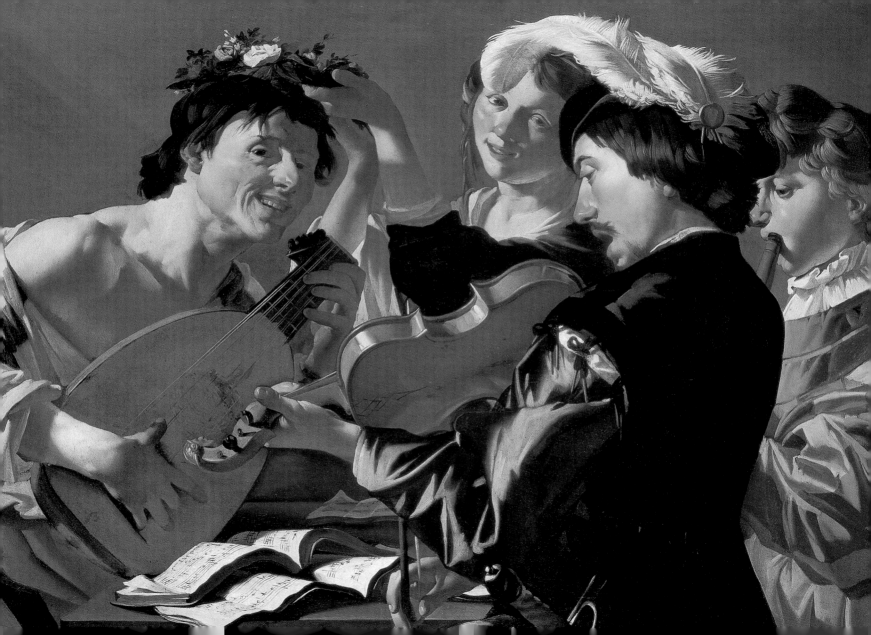

Ring out the old, ring in the new,
Ring, happy bells, across the snow:
The year is going, let him go;
Ring out the false, ring in the true.

<small>ALFRED LORD TENNYSON</small>

The Three Philosophers, 1508–09
Giorgione
Kunsthistorisches Museum, Vienna

1 2 3 4 5 6 7 8 9 10 11 12 13 14 15 16 17 18 19 20 21 22 23 24 25 26 27 28 29 30 **31**

DECEMBER

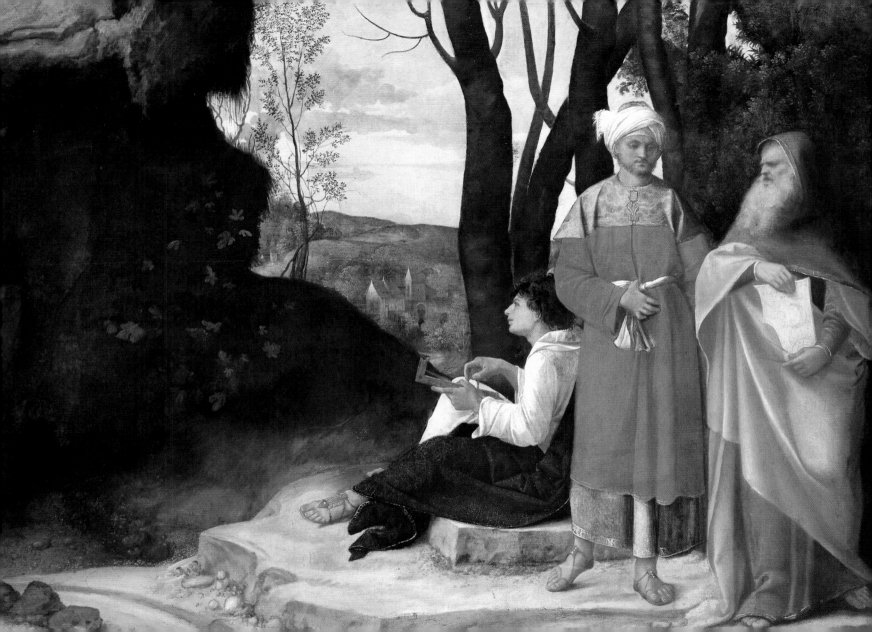

List of Artists

Altdorfer, Albrecht (c. 1480–1538) *June 8, November 17*

Amann, Jost (1539–1591) *January 11*

Anquetin, Louis (1861–1932) *October 16*

Arcimboldo, Giuseppe (1527–1593) *April 20, August 22*

Ast, Balthasar van der (1593–1657) *November 13*

Avercamp, Hendrick (1585–1634) *February 26, December 28*

Baburen, Dirck van (1595–1624) *December 30*

Backhuyzen, Ludolf (1631–1708) *November 25*

Bakhtin, Konstantin (20th century) *October 6*

Baldung, Hans (1484/85–1545) *December 3*

Balen, Hendrik van (1575–1632) *August 20*

Bassano, Giacomo (1517–1592) *April 9*

Beckmann, Max (1884–1950) *January 21*

Bellini, Giovanni (1400–1470) *January 22*

Berckheyde, Gerrit Adriaensz (1638–1698) *November 2*

Berruguete, Pedro (c. 1450–1504) *December 22*

Bertier, Louis Eugène (1809–?) *March 26*

Bettera, Bartolomeo (1639–1688) *March 18*

Boccioni, Umberto (1882–1916) *April 25*

Borch, Gerard ter (1617–1681) *October 30*

Borisov, Alexander (1866–1934) *January 20*

Bosch, Hieronymus (1450–1516) *March 22, May 5, June 13, September 12*

Botticelli, Sandro (1444–1510) *March 3, May 17*

Boucher, François (1703–1770) *July 20, July 27, September 29, December 12*

Bray, Jean de (1627–1697) *October 26*

Bronzino, Agnolo (1503–1572) *June 22, December 21*

Brueghel the Elder, Jan (1568–1625) *February 7, April 4, August 20*

Brueghel the Elder, Pieter (1525/30–1569) *January 5, February 21, July 22, October 1, November 7, December 17*

Brueghel the Younger, Pieter (1564–1638) *January 26*

Brugghen, Hendrick ter (1588–1629) *October 13*

Caillebotte, Gustave (1848–1894) *August 19*

Canaletto (1697–1768) *March 11, June 3, November 27*

Caravaggio (1571–1610) *September 15, October 8*

Cassatt, Mary (1845–1926) *July 8*

Cézanne, Paul (1839–1906) *January 1, January 24, March 19, June 16, July 30, August 21, September 30*

Chagall, Marc (1887–1985) *January 31, June 4*

Chardin, Jean-Baptiste S. (1699–1779) *April 6*

Chase, William Merritt (1849–1916) *August 15*

Chirico, Giorgio de (1888–1978) *February 3*

Church, Frederic Edwin (1826–1900) *September 7*

Claesz, Pieter (1596/97–1661) *January 8, October 25, December 10*

Cleve, Maerten van (1527–1581) *March 31*

Corinth, Lovis (1858–1925) *February 20, February 27, July 21*

Correggio (1489–1534) *March 10*

Courbet, Gustave (1819–1877) *June 21*

Cranach the Elder, Lucas (1472–1553) *March 5, October 24*

Crespi, Giuseppe (1600–1630) *March 7*

David, Jacques-Louis (1748–1825) *March 1, November 26*

Degas, Edgar (1834–1917) *February 12, March 23, May 3, August 11, August 27, October 20, December 13*

Delacroix, Eugène (1798–1863) *July 28, September 13, October 9*

Dossi, Dosso (1489/90–1542) *January 30, November 15*

Dou, Gerrit (1613–1675) *February 14, May 2*

Dürer, Albrecht (1471–1528) *May 9, August 23, November 1*

Dyck, Floris van (1599–1641) *September 24*

El Greco (1541–1614) *June 19, November 11*

Eyck, Jan van (c. 1390–1441) *June 2, November 29*

Fabriano, Gentile da (1370–1427) *January 6*

Fiorentino, Rosso (1494–1540) *May 29, December 7*

Flemish (17th century) *August 13*

Fortuny, Mariano (1838–1874) *August 12*

Fragonard, Jean-Honoré (1732–1806) *April 29, May 27, November 22*

Francken II, Frans (1581–1642) *November 4*

Fresco, Pompeii (1 AD) *January 29*

Friedrich, Caspar David (1774–1840) *September 14, October 2, November 3, December 6*

Gabbiani, Anton Domenico (1652–1726) *October 22*

Gainsborough, Thomas (1727–1788) *May 16, September 17*

Gauguin, Paul (1848–1903) *June 20, July 26, August 17, December 20*

Géricault, Theodore (1791–1824) *September 26*

Giaquinto, Corrado (1699–1765) *April 24*

Giordano, Luca (1634–1705) *November 8*

Giorgione (1478–1510) *May 13, August 6, December 31*

Gogh, Vincent van (1853–1890) *January 4, March 2, May 10, June 26, August 14, September 19*

Goya, Francisco José de (1746–1828) *February 15, March 17, May 11, June 25, July 1, August 4, September 6, December 9*

Grünewald, Matthias (1470/83–1528) *April 16*

Hamilton, Johann Georg de (1672–1737) *October 12*

Hassam, Childe (1859–1935) *February 10, August 15, August 28, October 31*

Heem, Jan Davidsz de (1606–1684) *August 16*

Hiroshige, Utagawa (1797–1858) *January 16, March 13, June 10, October 14*

Hodler, Ferdinand (1853–1918) *March 9, June 18*

Hoecke, Jan van den (1611–1651) *February 5*

Hogarth, William (1697–1764) *November 10*

Hokusai, Katsushika (1760–1849) *May 12*

Holbein the Elder, Hans (1465–1524) *March 8*

Holbein the Younger, Hans (1497–1543) *October 21, December 18*

Homer, Winslow (1836–1910) *September 16, October 18*

Honthorst, Gerrit van (1592–1656) *October 27, December 16, December 25*

Hoogstraten, Samuel van (1627–1678) *August 18*

Horemans, Peter Jakob (1700–1776) *June 17*

Illustration of Anvar-I Suhaili for Jalaluddin Muhammad Akbar (16th/17th centuries) *April 13*

Johns, Jasper (1930–) *July 4*

Jordaens, Jacob (1593–1678) *May 25*

Kahlo, Frida (1907–1954) *February 23*

Kandinsky, Wassily (1866–1944) *May 22, September 5*

Kaulbach, Friedrich August von (1850–1920) *May 21*

Keller, Albert von (1844–1920) *February 6*

Kirchner, Ernst Ludwig (1880–1938) *March 30, April 14, October 11*

Klimt, Gustav (1862–1918) *January 19, February 25, April 3, May 18, July 14, August 24*

Kustodiev, Boris H. (1878–1927) *March 16*

Photo Credits

The images in this book were kindly made available by Artothek Weilheim:
(Artothek / Joachim Blauel: January 3, 11, 21, 28, 31, February 2, 14, 27, 28/29, March 2, 4, 5, 6, 14, 30, April 19, 22, 26, 28, May 1, 15, 19, June 4, 6, 8, 18, 26, July 3, 5, 7, 21, 23, August 6, 17, September 5, 6, 14, 18, 19, October 7, 21, 28, 31, November 19, 30, December 2, 3, 11, 12, 25, 28; Artothek / Blauel / Gnamm: January 17; Artothek / Jochen Remmer: January 5, 19, 27, February 4, 24, March 8, 16, April 3, 23, May 2, 23, 28, June 21, 27, July 10, 14, 29, August 9, 24, 27, September 9, 10, October 9, 24, November 16, December 8, 16; Artothek / Paolo Tosi: January 6, 10, 30, February 5, March 3, 7, 11, 20, 24, 29, April 1, 24, May 8, 17, 29, 30, June 23, 24, August 16, October 8, 15, 22, 27, November 25, December 1, 5, 7, 21; Artothek / Joseph S. Martin: January 7, 12 , 23, February 1, 15, 17, 19, 21, March 1, 17, 21, 22, 28, April 8, 10, 16, 20, 21, 25, 27, 29, 30, May 7, 9, 13, 16, 20, June 5, 16, 19, 25, July 1, 8, 9, 12, 16, 17, 19, 25, 30, August 4, 7, 8, 12, 25, September 12, 17, 26, 27, 28, October 20, 29, November 8, 10, 22, 24, 29, December 4, 9, 18, 20, 22, 27, 29; Artothek / Photobusiness: January 22, 25, February 7, 13, March 10, April 4, 15, May 24, 25, June 9, 15, August 10, 13, 20, 22, 29, 31, October 1, 10, 12, 13, 30, November 7, December 26, 31; Artothek / Sophie-R. Gnamm: February 8, March 18, May 6, September 11, October 2, December 6; Artothek / Peter Willi: February 11, October 17; Artothek: January 1, 2, 4, 8, 9, 13, 14, 15, 20, 24, 26, 29, February 3, 6, 12, 16, 20, 25, 26, March 9, 15, 19, 23, 25, 26, 27, April 2, 5, 6, 7, 9, 11, 17, 18, May 3, 5, 10, 21, 22, 27, 31, June 1, 3, 7, 11, 12, 17, 20, 22, 28, 29, 30, July 6, 11, 15, 18, 20, 22, 24 26, 27, August 5, 14, 23, 26, September 1, 3, 4, 13, 15, 21, 22, 23, 24, 25, 30, October 5, 6, 16, 19, 23, November 1, 2, 3, 4, 5, 6, 9, 11, 12, 15, 17, 20, 26, December 13, 14, 15, 17, 19, 23, 30)
with the exception of akg-images, Berlin: July 4.
Artwork not listed here was taken from the Publisher's archive.

Images on the cover:
Front cover: see August 1
Spine: see June 26
Back cover (from left to right): see March 3, July 8, December 23 and February 28/29

www.artothek.de